NEW PERSPECTIVES IN ITALIAN CULTURAL STUDIES

The Fairleigh Dickinson University Press Series
In Italian Studies

General Editor: Dr. Anthony Julian Tamburri, Dean
John D. Calandra Italian American Institute (Queens College–CUNY)

The Fairleigh Dickinson University Press Series in Italian Studies is devoted to the publication of scholarly works on Italian literature, film, history, biography, art, and culture, as well as on intercultural connections, such as Italian-American Studies.

Recent Publications in Italian Studies

Parati, Graziella, *New Perspectives in Italian Cultural Studies—Volume 2: The Arts and History* (2012)
Pezzotti, Barbara, *The Importance of Place in Contemporary Italian Crime Fiction* (2012)
Aliano, David, *Mussolini's National Project in Argentina* (2012)
Parati, Graziella, *New Perspectives in Italian Cultural Studies—Volume 1: Definition, Theory, and Accented Practices* (2012)
Smith, Shirley Ann, *Imperial Designs: Italians in China, 1900–1947* (2012)
Rosengarten, Frank, *Giacomo Leopardi's Search for a Common Life through Poetry: A Different Nobility, a Different Love* (2012)
Baliani, Marco (au.), Nicoletta Marini-Maio, Ellen Nerenberg, Thomas Simpson (trans. and eds.) *Body of State: A Nation Divided* (2012)
Ducci, Lucia, *George P. Marsh Correspondence: Images of Italy, 1861-1881* (2012)
Verdicchio, Pasquale, *Looters, Photographers, and Thieves: Aspects of Italian Photographic Culture in the Nineteenth and Twentieth Centuries* (2011)
Parati, Graziella and Anthony Julian Tamburri (eds.), *The Cultures of Italian Migration: Diverse Trajectories and Discrete Perspectives* (2011)
Trubiano, Marisa S., *Ennio Flaiano and His Italy: Postcards from a Changing World* (2010)
Halliday, Iain, *Huck Finn in Italian, Pinocchio in English: Theory and Praxis of Literary Translation* (2009)
Serra, Ilaria, *The Imagined Immigrant: The Images of Italian Emigration to the United States between 1890 and 1924* (2009)
Lucamante, Stefania (ed.), *Italy and the Bourgeoisie: The Re-Thinking of a Class* (2009)
Van Order, Thomas, *Listening to Fellini: Music and Meaning in Black and White* (2008)
Billiani, Francesca, and Gigliola Sulis, *The Italian Gothic and Fantastic: Encounters and Rewritings of Narrative Traditions* (2008)
Parati, Graziella, and Marie Orton (eds.), *Multicultural Literature in Contemporary Italy*, Volume 1 (2007)
Orton, Marie, and Graziella Parati (eds.), *Multicultural Literature in Contemporary Italy*, Volume 2 (2007)
Scambray, Ken, *Queen Calafia's Paradise: California and the Italian-American Novel* (2007)
Polezzi, Loredana, and Charlotte Ross (eds.), *In Corpore: Bodies in Post-Unification Italy* (2007)
Francose, Joseph, *Socially Symbolic Acts: The Historicizing Fictions of Umberto Eco, Vincenzo Consolo, and Antonio Tabucchi* (2006)
Kozma, Jan (trans.), Grazia Deledda, *Marianna Sirca* (2006)

On the Web at http://www.fdu.edu/fdupress

NEW PERSPECTIVES IN ITALIAN CULTURAL STUDIES

Volume 2: The Arts and History

Edited by Graziella Parati

FAIRLEIGH DICKINSON UNIVERSITY PRESS
Madison • Teaneck

Published by Fairleigh Dickinson University Press
Co-published with The Rowman & Littlefield Publishing Group, Inc.
4501 Forbes Boulevard, Suite 200, Lanham, Maryland 20706
www.rowman.com

10 Thornbury Road, Plymouth PL6 7PP, United Kingdom

British Library Cataloguing in Publication Information Available

Library of Congress Cataloging-in-Publication Data

New perspectives in Italian cultural studies : the arts and history / edited by
Graziella Parati.
 p. cm.
 "Volume 2."
 One of two volumes originating from a conference on Italian cultural studies
held at Dartmouth College in 2010. The first volume is entitled New perspec-
tives in Italian cultural studies : definitions, theory, and accented practices.
 Includes bibliographical references and index.
 ISBN 978-1-61147-566-1 (cloth : alk. paper)—ISBN 978-1-61147-568-5
(electronic) 1. Italy—Social life and customs—1945—Congresses. 2. Popular
culture—Italy—Congresses. 3. Italy—Civilization—1945—Congresses. I.
Parati, Graziella. II. New perspectives in Italian cultural studies
 DG451.N494 2012
 945—dc23 2012025359

Printed in the United States of America

CONTENTS

PART II FILM

PART III THE ARTS

PART IV FASCISM

ACKNOWLEDGMENTS

These two volumes of essays would have not have been possible were it not for the wonderful people at Dartmouth College who first supported the Conference on Italian Cultural Studies held in May 2010 and, later, the collected essays from that event. In particular, I need to thank Ken Yalowitz and Christianne Hardy Wohlforth at the Dickey Center for International Understanding, Adrian Randolph, director of the Humanities Center, Carol Folt, dean of the Faculty of Arts and Sciences, Kate Conley, associate dean of the Humanities, and Barry Scherr, provost of Dartmouth College, and the Ramon and Marguerite Guthrie Fund of the Department of French and Italian at Dartmouth College. I am particularly grateful for the funds from the Paul D. Paganucci Chair in Italian Literature and Language. I owe thanks to every one of the contributors to this collection, all of whom considered it worthwhile to devote a great deal of time and energy to participating in this collection of essays. Special thanks go to Marie Orton for her help, as usual, and to a wonderful librarian Miguel Valladares.

VOLUME II INTRODUCTION: CULTURAL CRITIQUE AND ITALIAN CULTURAL STUDIES

Graziella Parati

> [Cultural studies needs] a theoretical foundation that may enable us to move beyond a critical understanding of the hegemonic power of euro-modernity not only over people's lives but also over the very imagination of possible ways of being modern, to the recognition of other possibilities—of other modernities as well as alternatives to modernity.[1]

In her book, *The Task of Cultural Critique*, Teresa Ebert criticizes cultural studies, defining it as a canonic cultural critique that has made it impossible to "understand social injustice, class difference and the violent rule of capital as objective historical reality."[2] According to Ebert, cultural studies focuses on categories that privilege representation in which that freedom that cannot be found in the daily life of workers still finds an unthreatening space. That freedom is unthreatening to capitalism inasmuch as it is the subject of cultural studies that focuses on singularities and ignores what really threatens capitalism, namely an understanding of "social totality."[3] Ebert promotes a cultural critique that can "understand culture in materialistic terms as an extension of the social relations of production."[4] Only this approach to culture can produce real activism and chance in the world while cultural studies' "eclectic activism"[5] remains "textual,"[6] that is, academic and ineffectual.

Ebert demands that we rewrite "materialism and class back into cultural critique"[7] and that we do away with the fragmentation and plurality of approaches to cultural analysis that we find in "contemporary cultural critique [that] has turned culture into zones of nomadic meanings and floating singularities."[8] Ebert eloquently invites us to embrace the concept that cultural critique "must become an explanation of totality and understand the singular in the collective," stressing the subordination of the singular to the totality.[9]

Ebert's incisive criticism of cultural studies betrays a certain nostalgia for master narratives that can offer clear answers to complex issues. Her focus on class is particularly pertinent at a time when class has been upstaged by other categories such as gender or ethnicity, and a return to its centrality is necessary if we are to understand the present "in the service of the future."[10] Ebert emphasizes the role that the intellectual must have in changing the world; cultural studies stresses the role of the intellectual in cultural contexts that demand to be understood in their complexity so that change can be enacted. The goal of cultural studies and of Ebert's approach based on class and materialism are related. Cultural studies affirms the need to take a number of critical categories into consideration including singularity, identity construction, gender, class, ethnicity, and even feelings through valuable tools such as affect theory. While Ebert considers cultural studies to be ineffective outside of academia, Lawrence Grossberg's recent observations on cultural studies remind us that ideas matter and cannot be easily erased.

In his book *Cultural Studies in the Future Tense*, Grossberg responds to criticism such as Ebert's and emphasizes that "theory is always in the service of the concrete, enabling one to produce the concrete in more productive ways."[11] However, cultural studies and its plural approaches to culture must think of its future transformations. Grossberg's articulation of the possible futures in cultural studies informs my description of the structure of this second volume of essays that were first presented at the conference on cultural studies at Dartmouth College, held in May 2010. *New Studies in Italian Culture: The Arts and History* is shaped by an awareness that, as Grossberg observes, although cultural studies is grounded in interdisciplinarity, the work done in individual disciplines cannot be discounted.

New Studies in Italian Culture focuses on the research undertaken in Italian studies around issues that have a wider reach, and with this volume in particular: the articulated constructions of North and South within the same ostensibly homogenous national context, the role of a culture located at a crossroads in the Mediterranean, the ever present legacy of the fascist dictatorship whose ideological traces remain visible, even in the identity of Italian cities, and the role of Italy in the American cultural imagination, which at one point viewed Italian culture as a starting point for America's cultural internationalization. Inevitably, this project can only constitute a small contribution to the debate on practicing cultural studies by starting from a limited national context in order to connect investigations of local cultures to more global and nuanced approaches, and thus articulating accented interpretations that can only be limited and limiting unless a more collaborative and interdisciplinary project can be developed.

In this regard, Grossberg underscores the complexity of interdisciplinarity, which requires collaborations across disciplines and among people in and outside academia, and erases the traditional separation between what is done inside and outside OF a university environment. The goal is to offer "better and more useful stories and analyses of the contemporary context of living in all their complexity."[12] It is the inevitable reiteration of the word complexity that compels us to admit that, as Grossberg stresses, cultural studies has relied upon Western theoretical frameworks that a politically responsible cultural studies practitioner must question. Grossberg adds that we must begin "to take the category of modernity out of the hands of the west"[13] and think "about multiple modernities."[14] This new approach will lead us "to embrace a different kind of universality: not the universal singular but the singular universal. . . . [That is] universality as movement across non-hierarchically arranged particulars. This is a universality that is neither teleological (developmental) nor expansive (totalizing)."[15] This project on Italian cultures focuses on the complexity of a border culture that bridges a North and South and uncovers narratives of exchanges between Europe and the Mediterranean context. As one example of Mediterranean modernities, Italy offers only a limited "story" about the complexity of issues in a border area and that very complexity demands future collaborations and more articulated discussions on the cultures in the Mediterranean basin.

SECTION ONE: FICTION

While Grossberg reminds us that "bad stories make bad politics," David Ward's article explores an example of politicians that pillage fascinating stories in order to create bad politics. "Massimo D'Azeglio's *Ettore Fieramosca*: The Necessity and the Joy of Fiction" discusses conflict in Southern Italy and its representation throughout the centuries by examining interpretive approaches to the *Disfida di Barletta,* a belligerent confrontation that took place in 1503 between the Italians (though at the time "Italy" did not yet exist politically) and the French. Throughout the centuries, the "Italian" victory with its attendant perception of "Italy" has been represented very differently in literature, film, and in the cultural imagination, and with very different meanings. The representation of a local victory has served to give meaning to borders and boundaries that define North and South as well as to the lines of demarcation between Europe and what is "the real South." In fact, this "historical" event, which actually took place in Apulia, has been employed recently by the Northern League to sustain its politics of Northern micro-nationalism. The League's interpretation of the *disfida* adds other layers to the malleable definitions of Italian borders as a cultural context. Italy is a border area that complicates the definition of separations between Europe and "the South."

Roberto Derobertis follows Ward's ironic discussion of the appropriation of Southern narratives with an essay that continues and complicates the definition of what "the South" is in contemporary Italy. His "From *Serie A to Serie Africa* and Back: Soccer, Race, and the Making of an Italian Identity in Brizzi's *L'inattesa piega degli eventi*" examines a dystopic space located at the center of Brizzi's political fiction novel in order to investigate racist strategies in the hypothetical 1960s, still ruled by a fascist dictatorship. Brizzi's narrative about an Italian coach sent to East Africa to organize the soccer championship centers on sports as a cultural space dominated by normative practices in the colonies. Derobertis' analysis moves from a discussion of a historical fiction to a discussion of the interpretation of otherness in contemporary Italy, particularly in soccer, and, specifically, of the perceptions of the complex identity of the first-division soccer player

Mario Balotelli, a black Italian citizen. In Derobertis' essay, literature functions as a powerful cultural studies tool in *his* investigation of the perception of "race" in contemporary Italian culture. This novel of historical fiction creates a contextualized inscription of racism in a dictatorial environment, revealing parallels to the widespread racism in a later "democratic" Italy. The result is a frightening portrayal of the traces of a checkered historical past so relevant to the present construction of exclusions.

Floriana Bernardi's "Roberto Saviano: A Media Phenomenon to Recount the South" analyzes the impact that Roberto Saviano has had in Italian culture through his book *Gomorrah* and his revelation of the connections between organized crime and political and economic powers in Italy. Frequently appearing in the media, his engagement as a public intellectual has sparked the emergence of a "Beyond Gomorrah" phenomenon that revolves around his position as an intellectual (one who defines himself as "a man of the South"), and his take on interpretations of the "Southern question." He encourages people to actively contest any traditional relationship with local and national institutions of power with which they come in contact. Saviano is a valuable model of engagement in public discourses. In his position as a public intellectual, he demands change in the traditionally corrupt political system and invites other intellectuals to provoke and enact change in Italian culture.

Gabriella Turnaturi portrays the Mediterranean as a border area in which a literary genre can braid together cultural strands and become a popular product in Italy. The Mediterranean as the imagined location of mystery novels is the subject of her essay, "The Invention of a Genre: The Mediterranean Noir." Turnaturi approaches space from a literary/geographic/sociological point of view that connects "movement" to literary narratives with the construction of otherness in space. Turnaturi's contribution helps us understand the location of literature in cultural studies as a means for analyzing the transformations of definitions of otherness and of identities in space, as well as a means for revealing the "limits of solutions that are purely normative and controlling."

Krešimir Purgar's "Literature as Film: Strategy and Aesthetics of 'Cinematic' Narration in the Novel *I'm Not Scared* by Niccolo' Ammaniti" not only blurs the boundaries between literary and cinemato-

graphic texts, but also redefines the traditional translations of literature into film. In fact, Purgar destroys the typical linear movement from text to screen and highlights the overlapping processes of construction in writing literature and in filmmaking.

SECTION TWO: FILM

Eugenia Paulicelli follows an agenda similar to Purgar's as she hybridizes her analysis of Italian cinema with the art of fashion in Antonioni's films. Her "*Cronaca di un amore*: Fashion and Cinema in Michelangelo Antonioni's Films (1949–1955)" looks at the use of the artistically clothed female body in films that are often screen versions of literary texts. She interprets these films as both explorations of female identities and of Italian culture during the post-war years and the beginning of the economic boom.

Antonella Sisto's "Dubbing for Fun, Dubbing for Real" focuses on the post-war transformations of the meaning of dubbing in Italian cinema. She documents the value that dubbing acquires once it ceases to be used as a fascist tool for control and censorship. Sisto highlights the role that contemporary dubbing has played in talking back to the use of dubbing during fascism due to the playful nature that dubbing has acquired. She terms this transformation "dubbing for fun," and investigates the changes in the relationship between original text, translation, and dubbing.

Given that, cultural studies as a field has been highly indebted to feminist theory for the attention it has paid to equality and difference in theory and social practice, and in particular to identity politics, it is therefore quite appropriate to conclude this section on film with an essay that focuses of feminism and its interpretations in the film industry. Bernadette Luciano and Susanna Scarparo's "Contemporary Italian Women Filmmakers: Reframing the Past, the Present, and Cinematic Tradition" examines the negotiations at play in the definition of the identity of women filmmakers who often reject the label of feminist. Their discussion moves beyond the realm of Italian film production because the authors are interested in exploring how the intellectual positioning of a film director influences her interpretation of present and past histories.

SECTION THREE: THE ARTS

Elizabeth Mangini contributes to this section by evaluating the way in which "Mediterranean" nature is used in *arte povera*, specifically in Giuseppe Penone's sculpture. Her "Feeling One's Way through a Cultural Chiasm: Touch in Giuseppe Penone's Sculpture c. 1968" scrutinizes the artist's employment of the rural landscape in creating depictions of relational identities that manipulate the environment in order to represent tensions and violence in the 1970s, a decade marked by violence. Mangini approaches Perrone's art as a political project that, crossing the separations in art between vision and touch, aims to redefine the artistic experience.

Malcolm Angelucci's "Bolzano Bozen's Monument to Victory: Rhetoric, Sacredness, and Profanation" understands the role that monuments play in defining Bolzano as a space at the border between cultures. He focuses on the use of specific monuments that aimed to Italianize the city and creates a geosemiological reading of urban space. Angelucci interprets the transformations and use value of specific city markers through the periods of Austrian domination, Italian annexation, and fascism. These urban interventions on the city architecture embody the ever-changing ways in which this city has been imagined and offer an example of an international architecture that symbolizes conquest, appropriation, and an urban identity that is always in flux. "International" here acquires a negative connotation as it is always linked to some kind of oppressive design over the city. However, the essays that follows Angelucci's talks about a very different internationalizing project that took place in a rather remote area close to the border between the United States and Quebec.

Alberto Bologna's "The Cultural Contributions of Pier Luigi Nervi in the United States:1952–1979" tells of a project of internationalization that took place about fifty years ago in Hanover, New Hampshire, where Dartmouth College chose to hire the Italian architect who had planned the buildings for the 1960 Rome Olympic Games. Bologna delineates the meaning assigned to Italian architecture and, in particular, Pier Luigi Nervi's architectural designs in the United States and at Dartmouth College in the 1960s, in particular. Nervi's designs for the Leverone Field House and the Thomson Arena were

chosen by the College's administration to indicate their intent to acquire a more international identity, that is, to appear more international when international meant "European." Those designs created by an Italian architect demonstrated a new direction in the cultural inspirations of an Ivy League college whose geographical and cultural identity as an all male institution had made had been rendered quite insular.

SECTION FOUR: FASCISM

Maria D'Anniballe discusses urban space as portrayed in the cultural imagination beyond borders and languages. Her "Form Follows Fictions: Redefining Urban Identity in Fascist Verona through the lens of Hollywood's Romeo and Juliet" recounts the construction of the location where the legendary love between Romeo and Juliet presumably unfolded in Verona and focuses on the modifications of space to fit the representations of the fictional story seen in the movies. Construction here means an invention first inspired by Shakespeare's play and then by commercial representation on the screen of both the love story and the location where that love story took place. What we see now in Verona is a balcony that is in fact a sarcophagus, and a Romeo and Juliet courtyard identified by playing fast and loose with history. What is particularly striking is how film made in the United States impacted the plan to restructure an area the city of Verona at the time when American film was considered—and even publicly labeled—as a contaminating force on fascist culture.

In "Reading Crime in Fascist Italy" Victoria Belco elaborates the discussion on the complexity of Italian culture during fascism, focusing specifically on the legal system. She studies criminal cases in a rural area located in the province of Lucca and comes to the conclusion that these cases, "do not reveal a powerful Fascist State in action," but notes the efficient use of fascist connections when a case reached the courts. Legal culture testifies to the complex, but nevertheless incomplete penetration of a system of state control in the Italy of the 1930s while, at the same time, the "unofficial" but widespread use of connections (which

predates and postdates fascism) took on the character of an ideologically marked fascist network.

More direct fascist control on culture is documented in Eden Rebecca Knudsen's "The Rhetoric of Race in Fascist Elementary Education." Knudsen points out that the goal of the revisions of curricula in 1930s Italy was to create paradigms of whiteness and superiority grounded in a revision of historical narratives that would prove the superiority of the Italian *stirpe* and elevate the location of Italy and its culture from a geopolitical South to an aryan north.

CONCLUSION

Every time I am in the process of completing the editing of a volume or the writing of a book, I wonder if my work will be a worthwhile contribution to the field. I have finally found a statement on publishing in cultural studies that I find describes my approach to writing in this field. Lawrence Grossberg affirms: "our contribution should be measured by our participation in the collaborative conversation, not by claims of originality and difference, which can only be established by demonstrating the utter failure of everyone else."[16] The goal is, of course, to create intellectual communities whose work dialogues with the present and the past and promotes teaching differently. If interdisciplinarity and collaboration are the key words in the way we do research and teach in cultural studies, we also need to rethink the way we talk in class about the "possible relations"[17] between different worlds that our students should connect and study. I hope that it is in this spirit that both *New Perspectives on Italian Cultural Studies* and *New Studies in Italian Culture: The Arts and History* will be received.

NOTES

1. Lawrence Grossberg, *Cultural Studies in the Future Tense* (Durham and London: Duke University Press, 2010), 288.

2. Teresa Ebert, *The Task of Cultural Critique* (Urbana and Chicago: University of Illinois Press, 2009), ix.

3. Ibid., xii.
4. Ibid.
5. Ibid.
6. Ibid., xv.
7. Ibid.
8. Ibid., 196.
9. Ibid.
10. Grossberg, 1.
11. Ibid., 2.
12. Ibid., 3.
13. Ibid., 288.
14. Ibid., 289.
15. Ibid.
16. Ibid., 291.
17. Ibid., 293.

BIBLIOGRAPHY

Ebert, Teresa. *The Task of Cultural Critique*. Urbana and Chicago: University of Illinois Press, 2009.
Grossberg, Lawrence. *Cultural Studies in the Future Tense*. Durham and London: Duke University Press, 2010.

I

FICTION

I

MASSIMO D'AZEGLIO'S
ETTORE FIERAMOSCA

The Necessity and the Joy of Fiction
David Ward

If no historical event can exist prior to or outside of representation, it is also the case that some historical events owe their place in history and consciousness to representation more than others. One of these—la *Disfida di Barletta*, usually translated as the Barletta Challenge—is the subject of this chapter. The event itself took place in 1503, on a piece of land somewhere between Barletta, Andria, and Corato in Puglia. It took the form of a tournament fought out between two teams of knights, one French, the other Italian. The tournament had been occasioned by a French knight, fighting against Spain for control of territory in southern Italy, who when captured made an insulting remark about the lack of military prowess and valour of the Italian knights. This remark was relayed by the Spanish to the Italian knights who, in order to defend their honor and good name, challenged the French knights to a joust. So, on February 13, 1503, thirteen Italian knights, headed by Ettore Fieramosca fought against thirteen French knights headed by a certain Guy de la Motte/Guido della Motta.

The Barletta Challenge is but one of a long line of events that pitted Italy (even when the nation as such did not yet exist) against France, the one in competition with the other for a prize of some sort. In these competitions, Italy was always the underdog. In more recent times,

such competitions have taken place in a variety of arenas in which the two nations are pitted against each other, including fashion and sports such as cycling and football, the *Tour de France*, for example. Here Italian prowess has been immortalized by Paolo Conti's song about the time an Italian, Gino Bartali actually won the *Tour* in 1948;[1] or football, especially the European or World Championships, as was the case in 2006 in a game, the final of the World Cup, marked by what can only be called nonchivalric behavior by two of the players. As with the Barletta Challenge, an insult was issued, this time delivered by an Italian player, Marco Matterazzi, who apparently said something injudicious about the sister of an opposing player, Zinedine Zidane, who responded in kind by attempting to head-butt Matterazzi, which led to him being sent off the field of play and turned out to be major contributing factor to France's defeat (and Italy's victory). My sports references are actually less gratuitous that might appear at first sight. Duels between knights as a kind of free time activity were quite common in the fifteenth and sixteenth centuries, especially during the winters, when the knights were confined to their barracks, and when "la guerra 'horrenda,'" as it was known, with all its spilling of real blood, could not be fought. Now the enemy to be faced was boredom, and it was with duels that this battle was fought.[2]

Just as the Italian soccer team achieved victory in 2006, so did the Italian knights in 1503, but the manner of their victory was far more chivalric. Indeed, the Italian victory was more significant for the way it was achieved and what it said about the "Italian" character than for its military value (from which standpoint it was close to being irrelevant). The Italian Knights, in fact, impressed even their defeated French opponents with their complete and utter adherence to the dictates of the chivalric code. After comprehensively defeating the French knights, the Italians paraded triumphantly through the streets of Barletta. The event is marked now by a statue in the center of the town and on occasion, especially in 2003, the five hundredth anniversary of the *Disfida*, by a recreation of the event in the style of twenty-first-century Renaissance tourist culture replete with young men in striped tights waving flags.

However, it was in the 1830s, some three hundred years after the event, that the *Disfida* was really rediscovered. As we shall see shortly, the *Disfida* was lodged in Italian memory by way of the many nineteenth and twentieth century artistic representations that took it as their

central motif. One of the reasons why this particular event proved so popular, especially in the nineteenth century and the years leading up to unification, is that it reversed a national stereotype that began circulating in fifteenth and sixteenth century Europe and endures even into the present: namely, the charge that Italian were not chivalric warriors, far more inclined to stab their opponents from behind in the back than fight them face-to-face in the more refined and nobler chivalric mode of combat. This was a negative stereotype that was to have a long life, appearing in that hymn to the underdog that is Giovanni Pascoli's *La grande proletaria si è mossa*, as one of the reasons why Italians abroad were disdained: "Italians had never held a rifle in their hands, aimed a lance, handled a sabre: all they knew was how to use a dagger."[3]

Although the *Disfida* features in Guicciardini, and features as an oblique remark in chapter 26 of Machiavelli's *Principe*, as well as some more minor chronicles, the event did not enjoy a very high profile in other historical narratives.[4] All that was changed by Massimo D'Azeglio who discovered the event, initially as a subject for a painting he began but never finished, and then as the subject of a novel, *Ettore Fieramosca, ossia, La disfida di Barletta* on which he set to work after abandoning the idea of the painting. Published in 1833, the novel was an immediate success, something of a bestseller, so much so that it spawned a host of other treatments of the event, all of which owe their mould more to D'Azeglio's novel than to the historical record, so much so that for the authors of the operas and films to come it is the novel that effectively constitutes the historical record. There are, for example, at least twelve operas dedicated either to Ettore Fieramosca or to Ginevra, the beloved he is given in D'Azeglio's novel (there would be at least one more had not Giuseppe Verdi declined to compose one claiming that it had been done to death); there are sculptures and statues; and four films, two silent ones made in the second decade of the twentieth century, now lost, alas; a third film, *Ettore Fieramosca*, made under fascism by the leading director of the time Alessandro Blasetti; and a 1965 Bud Spencer movie entitled *Soldato di fortuna*, directed by Pasquale Festa Campanile.

It would be safe to say, then, that the *Disfida di Barletta* or its characters or both caught the imagination of both consumers and producers of all kinds of art. That enthusiasm has spilled over into a kind of competition to lay claim to the *Disfida*, either to its characters for whom all sorts

of towns and municipalities have made the case to be the birthplace of this or that knight, but also for the name of the event itself. In the 1930s, for example, the towns of Bari and Trani came to blows, literally, when violence broke out, leading to the deaths of two people. The confrontation came about as a result of the protests that were made when the town of Trani suggested that the Barletta Challenge would be more accurately named the Trani Challenge on the grounds that is was fought on land closer to Trani than Barletta.[5] All this is quite paradoxical, given that the reason for the *Disfida*'s popularity is the image it projects of Italian unity, a solidly compact coalition of disparate but always Italian elements lined-up against a common foe, ready to defend their dignity in the face of insults.

What drew D'Azeglio to the *Disfida* was his pursuit of an ethical-political project to make Italians, to create, that is, an otherwise missing national consciousness and pride in a national identity. Even several decades before actual unification, D'Azeglio was acutely aware of this absence and how it threatened to compromise the actions of patriots like himself. It was to this project that he dedicated his artistic and political life. At the heart of his intellectual activity, though, there is a contradiction that turns out to be its most productive guiding force. In order to build and foster the national spirit that is missing in the present, D'Azeglio looks back into Italy's past to locate the instances of an embryonic national consciousness that he hopes will serve as the harbinger of and the basis for things to come, the construction of the badly-needed but lacking national consciousness. But what he discovered was that there were precious few examples of embryonic national consciousness in the past. That, though, perhaps is not surprising. If a national consciousness is lacking in the present, one of the reasons for this is that it was also lacking in the past. Indeed, Italian literature is full of complaints made by the likes of Dante, Petrarch and many others that Italy is an almost hopelessly divided nation split apart by political factions and warring families in the Medieval and Renaissance periods, equally split apart in later years by ideological disputes and by a huge north/south gap. In his writings, D'Azeglio solves the quandary by way of fiction. D'Azeglio does not so much go into the past to find such examples as go into the past to find pretexts that offer him the opportunity to create such instances of national consciousness. In other words, he creates an

embryonic national consciousness either where it hardly existed or in the most embryonic of forms or simply did not exist at all. Deeming it important and necessary that it exist, D'Azeglio makes it exist. Fictional writing, then, is the basis of his ethical-political project, the motor that drives his art and the means by which D'Azeglio carries the project out. In other words, D'Azeglio's project is spurred on by an ethical drive to create in the present by way of a newly created or recast past that which is presently absent (and was largely absent also in the past). His writing, then, is a writing with an agenda; and insofar as it is a writing about history, the history he creates is a history with an agenda.

This is why there is considerable distance between what the historical record tells us of the *Disfida* and D'Azeglio's rendition of it. For example, the geography of D'Azeglio's Barletta and surrounding areas is very different from the town itself. In the novel, D'Azeglio tells us there is an island midway between Barletta and the Gargano to which Ettore repairs to visit his *beata*, Ginevra. A glance at a map or a walk along the promenade of one of the towns that lie between Barletta and the Gargano are enough to see that there is no such island. In addition to his imaginative topography, D'Azeglio includes characters like Cesare Borgia, who played no part in the actual event, but appears as a "baddie" in the novel. But D'Azeglio's most blatant fictive intervention is to endow the event a prominent nationalist underbelly, portraying it as an allegory of Italian unification avant la lettre. Although the concern to redress the image of Italy as "serva" that had been transmitted by the writings of Dante and Petrarch is present in the chronicles and other accounts of the *Disfida* that appeared in its immediate wake, D'Azeglio's treatment, like those of the other nineteenth century authors, painters, composers and sculptors who took up the event, is overtly nationalistic. Great store, for example, is set by the fact that D'Azeglio's thirteen knights come from all over Italy, whereas the historical record is vague about where they actually came from, and even if there were thirteen of them; and the motive for fighting these texts give them is their battered national rather than chivalric pride (which is a questionable assumption). The last words of Blasetti's film, for example, are "Italy has won!" D'Azeglio also includes among the French knights an Italian traitor, whose actual presence at the *Disfida* was, to say the least, dubious and, as traitors are destined to come off worst, is the only one of the enemy to come to a nasty end.

In the nineteenth century push toward unification, and in the years that followed, D'Azeglio was far from being the only patriot with an ethical-political nationalist project; nor was the *Disfida di Barletta* the only event that was revisited with a nationalistic eye. The Battle of Legnano, for example, fought on May 29, 1176, between the Lombard League, an alliance of northern Italian city states, and the Holy Roman Emperor Frederick Barbarossa, and won against the odds by the former, has had an even higher profile than the *Disfida di Barletta*. In its nineteenth-century revisitations, the heroics and unity of purpose of the Lombard towns are seen as forerunners of what would happen in the unification process and as a sign of Italy's deeply-rooted but always frustrated desire to be a proud and independent nation. In 1829, Giovanni Berchet published his *Le fantasie*, a text about the heroics of the battle.[6] And although, as we saw earlier, Verdi declined the invitation to compose an opera around the *Disfida*, in 1849—at the time of the Roman Republic—his *La battaglia di Legnano* was performed for the first time. The opera's final act is entitled "To defend the Fatherland," and its final words are "Italy is saved." Giosuè Carducci's "Della canzone di Legnano," written in 1879, also draws inspiration from the battle, as does the Italian national anthem, "L'Inno di Mameli" (after its author), with its verses "From the Alps to Sicily//everywhere is Legnano." Last but by no means least, the Battle of Legnano is also the subject of a painting by D'Azeglio, which dates from 1831, the period of his *Ettore Fieramosca.*

More recent fans of the battle have been the ideologues of the anti-immigration, anti-south, once secessionist now pro-federalist *Lega Nord* political party. This time, though, the heroics of the inhabitants of the northern towns are praised not so much for the way they illustrate a trait of the Italian national character as an example of local prowess that illustrates the superiority of northern Italians over southerners. Indeed, as its name suggests, the *Lega Nord* defends the Italian north, which it has renamed Padania (an entirely fictional geographical and cultural entity), against what it sees as threats to its interests from Rome, the seat of national government, now called *Roma ladrona*, from the south (the original number one enemy of the *Lega Nord* was the southern Italian immigrant), and now foreign immigrants. The symbol with which the *Lega* identifies itself at elections and in propaganda material is the

figure of a certain Alberto da Giussano. His claim to fame is his leadership of the so-called Company of Death whose members fought to their last in the Battle of Legnano.[7]

Encouraged by the leadership of the *Lega Nord*, and by the public funds—to the tune of 30 million—that were copiously made available to him, in 2009, Renzo Martinelli directed a very expensive Italian State-funded film, entitled *Barbarossa* that extolled the heroics of Giussano, played by the heart-throb Raz Degan, and the Lombard League. This film has been called, rather facetiously, the "Birth of the Nation of the *Lega Nord*."

The figure of Alberto Da Giussano is not the only element of the paraphernalia surrounding the Battle of Legnano that has been incorporated into *Lega Nord* iconography. The *Lega*, in fact, is sometimes also known as *Il Carroccio*, a reference to the four-wheeled altar where a city's flag or standard was displayed during battles (and which was defended in the Battle of Legnano by da Giussano and his Company of Death); and each year reenacts with great pomp and ceremony the Giuramento di Pontida, which originally took place in April 1167, before the Battle of Legnano, in which the cities that were to make up the Lombard League swore allegiance to each other and against the Holy Roman Emperor.[8]

It should come as little surprise that much of the mythology that the *Lega Nord* draws on is either groundless or built on the flimsiest of foundations. Padania is an entirely fictional geographical entity; and there is very serious doubt, for example, about whether Da Giussano ever existed and if the swearing-in ceremony ever took place. Both man and ceremony first put in an appearance in texts published several centuries after the events themselves.[9] This, however, has not prevented Giussano from having his own Facebook page. What the reaction of *Lega Nord* militants to such revelations would be, given the emotional investment large numbers of them have in the mythology, is an open question. But I doubt that many of them would take kindly to the suggestion that they are residing in an almost entirely fictional universe.

This is certainly not the case with D'Azeglio and the fictional universe he created around the *Disfida di Barletta*. In fact, he appears not to care at all about the factual inaccuracies his account of the *Disfida* contains. Indeed, he seems proud of them and is remarkably blasé about the extent to which his account of the Barletta Challenge is beholden to the

workings of his imagination and his ethical-political desires rather than to what the historical record could have told him about the event. He readily admits that he had never been to Barletta, having only looked briefly at a map to see the approximate distance between the town and a nearby mountain that appeared in the novel. Nor had he made any concerted effort to consult the extant historical documents and texts that covered the *Disfida*. Of the painting of the *Disfida*, for example, he notes that the setting was one of "rich vegetation," unknown in those parts, confessing a little sheepishly, in response to a critic who had pointed this out to him, that "even supposing there are now no fine trees between Andria and Corato, who can say they have not been cut down since 1503?."[10] Once the decision to write a novelistic account of the *Disfida* was taken, D'Azeglio, he tells us,

> instead of making historical inquiries about the period, artistic and topographical researches concerning the places, or, better still, going to see them, and familiarising myself with the spots I was to describe, as I ought to have done, I hardly had the patience to read through the pages Guicciardini has dedicated to the subject; and at once began the scene on the piazza of Barletta, about the Ave Maria, without the slightest notion of what sort of mess the result might be. What did I know about those localities? I measured the distance between Barletta and Mount Gragano on the first map of Italy I came across; and taking for granted that the latter must be visible from the former, at once brought it into my description as a background; I invented a Barletta, a fortress, an island of Sant'Orsola entirely my own, and thus went on straight as an arrow; creating first one of my *dramatis personae*, then another, giving birth, as I subsequently found, to a larger family than was wanted.

Although it is certainly the case that D'Azeglio's twisting and turning of the historical record are a function of his desire to tell a memorable story, it is also the case that the desire to tell such a story is a function of D'Azeglio's ethical-political project to supply Italy and Italians with useful nationalist myths. Despite the off-hand, almost self-disparaging manner with which D'Azeglio often speaks of his writings, we would do well not to lose sight of the project that drives them. Writing is at the core of this project. If, thinks D'Azeglio, patriotic Italian intellectuals are to have any role to play in the desired outcome of a united Italy, the

strongest card they can play is to influence public opinion through writing. On more than one occasion in his *Ricordi*, D'Azeglio associates political action with the written word. In the course of an audience he had requested with King Carlo Alberto, for example, in which he expounded his fears for the future, the conversation concluded with the exhortation that "it would now be advisable to write something."[11] And in a slightly later conversation with Cesare Balbo, again, as he says, about how to prepare "men's minds and characters in Italy," they resolved that "First of all it was necessary to write a book."[12]

But what kind of book, what kind of writing, and in what kind of language? Not only does D'Azeglio seek to write a book that tells the story of his "work for the slow regeneration of the national character. I had no wish but to awaken high and noble sentiments in Italian hearts";[13] he also seeks to write a book that tells a more counter-hegemonic story, one that aims to rid Italian hearts and minds of the pernicious influence that had conquered them, namely that of the radical, republican, and revolutionary agenda of Giuseppe Mazzini. D'Azeglio had no time at all for Mazzini or for Mazzinian politics. He speaks thus of the young Mazzinians in Milan who are engaged in exactly the same kind of activity as he is, D'Azeglio with his novels, involved in the

> dark and useless proceedings of the *Giovine Italia*, which merely consisted in the circulation of letters, documents, newspapers, and passports; assisting the flight of a secret agent, or such as were compromised; keeping up communications with prisoners, and the like. And to what purpose? They did not even know themselves, and I defy anbody else to tell. Not sharing in the views of the *Giovine Italia*, knowing the perfect inutility of all the agitation in which its devotees indulged; and, moreover, detesting those habits of perpetual lying (not to speak of the daggers), I completely eschewed the whole thing. I was, and am still, of the opinion that it is the national character which requires cultivation; that it is necessary to form the Italian mind, if we want Italy to be one nation; and when once it is formed, we shall indeed be able to say *Italia farà da sè*. Consequently I had devised a plan of acting on the public spirit by means of a national literature, and *Ettore Fieramosca* was the first step in that direction.[14]

D'Azeglio's project, then, is not so much to make Italians as to remake them, or unmake them, divesting them of the Mazzinian ideology he

feared had taken hold of them. D'Azeglio sums up his far more moder-
ate politics, which he shared with Balbo, as follows: "No revolution: we
had already had too many. No war; because we had neither means nor
strength. Therefore to prepare for battle on that field in which every
individual must possess a certain force, provided he be not an idiot, and
is willing to risk his life—the field of opinion and publicity."[15] Indeed,
this was the aim of another book that D'Azeglio set out to write after
Ettore Fieramosca: "Our conversations," he writes, referring to Balbo:

> turned chiefly on the necessity of preparing (and this is the key-stone
> of the arch, and till this principle be acted upon, the results will be very
> small) before proceeding to deeds; on the power and influence public
> conspiracy was likely to have in helping forward such an end; and his-
> tory furnished many examples of the excellent effects obtained by open
> and persevering protests of the weak against the strong. Therefore, after
> much discussion, we resolved to set to work. The object of the book was
> already predetermined, but its subject was yet to be found, or rather its
> opportunity and pretext.[16]

The book in question was to be D'Azeglio's *Gli ultimi casi della Ro-
magna*.

Whatever sympathies we may or may not have for D'Azeglio's na-
tionalist and moderate politics, books and writing play a central role
in it. His ethical-political project also determines the kind of language
he employs. To win over hearts and minds, it has to be by necessity an
open, accessible writing, to such an extent, he writes, that utility—the
force and clarity with which the message is delivered—trumps artistic
value, as I think that anyone who actually reads his novels would readily
agree. In his *Recollections*, he asks:

> What is the use of literature? In certain countries, and at certain epochs,
> either none whatsoever, or a bad one. Now, what ought it to be? Of most
> beneficial utility. Therefore, even if a literary work has little value in an ar-
> tistic point of view, it may be extremely valuable in another way, provided
> it serves a useful end. In that case it will have value of a different kind, and
> consequently cannot be called without merit. Regarded from this point of
> view, I believe *Fieramosca* has real merit, and for this once I must throw
> modesty fairly overboard.[17]

But not only does the urgency of his task to be useful and effective trump aesthetics, it also trumps history. And this takes us back to the liberties D'Azeglio takes with the historical record. The kind of Italy, the kind of Italians, the kind of exemplary past he was loooking for existed only to the extent he made it exist in a fictionalized recasting of the historical record. D'Azeglio, of course, was far from alone, as Alberto Asor Rosa has put it, in supplying a "projection of certain ethical and social models that had not yet been realized."[18] The children's books published in the postunification period and that proved to be such best-sellers, *Cuore* and *Pinocchio*, both have a pedagogical function very similar to that which informs D'Azeglio's project and writings. What is perhaps most remarkable about *Cuore* is that its author, Edmondo de Amicis, a positivist, follower of the school of Cesare Lombroso, wrote a book about dreams, hopes, aspirations and desires, a book about that which does not yet exist, and not a book about facts. At least in the case of *Cuore*, he shared D'Azeglio's poetics and politics of the useful and how a writing that is in great part fictional is indispensible to such a project.

If the invention of a past was a necessity of D'Azeglio's project, it was also his joy. The days and weeks he spent writing *Ettore Fieramosca*, he tells us, were among the happiest of his life. He writes:

> No words of mine can ever express all the peculiar delight, the internal happiness I exprienced while depicting and describing those scenes and characters. Absorbed heart and soul by that life of chivalry, to the entire forgetfulness of the present, it was undoubtedly one of the happiest periods of my existence. I spent nearly all my time in the society of my fantastic personages; in the evening I went to bed early, and thought morning would never dawn, so great was my impatience to be once more among them. I was never keen after any diversions, and always found them great bores (except the theatre, in the days when the actors could sing); but then—Barletta and its knights! Many people often wonder that one does not care for balls, dinner-parties, and so-called entertainments; if they could but experience for an hour the pleasures of the imagination, and of moving in a fantastic world of your own creation, they would no longer be astonished, but comprehend the vast difference.[19]

In the company of knights, defending Italian valor against French perfidy was an experience, although entirely textual, that was to give D'Azeglio as

much, pehaps more, than he took from it. And the joy of that fictionalized world seems to have been contagious. How else to explain the success of the novel, the host of successive imitations, all based on the novel rather than on the historical record, the many Italian towns who have expended great energy in claiming to be the birthplace of a non-existent knight, the fact that if you want to play football in Lodi one of the teams you can play for is named after Fanfulla, one of D'Azeglio's knights, and that in Trastevere one can visit the Torre Ettore Fieramosca, where the real Ettore Fieramosca never slept, but where the fictional one may have.[20]

On the Web site of *RomaSegreta*—romasegreta.it—the house is described thus:

> Tradition tells us that here lodged the famous soldier of fortune Ettore Fieramosca, recently returned from the Disfida di Barletta fought on February 13th 1503, before following Prospero Colonna in May 1504, to transfer the prisoner Cesare Borgia to Spain. Perhaps the legend has its origin in the scene that D'Azeglio described in his *Ettore Fieramosca*, but we like to imagine that the Captain actually slept in this beautiful house.

Although a fairly prolific writer, D'Azeglio's name is far better known as the author of the famous remark, according to which, "now that Italy has been made, it is now time to make the Italians." Indeed, D'Azeglio is far more cited than studied.[21] Although the sense of some of his writings that are on the record is close to the above remark, D'Azeglio never formulated his thought in quite that way. D'Azeglio, then, has become famous for a remark he didn't quite say or write, or didn't quite say or write the way it has been recorded in history and attributed to him. But so pithy and memorable is the remark, so well does it roll off the tongue in both English and Italian, it is as if D'Azeglio had actually said it, so much so that it has become history and has taken its place in the Italian panoply of memorable phrases. Had he known, I am sure he would have derived much pleasure for going down in history for having said something he didn't quite say.

NOTES

1. The song is entitled *Bartali* and celebrates his 1948 victory. Bartali had already won the *Tour de France* ten years earlier in 1938.

2. For the role of duels, the historical background to the *Disfida di Barletta*, and the place it has occupied in Italian cultural memory, I have availed myself of Giuliano Procacci, *La disfida di Barletta. Tra storia e romanzo* (Milan: Paravia Bruno Mondadori Editori, 2001). See especially pp. 1–8.

3. Giovanni Pascoli, "La grande proletaria si è mossa," in *Patria e Umanità: Raccolta di scritti e discorsi* (Bologna: Zanichelli), 236 (my translation).

4. See Procacci, 11–39.

5. See Procacci, 79–98.

6. Giovanni Berchet, *Le Fantasie: Romanza* (London: R. Tayor, 1829).

7. Image used with permission of the Segreteria Organizzativa Federale, Lega Nord.

8. Here is how one *Lega Nord* militant describes the swearing-in ceremony in its current guise: "sendo84—April 5th, 2008—More than eight centuries after the oath of Pontida that gave life to the Lombard League, the representatives of the Padanian nation renew that oath, each one in his mother tongue. The enemy is no longer Emperor Frederick II, but Roman centralism. Today like yesterday, we gather again before the Basilicata, on the sacred ground of Pontida, each with his own flag, own language and own history, united for the common good, united for the Freedom of our peoples" (http://www.youtube.com/watch?v=8TQzTbb6XMQ [accessed June 10, 2010]). The Company of Death is the subject of a recent novel, *La Compagnia della morte* by Franco Forte (Milan: Mondadori, 2009).

9. First mention of Giussano comes in a chronicle of the city of Milan—*Chronica Galvanica*—written by Galvano Fiamma in the early fourteenth century for Galeazzo Visconti. It is also in this chronicle that we find reference to Giussano's involvement in the Company of Death. For the *Giuramento*, see Elena Percivaldi, *I lombardi che fecero l'impresa* (Milan: Ancora Editrice, 2009), and in general on the history of the *Lega Lombarda*, Franco Cardini, *La vera storia della Lega Lombarda* (Milan: Mondadori, 1991). In English, see Gianluca Raccagni, *The Lombard League, 1167–1225* (Oxford: British Academy/Oxford University Press, 2010).

10. Massimo D'Azeglio, *Recollections of Massimo D'Azeglio*, trans., notes and intro., Count Maffei (London: Chapman and Hall, 1833), 322.

11. Ibid., 485.

12. Ibid., 488.

13. Ibid., 366.

14. Ibid., 354–35.

15. Ibid., 486.

16. Ibid., 488.

17. Ibid., 366–69.

18. Alberto Asor Rosa, *La Cultura* (Turin: Einaudi, 1975), 929 (my translation).
19. D'Azeglio, 322.
20. Image used with permission of the Redazione of romasegreta.it: http://www.romasegreta.it/casa_di_efieramosca.html (accessed March 18, 2011).
21. The exhibition, co-curated by Giovanni De Luna and Walter Barberis at the Museo del Risorgimento in Turin to celebrate the 150th anniversary of Italian unification, is entitled "Fare gli Italiani."

BIBLIOGRAPHY

Asor Rosa, Alberto. *La Cultura*. Turin: Einaudi, 1975.
Berchet, Giovanni. *Le Fantasie: Romanza*. London: R. Tayor, 1829.
Cardini, Franco. *La vera storia della Lega Lombarda*. Milan: Mondadori, 1991.
D'Azeglio, Massimo. *Ettore Fieramosca o La disfida di Barletta*. Milan: Per Vincenzo Ferrario, 1833.
———. *Recollections of Massimo D'Azeglio*. Translated, with notes and introduction, by Count Maffei. London: Chapman and Hall, 1868.
Forte, Franco. *La Compagnia della morte*. Milan: Mondadori, 2009.
Pascoli, Giovanni. "La grande proletaria si è mossa." In *Patria e Umanità: Raccolta di scritti e discorsi*, 235–38. Bologna: Zanichelli, 1914.
Percivaldi, Elena. *I lombardi che fecero l'impresa*. Milan: Ancora Editrice, 2009.
Procacci, Giuliano. *La disfida di Barletta. Tra storia e romanzo*. Milan: Paravia Bruno Mondadori Editori, 2001.
Raccagni, Gianluc. *The Lombard League, 1167–1225*. Oxford: British Academy/Oxford University Press, 2010.
Sendo84. "Giuramento di Pontida: Lega Nord Padania." Accessed June 10, 2010. http://www.youtube.com/watch?v=8TQzTbb6XMQ.

2

FROM SERIE A TO SERIE AFRICA AND BACK

Soccer, Race, and the Making of Italian Identity in Brizzi's *L'inattesa piega degli eventi*[1]

Roberto Derobertis

I. AN ENTANGLEMENT OF TEXTS

Enrico Brizzi's novel *L'inattesa piega degli eventi* (2008; *The Unexpected Turn of Events*) is set in a 1960 Italy where fascism is still in power and the country has been renamed Republic of Italy. Brizzi's alternative story (or *uchronic* or *what if* novel) interrupts the official history time line, and brings back the issues of fascist totalitarianism, Italian recent colonial past, racism and segregation, and at the same time it casts an allegorical image of today's Italy by narrating the widespread and institutionalized racism and the multiculturalism which is allegedly a matter of fact and yet still missing.

Through a reading of the novel taking into account its manipulation of official history, its references to the Italian twentieth century historical archive and its references to contemporary Italian *ethnoscapes*, this chapter aims at analyzing how the questions of race and racism are constituent and relevant elements of the genealogy of Italian identity. It specifically focuses on the historical and geographical dislocation of the novel and on its setting in the soccer world, mainly concentrating on the fascist teams which include only white Italian players and the antifascist ones which are mixed, on soccer fans' rituals and organization

from a social, political, cultural, and racial perspective. The chapter aims at raising mainly two issues: how the production of belonging and of citizenship in the Italian context relates to historical phenomena such as colonialism and migration; what is the role played by everyday life and cultural practices in a national community building process in the post-colonial condition. Finally this case study tries to combine literary criticism, historical research, and discourse analysis in order to understand the relationship between *culture* (forms, practices, representations), history and (hi)storytelling and the relationship between race, identity, and politics in today's Italy.

The Unexpected Turn of Events explicit sources, which are revealed in the initial epigraph and in the final acknowledgments, are mainly referred to race, Italian colonial and fascist past. In the final pages, Brizzi (1974) mentions Matteo Marani's *Dallo scudetto ad Auschwitz. Vita e morte di Arpad Weisz, allenatore ebreo* (2007, *From the Championship to Auschwitz. Life and Death of Arpad Weisz, Jewish Coach*). Weisz trained several teams of Serie A and won the Italian championship with Inter Milan and Bologna which became very popular all over Europe between 1935 and 1937 when it defeated the incomparable English masters of soccer. He had a crucial role in the apprenticeship of Vittorio Pozzo, trainer of the Italian national team that won the 1934 and 1938 World Cups. In fact, Pozzo was highly influenced by a soccer manual co-authored by Weisz: *Il giuoco del calcio* (1930, *The Game of Soccer*). Moreover, Weisz launched Giuseppe Meazza: one of the legendary players of Italian soccer history. But in early 1939 Weisz and his family were forced to leave Italy because of the racial laws (1937–38); they ended up in Holland, where, within a few months, they were captured by Nazis and deported to Auschwitz where they all died. From then on his figure, the most important one in Italian soccer between the 1920s and 1930s, was obliterated.

On the other hand, the epigraph of the novel is a quotation from Paolo Caccia Dominioni's *Amhara. Cronache della pattuglia astrale* (*Amhara. Chronicles of the Astral Patrol*). Originally published in France and in French in 1937, the book is the diary of an Italian army officer (the author himself) who led a small patrol of indigenous soldiers in the Italian East Africa army during the Italian colonial invasion between 1935 and 1937. This book, illustrated by the author's drawings depicting African

soldiers and landscapes, was only first translated into Italian in 2006. In the preface to the Italian edition Caccia Dominioni is referred to as a memorable Italian person of the twentieth century and indeed the subtitle is "Homage to Paolo Caccia Dominioni." But he served in the army during World War I, then in Libya, in Ethiopia, during one of the most atrocious colonial war in history, and then he fought in the battle of El Alamein during World War II. The book is full of exotic, orientalist, and colonial stereotypes and it glorifies military life. Africa is described as a primitive land at Italian colonizers' disposal and indigenous soldiers' *nature* is often compared to that of animals.

According to these two sources, in the novel the obliterated story of one of the most important figure of Italian soccer history who died in Auschwitz and an army officer's colonial diary proudly published in Italy in the twenty-first century are landmarks that frame the text and connect the past and the present through the removed racial and colonial memory.

2. A POSTCOLONIAL UCHRONIA: BETWEEN HISTORY AND FICTION

In Brizzi's novel Fascist Italy has broken up the alliance with Hitler, has opposed Nazi ambitions, and has finally gained a place at the winners' table in 1945. Fascism successfully got out of a troubled war and removed the royal family thus becoming a Republic. In 1960, fifteen years after the armistice, Benito Mussolini is a seventy-seven-year-old man close to death and whose dictatorship goes on corrupted and torn by the conflict between the two aspiring successors: Alessandro Pavolini (journalist, writer, and politician, 1903–1945) and Italo Balbo (popular aviator and politician, 1896–1940). Malta and Corsica are now part of Italy and Eritrea, Ethiopia and Somalia are not strictly speaking "colonies" and are renamed as associated Republic of East Africa. Within this historical and geographical frame the sports writer Lorenzo Pellegrini is exiled in East Africa in order to deal with the local soccer league: Serie Africa. He has to report about the state and progress of East African soccer which is usually ignored in Italy. But media start to get interested in it as on the occasion of the 1960 Olympics a Championship of the Seven

Nations will be held in Rome and it will include the champions of Italian
Serie A and of the other five Italian colonies' leagues. Hence Pellegrini
starts a long and unexpected discovery travel which will turn him from
an Italian politically unaware *everyman* under the fascist regime into a
supporter of Ethiopian antifascist and antiracist groups. At the end of
the story Pellegrini will follow with the winning team of Serie Africa,
San Giorgio Addis Ababa, to Rome in order to cover the Championship
of the Seven Nations, where the multiracial African team can finally
challenge the most popular teams of Italian and European soccer in the
capital of the colonial metropole. This movement in the protagonist's
life, which follows the typical structure of a Bildungsroman, places the
experience of Italian colonialism, cultural practices and everyday life
between the metropole and the colony at the very centre of our experi-
ence as contemporary readers.

It is relevant to underline that the space-time displacement effect is
emphasized by the uchronic outline of the novel. Paraphrasing Roland
Barthes's reflections about uchronia in the conclusions of *The Fashion
System* (1967), it can be argued that *The Unexpected Turn of Events*
brings back the "shameful past" of Italian colonial history while the pres-
ent is "eaten up" by a future multicultural society, which is announced
and yet thwarted.[2] As Barthes clarifies, "uchronia" means "a time which
does not exist"[3] and thanks to a temporality which is created from some
actual historical events, literary writing lays bare the fact that invention is
a constituent part of History as a discipline. If the work of the historian is
based on speaking in the name of a past which is absent, pursuing trans-
parency and intelligibility in order to self-legitimize and creating a narra-
tion that is supposed to be *objective*, it can be easily noticed that by means
of uchronia the work of literature mocks the work of history by simply
organizing events, facts and documents in a different story, with different
meanings and different omissions. The referent is the same but the "real-
istic effect" is lost because the past, intended as a relic, is profaned.[4] For
this reason the title of the novel itself, which occurs at least seven times
in crucial moments of the novel, can be read as a manifesto of how to
disavow the coherent historical development and its objective narration.

What Pellegrini experiences in East Africa is totally different from
what he had expected to find there and from what the readers of his
sports chronicles in Italy expect to read:

We had to be clear. Write short sentences. No flourishes. Always bearing in mind that our average reader was a forty-year-old guy with a primary school level, a supporter of Bologna, Fiorentina or Rome. You could figure him out like someone moderately hostile to Northern metropolitan teams, but curious to meet the champions. Telling him stories about African teams was not so obvious. Africa, for him, was something to laugh about. Ethiopians, or rather Abyssinians, had to be something like a hoard of yokels, maybe pagans, surely ignorant of modern activities such as architecture, rational agriculture and high-level soccer.

It would have been a waste of ink to explain that so-called ideal reader that, actually, they were the proud heirs of a millenary civilization. In order to charm him I should have described Ethiopia as a small Brasil and the stadium "Nuovo Fiore" as the temple of an emerging soccer, still naïve but rich in talents.

A reservoir that tomorrow, and this reader should keep it in mind, could enrich the ranks of our teams. Maybe, one day, even of the National team.[5]

In this meta-historical and meta-narrative passage, the protagonist and narrator plays a double role: that of the writer/reporter within the plot and that of the historian (of a different history) for the implicit readers of the novel. With reference to Gayatri C. Spivak's *Death of a Discipline*, it can be argued that Pellegrini turns upside down the typical protagonist of European colonial novels who underwent a process of barbarization by coming in contact with primitive Africa and Africans[6] and reveals modernity as a shared experience between Italy and its colonies. To put it with Spivak's words, *The Unexpected Turn of Events* "contains the elements of surprising the historical"[7] and in this sense it can be defined a "postcolonial uchronia," as it questions the way how the "past is narrated via the simultaneous operation of representation and repression."[8] As we will see further on, still today this process of representation and repression allows racist discourses which are meant to prevent black Italian soccer players to play for the national team.

3. SOCCER AND RACE: FROM GAME TO POLITICS

The passage quoted above shows that the issue of race is always at the very center of the novel. However, sport and race were very important

issues for the fascist ideologists since the 1920s and with more emphasis during the 1930s when they started the Empire-building process. As Giulietta Stefani has noticed,[9] between the end of nineteenth century and the beginning of the twentieth century, militarism and war, patriotism and body discipline were the cure for the *crisis of masculinity*, which was very important issue in the European social and political agenda. As Stefani explains, the promotion of sport and the emphasis on nature, instincts and body should shape the fascist male and his athletic build. The colony, then, was seen as the perfect gym to try a masculinity therapy. Sports chronicles of the late 1930s, after the Italian invasion of Ethiopia, tell enthusiastically of boxing and cycling and above all of Eritrean and Somali soccer leagues which, under the supervision of Italian soccer federation, would become serious championships to glorify Latin Italian fascist males:

> The Colony, vital organ of the harmonic Imperial Fascist whole, must record no deficiency in comparison to the Motherland. Colonial sport will have to shine with bright light, will have to obtain the same awards provided by the champions in the Italic peninsula to the wreath of national sport. Once more the Fascio Littorio, on the African land, will draw the indelible figure of the Italian, strong, imperturbable, male in his most traditional Latin race of the Mussolini Era.[10]

Pellegrini reaches Italian East Africa in a similar moment of transition in East African soccer: from localism to international fame. Just arrived in Africa, Pellegrini asks himself why an Italian soccer fan should be interested in Serie Africa in 1960 Italy:

> After the constitutional reform of 1948, the former colony had been raised to the level of associated Republic, and since then the best sixteen teams had been fighting together in a league without relegations, highly financed by the "Federcalcio" in Rome and by private companies working in the Horn of Africa.
> The teams, with a disputable technical level, wore garish uniforms resembling those of horse-jockeys, and I smiled in reading that the trophy awarded to the winners of the championship was a symbolic sceptre dedicated to king Solomon.
> Starace Gondar; Garibaldi Asmara; Fiamme Nere Gibuti.

Names that nobody knew in the Motherland.

And not even the most credited clubs seemed a breeding ground of champions: the Audax Addis Abeba and the fellow citizens of San Giorgio, Marittimo Mogadiscio and Birra Venturi.

Nobody coming from such teams, named like working men's clubs, had ever made it to Italy. Not even an echo. In the best case, some modest player had gone there to finish his career.

But to a journalist's eyes the "Serie Africa" showed a peculiar feature: it was the only championship affiliated to the Federcalcio, in which whites and blacks, former native inhabitants of the kingdom and former subjects played together.[11]

Since the very beginning and from the teams' names one can see that fascist and colonialist loyalty clashes with a reality that is undergoing deep transformations that fight back racism and segregation. The novel moves between Asmara, Massawa, and Addis Ababa, in a not-yet-decolonized East Africa whose social, cultural, and political space is marked by a segregation that is strictly based on class and race axis. In order to display such social structure literary writing crosses two separate and different spaces: the closed ones (mansions, brothels, and bars) and the open ones (the streets and the stadium).

Several scenes describe life on the streets where subcultural rituals take place among a multicultural population who constantly rearticulates different cultural practices by means of cultural translations and style transgressions:

By instinct I would classify black people according to their degree of integration to our model: at the top of the social pyramid, right below white people, I would recognize the local dignitaries, dressed in the European manner, state or Army officers that, in spite of their origins, could boast the certificate of assimilation to the *gens italica*, could vote at the elections and could hold public offices.

Immediately below this scarce minority, there were the former askaris that had retired from the Army and the half-breed recognized by their fathers, almost always military men with wives and children in Italy; although many of them lived in poverty with their Eritrean mothers rejected by their own families, they were protected by the republican law that granted them a public job ranging from that of zaptié, the African equivalent of the "carabiniere," to that of postman or janitor.

No right to vote or access to public offices was provided for the rest of the population, the great majority of the 25 millions of Tigrinya, Dankali, Amhara, Galla and Somali people that inhabited the unlimited territory of the former Italian East Africa (AOI).

The young ones could be seen trying to look as much as possible like the Italians of their same age. They were everywhere, white, black and mixed kids gathered in knots in the courtyards, around a copy of *Calcio illustrato*, or racing on two old patched up Legnanos, under the amused gaze of their older brothers, dressed in their black soldier-like shirts, proud to walk through the neighborhood with the hanging cartridge belt and the masket slung across their shoulders.[12]

This typical colonial milieu clearly recalls some relevant elements of Italian colonialism: the division of natives between the elites, who were in favor of the colonizers, and the rest of the population; the role of indigenous soldiers in the pay of the Italian army; and the phenomenon of *madamato* (a practice forbidden by racial laws after 1937), that is to say those relationships between Italian men and native women that were limited to the colony and often gave birth to mixed children who were abandoned by the fathers. Of course some elements have been changed according to the structures and needs of a uchronic novel. As the historian Angelo Del Boca has noticed, though segregation and racist laws were peculiar to Italian colonialism before the rise of the fascist regime, the highest stage of apartheid was reached after 1936 when it was forbidden to Italians, Eritreans, Ethiopians, and Somalis to live in the same neighborhood.[13] Such a context is reflected in the novel, so that in the streets there are also racist acts of violence[14] and antifascist riots. These conflicting situations seem to be faced by means of the birth of hybrid cultural formations or by armed struggle (car bomb attacks and low intensity guerrilla).

Other spaces of conflict between fascist and racist Italians and antifascist groups of blacks, mestizos and Italians are the stadiums. In a permanent tension between the pitch and the terraces, between players' competitive tension and fans' violent political excitement, the novel offers long descriptions of Serie Africa matches:

the entrances of the stands in front of us were opened, and in a few moments the empty terraces were filled with people. They were flowing in

like rivers, waving handkerchiefs and red flags, and some of them bustled to hang some banners on the lower banisters: on the sides of the Garibaldi Club Centrale there was the section occupied by the Settantotto neighbourhood and by that of Ghezzabanda, while the sector on our right was occupied by a long roll of paper with the writing "Garibaldi first Eritrean team. Go boyz," written with a Z.

"Ignorants," people around me were shouting. "Go back to SCHOOL!"

When all of them took a seat, chants started to rise, underlined by the beat of a continuous clapping, as if they had decided to scare us by singing. They started to sing the march "Garibaldi fu ferito" and when they got to "soldà," they let themselves fall on the terraces, as if they had been hit by the ray of death

In a moment they were up again and ready to start: "E la camicia rossa e i pantalon turchin, evviva Garibaldi e i suoi Garibaldin!"

I had rarely seen something like that in Italy . . . [15]

In this passage the colonized re-use Italian Risorgimento mythologies (such as that of Garibaldi and its red shirt, the most libertarian and ambivalent hero of Italian Unification) to fight back the colonizer with his own history and values. Every element, dress code, singing, and moves, is oriented to political struggle. In his 1990 sociological survey on soccer, *Descrizione di una battaglia. I rituali del calcio (Description of a battle. On Soccer Rituals)* Alessandro Dal Lago wrote that soccer is a "total social fact" because of its economic and symbolic implications, and because of its peculiar way to move desires, passions and emotions.[16] Within this general frame according to Dal Lago, for organized soccer fans "a match is the occasion of a friends/enemies ritual fight which can turn . . . into a riot,"[17] even though this fight, Dal Lago says, does not usually sums up actual political tensions that are external to the stadium scene. But the novel underlines how in specific fighting contexts, soccer rituals can re-signify the stadium terraces in another possible arena of a wider political struggle.

One of the players in Serie Africa, Ermes Cumani, is a border figure between game and politics. Cumani, who was born in Italy and then exiled with his family at the age of three in East Africa, is an antifascist who believes in a multiethnic and multicultural society and secretly takes part in political resistance groups. Cumani is a talented soccer player in daytime and a conspirator during the nights. Thanks to this

coprotagonist, Pellegrini discovers the whole underground world of the illegal Communist party and of the East Africa Liberation Front. Cumani is a white soccer player of Italian origins who is eager to visit Italy as he cannot remember anything of his fatherland. Before the end of the Serie Africa season Cumani becomes a player of San Giorgio Addis Abeba which is likely to win the championship and then to fly to Italy for the Championship of the Seven Nations. That is his possibility to finally go back to Italy. But because of his political activity Cumani becomes a wanted person and the only way to fulfil his desire to return is to take on the identity of one of his fellow player, an Uruguayan one: Horacio Reyes. And so Cumani can reach his own country only disguised as a foreigner.

This sort of passing of identity recalls the history of Italian soccer from the 1930s to the 1960s, that is a history of unexpected successes and resounding failures. In that span of time soccer players became professionals and very popular thanks to the media and the jet-set life with its excesses and scandals.[18] The increasing fame of the game was certainly due to the propaganda investments of the fascist regime that saw the game and the passion around it as something that could turn people's attention away from politics and, at the same time, could raise Italians' patriotism. In those years the protagonists of Italian soccer improvement were foreigner coaches, above all the so called Danubian school coaches: Hungarians (like Arpad Weisz), Austrians and Czechs who brought to Italy some crucial innovations in the game. And it must be underlined that in the Italian national teams who won 1934 and 1938 World Cup the majority of the most talented players were so called *oriundi*, a word that mainly referred to players who were born in South America within families of Italian emigrants. At the beginning, the employment of oriundi players was an attempt to avoid the prohibition to employ foreign players in the Italian soccer league, decided by fascist institutions in 1926. Apart from soccer, oriundi had a central role in the "greater Italy" discourse which promoted the idea of a larger country that should claim its identity far beyond its political borders in order to include emigrants and colonizers. In Argentina (who tried to prevent Italy from naturalizing Argentinean players of Italian origins) oriundi were called "criollos,"[19] a word that is usually translated as "creoles" and was rooted in the beginning of

Spanish colonialism in South America when it meant a person of Spanish origins with some Amerindian ancestry. On the contrary, in Italy they were called "repatriated" in order to underline a sort of return-to-the-origins narrative. Clearly in both cases there are no firm origins but rather travelling cultures and people.

Following these travelling cultures as its main path, *The Unexpected Turn of Events* references to the historical archive are not limited to the colonizer country but they raise up interesting insights into the ex-colonized country archive and thus show how they are significantly overlapped. In the final acknowledgments Brizzi pays tribute to the figure of Luciano Vassallo, a soccer player who was born in 1935 in Eritrea from an Eritrean mother and an Italian father who didn't recognize him at first and then migrated to Italy in 1978. He still lives in Italy, he is a mestizo or, as he calls himself, "a son of two flags or nobody's son."[20] Vassallo has been an authentic hero for East African masses: an Eritrean with Italian blood who ended up playing in the Ethiopian soccer national team (after the unification of Eritrea and Ethiopia) and led it to the victory of the Africa Cup of Nations in 1962. Vassallo belongs to Eritrea's and Ethiopia's legends and, at the same time, he joins in Italian twentieth century history. Colonialism and hybridity, postdecolonization nationalism and migration are epitomized by the peculiar story of this soccer idol.

Vassallo played for the Saint George FC, a team whose name in *The Unexpected Turn of Events* is turned into San Giorgio Addis Abeba. According to the team official website, Saint George FC was founded in 1928 in the Arada neighbourhood in Addis Ababa and its uniforms resembled the Ethiopian flag; but after the Italian invasion in 1935 the fascist institutions prevented the team from wearing those colours and changed its name into Lotorio Woubee Sefer Arada.[21] In the novel San Giorgio Addis Abeba is the multicultural team par excellence owned by Aaron Melchiades, a Greek Jewish white Ethiopian. San Giorgio moves relevant political feelings:

> When they play an important match, thousands of people come down the mountains to see them. Maybe they do not know what an offside is, but they are in love with their team so full of Africans and antifascists, the only one in the Country that could beat the white only clubs.[22]

Soccer is represented as a location where different histories, traditions, and cultures meet in order to resist to oppression and racism:

> Soccer around here is a carnival of joyous uniforms hiding the reality of a Country where white and black people have very different opportunities. That is why it is important that such teams as San Giorgio or ourselves can compete in Seric Africa against white only clubs. The field of soccer here is the only one where a different society can be proposed, where racism will be only a bad memory.[23]

As Dal Lago wrote, "the soccer scene becomes the occasion to organize shows that are addressed to the whole population, included those who are not interested in soccer."[24]

4. CULTURAL STUDIES, SOCCER, AND LITERATURE IN TODAY'S ITALY

In an interview published in the Italian academic review *Studi Culturali* in 2004, Stuart Hall clarified that the unifying subject of cultural studies was and still is the relationship between culture and power. According to Hall a cultural studies analysis cannot be restricted to values and meanings but it should connect these cultural elements to other spheres of social life such as economics, politics, race, class structure, and gender.[25] From this perspective *The Unexpected Turn of Events* is an exemplary literary text that can allow us to set to work a cultural studies oriented literary text analysis within the field of Italian studies; even though, it must be underlined, *Italinistica* in Italy is much more stuck on Italian literature studies than Italian Studies are in the English speaking world.[26]

However, in *The Unexpected Turn of Events* the antinomical couples colony/metropole, colonizer/colonized and white/blacks are questioned, as the narration crosses in-between spaces where black and mestizos colonized and white antifascist Italians trigger counter-discourses and counter-practices that are meant to subvert power relations. The text clearly transfigures, within an imagined time-space location, contemporary cultural phenomena widespread in Italy but often confined to the margins or beyond the borders of mainstream

media. Indeed the novel and its late colonial setting, its uchronic features and its exceeding figures such as that of Ermes Cumani and its references to oriundi, criollos and repatriated brings back to the future something that had gone astray or lost, that is to say the hybridity of Italian identity and its being part of a wider and not quite white nor European historical and geographical canvas. And it rises what Ruth Ben Ghiat has called the "diasporic quality of Italian nation" that "invites treatments of Italian national identity" that should "include relations among the Italian metropole, Italian colonies and Italians who lived abroad under a variety of national and imperial sovereignties."[27] Moreover it pushes one to raise objections to a still deep-rooted "narrative about Italy based on continuity, homogeneity and linearity."[28]

Close and historical readings of the novel invite cultural theorists to face the fact that a certain fascist and racist discipline and ideology has in some sense slid down toward our present and cannot be simply confined to the exact twenty years of the regime. Recently Dal Lago used the term "fascistoid" in order to describe "a frantic devotion to property, profiteering, decision-making tendency used against weak subjects, mythology of . . . the nation or of the small country, . . . suspect about everything that comes from outside, utter indifference towards others' rights."[29] Using Karen Pinkus's words, it might be said that "the cultural effects of decolonization in Italy" are a "nonevent,"[30] as something that has never really taken place. This could help us interpreting today's neocolonial division of urban spaces that are more and more visible in Italy: border walls that separate neighborhoods inhabited by migrants and Roma from those inhabited by Italians, the use of separate urban buses for asylum seekers and separate classes in primary schools for migrants' children. In this context migrants and second generations are claiming their own space and visibility in the public discourses in order to become agents and not only objects of discourse. Soccer, intended in a wider sense as the game, the fans' organizations, the concentration of symbolic and economic values and of peculiar media appeal, can offer a wide range of issues for cultural studies.

In the specific Italian context it must be mentioned the case of Mario Balotelli: a young and popular black soccer player, born in a Ghanaian family in Palermo and then adopted by an Italian family from Brescia,

who plays for Inter Milan. According to Italian citizenship law, Balo-
telli after turning eighteen gained the right to become Italian and thus
the right to play in the Italian national team.[31] This event immediately
provoked racist reactions that can be summarized by the slogan "there
are no Italian niggers" which quickly became very common in all Ital-
ian stadiums. That slogan echoes recent remarks by the Italian national
team's coach who, under journalists' pressure about the issue of capping
oriundi players for the forthcoming World Cup in South Africa, said
that "Italian soccer players are enough." Finally, in May 2009, when
he was trying to justify the migration politics of his government, Italian
prime minister Silvio Berlusconi said that his idea of Italy is not that of
a multiethnic country.[32] Balotelli, oriundi and the refuse of a multiethnic
Italy trace the uncertain border of Italianness which crosses race, terri-
tory and blood but accurately dodges both a wider idea of belonging to
the nation and its diasporic quality. In a certain sense Italy lives as if it
had been trapped in the same uchronic no-time of Brizzi's novel, where
politics is racked by a repetition compulsion of fascism in its postmodern
version while society has undergone radical changes from both racial
and cultural points of view.

In a country where the prime minister gathers in his own hands the
monopoly of conservative politics, the property and control over the 80
percent of mainstream media communication and the property of one
of the major national soccer team, it is clear how imagination, rights,
freedom, race, production of citizenship, and cultural practices are en-
tangled and become today's central issues. Within this frame soccer and
sport can be considered as a sensible site of conflicts under a general
global context of social and cultural unrest. Hence the role of literature,
of literary studies and of their relationships with cultural and social for-
mations is that of reactivation of lost memories, critique of the present
and imagination of the future, not as repositories of fixed representa-
tions but rather as part of a process of deconstructing the social.

As Barthes wrote in his *Le sport et les homes* (2004, *Sport and men*),
sport has to do with the spheres of passion and aggression and thus it
is "the border that separates struggle from insurrection."[33] And thus,
literature and sport rather than being consolatory hobbies for domesti-
cated masses, can be crossed as sites of protest that verges on uprising
and final liberation.

NOTES

1. This chapter was made possible thanks to the collaboration, support, and precious suggestions of two colleagues of mine who are working on close subjects: Dr. Angela D'Ottavio (working on her research project "'There ain't no black in the Italian flag': The language and politics of race and nation in contemporary Italian soccer") and Dr. Francesco Altamura (working on his research project "Arpad Weisz, soccer and race in fascist Italy").

2. Roland Barthes, *The Fashion System* (Berkeley-Los Angeles-London: University of California Press, 1990), 289, note 17.

3. Ibid.

4. See Roland Barthes, "The Discourse of History," *Comparative Criticism* 3 (1981): 7-20.

5. Brizzi, *L'inattesa piega degli eventi* (Milan: Baldini Castoldi Dalai, 2009), 302; as in this case, all the translations of quotations from texts in Italian are mine.

6. See Gayatri Chakravorty Spivak, *Death of a Discipline* (New York: Columbia University Press, 2003).

7. Ibid., 55.

8. Iain Chambers, *Mediterranean Crossings: The Politics of an Interrupted Modernity* (Durham, NC: Duke University Press, 2008), 26.

9. See Giulietta Stefani, *Colonia per maschi. Italiani in Africa Orientale: una storia di genere* (Verona: Ombre corte, 2007), 40–45.

10. L'Asmarino, "Lo Sport nell'Impero Dall'ASMARA. Pugilato che passione! – L'imminente varo del 1. Campionato Calcistico Eritreo," *Cine-Sport* 39 (1937): n.p. I could read this and other articles from the same magazine and the same period thanks to the researches of Dr. Francesco Altamura.

11. Brizzi 35–36.

12. Ibid., 44–45.

13. See Angelo Del Boca, "Le leggi razziali nell'impero di Mussolini," in *Il regime fascista. Storia e storiografia*, ed. Angelo Del Boca et al. (Rome-Bari: Laterza, 1995), 329–51.

14. Brizzi, 93.

15. Ibid., 189–90.

16. See Alessandro Dal Lago, *Descrizione di una battaglia. I rituali del calcio* (Bologna: il Mulino, 1990).

17. Ibid., 34.

18. Antonio Papa and Guido Panico, *Storia sociale del calcio in Italia* (Bologna: il Mulino, 2002), 127–45.

19. Ibid., 147–60; and Antonio Ghirelli, *Storia del calcio in Italia* (Turin: Einaudi, 1990), 99–100.

20. Italico Abyssino Latino, accessed April 30, 2010, http://lucianovassallo. ning.com/video/luciano-vassallo.

21. Saint George Football Club, "Saint George History," http://www.saint-georgefc.com/index.php?option=com_content&task=view&id=12&Itemid=73; in the fascist renomination "Lotorio" is probably the misspelling of "Littorio," that was the heraldic symbol of the fascist regime.

22. Brizzi, 89.

23. Ibid., 69.

24. Dal Lago, 26.

25. Miguel Mellino, "Teoria senza disciplina. Conversazione sui «Cultural Studies» con Stuart Hall," *Studi Culturali* 2 (2007): 310.

26. Rebecca West, "The Place of Literature in Italian Cultural Studies," in *Italian Cultural Studies*, ed. Graziella Parati and Ben Lawton (Boca Raton, FL: Bordighera Press, 2001), 13.

27. Ruth Ben Ghiat, "Italy and Its Colonies: Introduction," in *Historical Companion to Postcolonial Literatures: Continental Europe and Its Empires*, ed. Prem Poddar, Rajeev S. Patke, and Lars Jensen (Edinburgh: Edinburgh University Press), 265.

28. Graziella Parati, *Migration Italy: The Art of Talking Back in a Destination Culture* (Toronto: Toronto University Press, 2005), 23.

29. Dal Lago 144.

30. Karen Pinkus, "Empty Spaces: Decolonization in Italy," in *A Place in the Sun: Africa in Italian Colonial Culture from Post-Unification to the Present*, ed. Patrizia Palumbo (Berkeley: University of California Press), 300.

31. See Angela D'Ottavio, "Balotelli e il mito della nazionale di calcio," in *Mitologie dello sport. 40 saggi brevi*, ed. Pierluigi Cervelli, Leonardo Romei and Franciscu Sedda (Rome: Edizioni Nuova Cultura, 2010), 170–76.

32. Mr. Berlusconi's words can be read at: Il Sole 24 Ore, "Berlusconi: «La nostra idea dell'Italia non è multietnica»," May 9, 2009, http://www.ilsole24ore. com/art/SoleOnLine4/Italia/2009/05/berlusconi-no-italia-multietnica.shtml.

33. Roland Barthes, *Lo sport e gli uomini* (Turin: Einaudi, 2007), 43.

BIBLIOGRAPHY

Barthes, Roland. "The Discourse of History." *Comparative Criticism* 3 (1981): 7–20.
———. *The Fashion System*. Berkeley-Los Angeles-London: University of California Press, 1990.

———. *Lo sport e gli uomini*. Turin: Einaudi, 2007.

Ben Ghiat, Ruth. "Italy and Its Colonies: Introduction." In *A Historical Companion to Postcolonial Literatures. Continental Europe and Its Empires*, edited by Prem Poddar, Rajeev S. Patke and Lars Jensen, 263–67. Edinburgh: Edinburgh University Press, 2008.

Benvenuti, Giuliana. "A proposito del dibattito sulla narrazione della storia." *Intersezioni* 1 (2009): 131–48.

Brizzi, Enrico. *L'inattesa piega degli eventi*. Milan: Baldini Castoldi Dalai, 2009.

Caccia Dominioni, Paolo. *Amhara. Cronache della pattuglia astrale*. Milan: Libreria militare, 2006.

Chambers, Iain. *Mediterranean Crossings: The Politics of an Interrupted Modernity*. Durham, NC: Duke University Press, 2008.

Dal Lago, Alessandro. *Descrizione di una battaglia. I rituali del calcio*. Bologna: il Mulino, 1990.

———. "Felici di odiare." *MicroMega* 6 (2009): 142–51.

Del Boca, Angelo. "Le leggi razziali nell'impero di Mussolini." In *Il regime fascista. Storia e storiografia*, edited by Angelo Del Boca et al., 329–51. Rome-Bari: Laterza, 1995.

D'Ottavio, Angela. "Balotelli e il mito della nazionale di calcio." In *Mitologie dello sport. 40 saggi brevi*, edited by Pierluigi Cervelli, Leonardo Romei and Franciscu Sedda, 170–76. Rome: Edizioni Nuova Cultura, 2010.

Ghirelli, Antonio. *Storia del calcio in Italia*. Turin: Einaudi, 1990.

Il Sole 24 Ore. "Berlusconi: "La nostra idea dell'Italia non è multietnica"." May 9, 2009. http://www.ilsole24ore.com/art/SoleOnLine4/Italia/2009/05/berlusconi-no-italia-multietnica.shtml.

Italico Abyssino Latino. Accessed April 30, 2010. http://lucianovassallo.ning.com/video/luciano-vassallo.

L'Asmarino. "Lo Sport nell'Impero Dall'ASMARA. Pugilato che passione! – L'imminente varo del 1. Campionato Calcistico Eritreo." *Cine-Sport* 39 (1937): n.p.

Marani, Matteo. *Dallo scudetto ad Auschwitz. Vita e morte di Arpad Weisz, allenatore ebreo*.Rome-Reggio Emilia: Aliberti, 2009.

Mellino, Miguel. "Teoria senza disciplina. Conversazione sui "Cultural Studies" con Stuart Hall." *Studi Culturali* 2 (2007): 309–41.

Papa, Antonio, and Guido Panico. *Storia sociale del calcio in Italia*. Bologna: il Mulino, 2002.

Parati, Graziella. "Introduction: Studying Italian Studies Doing Cultural Studies." In *Italian Cultural Studies*, edited by Graziella Parati and Ben Lawton, vii-xx. Boca Raton, FL: Bordighera Press, 2001.

————. *Migration Italy: The Art of Talking Back in a Destination Culture.* Toronto: Toronto University Press, 2005.

Pinkus, Karen. "Empty Spaces: Decolonization in Italy." In *A place in the Sun: Africa in Italian Colonial Culture from Post-Unification to the Present*, edited by Patrizia Palumbo, 299–320. Berkeley-Los Angeles-London: University of California Press, 2003.

Pisanty, Valentina. *La difesa della razza.* Milan: Bompiani, 2007.

Saint George Football Club. "Saint George History." Accessed April 30, 2010. http://www.saintgeorgefc.com/index.php?option=com_content&view=article&id=5&Itemid=12

Spivak, Gayatri Chakravorty. *Death of a Discipline.* New York: Columbia University Press, 2003.

Stefani, Giulietta. *Colonia per maschi. Italiani in Africa Orientale: una storia di genere.* Verona: Ombre corte, 2007.

West, Rebecca. "The Place of Literature in Italian Cultural Studies." In *Italian Cultural Studies*, edited by Graziella Parati and Ben Lawton, 12–26. Boca Raton, FL: Bordighera Press, 2001.

Wu Ming. *New Italian Epic. Letteratura, sguardo obliquo, ritorno al futuro.* Turin: Einaudi, 2009.

③

ROBERTO SAVIANO

A Media Phenomenon to Recount the South
Floriana Bernardi

I. FROM READING TO REACTING: THE CRUCIAL ROLE OF *GOMORRAH*'S AUDIENCE.[1]

"**T**o S., damn it." With this dedication Roberto Saviano opens his successful first book, *Gomorrah*. Pronouncing them again and again, with a special stress on "damn," they sound like a scream that starts reverberating in 2006, the year of the book's publication, and echoes till today. The loud and obsessive sound you can imagine hearing marks two destinies of damnation which are inextricably intertwined: the ruin brought to Naples by intimidation, corruption, drug trafficking, toxic waste, and murders, and Saviano's destiny of damnation, an inexorable journey toward the loss of his physical liberty (October 13, 2006) that he had to succumb after the mechanisms of the modern camorra gained the interest of worldwide audiences.

Roberto Saviano can arguably be considered as an author "on the border" between journalism and literature. As it should always happen in journalism, in fact, both in his articles and in *Gomorrah*, Saviano denounces the corruption of Italian reality, so his writing is "transitive" (to use Roland Barthes' words), productive, functional to knowledge. In this case, as a journalist-writer, his task is that of

respecting his role, even putting his freedom and life in danger. Instead, since *Gomorrah* has also been considered as a deeply literary book, Roberto Saviano encourages his audience to reflect on issues that exceed the limits of the contemporary world, such as the value of moral and civil engagement, the power and agency of literature. Saviano's writing has questioned the foundation of the linguistics of silence, inviting his readers to assume a listening attitude, no longer that of quiet resignation to the common state of things. Saviano encourages his readers to assume an "active responsive attitude," to use Bakhtin words, which can transform their understanding of events in ethical and political action, delay it or keep it quiet. A quotation from Bakhtin will surely clarify this concept:

> when the listener receives and understand the meaning (the language meaning) of speech, he simultaneously takes an active responsive attitude towards it. He either agrees or disagrees with it (completely or partially), augments it, applies it, prepares for its execution, and so on. And the listener adopts this responsive attitude for the entire duration of the process of listening and understanding, from the very beginning. . . . Any understanding of live speech, a live utterance is inherently responsive, although the degree of this activity varies extremely. Any understanding is imbued with response and necessarily elicits it in one form or another: the listener becomes the speaker. . . . Of course an utterance is not always followed by an articulated response. An actively responsive understanding of what is read . . . can be directly realized in action . . . , or it can remain, for the time being, a silent, responsive understanding . . . with a delayed reaction. Sooner or later what is heard and actively understood will find its response in the subsequent speech or behavior of the listener.[2]

Thus, the crucial role of *Gomorrah* audience starts from these assumptions, particularly the one that "sooner or later what is read and actively understood will find its response in the subsequent speech or behavior of the listener." With three million copies of the book sold, translated into more than forty languages, Roberto Saviano's nonfiction novel *Gomorrah* becomes a literary phenomenon of astonishing proportions. In Italy many books deal with mafia issues[3] but so far only *Gomorrah* has reached a triumphal success. The reason is explained by the writer Helena Janeczek in one of her articles:

> *Gomorrah* is no doubt the first book on mafias . . . which has had a similar diffusion in Italy and in the world. *Gomorrah* has changed the way of representing and seeing mafias: no longer a local phenomenon, but a ubiquitous presence intertwined with the globalized world; no longer a tangle of criminal and political power, but the supremacy of the economic power to which all the rest is subdued.[4]

Gomorrah deals with the camorra not only in abstract terms, but it names real names, places, and describes vividly the people and their "businesses." This way, the audience realize the extent of the problem and how it affects the smallest things in their everyday life, such as the clothing and shoe manufacturing, the illegal commercial network of high-tech products imported from the Chinese market, as well as the distribution of goods, their retail chain, and prices.

Moreover, with *Gomorrah* Saviano manages to deconstruct the mythology of mafia heroes by showing not only powerful epic moments in their life, such as summit meetings, killings, shiny cars, and gorgeous women—as portrayed in classic movies like *The Godfather* (1972) directed by Francis Ford Coppola or *Goodfellas* (1990) by Martin Scorsese—but above all *Gomorrah* displays their miserable daily existence, the smell of their money, their hunted life. *Gomorrah* has struck the audience's attention because it occupies a sort of "empty space" in the Italian news system. In fact, despite Italy being penetrated by mafias, journalism deals with the camorra (and mafias in general) as criminal organizations; it hardly ever denounces and points out the connections between mafias, politics and "businesses." This means that the audience are usually told about criminal events, above all murders, but they are hardly ever guided to understand reality in depth. Besides, as Roberto Saviano maintains, when local newspapers report such news, they often use a kind of language and pictures that seem to "anesthetize" the readers' conscience and make the audience accustomed to the "banality of evil" and to the passive acceptance of the existing order of things (see paragraph 2).

Among the traditional features assigned to people living in a place affected by mafias there is their conspiracy of silence, their "omertà," which is the vehicle for a hopeless and resigned world view. In *Gomorrah* Saviano states that truth is almost never stated in his land, because

living as if you actually believe truth can exist is incomprehensible. So the people around you feel uncomfortable, undressed by the gaze of one who has renounced the rules of life itself, which they have fully accepted. And accepted without feeling ashamed, because in the end that's how things are and have always been; you can't change it all on your own, and so it's better to save your energy, stay on track, and live the way you're supposed to live.[5]

However, it is this resigned mind attitude that the Italian writer aims at subverting and in more than a sense he is succeeding in it, as it results from my investigation. First of all, I will focus on how readers received Roberto Saviano's book in terms of rating. To do this, I analyzed the customer reviews of *Gomorrah* on www.amazon.com, one of the most well-known bookstore websites in Italy and abroad. Amazon average customer assigns four appreciation stars out of five[6] to the translation of Saviano's *Gomorrah* by Virginia Jewiss (2007). The reader sample is from all over the world: Greece, Austria, Italy, Malta, and especially from the United States.

The readers' debate on Amazon is very lively and it mainly focuses on the language and the narrative thread of *Gomorrah*, the characters' insight, and the author's approach to the subject matter. Negative reviews to Saviano's book mainly concern translation, in fact, apart from a few contrasting opinions, many readers declare they found themselves "lost in translation." They maintain the English language does not come through clearly, being "stark and breathless" with a "spare and unadorned" writing. Besides, the readers state that the translation lacks some critical elements that would help to make the story more than a timeline of crime. Negative reviews to Saviano's book also concern the narrative thread, which in their opinion lacks fluency, as well as a deep insight into the minds of the characters, hence the readers carry out a "heartless" reading. Moreover, the "dizzying array of names" and "the tedious overuse of allegory and metaphor" causes, according to a part of the audience, some "problems of readability." They define *Gomorrah* as a "good story, poorly told" and as a "wasted opportunity."

An accurate critique to these opinions requires a literary analysis that I cannot deal with properly in this chapter. However, what I want to stress here are the several positive reviews of *Gomorrah*, which are actually, in my opinion, the reasons for the "transformation of the audience."

Besides being considered as a work of objective and analytic journalism, *Gomorrah* is judged by many reviewers as an "act of bravery" and as a "compelling, excellent, fabulous and magnificent book," conveying "a fascinating and unique perspective on the world today." For a large part of the audience, *Gomorrah* is a book written with passion in a punchy writing style. One must get used to the style to breathe the breathlessness Roberto Saviano tries to give the reader. The readers think that "the feeling of sick indignation is palpable in each sentence" and according to them, using intelligence and heart, Roberto Saviano has a way with words that at times sound like poetry. Talented as a writer, curious as a journalist, and with an intense love for his hometown, for many reviewers the author simply tries to understand what is happening around him and explain "why things are the way they are."

So the too intimate approach to the subject matter is not a limitation of Saviano's writing. It represents his own idea of writing and of the writer's task: "I believe that the way to truly understand, to get to the bottom of things, is to smell the hot breath of reality, to touch the nitty-gritty," he writes.[7] When one writes, one has to "look, at the same time, at the hell of the human beings and the wonder of the life impulse."[8] The writer's gaze, in his opinion, must be a two-headed one, obsessed by truth and distracted by beauty."[9] Saviano's aim is "not only to write a good book, build a story, polish words until a beautiful and recognizable style is achieved."[10] Saviano is not interested in "literature as a vice, as a weak thought," neither is he interested in "nice stories uncapable to sink hands in the blood of his time, and stare at the rot of politics and the stench of business."[11] Making reference to Hemingway, Saviano maintains that the narrative style is very important but "the grace of writing, its dilated time and the deep thought must be kept hostage by the situation, by the imperative of words to act and unveil."[12] Writing means "to be able to inscribe a word in the world, pass it to someone as a little sheet of paper with a secret information, one of those you have to read, learn by heart and then destroy. . . . Writing means resisting.[13]

According to Roberto Saviano, "the pretension to change is not an ingenuity" and the kind of writing addressed to a very wide audience "is not like a salesman' cheating."[14] As the author proudly states, his words, in the hands of so many readers, have become a means of change. Saviano maintains that "the riskiness of words does not derive

from what he wrote, but from what is read. The criminal mobs are never afraid of words *in sé*, but they are scared of words' diffusion around the world; they fear publicity, more than they fear a trial. The criminal mobs do not deny the right of writing and/or speaking, if it is limited to a restricted audience."[15]

What must never happen is that the audience become informed, that talk shows reveal the names of their enterprises. Saviano's case, in a sense, has brought to the renaissance of empathy, a "basic democratic principle," as he defines it. This strong but somewhat forgotten feeling has developed between the audience and the writer. The audience, particularly the Italian one, have felt Roberto Saviano's grief and indignation as their own.

For this reason many initiatives arose, especially out of the cyberspace. I like naming the whole of these initiatives "*OltreGomorra*" ("BeyondGomorra"). Particularly, I refer to the opening of several Web sites in support of the writer, the initiatives arisen from the social networks MySpace and Facebook, *Gomorrah*'s choral readings in schools and squares, honorary citizenships conferred to Saviano by many towns, the plea signed by many Nobel Prize winners and the thousand citizens' online petitions in his support. In short, I refer to everything that revolves around Roberto Saviano as an icon, as well as what is intended to "de-savianize" him, as writer Wu Ming 1 says, that is to deconstruct his mythical and heroic figure.

OltreGomorra is also the name of one of the most important initiatives born on the net; more precisely it is the natural development of Roberto Saviano's MySpace group. It is a very interesting and useful website (www.oltregomorra.com) opened in June 2008 by a group of volunteers coordinated by a young student from Caserta, Alessandro Pecoraro, who was also the manager of Roberto Saviano's web communication—including the writer's official website (www.robertosaviano. it), MySpace and Facebook pages—for about four years.[16] According to the members of *OltreGomorra*, Saviano's literary work was an essential and extremely relevant starting point, but their aim is to "go BEYOND, make sprouts become deep roots."[17]

By using an Internet space always *in fieri*, *Oltregomorra* points at giving the audience "a view on mafias different from the one suggested by the traditional media."[18] All the website sections aim at creating a databank

on mafias and promoting the way of thinking and acting of the "Italy that resists," that is the whole of associations and institutions which try, daily, to deconstruct the several expressions of mafias' ideology. One of the seven sections that constitute the website is an accurate "Dictionary of the camorra," coordinated by Alessandro Pecoraro. As the project's authors maintain, this is perhaps the section that best embodies the goals of the website, as it aims at shaping a critical citizenship showing the connections between very common words, (such as coffee, dog, sea, water, etc.) and the camorra, providing information and results of inquiries.

So, as I tried to prove so far, the role of Roberto Saviano's audiences has been crucial; so crucial that he dedicates to his readers his second book, *La bellezza e l'inferno*, which is a collection of articles written from 2004 to 2009. He writes:

> This book is for my readers. For those people who made *Gomorrah* a risky book for some powers which need silence and shadow, for those who assimilated its words, for those who passed it to their friends and relatives, for those who chose it as a textbook in schools. For those who gathered in the squares to read some of its pages witnessing that my story had become everyone's story, because my words were everyone's words. This book is for all of them, because I don't know whether I could have gone on without them. I don't know whether I could have continued writing and thus resisting and existing thinking to a future.[19]

Thus, throughout these years Roberto Saviano's audience have had a double importance. First of all, they have made *Gomorrah* a risky book for the mafia clans, who need silence to carry out their misdeeds, and they have fostered the creation of a network of critical, active citizenship who wish to rescue Italy from mafias' tangled power and stop the silence on such a dirty business. As Saviano writes,

> thanks to the thousand citizens' signatures, now I know that something mine has become something ours, and, after this experience, a country is no longer a geographical entity, but the whole of women and men who have decided to resist, change and participate, doing what they can do to the best of their ability.[20]

Without the readers, the issues Saviano deals with in his works would not have had so much attention on prime time TV shows, newspapers

front pages and Roberto Saviano would not have become a "media phenomenon" as he now is. He writes:

> Now I'm no longer afraid of using any medium—tv, web, radio, music, cinema, theatre—because I believe that media, if used without cynicism and cunning, are exactly what their name signifies: means that allow to break indifference and amplify what should be often shouted at the sky.[21]

Finally, the audience has protected Roberto Saviano's life, giving him the strength to continue living and resisting, despite the slanders he often undergoes and the sad and limiting condition of his life under police protection.

I. RECOUNTING THE SOUTH: TOWARD A POLITICS OF RESISTANCE AND CHANGE

The pages where Roberto Saviano reveals his most intimate rapport with his homeland, and at the same time his harsh representation of it, are those of "Lettera alla mia terra," an article first published in the Italian newspaper *La Repubblica* (September 22, 2008) after the Castel Volturno massacre, one of the most cruel episodes of terrorism and violence in which six innocent African migrants were fiercely killed in September 2008. The cruelty of an ongoing lenghty violence, exerted on the only group of people who had tried to defend their dignity and one of the most basic human rights like the right to work, results in Saviano's civil interrogation:

> And I wonder: in *your* land, in *our* land a number of killers has been lurking undisturbed since months slaughtering mostly innocent people. . . . How can this happen? I wonder: how does this land *see* itself, how does it *represent* itself, how does it *imagine* itself? How do *you* imagine your land, *your* country? How do you feel when you go to work, walk, make love? Do you consider the problem or is it enough for you to say "it has always been like that and it will always be like that?" Is it really enough for you to believe that everything that happens does not depend on your engagement and indignation? . . . Is it enough for you to say "I do not do nothing bad, I am a honest person" to feel yourselves innocent? Let the news slip down your skin and soul? . . . Is it really enough for you?[22]

With the deeply interlocutory tone of the narration rich in driving pro-
vocative questions on reality, everyday life, passivity and resignation,
Saviano tries to shake emotionally (and actually it seems to shake physi-
cally) each recipient of his letter asking explicitly for clear answers:

> And I ask my homeland: what is left to us? Tell me. To float? To act as if
> nothing happens? . . . How long are we still going to wait? How long are
> we supposed to see the best people emigrate and the resigned ones to
> stay here? Are you really sure this really suits you? That the evenings you
> spend flirting, smiling, quarrelling, damning the smell of burnt rubbish
> could be enough for you? How did we grow so blind? So enslaved and
> resigned? So subdued? How is it possible that only the very last people,
> Castel Volturno Africans who suffer exploitation and violence by Italian
> clans and other Africans, were able to take out more rage than fear and
> resignation? I cannot believe that a South so rich in talents and strengths
> could really be settled for only this.[23]

In these excerpts from "Lettera alla mia terra," as well as in most of
his works, Saviano's reflections and considerations deal with the South,
his South, and the still urgent and unsolved "Southern question." For
Saviano the South is not a separate and distinct entity from the North;
rather, the South is a part of the intricate and wicked network of cultural,
industrial and economic links with it. According to Gabriella Gribaudi,

> it may seem obvious that the idea and therefore the identity of the South
> of Italy (*Sud, Mezzogiorno, Meridione*) has been moulded through its dia-
> logue with the North, yet the various works which have been published on
> this subject rarely take this factor into consideration. . . . North and South
> have interpreted each other through scientific paradigms and preexisting
> stereotypes; they have exchanged images and representations, fashioning
> their respective identities by reflecting one another. . . . The South is
> much more than a geographical area. It is a metaphor which refers to an
> imaginary and mythical entity, associated with both hell and paradise: it is
> a place of the soul and an emblem of the evil which occurs everywhere,
> but which in Italy has been embodied in just one part of the nation's ter-
> ritory, becoming one of the myths on which the nation has been built.[24]

As also Derobertis points out,[25] Saviano shows the knots of this complex
web and the role of the South in it focusing on the workings of the

economy and trying to understand what it leaves behind that is "the most concrete emblem of every economic cycle":[26]

> Accumulating everything that ever was, dumps are the true aftermath of consumption, something more than the mark every product leaves on the surface of the earth. The south of Italy is the end of the line for the dregs of production, useless leftovers, and toxic waste.[27]
>
> The clans manage to drain all sorts of things from north to south. The bishop of Nola called the south of Italy as the illegal dumping ground for the rich industrialized north.[28]
>
> The south is flooded with trash and it seems impossible to find a solution.[29]

The representation of Saviano's homeland is also conveyed to the readers through the deceptive language of some major local newspapers, mainly sold in Campania: *Il Corriere di Caserta*, la *Gazzetta di Caserta* and *Cronache di Napoli*. In many occasions Saviano has commented on the communication strategies used by these newspapers (owned by the clans and read by many people of the region) focusing on their textual analysis (headlines, titles, language and pictures). Some of the titles discussed by Saviano are: "Bin Laden and 'O sceriffo" controlled business affairs" and "Jovine's murder: 'O lupo and «nasone» in court."

The readers' attention is immediately caught by the large use of nicknames (Bin Laden, 'O sceriffo, 'O lupo, nasone) to name the bosses. As Saviano states, "Nearly every boss has a nick-name, an unequivocally unique, identifying feature. A nickname for a boss is like stigmata for a saint, the mark of membership in the System."[30] Nicknames "pump their bodies full of the power they hope to suture onto their skin";[31] no one chooses his own nickname, but such labels can be old family names, they can based on physical traits or emerge suddenly out of somewhere. Basically, nicknames avoid the mention of bosses' names, thus promoting the construction of a mythical halo around them. According to Saviano, besides, local newspapers use such labels as a linguistic strategy to create a sort of intimacy between the journalists who write titles and the people who read them. This results in the spreading of obscure messages for people who do not live in those places and ignore the clans' national and international business affairs.

Saviano's analysis of a large number of pictures published by the same local newspapers, shows that their main protagonists are children who, undisturbed, often see murders in the streets or follow their killed mates' white coffins riding roaring motorbikes. As Saviano says, to follow these coffins using the motorbikes they received as a gift by the camorra in return of their employment as drug pushers seems to be "the only worthy requiem" for them.

It is acknowledged that newspapers, as all other media, transmit underlying and implicit messages which exert, as Patrizia Calefato argues, "the most important function in communication." In fact, as Calefato points out, "they both build the ideological framework of a message and express its illocutive function, they induce audiences to behave in a precise manner and adopt a precise hierarchy of values." For Calefato, "news titles are a proper example of verbal signs that orientate audiences in understanding texts and even words contained in the title."[32] For this reason the frequent use of slanders ("Don Peppe Diana was a Camorrist"[33]), the semiotic construction of bosses' boastful playboy image ("re degli sciupafemmine"), the repeated use of pictures portraying young people watching street murders, the act of hosting inmate bosses' letters in the news are only a few examples of that "anaesthetic language" for the audience' consciences which make them accustomed to the "banality of evil" and to the passive acceptance of the existing order of things. As Saviano writes,

> Addiction [to this kind of language] becomes so strong that you end up reading and interpreting these facts as they are told you, without doubting on their genuineness. These titles, this kind of information construct a world that it would be a mistake to consider a world of its own. It is the world of business, and it is the world of massacres. It is the world which invests money in Milan, invests money in Parma, invests money in Barcelona, invests money in Berlin. But it has its roots in the South of Italy.[34]

Saviano's personal cartography of the South also shows accurate insights into the role of women in the physical and mental microcosm of *Gomorrah*, as well as into the subverted values of religion, family, and honor. But the core of the Southern question, coinciding with the tragic diaspora of "Southern brains" from Campania, Puglia, Calabria, and Sicilia toward the north and caused by the power of criminal mobs

in the silence of politics and media, is clearly stated by Saviano in the
following passage:

> Criminal mobs decide about everyone's destiny in this damned South,
> where one must choose between emigrate and be lucky enough in finding
> someone who could help you—a politician, a relative, a friend, a friend's
> friend—and take you on there. It is as if the land is split between the
> resigned people staying there and the ambitious ones going away. The
> famous southern question . . . not only has not yet been solved, but it has
> not even been faced. There is a huge internal emigration. In these years
> millions of people have left from the South, also and above all because
> criminal mobs prevent their happiness. And preventing one's happiness
> means leading one to think of being powerless and not able to do anything
> that is not authorized by others.[35]

Beside reopening a front of debate on the Southern question, often
silenced by media, analyzing the reasons of its ongoing crisis and wide-
spread inability of modernization, it seems to me that *Gomorrah* and
Saviano's whole work has also suggested a way to change the actual
representation of the South and, possibly, for the emergence of a new
paradigm opening new possibilities and solutions for Italian politics,
society and culture.

As sociologist Franco Cassano points out, in Italian history, par-
ticularly since the end of World War II, the representation of the
South and the Southern question has been classified into three main
paradigms: the paradigm of dependence (representing the South as
the victim of a systematic process of resource exploitation and ex-
propriation in favour of richer and stronger areas), the paradigm of
modernization (interpreting the South as an area affected by a "delay
of modernity" where social, economic and cultural traits prevent the
progress) and, finally, that of autonomy.

Particularly, the paradigm of autonomy discusses the basic assump-
tion of the Southern question assuming the "pathologic condition" of
the South as the result of a cultural construction reinforcing a dominant
image of the South built by stronger subjects. Moreover, for Cassano
the paradigm of autonomy suggests a new representation of the South
as an independent entity able to rescue itself from any complex of infe-
riority and so read and interpret critically crucial aspects of modernity.[36]

In this sense, "Lettera alla mia terra" can be arguably considered as Roberto Saviano's political, civil, and literary manifesto: to observe reality, be indignant of its order of things, understand, resist and act jointly. As the author states,

> I cannot believe that only a few exceptional people are able to resist. That denunciation is by now the task of few individuals: priests, teachers, doctors, a few honest politicians and groups that interpret the role of the civil society. And the others? Do they keep quiet and silent knocked out by fear? Fear. The major alibi. It makes everyone have a clear conscience because it is in its name that families, affections and one's innocent personal life are protected, one's sacred right to live it and defend it. Yet, having no fear would not be difficult. It would be enough to act, but not alone.[37]

To use Gramsci's words, the Southern question described by Saviano can be considered as an "organic crisis" involving politics in a much broader sense and Saviano could be considered as an "organic intellectual." As Stuart Hall points out, in fact, Gramsci's concept of organic crisis includes the "«trenches and fortifications» of civil society and the creation of a new level of «civilization», beside the questions of moral and intellectual leadership and the educative and formative role of the State."[38]

In this sense, Saviano constantly attempts to create a new level of civilization informing and educating citizens through his *all-media strategy*. Moreover, as an organic intellectual who is a "constructor, organizer, «permanent persuader» and not just a simple orator,"[39] Saviano has sparked a renewed attention on mafia subjects especially in terms of audience quantity, using actively all mass media as the site of the possible cultural change and as an instrument to spread a counterhegemony. Roberto Saviano's words question the existence of a new cultural, political and economic paradigm, a new ideology, both in his homeland and in the whole Italy, encouraging people to become empowered through their knowledge, civil and political engagement.

To conclude, it is in this last excerpt from "Lettera alla mia terra," and particularly in that "first act of liberty" wished by Saviano, that one can trace the major task of cultural studies as the area of critical intervention and ethical-political project:[40]

I ask my homeland if it can still imagine to choose. I ask my homeland if, at least, it can accomplish that first act of liberty consisting in being able to imagine itself different, free. Being not resigned to accept as a natural destiny what is, instead, people's construction. Those men can tear you away from your land and your past, take away your quiet, prevent you from finding a house, write slanders on your town walls; they can isolate you. But they cannot tear off what is a certainty. . . . We need to find the strength to change. Now or never again.[41]

Thus, besides being a journalist and writer, Saviano is a cultural theorist: the aim of his intellectual, critical, and analytical effort is to change reality and he tries to succeed in this by practicing alterdisciplinarity, to use Bowman's words. As Bowman argues, the aim of alterdisciplinary practice, which remains grounded in poststructuralism and deconstructive discourse theory,

is to alter *other* disciplinary discourses and their productions (knowledges) not by critiquing them (from afar) but intervening in the disciplinary spaces of their production and legitimation—that is: *getting inside* knowledge and *undoing other methodologies* as an alternative practice of consequential intervention.[42]

As Stuart Hall makes clear in his influential 1992 essay "Cultural Studies and Its Theoretical Legacies," cultural studies was never "merely academic" and Roberto Saviano works outside academy within spaces of knowledge production like literature, journalism, and mass media. In this way he intervenes *in* their disciplinary areas and gets inside their knowledges focusing on *real* political, cultural, social and economic issues in the *real* world arguing for an effective action and change.

NOTES

1. The first paragraph of this article, titled "From Reading to Reacting: The Crucial Role of *Gomorrah*'s Audience," is based on my paper presented at the international conference Transforming Audiences 2, University of Westminster, London, September 3-4, 2009.

2. M. M. Bakhtin, *Speech Genres and Other Late Essays* (Austin: University of Texas Press, 1986), quoted by Ponzio, *Signs, Dialogue and Ideology*, 144–45.

3. The terms "mafia" and "camorra" are not synonyms, although both are secret criminal societies whose main aim is getting favours or money in an illegal way, especially by practicing intimidations, usury and extortions to little and big companies and enterprises. The mafia and camorra criminal nature is quite similar to other Italian criminal organizations too, such as 'Ndrangheta in Calabria and Sacra Corona Unita in Puglia. What is different is their place of origin and, above all, their size and structure: mafia arose in nineteenth century in Sicily (South Italy) and developed later on at a national and international level, while the camorra arose in Naples in the same years. As Saviano maintains, for a long time the camorra has remained almost unknown because the media were reporting on Sicilian mafia bombs, which killed—among other people—two great anti-mafia magistrates in 1992: Giovanni Falcone and Paolo Borsellino. However, the camorra is the most solid criminal organization in Europe in terms of memberships. It arises in the South of Italy, but its production and commercial chains are everywhere in the world. The camorra structure is "horizontal" and "flexible," pursuing a purely economic role. For this reason, the camorra is more permeable to new alliances with new clans than the Sicilian mafia and the Calabrian 'Ndrangheta. Clans operate as business committees "to move capital, set up and liquidate companies, circulate money and invest quickly in real estate without geographical restrictions or heavy dependence on political mediation" (Saviano, Gomorra, 45). However, as Saviano writes, "camorra is a non existent word, a term of contempt used by narcs and judges, journalists and scriptwriters; it's a generic indication, a scholarly term, relegated to history. . . . The word clan members use is System . . . an eloquent term, a mechanism rather than a structure. The criminal organization coincides directly with the economy, and the dialectic of commerce is the framework of the clans" (Ibid., 38).

4. Janeczek, "Siamo tutti Saviano?," Nazione Indiana, 28 Oct. 2008 http://www.nazioneindiana.com/2008/10/27/non-siamo-tutti-saviano/. Accessed March 19, 2010. [My translation from Italian].

5. Saviano, Gomorrah (English translation), 280.

6. On April 12, 2010, the online bookstore www.amazon.com displays seventy-five comments on the translation by Virginia Jewiss of Saviano's Gomorrah. The readers rate the book on a five-star scale; more precisely, the readers assign: 37 five stars/75, 21 four stars/75, 3 three stars/75, 8 two stars/75 and 6 one star/75 (see: http://www.amazon.com/Gomorrah-Personal-Journey-International-Organized/dp/0312427794/ref=sr_1_1?ie=UTF8&s=books&qid=1245426566&sr=1-1).

7. Grimes, "Where Savage Parasites Rot a Nation From Within," The New York Times, November 14, 2007. http://www.nytimes.com/2007/11/14/books/14grim.html.

8. Saviano, *La bellezza e l'inferno*, 45 [my translation from Italian].

9. Ibid., 46 [my translation from Italian].

10. Ibid., 9 [my translation from Italian].

11. Ibid., 242 [my translation from Italian].

12. Ibid., 242 [my translation from Italian].

13. Ibid., 11–12 [my translation from Italian].

14. Ibid., 9 [my translation from Italian].

15. Roberto Saviano in a radio interview with Fabio Fazio, "Che tempo che fa," *Rai Tre*, 30 March 2008 [my translation from Italian].

16. At present Alessandro Pecoraro is the editor of theWeb site http://www. oltregomorra.com.

17. Pecoraro, http://www.oltregomorra.com/documenti/9833/ [my translation from Italian].

18. Ibid. [my translation from Italian].

19. Saviano, *La bellezza e l'inferno*, 14 [my translation from Italian].

20. Ibid. [my translation from Italian].

21. Ibid., 16 [my translation from Italian].

22. Ibid., 20 [my translation from Italian, my italics].

23. Ibid., 27–29 [my translation from Italian].

24. See Gribaudi, Gabriella, "Images of the South," in *Italian Cultural Studies. An Introduction*, 73–74. Gabriella Gribaudi argues that it was during the late nineteenth century that the theoretical construction of Italian dualism and a form of "positivist racism" originated: the South was portrayed in photographs circulating around the country as "a paradise inhabited by devils": "a happy land, kissed by the gods, favoured by the climate and the fruitfulness of the soil," yet characterized by violence, anarchy, rebellions, endemic corruption, as well as by poverty and ignorance, which were actually the reasons for all these social problems.

25. Brunetti, Bruno, and Roberto Derobertis, ed., *L'invenzione del Sud. Migrazioni, condizioni postcoloniali, linguaggi letterari* (Bari: Edizioni B.A. Graphis, 2009), xix.

26. Saviano, *Gomorrah* (English translation), 282.

27. Ibid.

28. Ibid., 287.

29. Ibid., 295.

30. Ibid., 56.

31. Ibid., 222.

32. Calefato, Patrizia, *Sociosemiotica 2.0* (Bari: Edizioni B. A. Graphis, 2008), 75 [my translation from Italian].

33. Don Peppino Diana was a crusading priest who denounced the camorra from his pulpit in Casal di Principe, organized protest marches and set up com-

munity programs to siphon support from the camorra. As Saviano writes, Don Peppino Diana "decided to take an interest in the dynamics of power and not merely its corollary suffering. (…) He didn't want merely to clean the wound but to understand the mechanisms of the metastasis, to prevent the cancer from spreading, to block the source of whatever was turning his home into a gold mine of capital with an abundance of cadavers." (See Saviano, *Gomorrah*, 221).

34. Saviano, *La Parola contro la camorra*, 36 [my translation from Italian].
35. Ibid., 46 [my translation from Italian].
36. See Cassano 52.
37. Saviano, *La Bellezza e l'Inferno*, 29 [my translation from Italian].
38. See Hall, *Representation: Cultural Representations and Signifying Practices*.
39. Gramsci, quoted by Bowman, 124.
40. See Hall, *Representation: Cultural Representations and Signifying Practices*.
41. Saviano, *La Bellezza e l'Inferno*, 30 [my translation from Italian].
42. Bowman, 171–86.

BIBLIOGRAPHY

Amazon.com. Accessed March 19, 2010. http://www.amazon.com/.

Bakhtin, M. M. *Speech Genres and Other Late Essays*. Austin: University of Texas Press, 1986.

Barisione, Mauro. *Comunicazione e società. Teorie, processi, pratiche del framing*. Bologna: Il Mulino, 2009.

Boni, Federico. *Teorie dei media*. Bologna: Il Mulino, 2006.

Bowman, Paul. *Deconstructing Popular Culture*. New York: Palgrave MacMillan, 2008.

Brunetti, Bruno, and Roberto Derobertis, ed. *L'invenzione del Sud. Migrazioni, condizioni postcoloniali, linguaggi letterari*. Bari: Edizioni B.A. Graphis, 2009.

Cassano, Franco. *Tre modi di vedere il Sud*. Bologna: Società editrice il Mulino, 2009.

Forgacs, David, and Robert Lumley, eds. *Italian Cultural Studies: An Introduction*. Oxford: Oxford University Press, 1996.

Gramsci, Antonio. *Letteratura e vita nazionale*. Turin: Giulio Einaudi Editore, 1972.

———. *Gli intellettuali e l'organizzazione della cultura*. Turin: Giulio Einaudi Editore, 1973.

Gribaudi, Gabriella. "Images of the South." In *Italian Cultural Studies. An Introduction*, edited by David Forgacs and Robert Lumley, 72-86. Oxford: Oxford University Press, 1996.

Grimes, William. "Where Savage Parasites Rot a Nation From Within." *The New York Times*, 14 November 2007. Accessed March 19, 2010. http://www. nytimes.com/2007/11/14/books/14grim.html.

Hall, Stuart. "Gramsci and Us." 1987. Accessed March 15, 2010. http://www. scribd.com/doc/18010709/Gramsci-and-Us-Stuart-Hall.

———. "Representation, Meaning and Language." In *Representation: Cultural Representations and Signifying Practices*, edited by Stuart Hall, 15–64. London: Thousand Oaks; New Delhi: Sage Publications, 1997.

———. *Cultural Studies and Its Theoretical Legacies*. Originally published in *Cultural Studies*, edited by Lawrence Grossberg, Cary Nelson, Paula Treichler, 277–94. New York and London: Routledge, 1992.

Janeczek, Helena. "Siamo tutti Saviano?" *Nazione Indiana*, 28 Oct. 2008. Accessed March 19, 2010. http://www.nazioneindiana.com/2008/10/27/non-siamo-tutti-saviano/.

Oltregomorra.com. Accessed March 20, 2011. http://www.oltregomorra.com/.

Ponzio, Augusto. *Signs, Dialogue and Ideology*. Edited and translated by Susan Petrilli. Amsterdam and Philadelphia: Benjamins, 1993.

"Roberto Saviano: The Official Website." Accessed March 20, 2010. http:// www.robertosaviano.it/.

Saviano, Roberto. *La bellezza e l'inferno. Scritti 2004-2009*. Milan: Arnoldo Mondadori Editore, 2009.

———. "Il coraggio dimenticato. Il valore degli africani e la speculazione delle mafie nel mondo." *La Repubblica*. 13 May 2009.

———. *Gomorra. Viaggio nell'impero economico e nel sogno di dominio della camorra*. Milan: Arnoldo Mondadori Editore, 2006.

———. *Gomorrah: A Personal Journey into the Violent International Empire of Naples' Organized Crime System*. Trans.Virginia Jewiss. New York: Picador, 2007.

———. "Lettera alla mia terra." *La Repubblica*. 22 September 2008.

———. *La parola contro la camorra*. Turin: Einaudi, 2010.

———. "Scrivere le cose." In *Il terzo anello. Napoli, Dentro il Vulcano*. 8-12-2006. Accessed March 16, 2010. http://www.radio.rai.it/radio3/view. cfm?Q_EV_ID=195950#. As of May 30, 2011 the link is http://www.radio. rai.it/radio3/terzo_anello/napolidentroilvulcano/.

THE INVENTION OF A GENRE

The Mediterranean Noir

Gabriella Turnaturi
(Translated by Karina Mascorro and Marie Orton)

I.

The noir genre and the Mediterranean are two cultural productions charged with myths and stereotypes. "Mediterranean noir," the offspring of crossbreeding, is today a fashionable phenomenon. The Mediterranean noir can only make reference to its parents, to its generative seeds the Mediterranean and the noir. What are we talking about when we say "Mediterranean"? Where does Mediterranean culture begin and where does it end? Are we referring to Braudel's studies? To those of Matvejevic? To geopolitical studies or to cultural ones? To literature? To travel writings? To the Grand Tour's chronicles? To the most recent studies by Cassano and Latouche? How do we position all the images that have been accumulated about the Mediterranean notion? What are the contours of an idea that has been rooted throughout the centuries as a kind of cultural objectification?

If we turn to the literary genre called noir, attempts at identification are no easier. We have, for instance, a shared definition for the "historical novel" genre, but there is no universal understanding of what is meant by the term noir. Yet it is a fact that the label "Mediterranean noir" has established itself in the commercial and cultural market. What

exactly informs this label is difficulty to say because authors and stories are defined as "Mediterranean" simply by being located in contexts touched by the Mediterranean and become confused with authors who produce narratives very different from previously established Anglo-Saxon models and rhetoric. To understand the meaning of the label "Mediterranean noir," it would be useful to first deconstruct the stereotypes and the representations that surround and at the same time identify a certain lifestyle as "Mediterranean."

If, as Franco Moretti maintains, "that which occurs strictly depends on *where* it occurs"[1] and if a close link exists between geography and literary narratives, that Mediterranean area to which the label refers should be deconstructed and observed carefully to trace morphological, spatial, and narrative differences. The common denominator of "Mediterranean," precisely because it is polysemous, actually signifies very little. If, by "Mediterranean noir," one instead wants to discuss "crime stories" anchored to a territory and a geographical notion in order to highlight how a place is generative of plots and narrative styles, that is a completely different matter. In fact, the reference to space has to be understood not as a landscape but as a "narrative matrix."[2] Thus, the difference between "crime stories" produced in the context of various countries that face the Mediterranean should be isolated and then compared to better understand the points of contact and divergence that exist, both geographically and narratologically between a story, for example, set in Barcelona and another set in Marseilles or Palermo. The existence of a new phenomenon—that of "crime stories" set near the sea and under the sun—is undeniable. Numerous critics interrogate the phenomenon and there have been many international conferences on the subject such as, "Murder and Mayhem in the Mare Nostrum: Contemporary Configurations of Mediterranean Detective Genres," organized by Monash University and Manchester Metropolitan University at Prato in July 2004, and the first meeting of "Novela Negra" in Barcelona in January 2004 to honor the memory of Manuel Vasques Montalban.

The production of the "Mediterranean noir" is relevant as a sociological phenomenon, which does not necessarily mean that it also is relevant from the literary perspective. One must differentiate between the realm of the consumer market and that of literary innovation. The question to ask is, why, in the sunny lands and azure skies of the Mediterranean, is

there such a high production and consumption of noir today? One also needs to question the social transformations, the everyday changes, and the modifications in the current cultural landscape of the Mediterranean. I will therefore pose the following questions:

> Are we at the front of another type of acculturation that, although belated, turns fashionable all that has been produced and consumed for more than a hundred years in the Anglo-Saxon world?
>
> Are Mediterranean noir and neonoir also the offspring of globalization, in which the same cultural productions are written and read all over the world?
>
> Has the social reality, the everyday life, even on the seashores of the Mediterranean, been perhaps transformed to the extent that it could only be narrated through the noir?
>
> Are we becoming modern and therefore producing killers, assassins and contemporaneously their bards? Does modernity mean that we are no longer consoled by the stories of a mythical past, by domestic and intimate narratives, and instead have become glued to a present that readers and writers did not foresee?
>
> Do political critiques that call public attention to social conflicts only find space and listeners in "crime novels"? Or as as Elisabetta Mondello maintains, "If the world of the media (new and old) has assumed the role of predominant form of production of the contemporary imagination, it becomes literature's duty to combat the deleterious effects that the mass media has created and restore reality to readers."[3]

Important indications about the phenomenon come from the Italian bookstore market: some findings are particularly significant.

Traditions and precedents aside, the fact remains that in the beginning of the 1990s, the Italian noir, whose authors no longer felt the need to hide their identity under their Anglo-Saxon pseudonyms, achieved extraordinary and unprecedented success. In 1990, *Il gruppo dei 13*, formed by authors like Loriano Machiavelli, Pino Caccucci, Marcello Fois, Massimo Carloni, Carlo Lucarelli, was created in Bologna, followed by *La scuola dei duri* in Milan, which among many other writers includes Andrea Picketts, Sandrone Dazieri, and Gianni Biodillo. In 1993, with

The Trastevere Factory, the neonoir group was created by Alda Teodorani, Marco Minicangeli, Ivo Scanner (alias Fabio Giovannini) and still includes many other authors. Throughout the whole peninsula, authors of noir and detective stories sprang up. For example, in Bari, Gianrico Carofiglio; in Palermo, the city with highest number of noir authors, we can find among many others Santo Piazzese, Gery Palazzotto, Gaetano Savatteri, Piergiorgio Di Cara and Valentina Gebba; in Naples, Diego de Silva and Andrej Longo; finally, between the Northeast and Cagliari, Massimo Carlotto with a group of eight Sardinian authors united under the name, *Mama Sabot*, recently published the islander noir: *Perdas De Fogu*. A certain type of noir fever is spreading. In the beginning, noir novels predominantly found a niche with small publishing companies and very quickly became a leading market sector, even by the commercial standards of the large publishing houses, always so eager to launch new series. The forerunners of these small publishing companies include: *Datanews, Deriveapprodi, Granata Press, Il Minotauro, Meridiano Zero, Addiction, Stampa Alternativa, Theoria Edizioni, Fahrenheit 451, Fanucci, Fazi, Fermento, Castelvecchi, Lapis, Minimum fax, Nottetempo, Robin-Biblioteca del vascello, Fandandgo,* and *Flaccovio,* among others and are typically closer to alternative cultures and allow for the artistic expression of young authors.[4] The larger publishing houses soon followed suit with new series: Einaudi's liberal noir style, Marsilio's black, *"Mediterranean noir,"* from e/o, and Feltrinelli, which publishes more and more noir authors even without beginning a new series. Mondadori, meanwhile, launched the series *Colorado noir*, which is a collaboration with an enterprise that is a combination of a film production publisher and a publishing house, also called *Colorado noir*. On the fourth cover of one of their noir novels it states: "Today the noir genre is better suited to narrate the extremely abnormal and obsessive reality in which we live. "Illegal" is a point of view that has gone astray and a director's first priority is to find the point of view, 'the noir point of view.' This is one of the reasons why we enthusiastically founded *Colorado noir,*"[5] a thriving enterprise that causes reflection not only about a new artistic trend, but also about the reasons for its increasing interest and demand. Elisabetta Mondello, an attentive observer and scholar of the phenomenon and creator of the annual conference "Roma noir" at La Sapienza University writes: "In the early 2000s, almost all large

publishing houses and many small ones put into circulation crime series magazines and even inaugurated new online magazines such as fanzine and webzine on line, in order to stay in the noir arena. The enthusiastic public response was unexpected: the number of readers multiplied in newsstands and bookstores, transforming the old audience of the "Mondadori Mistery"; for weeks, Italian crime and mystery novels were top sellers; book clubs were created . . . television was turning on the cameras for Lucarelli . . . in 2002, Faletti's *Io Uccido* had great success, selling over one million three hundred thousand copies . . . in 2004, two of the main national newspapers *La repubblica* and *Il corriere della sera* rushed to edit a series of mystery/crime novels that were sold next to international and Italian literature classics.[6]

Specialized magazines with a wide circulation like *M rivista del mistero* and *Il falcone maltese* were born. A survey conducted by the editorial staff of *Il falcone maltese* published under the title "Soluzione al 1700 per cento"[7] shows how, from 1994 to 2003, Italian authors of detective stories, horror and noir went from representing 7 percent of the market to representing 24 percent, in a market that grew by 450 percent, meaning that in ten years the number of Italian authors in this genre has increased by 1700 percent. Furthermore, this percentage has progressively increased reaching 28 percent during July 2003–July 2004, and the percentage of authors in the Italian market rose 2000 percent from April 2003 to April 2005. This means that nearly one out of three detective stories sold during that time was by an Italian author. At the same time, not only did the percentage of total readers increase, but also the percentage who consider the noir genre, detective stories, and crime stories as texts similar to *tout court*[8] novels.

This leads to some reflections:

1. Authors and readers are united in a need for narratives set in well-known places and practical everyday settings, and for narratives rooted in a sort of realism of the quotidian that mirrors lived experiences.
2. These needs become intercepted and amplified by the publishing market.
3. The end of the distinction between high culture and low culture, and between children's literature and escapist literature is confirmed.

4. Italian authors become legitimized by their public success and venture into this noir genre, which was up until this point scarcely practiced in Italy.

Can we, therefore, deduce that an Italian noir is being established? Or would it be more prudent to say that Italian noir authors are affirming themselves within this genre? It would be necessary to analyze the form and content of individual texts in order to identify those writings which are not merely "cultural meditations/translations," or ones that superficially alter their scenarios and settings but whose techniques, characters and plots represent simple transpositions of Anglo-Saxon literature. Before the invasion of the noir within the Italian literary panorama, there had been only one main author, Giorgio Scerbanenco, who had risked this literary genre. Giorgio Scerbanenco, whose greatness has been recognized only in the last decades by critics and the public, is without a doubt an author who has invented a particular Italian noir writing style. Not only are his novels set in Milan, but they address the Milan of the Sixties that was transformed by the economic boom and urban renewal. Scerbanenco noir novels are "generated" by a precise social and spatial context, from the *nouveau riche*, from new lifestyles in which the figures of police officers and criminals develop in an Italian setting and do not reflect "imported" models. Scerbanenco has narrated the modernization of Italy—and of Milan in particular—the cultural transformation, the rapid change in fortune, and the social mobility that resulted from the economic boom, not only in his noir stories, but also in his more sentimental novels. The originality of his writing and his ability to depict what was happening culturally, to describe a society in transformation not only economically, but also emotionally, if not anthropologically, make him the precursor of a genre only recently taken notice of. Among the many noir Italian authors published in the last decade, only few display an original style. Many merely limit themselves to "transposing" Anglo-Saxon models to an Italian setting, often achieving a mediocre level of writing. In my opinion, only Carlo Lucarelli of Bologna, Piero Colaprico and Gianni Biondillo of Milan, and Diego De Silva of Naples are able to distinguish themselves by their innovation and ability to convey to the reader through narrative form the everyday life of the Italian metropolitan areas.

Precisely because of its local setting and adherence to social reality, the Italian noir has paved the way for a new phenomenon within the Italian narrative. I'm referring to the New Italian Realism (NIR), a recent literary wave that includes many writers, and that has initiated an interesting debate.[9] Despite being a fashionable phenomenon with great market success, the Italian neonoir has deeply penetrated contemporary Italian fiction, restoring the important role that narrative plays in our social reality.

But how does the Italian noir inscribe itself within the vast panorama of the "Mediterranean noir"? I think it is necessary to ask this type of question in order to avoid falling into the error of "inventing a new tradition" and being overcome by the celebration that accompanies the christening of a new genre. The fact that in the last decade there has been such a high production of noir in the Mediterranean area, especially in Italy and France, does not imply to refer to primitive traditions. Furthermore, it is not clear to me why this tradition, if it even exists, has so boldly and prolifically arisen. Attempting to understand what places and spaces produce in a diachronic or synchronic dimension is a legitimate and necessary operation. But one needs to be aware of swerves, leaps, and innovative and unthinkable ties that could be created between contexts that are different and distant from each other. Trying to trace a first, a precedent, or a lineage could lead to missing innovations, and hidden links, or even worse, to the construction a bogus tradition.

A kind of an "invention of tradition" can be attributed to those who believe they are able to trace a continuity of the Mediterranean noir literature from the Bible to the neonoir of our day and take into account *The Illiad*, Greek tragedy and Albert Camus. A fascinating hypothesis, but weak if one considers the assertion that all these texts, so different among themselves, are associated by: "the narration of crimes and criminals that have founded the Mediterranean civilization"; "by the pursuit of truth"; "by a search for themselves"; "by the discovery of evil in everyone"; and "by the narration of a setting impacted by fratricidal violence and beauty."[10]

But what about these texts is specifically Mediterranean? What civilizations were not born and were not affirmed through the struggle for power, assassinations, treason and violence?

Is not all literature, from Oriental to German, in pursuit of truth? And the search for oneself and for our dark side, have they not already been narrated by Goethe, Dostojesky, the great Romantics, Poe? Have not all fratricidal struggles, like everything else, been narrated by Shakespeare? Or the great bard, perhaps, was the natural son of some Greek shepherd?

But what exactly about the Bible and Greek tragedy is noir? In the noir there is no opposition between good or evil, no idea of justice on earth or after-death, and most likely, no search for a universal truth, themes that are instead present in the Bible and Greek tragedies. If Oedipus's tragedy is already a noir, as Jean Claude Izzo maintains, all stories and narration written in every region of the world could equally be so defined for the mere fact of containing tragic elements. The noir is the narration of the impossibility of clear boundaries between good and evil, between truth and untruth; noir is the narration of a present, often charged with dark past, but without a future; it is the narration of chaos and disorder, and not of re-established order. The persistence on behalf of editors and writers in trying to find the precursors of the "Mediterranean noir" is probably a response to a demand for the legitimization and for the recognition of a Mediterranean genre that up until now had not received any interest from critics and had achieved scant commercial success. On the other hand, I cannot recall Hammet, Chandler, Ellroy, or the Anglo-Saxon editors claiming noble origins for the noir, nor searching for the roots of this popular genre in Milton, Shakespeare, or the Bible. Indeed, although set and created in the lands touched by the Mediterranean, the Bible ha not been relevant of education and socialization in Mediterranean countries as it has been in Anglo-Saxon countries.

The "invention of traditions," as seen in other contexts, are forms of fantastic narrations and seductions that do not lead to an understanding or produce knowledge.

We should leave behind any useless desire to search for a tradition or continuity and instead look for similarities, common characteristics between the underground narrations produced across the various banks of the Mare Nostrum.

To begin a general mapping of this production:

France: is the country that for the longest period produced original noir novels that later became themselves models, especially thanks to authors such as Patrick Manchette, Jean Claude Izzo, Didier Daenincks, Serge Quadruppani, Pierre Siniac, Leo Malet, Serge Brussoro, Emanuel Carter, Patrick Modiano, and Fred Vargas.

Spain: Here Manuel Vasquez Montalban, whose popularity and Mediterraneaness are indisputable, has not always been classified under the noir genre; the same applies to novels written by Andreu Martin, Juan Manuel De Prada, Eduardo Mendosa, and Antonio Munoz Molina.

Israel: Here we find Benjamin Tammuz, Edna Mazya, Batya Gur, Shulamit Lapid, and Etgar Keret.

Egypt: We find Tawfiq al-Hakim and Albert Cossero.

Algeria: Here Yasmina Khadra (whose pseudonym is Mohamed Moulessehoul) excels. Her writing is very Mediterranean and very noir, as for style and for political commitment, one could say that her writing is similar to that of French authors.

Marocco: We find Driss Chraibi, whose work is more comical than noir.

Greece: Vasili Vasilikos, Petros Markaris, and Yorgi Yatromanolakis.

Portugal: Josè Cardoso Pires and Arturo Pertez-Reverte.

II.

Many of these authors' novels share some common elements, however, not all elements can be found in the works of every author. I will attempt to highlight some of these.

I.

The presence of humor in the noir is a very new and atypical element compared to the masters of the Anglo-Saxon noir. (Jim Tompson's stories, however, are an exception to this rule. Although Tompson writes about fierceness, cruelty, and evilness as an existentialist condition, almost without awareness, he offers his readers pages filled with humor).

Reading the stories written by Moroccan author Driss Charaibi, the reader smiles or laughs at the protagonist, the police superintendent Ali, or at Tawfiq-Hakim, the Egyptian country attorney, or at the misadventures of Sarti Antonio, the protagonist of almost all of the novels by Loriano Machiavelli, or by some scenes by the Sicilian Santo Piazzese, or at many pages by Andrea Camilleri, Manuel Vasquez Montalban, and Eduardo Mendoza. In a masterly fashion, Sandrone Dazieri is able to carry off the theme of the double in a humorous manner; Etgar Keret in Pizzeria Kamikaze mixes Jewish humor and death, and Gianni Biondillo's interventions by the chief inspector Lanza are comic. The habitual and passionate noir reader is surprised by the sudden burst of comical situations, lines and dialogues. Especially since the comical mood that I'm referring to has nothing to do with black humor but rather with the grotesque. This is an important stylistic innovation that delineates cultural diversity and originality which could allow us to speak about a noir born on Mediterranean shores.

The noir genre is paradoxical. It is a genre of excesses that does not leave space for hope or redemption, and yet by showing reality through a deformed mirror allows us to catch a glimpse of absurd and surreal situations that flow into comedy. The anti-hero quality of all the noir protagonists is taken to an extreme in these texts: detectives, police commissioners, and killers are frequently physically reduced to a pitiful state. They are usually afflicted by real or imaginary ailments, tormented by wives, mothers, sisters and impertinent daughters, and they love word games and jokes. More than *maudit* writers they *petits bourgeois* who have found themselves by chance in the noir genre. They are constrained to live in situations that they would have never imagined and would prefer to live a peaceful and comfortable life. (I am excluding Izzo, Manchette, or Kadra from this generalization.)

But from where do the comical elements and humorous inserts arise? What function do they serve? What are they trying to tell us and make us see?

I don't think that we should be satisfied by a type of "character-climate" explanation that could potentially ascribe the *vis comica* to the presence of sun and blue sky, or to an "innate" optimism, to "the sunshine that is found in the Mediterranean's soul," or to the pleasantness of life in these areas.

Therefore, I suggest two hypotheses:

a) Authors and readers have been constrained to see a new reality since they are forced to face the rapid and distressful transformations of the urban order, everyday life, and social and interpersonal relationships. In addition, they are forced to liberate themselves from old and stereotypical ways of narrating stories. But that which appears an unexpected horror, a loss of meaning, requires a type of distance, a kind of estrangement in order to integrate the trauma. What better exorcism than irony and humor? And what better way for confronting the incomprehensible than a moment of stepping back? The use of comical situations could have the function of naming that which is neither wanted nor accepted and makes less painful that which the text tell us.

b) From the point of view of rhetorical and stylistic choices, the comical elements are residual. They derive from other widespread genres, like the Commedia Latina, the picaresque, and short story novels (often learned through classroom education and other forms of socialization). Those genres we then find inserted into a new and strange genre: the noir. Therefore if one wants to discover a new literary tradition, it is not in the genre of "Mediterranean noir" that one needs to look, but in the permanence of figures, of situations and literary rhetoric that pass from one genre to another, altering the codes. Precisely because a traditional "Mediterranean noir" does not exist, these homemade noir are constructed as the offspring of hybridization, or like a pastiche of works made from culturally and socially available material (figures, settings, characters) with rhetorical resources that are known and practiced. Once again the subtle link between narrations and the geographical-cultural regions in which they are born into needs to be highlighted. With a new reality that needs to be narrated and made understandable, innovative stories are composed that fuse elements drawn from different genres and from different periods but placed in the same spatial area, give life to a new genre: the comic noir.

2.

In the so-called Mediterranean noir it is impossible to miss references to family, family life, domestic scenes, budgets that need to be balanced, children that must be attended to, jealous wives, almost to the point of

reinforcing the centrality and the pervasiveness of the family institution, and therefore its unavoidability when recounting everyday life. Di Cara, for example, in a Palermo that seems a "Mexican Los Angeles," is capable of making his police superintendent navigate among ruthless killers, drugs, and Sunday visits to his mother.

In the novels by Valentina Gebbia an entire family (mother, son, and daughter) becomes improvised detectives, carrying out investigations between squabbles and gargantuan familial lunches. Investigative clues and hints are buried in lasagna platters and sinked by flasks of wine. (Though the smell of food should be enough to destroy any type of noir atmosphere). Charitos, the protagonist of *Ultime delle notte* by the Greek author Petros Markaris, is a battered police superintendent who must daily disentangle himself from investigations, an oppressive and whining wife, and a loving family. Even in Diego De Silva's harsh and extraordinary *Certi bambini,* the eleven-year old protagonist, who is a killer in the service of the local mafia, cares for his old, sickly grandmother between one execution and the next. In this case the degradation of the family is addressed and depicted, yet the strong family bond is still upheld. We find the centrality of family ties even in Izzo, whether in the form of nostalgia for old community ties, or in representations of exiled and migrant families, or in established individual identities. But have we ever learned anything about the family of Sam Spade, Phillip Marlowe, or Hieronymus Bosch?

3.

The authors that we are referring to, even when they are harsh or ironic, all seem to be very attentive to registering and narrating social changes, the acceleration and the multiplication of conflicts. References are never lacking to the interconnectedness between politics and the business world, between old and new forms of corruption, between the underworld and economic businesses, between bad business deals and branches of the state's institutions. These elements are not new; they were already practiced in the earlier noir of Chandler and Hammet, two authors who influenced and were in turn influenced by the muckrackers. Yet these new texts offer something more: they are not only filled with criminal accusations, indignation, information and misinformation

about events that occurred, but they are also accompanied by forceful political and social critiques.

Izzo, Manchette, Khadra, Colaprico, Dazieri, and Didiedrick direct the reader's attention to new political assets, with their economic and social in their fallout and effects on relationships and everyday life. They narrate the dramas of immigration, of fundamentalism, of a past that is difficult to reconcile: the fascists, the Resistance, the Algerian War, the police operations, and the G8 demonstrations in Genoa. Because of this perspective, the theme of emigration and the new poverty is never absent. The new immigrants who move from one place to another in the Mediterranean are ever-present throughout these narrations, whether as protagonists, supporting actors or background figures.

Jean Claude Izzo's triology (*Casino totale, Chourmo, Solea*) set in Marseilles, is perhaps the most complete and reflective of today's reality regarding migrants, multi-ethnicity, and the new marginality. Izzo sweeps away the all the positive stereotypes of the Mediterranean and makes us observe what is happening currently under the sun and beside the blue Sea—so much that whoever reads *Casino totale* would not likely be surprised by the recent riots in the Parisian *banlieu*.

4.

In all these texts, a suffering nostalgia is a recurring theme, even in the most comical narratives. There are sorrow (regret?) for the rupture of community stability, for simple and immediate relationships, and for urban spaces that individuals can identify with. There is no mythicization of the past, but there is a flood of nostalgia for something that has been lost forever. There is a constant wondering: if things can and must change, will those changes always bring destruction? Does the past offer any possibilities for a different present? There is a search for *when* and *why* all innocence was swept away. These reflections, on the relationship of past to present, on those transformations that seem to have been forced upon us rather than desired, and reflections on modernization felt as an imposition are in almost all of these texts. But rather than presenting themselves as sermons or tidy lessons, they emerge from the story, from the unknotting of the plot, they spring from the gaze of the various characters. These characters, whether

they be in Marseilles, in Palermo, in Athens, in the Algiers, or in Barcelona cannot help but see how the spatial organization, the urban structure that surrounds them, has changed. They are unable to ignore it simply because of the kind of actions and choices that they make, in the same way that they cannot ignore how the Sea that marks the horizon has changed color and function.

Detectives, police officers, and killers (murderers) are all constantly moving: they are obligated to move around the city, to account for the loss of reference points, for the gutting of urban neighborhoods, for anything that arrives from or takes place across the Sea. Racketeering, speculations, new businesses, and new markets grow up behind the facades of the houses of the *nouveau riche*, in neighborhoods that were constructed and developed poorly and frantically, taking the road of the sea. This is why in many texts we find descriptions and reflections about the sea and urban transformations.

5.

The sea in the Mediterranean noir is a constant presence, and not only as scenery. It assumes a new role and has a central function: is the space of the passage and mutation; it draws inspiration, reflection, and even momentary reconciliation with itself. Fabio Montale, the protagonist of Jean Claude Izzo's trilogy, goes back to the sea every time he needs to think, just as the police superintendent Montalbano or Pepe Carvalho do.

But that sea no longer exists, if it ever did, as a place of innocence, for, out of that sea arrive new desperate people and new dangers. It is no longer the bluest Mediterranean of the Grand Tour travelers, nor that of fishermen's villages.

> Da Achour lives in a phantasmic village, East of Algiers. In a village made up of sacrifices, crouched on a curve that leads to the beach, it is so unruly that even terrorists refuse to attack it. Once upon a time it was a lovely village...Then the War happen and the geraniums disappeared. Nothing remained in this ex-oasis of country faires except for resentful houses, a shaky road and the feeling of not mattering at all. Few fishermen would cling to a dock that had been ignored by the waves, quickly hidden by the bed of petrified reeds.[11]

Often the bewilderment of finding oneself in an unrecognizable space is accompanied by the agony of finding oneself in front of a sea that has itself become unrecognizable. Speculative construction and the destruction of the sea—not just as a landscape, but as a source of productive power—join together in these spaces that are narrated, but not imaginary.

> Real state companies were very interested in the port. Two-hundred acres for construction, a real bed of roses. They imagined transferring the port to Fos and constructing a new Marseilles on the seashore. They already had the architects and the plan was at good point. But I was unable to imagine Marseilles without benches, the old hangar, and boats.[12]

I include these citations to highlight how urban destruction and speculative construction have been presented and developed in texts across different geographical and social situations. Despite their different scenarios, these texts still share a common history of modernization, dissimilar perhaps in details, but nevertheless shared.

This modernization that came from afar was never the product of any conscious development, is opposed in different languages, but always in the same way: with a passionate accusation often accompanied by self-criticism. In fact, if anything renders these noir alike, it is that accusation, that indignation and the fact that they are not ideological but rather political novels, in the most noble sense of the term. It is the highlighting of these choices that renders possible a present that is difficult to accept; it is bringing into question the inevitability of this present. The narrators of the Mediterranean shores attempt with their stories of blood and violence to escape from the role of unaware victims in order to instill and diffuse knowledge. The literary genre that they have chosen to express themselves whether it is called: the crime novel genre, the noir or the detective story, is no longer pulp fiction (pulp literature) but a kind of hyper-realistic literature. This genre—which has always and everywhere examined relationships of power—is now perhaps the only one capable of narrating reality and is becoming a resource for analyzing what is happening in many Mediterranean cities, a resource for the circulation of ideas and awareness, a resource for constructing an idea of the Mediterranean that goes beyond stereotypes, a resource for forming the consciousness of living in a common present instead of a common past.

In Izzo, an author who merits an individual analysis, this conscious-
ness becomes a utopian project and an alternative discourse: a discourse
that views the Mediterranean as that which divides, as the frontier
between Orient as Occident, a discourse that opposes the claim of a
"Mediterranean Creoleness," as a reconciliation that passes by way of
subjects (the new nomads) and not across territorial borders.

"[T]he Mediterranean is an appeal for a reconciliation . . . there is
nothing more beautiful, more significant for someone who has the same
love for Africa and the Mediterranean, than to contemplate their union
through this Sea."[13] And later in the same text: "It is here that every-
thing is at stake. Between the old separatist, segregationalist economic
thought (of the World bank and international private businesses) and a
new culture, diverse, hybrid, in which humans remain the masters of
their own time and geographic and social space."[14]

These new narratives present themselves as usable resources avail-
able to many because they are transmitted by way of a popular genre, a
product of mass consumption such as the noir. So welcome to the thou-
sands and hundreds of thousands of noir, crime novels, and detective
stories that narrate the Mediterranean from all the shores of that sea.

IV.

The elements listed above serve as evidence for some points of contact
between the various noir products in the vast and indefinite Mediter-
ranean area, but they also highlight a common outline that characterizes
today's noir regardless of where it is produced.

The neonoir is strictly an urban genre. If we think of the Marseilles
as narrated by Jean Claude Izzo, a city that has become an icon, that
people visit in order to trace the movements of the protagonist of the
Izzo's trilogy, Fabio Montale, step-by-step. If we consider the Rome
of De Cataldo, the Bologna of Lucarelli, the Los Angeles of Ellroy or
of Michael Connelly (who also pick up the testimony left by Hammet
and Chandler), the Stockholm of Larsen, or the New York of Richard
Price, they are all urban narrations, emotional mappings, social and
topographical contemporary cities. The neonoir is a powerfully local-
ized literary genre that is born and takes form in well-defined spaces

that produce knowledge. It brings to light spaces, places, and hidden marginal subjects that are excluded and often unknown. It amplifies familiar and known urban spaces: the investigation of this or that detective is above all the investigation of the author over a given territory. It is not the murderer or the crime that is discovered but the urban scenario. In the noir we find ourselves confronted with a remapping of the urban city, more a new definition rather than a representation. The noir reads territory as a space of continuous conflict among individuals, groups, social classes, genders, and generations. In this sense it depicts the urban life as one essentially made up of conflicts, a constant negotiation for the definition and use of urban spaces.

To narrations that are increasingly more intimate and uprooted, these genres oppose the narration of a continuous confrontation with the other, the one who is different from us, and the narration of conflicts that appear irresolvable rotate around the definition of whoever owns the city. Exactly to whom does the city belong? It is precisely on this question that the noir hinges and therefore reconstructs the definition of the urban context. The noir, among other things, while it shows conflict in action, also shows the impossibility of a reliable and definitive, reassuring answer and shows the constant reproduction of conflicts, the continuous emergence of new subjects, of new groups, of new nomads and wanders that need a section or a space within the city. By positioning itself as narrator, the highlighter of these struggles, I see the noir as revealing the limits of solutions that are purely normative and controlling: while one can find the author of a crime or a serial killer or defeat a gang of criminals, the struggle for spaces occupied by many different kinds of lives is constantly reproducing itself. The city eludes us, it is impregnable on both the narrative and material levels, and the detective or executioner is left with a kind of painful stubbornness, an endless hunt.

NOTES

1. Franco Moretti, *Atlante del Romanzo europeo* (Torino: Einaudi, 1977), 74.
2. Ibid.
3. Elisabetta Mondello, "Introduzione. Perché Roma noir," in *Roma Noir 2005. Tendenze di un nuovo genere metropolitano*, ed. Elisabetta Mondello (Roma: Robin, 2005), 9.

4. See Elisabetta Mondello, ed., *Roma Noir 2005. Tendenze di un nuovo genere metropolitano* (Roma: Robin, 2005), and *Il Falcone Maltese* 1 (2004) (Roma: Robin, 2004).

5. Piergiorgio Di Cara, *Hollywood-Palermo* (Milan: Mondadori, 2005).

6. Mondello, "Introduzione. Perché Roma noir," 10.

7. See *Il falcone maltese* 1, no. 1 (2004), and Massimo Mongai, "Il pubblico del *noir* in Italia," in *Roma Noir 2005. Tendenze di un nuovo genere metropolitano*, ed. Elisabetta Mondello (Roma: Robin, 2005), 73–82.

8. Mongai, "Il pubblico del *noir* in Italia."

9. Vittorio Spinazzola, ed., *Tirature 2010. Il New Italian Realism* (Milan: Il Saggiatore, 2010).

10. Sandro Ferri, "Azzurro e nero: per una bibliografia del "noir mediterraneo," accessed June 10, 2008, http://edizionieo.it/noirmediterraneo.html *passim*.

11. Yasmine Khadra, *Morituri* (Roma: e/o, 1997), 52.

12. Ibid.

13. Jean Claude Izzo, *Casino totale* (Roma: e/o, 2005), 32.

14. Jean Claude Izzo, *Aglio, menta e basilico* (Roma: e/o, 2006), 23–24.

BIBLIOGRAPHY

Braudel, Fernand. *Civiltà e imperi del Mediterraneo nell' età di Filippo II.* Torino: Einaudi, 1986.

Carlotto, Massimo, and Mama Sabot. *Perdas De Fogu.* Roma: e/o, 2008.

Cassano, Franco. *Paeninsula.* Bari: Laterza, 1998.

———. *Il pensiero meridiano.* Bari: Laterza, 2001.

Di Cara, Piergiorgio. *Hollywood, Palermo.* Milano: Mondadori, 2005.

Ferri, Sandro. *Azzurro e nero: per una bibliografia del "noir mediterraneo."* Accessed June 10, 2008. http://edizionieo.it/noirmediterraneo.html.

Gebbia, Valentina. *Per un crine di cavallo.* Roma: e/o 2005.

Giovannini, Fabio. *Storia del noir.* Roma: Castelvecchi, 2000.

Grimaldi, Laura. *Il giallo e il nero.* Milano: Nuova Pratiche Editrice, 1996.

Izzo, Jean Claude. *Aglio, menta e basilico.* Roma: e/o, 2006.

———. *Casino Totale.* Roma: e/o, 2005.

———. *Chourmo.* Roma: e/o, 2005.

———. *Solea.* Roma: e/o, 2005.

Khadra, Yasmine. *Morituri.* Roma e/o, 1997.

Larsen, Stieg. *Uomini che odiano le donne.* Venezia: Marsilio, 2007.

———. *La ragazza che giocava col fuoco.* Venezia: Marsilio, 2007.

———. *La regina dei castelli di carta.* Venezia: Marsilio, 2007.

Latouche, Serge. *Decolonizzare l' immaginario.* Bologna: EMI, 2004.

———. *Altri mondi, altre menti.* Soveria Mannelli: Rubettino, 2004.

Manchette, Jean-Patrick. *Piccolo blues.* Torino: Einaudi, 2002.

Markaris, Petros. *Ultime della notte.* Milano: Bompiani, 2004.

Matvejevic, Predrag. *Mediterraneo. Un nuovo breviario.* Milano: Garzanti, 1991.

Mondello, Elisabetta. "Introduzione. Perché Roma noir." In *Roma Noir 2005. Tendenze di un nuovo genere metropolitano,* edited by Elisabetta Mondello, 5–14. Roma: Robin, 2005.

———, ed. *La narrativa italiana degli anni novanta.* Roma: Meltemi, 2004.

———, ed. *Roma Noir 2005. Tendenze di un nuovo genere metropolitano.* Roma: Robin, 2005.

Mongai, Massimo. "Il pubblico del noir in Italia." In *Roma Noir,* edited by Elisabetta Mondello, 73–82. Roma: Robin, 2005.

———. "Soluzione 1700%." *Il Falcone Maltese* 1, no. 1 (2004): 16–19.

Moretti, Franco. *Atlante del Romanzo europeo.* Torino: Einaudi, 1977.

———. *La letteratura vista da lontano.* Torino: Einaudi, 2005.

Price, Richard. *La vita facile.* Venezia: Neri Pozza, 2008.

Robin Edizioni. *Il Falcone Maltese* 1 (2004). Roma: Robin, 2004.

Scerbanenco, Giorgio. *I milanesi ammazzano al sabato.* Milano: Garzanti, 1994

———. *Milano calibro 9.* Milano: Garzanti, 1993

———. *La ragazza dell'addio.* Milano: Rizzoli, 1984.

———. *I ragazzi del massacro.* Milano: Garzanti,1994.

———. *Traditori di tutti.* Milano: Garzanti, 1998.

———. *Venere privata.* Milano: Garzanti, 1998.

Spinazzola, Vittorio, ed. *Tirature 2010. Il New Italian Realism.* Milano: Il saggiatore, 2010.

Thompson, Jim. *Colpo di spugna.* Roma: Fanucci, 2003

⑤

LITERATURE AS FILM

Strategy and Aesthetics of "Cinematic" Narration
in the Novel *I'm Not Scared* by Niccolò Ammaniti
Krešimir Purgar

1. INTRODUCTION

In dealing with Ammaniti's "cinematic" narration, distinctive primarily of his novel *Io non ho paura*, various authors have hitherto mainly referred to short sentences, flexibility and modularity of a plot line, paratactic "American" syntax,[1] textual visualization of camera motion ("framing"), temporally sequential organization of narrative, fast narrational rhythm and similar.[2] All of these authors share a universal insight into the basic trait of "cinematic" narration, which became Ammaniti's main narrative procedure. Their actual concern is the "cinematic" technique of literary narration or, more precisely, insistence on creating the mental images within reader's mind. This is achieved by a precise and simple description of objects within the characters/narrator's visual field. For example, the optimal length of the description of objects which a character sees in front of him should equal the time one needs in a real situation to shot a glance at all these objects and perceive their distinctive features. Going into details exaggeratedly would disable the gaze's mobility, hence mental images created as a consequence of minute description would become pronouncedly static, i.e. noncinematic.

Here is an example of a typical "movie shot" from a novel *I'm not scared*:

> The house was falling to pieces and the roof had been roughly patched up with tin and tar. In the farmyard there was a heap of rubbish: wheels, a rusty Bianchina, some bottomless chairs, a table with one leg missing. On an ivy-covered wooden post hung some cows' skulls, worn by the rain and sun. And a smaller skull with no horns. Goodness knows what animal that came from.
>
> A great big dog, all skin and bone, barked on a chain.
>
> Behind the house were some corrugated iron huts and the pigsties, on the edge of a gravina.[3]

This description is perceived as markedly neutral. What we learn from it does not exceed the spatial range of character's visual field. Only the sentence *Goodness knows what animal that came from* can be considered as being superior to the description, since it brings forth a minimal authorial comment of the described situation and, at the same time, functions as quickly as the pronounced thoughts and therefore does not question the mobility of gaze and "shot's" impeccable visual objectivity.

Though the paratactic style is an essential point of reference in Ammaniti's narrative strategy, film theoretician Paolo Brandi warns of a fact that "cinematographic" procedure in the description of protagonist's visual field had been present in literary history ever since the early twentieth century avant-garde tendencies,[4] gaining aesthetic relevance in the 1950s French *nouveau roman*, that was known also for its indicative name *école du regard*, suggestive of the visual interpretation of literary text.[5] If we accept Brandi's journey into the past and situate the beginning of "cinematographic novel" into the era of historical avant-gardes and its golden age in the 1950s France (Michel Butor, Alain Robbe-Grillet et al.), we are still left with a question: does the Ammaniti's ekphrastic procedure comprise peculiarities that are closer to comprehending film as a medium possessing its numerous specifics, besides the most obvious one—the very images' mobility? In order to argument this, we shall refer to some indicative points of discussion on what truly distinguishes film as a medium, and what differs it from, for example, literary work or other narrative media. In this manner we can better perceive visual and cinematic predispositions of Ammaniti's literary style.

2. THEORETICAL IMPLICATIONS OF INTERMEDIA EN-COUNTER BETWEEN FILM IMAGES AND LITERARY TEXT

Deepening the knowledge on what we really see when we watch a film has been especially contributed by two disciplines within film studies: analytical film philosophy and cognitive film psychology. These two disciplines have yielded the exceptionally significant contributions to the scientific study of film and to the singular interpretation of particular works. In this endeavor, these disciplines used primarily "film itself," i.e. they attempted to establish what it is that differs the medium of moving pictures from other visual media and which are its original creative potentials. Gregory Currie and George Wilson have, among others, endeavored to discern the layers of culturally conditioned film interpretations from those characteristics that are immanently cinematic, or as Currie would put it, *medium specific*. In his programmatic work titled *Image and Mind*, Currie attempts to establish a plausible philosophical and cognitive theoretical apparatus in order to offer more rational interpretative model, significantly moving away from and actually totally opposing Deleuze's approach to film as a phenomenon whose real meaning lays beyond itself. In this manner, Currie challenges the heritage of the great theories of humanities risen from structuralism, and accuses disciplines such as psychoanalysis, and especially semiotics, for approaching the film analysis as a *film-is-like-something-else* phenomenon. Currie disputes the great theories' right to include film within a treasury of cultural products via unique (post)structuralistic interpretive methods. On the one hand, his arguments include definitive nonreducibility of film's cognitive nature to the structures of speaking language, while on the other hand they point at the delusions of Lacanian psychoanalysis.[6]

Paradoxically, it is precisely semiotics that helps Currie in establishing the basic differences between film and (written/spoken) language, this being a distinction between the sign's denotative and connotative dimensions. The literary text allows the clear delineation between a *denotative* plan of narrative, targeted at setting forth the facts on characters and action, and the *connotative* level of expression or figurative meaning. Whereas in film, connotative and denotative aspects are concurring, and denotation is always expressive, i.e. totally retracted into connotation. This is where the major semiotic postulate comes

from, claiming that literary language is symbolic, while the cinematic language is mimetic.[7]

In other words, now entirely following the Currie's trail, this means that what we see on a film screen is mainly what we should and could have seen, and that the analysis of the particulars of film "language" has to be based on the autochthonous descriptions of what we are seeing. A difference between cognitivist Currie's theses and poststructuralism generally is that the American philosopher's analytical scope grasps only the immediate visual experience, while semiotics presumes the rules of visibility in advance, demanding that we handle the knowledge on images. The identicalness of signifier and signified in film, of connotation and denotation, has led many that dealt with difference between literature and film to a conclusion that, when it comes to literature, we are talking about "evoking," while with cinematography it's about "showing." Inasmuch, the cinematic images would be the analogue of reality and would be limiting the subjective interpretations, while literary works would be stimulating mental projections, that are very personal and therefore inevitably arbitrary.[8] In the case of Currie's example, it is obvious that the analytical philosophy of film used the aporia of images and text, literature and film, along with particulars and universalities of specific artistic languages to solve a much broader problem of (in)applicability of great theories of humanities to the representational practices of moving pictures, where the language of literature and spoken language became the symbols of peculiar theoretical totalitarianism that reduced the entire mankind's cultural history to a linguistic sign.

Herein, we do not want to get involved with a discussion between cognitivists and poststructuralists by apriori accepting or rejecting their theses, but to consider whether it is possible, and under which conditions, to approach the structure of literary text in the same manner in which one would approach the analysis of cinematic piece's structure. Why do I hold such a discussion to be productive and what are the general expectations from the intermedia collision of image and text? Instead of attempting to once more affirm a thesis on the fateful referentiality of cinematic "language" to the spoken language, and of cinematic narration to literary narration, therefore the themes that have been exhaustively covered by Christian Metz and Seymour Chat-

man,[9] I find it more intriguing to submit a thesis on the influence of moving pictures on literary work. Actually, I would like to theoretically consider the consequences of a relation between image and text, when mental images stimulated by literary work are not just "evoked" but also "shown" by imitating the cinematic techniques. Besides Currie's theses, in this matter I will be assisted by George Wilson, who claims that the principal psychoanalytical positions on the film's basic illusory nature are not tenable. Wilson is relevant to this discussion because he believes in the autochtonous representational practices, developed within the framework of film medium. Consequently he goes on proving that the application of actual cinematic techniques produces concrete, clearly discernible meanings. The cognitive capacities offered by film camera and editing technique are summarized in his thesis on "imagining seeing," which he considers to be equally applicable to literary texts as well. The issue here is equaling the ontological statuses of a film viewer and a book reader. That is, the fact that the viewer really sees something (on film) does not make him any closer to the (fictive) event than the reader who has to make an extra effort and "imagine seeing," in order to visualize the fiction of a story he reads.

Wilson claims that both the viewer and the reader equally imagine seeing. The viewer imagines that what he sees could be possible in a reality that is other than his present reality, while the reader imagines and sees images that correspond with his experience of seeing "real" images and of the imaginational horizon in general.[10] Film demands the conscious imaginative surrender to on-screen fiction, where the viewer and the viewed are separated with a firm epistemological barrier. We simply know that what we see is a fiction, merely resembling the reality. Wilson claims that our capacity to see (i.e. *imagine*, in his terminology) on-screen occurrences with understanding doesn't depend so much on our inherent capacity to cognize something visually, as much as on our imaginative potential.[11]

In like degree, the capacity to visualize images and link them into the narrative wholes would be closer to the conventions of visual presentation, implying culture, knowledge and, why not, semiotic systems.[12] Consequently, our relation to film is not one of complete immersion into the "reality" of its fiction, but of a conscious surrender to being seduced by a continuing sequence of motion pictures. Therefore, this

surrender is voluntary. Not only it does not happen on a level of un-conscious cognition, it seeks our conscious help in order to become completely realized as a cinematic fiction. It requests our recognition of certain cinematic procedures that, accordingly, become necessarily conventionalized into the systems of meaning.

In Niccolò Ammaniti's novel *I'm Not Scared* we can recognize a systematic literary adaptation of those specifically cinematic proce-dures that are essential for conventionalizing the filmic meaning. Among those, an important position is occupied by the ontological status of film's character/subject in relation to a status of viewer/ob-server. The creative use of position and direction of camera motion, along with framing the visual field, are some of the most significant *medium specific* tools in the cinematographic production of motion pictures. Ammaniti's cinematographic technique of writing the liter-ary text is primarily made of constantly coercing the reader to visual-ize mental images from the offered descriptions. The reason for this is that the author programmatically omits situations that cannot be rendered visually or narratively, such as the characters' comprehen-sive inner psychological states or the descriptions of the situations outside of character's momentary visual field. Since the novel's nar-rative structure enables us, through internal focalization,[13] to know of the characters only what they know of themselves, their visual fields become crucial in discerning the narrative course. In this manner the visual field, enabled by Ammaniti's technique of framing and directing the perception, becomes leveled with that which Jerrold Levinson calls *perceptual enabling*,[14] whereas the mental images we create while reading the text are equivalent to Wilson's *imagining seeing* the fictional action on film. Though at this point I am already willing to claim that with Ammaniti this is a sort of "language iconiza-tion" and "text becoming film,"[15] I am not prepared to equal spoken/written language and the language of film. Rather, accepting Currie's and Wilson's argumentations, I shall advocate their general separa-tion, albeit with the concrete specific examples of the inflections of literary text caused by film's influence. Relying on the insights of cognitive psychology and analytical philosophy of film, we can formulate three theses to be elaborated, as they essentially define Ammaniti's literary style in the novel we are referring to:

1. the issue of the film viewer's ontological status presents the crucial philosophical problem in defining both the particulars and universals of cinematic experience, as well as the principal differences between spoken language and the language of film;
2. imagining seeing has to be active (i.e. consciously operationalized) when observing any media's fictional product;
3. literary work can have "cinematic" character if it succeeds in a paradoxical intent of imitating the film's actual specific qualities.

3. GEORGE WILSON: THE ONTOLOGICAL STATUS OF VIEWER/READER AND SUBJECTIVE SHOTS AS MENTAL IMAGES

My introductory point was that the thing enabling film fiction, i.e., enabling the events that indeed happened in front of a film camera to be experienced as fictional by viewer's mind, demands us to refrain from additional questions that could disturb the usual and generally acceptable convention of film fiction. For example, one of the most frequent and most trivial questions we ask and hence, tentatively, endanger cinematographic illusion is: "How was it possible for actor to throw himself from the twentieth floor and still survive?" Of course, we all know it was the merit of special effects, and we are aware that everything happened "only in film." Drawing on the notorious examples of film image's seduction, such as the above mentioned, George Wilson presents an essential epistemological divide between the constructive and perceptual levels of cinematic effects. On one hand there is, to phrase it in semiotic terms, an indexical record of events which (more or less credibly) happened in front of the film camera during the shooting. On the other hand we have a somewhat altered version of the same event: an actor who remains alive during the film's constructive (production) phase, dies in a perceptual phase, along with a fact that the time that took days in constructive phase, disappeared in a flash in a perceptive phase, etc. For Wilson, the constructive constituents of film are *motion picture shots*, while perceptual elements are *movie story shots*. In view of all this, if we wish to surrender to film fiction, we have to concentrate on imagining seeing only the *movie story shots*:

In other words, it cannot be that, in watching a fiction film, the viewer imagines seeing a motion picture shot of the portrayed events, because imagining this would entail imagining that it is fictional, in the movie or for the viewer, that a motion picture camera was present in the fictional circumstances and that it photographed the events before its lens.[16]

Deeply rooted in the culture of gaze, the perceptual aspects of cinematography are influenced by the unconscious or learned cognitive reactions to image, ever since the time of *camera obscura* and illusionist painting.

Therefore, an image visualized in the mind can never be separated from a real image, as the former will always remain a reflex of the real embodiment that physically already happened in front of our eyes once. If the real or, as we termed it, constructive image precedes the imagined i.e., perceptual image, then we can say that both of them precede the third kind of image, one that arises as a fruit of imageing the text. The latter, in an analogy with preceding two kinds, could be termed *the mental image*. Wilson demonstrates that images which are the products of literary/textual imageing demand the reader to imagine seeing what he actually does not see and that, similar to the case of a film viewer who surrenders to the integrated action of constructive and perceptual images, mental images give rise to a resembling logical problem. As a reader, I am not allowed to ask questions on the physical conditions of certain text's origination, and on the relation between author and text, since by doing that I disturb the ontological status of "my" reality against the reality (within) text, making them both untenable.[17]

What differs film from other media to such a degree are the imageing techniques at its disposal. Though theoretically unlimited in number, in practice these are very precisely defined and clearly differentiated procedures that help us *imagining seeing* exactly what the film's author had in mind as the targeted creative statement. In order to clarify his thesis and, in a way, release film from the frequently ascribed features of "manipulativeness" and "seductiveness," Wilson addresses the cinematographic technique of subjective shots, first by applying extensive analyses to extricate it from clearly technical implications of film craft. Then he compares it with the viewer's cognitive and perceptual reactions. Later on I shall use cinematic methods (*motion picture shots*, constructive images) that help viewers to imagine, for example, a subjec-

tive visual field of main character, or his interior psychics states (*movie story shots*, perceptual images), as a connection to the mental images in literary work. Before that, let us consider Wilson's division into the five kinds of subjective shots. These are:

1. veridical point-of-view shot
2. subjectively inflected shot
3. subjectively saturated shot
4. impersonal subjectively inflected shot
5. unmarked subjective inflection[18]

With the *veridical point-of-view shot* we are talking about maximal identification of fictional character's visual field with a viewer's visual field which is limited to a film screen. This is the simplest and also the paradigmatic case of subjective shot, since the fictional character's capacities of visualization and viewer's *imagining seeing* mainly coincide. In other words, if both could occupy the same physical space (if film screen would "disappear"), they would stand on a same spot, with their gaze oriented in the same direction.

With the *subjectively inflected shot*, the character's and viewer's points-of-view remain identical. However, the perceptual image which the viewer sees on a screen reveals yet other information on a physical or psychic state of fictional character. For example, if the fictional character is drunk and one wishes to transfer his subjective sense of vertigo or the blurry sight, the image seen by a viewer will also be blurred, camera motion can imitate clumsy movements, etc.

By further insisting on equating the character's and viewer's points-of-view the unique point-of-view ceases being a relevant measure, because in the case of the third category according to Wilson's division of shots, namely the *subjectively saturated shot*, the film's viewer no longer has insight into a real visual field of fictional character, but solely into his mental images. In other words, now the viewer sees that which the fictional character imagines to see.[19] The subjectively saturated shots are most often those when the character begins hallucinating or sees things that the other characters in the film do not see, the latter resulting from the shot's thorough "subjective saturation," causing us to abandon film's fictional reality and surrender to the new, hallucinatory reality of a main character.

This is the shot where the viewer has been left without the possibility of autonomous gaze outside the character's fictional reality. For this reason, the viewer's imagining seeing is literary directed by what the actual character, in his radically subjective perspective, is capable of seeing.

The fourth, *impersonal subjectively inflected shot*, is actually not subjective in a real sense of the word, because the "subjective" and the "inflected" in it do not match. In other words, character's visual field is different from the film viewer's visual field. Nevertheless, due to a specific and designated cinematic technique, the viewer has an impression of "seeing" through the eyes of a film character or, at least, of feeling that which the character should be feeling at a given moment. Wilson wants to draw our attention to a fact that the impersonality of the point-of-view does not mean the author is emotionally neutral toward either the characters or the viewer. Also, the subjectivity in the subjectively impersonal shot is much more than a mere standard category of cinematographic procedure. As we shall see, it is with the help of standard cinematographic procedures that the film can inflect (or influence) the style of literary narration.

The fifth kind of subjective shot, *unmarked subjective inflection*, is the most remote from what we deem to be a shot or sequence in the term's narrower connotation. Wilson's notion of the "unmarkedness" of inflection is used here because neither the fictional character nor the film's viewer are aware of what are they actually seeing. Only by the film's end will they be able to explain cause-and-effect "diversions" in the narrative course. Unmarked inflection is most often used exactly for those unexpected cuts and forward-backward shifts in action when, in the film, we imagine we are seeing earlier the action that happened later in the world of fictional character, or vice versa. Shifts are not only temporal in character, since total narrative epistemological twists occur just as frequently. The acclaimed examples of such films include *Vanilla Sky*, *Mulholland Drive* and *Memento*.

4. NICCOLÒ AMMANITI: NARRATION AS THE "SUBJECTIVE FRAMING" OF THE CHARACTER

Ammaniti's novel *I'm Not Scared* is told as a first-person narrative of Michele Amitrano, a ten-year old boy. The action evolves during the

1970s in Acqua Traverse, a village in the south of Italy. The untroubled Michele's childhood gets interrupted after his accidental discovery of a storeroom in an abandoned house, where he finds a boy somewhat younger than himself, completely starved, exhausted and frantic due to many days spent in a dark cellar, with no fresh air or daily light. Soon after this horrible discovery, Michele finds out that the other villagers, including his parents, are involved in kidnapping and capture of the boy.

Michele reveals this secret to his friend. However, the spiral of violence quickens as the friend betrays this to his own parents, endangering Michele besides the unfortunate captured boy. An almost idyllic start of the novel, with a suggestive atmosphere of open spaces and a sense of sticky sultriness of Italian south now transforms into crime suspense and a main protagonist's battle with time as he tries to rescue the kidnapped boy. In a furious finale, Michele sacrifices himself to save the boy's life, but ends up wounded by the bullet that his own father shot. The narrative is structured by a series of linear autodiegetic accounts of the main character and by the very consistent inner focalization.

At this point, I would like to expand theses outlined in the introduction by affirming that the author's treatment of subjective angle of the main character Michele Amitrano is what actually makes Ammaniti's cinematographic style an authentic literary-film procedure (this is where the quotation marks become superfluous). The visuality of novel *I'm not scared* is not made up only of descriptions of Michele's visual field (as we have noted before, this is actually an ordinary literary technique from the twentieth century), but of a whole range of subjectivizations, wherein the points-of-view incessantly change, only to emphasize more the centrality of main's character's position, his physical and emotional reactions. In my opinion, the key argument for this claim lays with nearly total applicability of Wilson's typology of subjective shots to the dynamic rhytmicization of situations, and with shifting the point-of-view in regard to a desired effect: slowing down or quickening of the action, drawing attention to protagonist's emotions, situating the action within a wider spatial context, narrowing and directing the visual field, and similar.

Let us consider the part of the book where Michele surreptitiously watches TV news and for the first time learns the identity of the captured boy, along with a fact that all of the adults in Acqua Traverse are involved in kidnapping:

I craned my neck over the sofa and nearly had a heart attack.

Behind the newsreader was a picture of the boy.

The boy in the hole.

He was blond. Well washed, his hair neatly combed, smartly dressed in a checked shirt, he was smiling and clutching an engine from an electric train set.

The newsreader went on: "The search goes on for little Filippo Carducci, son of the Lombard businessman Giovanni Carducci, who was kidnapped two months ago in Pavia. The carabinieri and the investigating magistrates are following a new trail which is thought to lead . . ."

I didn't hear any more.

They were shouting. Papa and the old man jumped to their feet.

The boy's name was Filippo. Filippo Carducci.

"We are now broadcasting an appeal from Signora Luisa Carducci to the kidnappers, recorded this morning."

"What's this cow want now?" said papa.

"Bitch! You fucking bitch!" growled Felice from the back.

His father cuffed him round the head. "Shut up!"

Barbara's mother seconded him. "Silly idiot!"

"For Christ's sake! Will you all shut up!" shrieked the old man. "I want to hear!"[20]

This description produces a very clear mental image. Michele is in the back of the room, observing the situation in his visual field from a position that enables him the optical surveillance of entire interior. He sees television that is presently broadcasting the news and people sitting around the table, also watching the television, and he witnesses their quarrel. We see everything Michele sees in this moment, from the same angle and the same situational overview. We could say this is a static master shot of the interior, to be followed by the narrower framing of characters involved in plotline. Ultimately, we can imagine that happening, because when the quarrel begins, particular characters' replicas would probably be "filmed" in closer shots than the Michele's first "establishing shot." However, even the descriptions of these medium to close-up shots of the quarrel would not influence the fact that, in that moment, the reader sees together with a novel's narrator/character. Since his views correspond with ours (readers'), this is a graphic literary example of *the veridical point-of-view shot*.

In his novel, Ammaniti uses a method which George Wilson does not mention in his typology of subjective shots. My term for this method is *the extended subjective shot*. This shot is about creating the mental images that aspire to be equivalent to the cinematic technique of shifting between shot and counter shot, since such shifts establish an optimal rate between subjectivity and objectivity of cinematic (in our case literary) narration. The extended subjective shot alternates with the veridical point-of-view shots which the film protagonist sees subjectively, i.e., those which the viewer (reader) sees together with the protagonist, and those others where the film protagonist is the object of someone else's (i.e. viewer's or reader's) gaze. This is still a subjective shot, since it maximally concentrates at the protagonist, but is nevertheless extended by some objectivizing insights that provide us with the additional information on character's psychological state (pleasure, confusion, panic . . .) or the situation in his surrounding which, in the given moment, is either outside his visual field or immediately eludes him.

An example of combining the veridical and extended subjective shots occurs when Michele goes to see little Filippo and, on the way, has to hide from an approaching car. To ease discernment, the small letters mark the parts that we are seeing together with Michele (credibility), while the capital letters mark the parts when we are imagining seeing him expressing his fear and doubt (extension–counter-shot):

> I was nearly there when a thick red dust cloud appeared on the horizon. Low. Fast. A cloud advancing in the wheat. THE SORT OF CLOUD THAT CAN BE RAISED BY A CAR ON A SUN-BAKED EARTH TRACK. It was a long way off BUT IT WOULDN'T TAKE LONG TO REACH ME. I COULD ALREADY HEAR THE DRONE OF ITS ENGINE.
>
> It was coming from the abandoned house. That was the only place the road led to. A car curved slowly round and came straight towards me.
>
> I DIDN'T KNOW WHAT TO DO. IF I TURNED BACK IT WOULD CATCH UP WITH ME, IF I WENT ON THEY WOULD SEE ME. I MUST DECIDE QUICKLY, it was getting closer. MAYBE THEY ALREADY HAD SEEN ME.[21]

As we have already mentioned, the second type of shot, *subjectively inflected shot*, is the one when we imagine seeing together with the pro-

tagonist, in a moment when his visual field is to a certain extent percep-
tively deformed (under the influence of hallucinogenic drugs, vertigo,
blow to the head and similar). Ammaniti uses this kind of inflection in a
form of short narrative digression that bears very little influence on oth-
erwise furious narrative tempo. In almost all the instances, he applies it
in combination with veridical and extended subjective shots. Subjective
inflection is marked by italics:

> Papa threw himself on Felice, grabbed him by the arm and pullled him
> off mama.
> FELICE ROLLED OVER ON THE GROUND AND I ROLLED
> OVER WITH HIM.
> *I banged my temple hard. A kettle started whistling in my head, and
> in my nostrils I had the smell of that disinfectant they use in the school
> toilets. Yellow lights exploded in front of my eyes.*
> Papa was kicking Felice and Felice was crawling under the table and
> the old man was trying to restrain papa who had his mouth open and was
> stretching out his hands and knocking over the chairs with his feet.
> *The hiss in my head was so loud I couldn't even hear my own sobs.*[22]

This example of alternating the subjective shot, objective counter-shot
and subjective inflection in "editing" discloses how removed is Amman-
iti from the cinematographic technique that would comprise a mere de-
scription of protagonist's visual field. In a nearly programmatic fashion,
the Italian writer demands from his readers to create mental images by
using their own cognitive capacities, those that are usually automatically
applied while watching the film.

Besides those already mentioned, Ammaniti applies narrative digres-
sions in *I'm Not Scared* that are quite comparable with *subjectively
saturated shot*, though we do not experience them as "cinematic"
interventions in the term's narrower sense. Actually, the subjectively
saturated shot is, by definition, very personal. Therefore, even on film,
it is being experienced as slowing down the action or the literarization
of film's pictorial essence. In our case, subjective saturation occurs in
those moments when Michele, with no doubt whatsoever in the truth of
his own visions, describes his fight with monsters that regularly hounded
him as he was falling to sleep. In that moment, all the other cinematic
procedures cede their place to the subjectively saturated Michele's vi-

sions, which continue to function as consistent stories within a story, in one instance stretching over several pages.

A very graphic example of *impersonal subjectively inflected shot* seems to have been applied at the very end of Ammaniti's novel. Michele, shot by his own father, lays in the latter's arms, while noise and reflectors of police helicopters surrounding the crime scene create a whirlwind of emotions, mixed with unbearable pain and the sense of fear:

> I opened my eyes.
>
> My leg hurt. It wasn't the leg that had been hurting before. The other one. The pain was a climbing plant. A piece of barbed wire twisting round my guts. Something overwhelming. Red. A dam that has burst.
>
> Nothing can check a dam that has burst.
>
> A roar was increasing. A metallic roar that grew and covered everything. It throbbed in my ears.
>
> I was wet. I touched my leg. Something thick and warm was smeared all over me.
>
> I don't want to die. I don't want to
>
> I opened my eyes.
>
> I was in a whirl of straw and lights.
>
> There was a helicopter.[23]

On regaining consciousness, Michele opens his eyes and at that point the images turn surreal. A metaphor of pain, portrayed through a climbing plant and barbed wire, belongs to a visual field of none of the characters but still (or actually for this very reason) penetrates deeply into Michele's subjectivity, demolished by the tragic event which he was unable to grasp. Here, a difference between the before described subjective saturation and impersonal subjective inflection is that in the first case the character totally looses connection with his reality (fictional to ourselves), while in the latter his phantasmagoric world still penetrates and clashes with the "real" world of novel or film.

Philosophers and theoreticians of film, such as Currie, Wilson and Bordwell, have written hundreds of pages of well-argumented analyses proving the autochthony of "the language of film," as opposed to all the other languages and sign systems. Communicating via image, when used within the complex structures of narrative film, is subject to human cognitive capacities and the universal laws of perception. As we have seen

in Gregory Currie's argumentation, the important difference between (cinematic) image and (literary) text is that the textual statement is comprised of a series of interrelated concepts, words and sentences which, in a certain sequence, produce the meaning open to precise denotation. Conversely, a single film shot can produce unlimitedly comprehensive connotational descriptions. Ammaniti's narrative style is made of employing the connotative dimension of written text and consequently shows signifying precision, primarily to describe what the main character sees and hears. Even in cases when the writer wishes to portray main character's introspection or imagination, he does so by describing Michele's hallucinatory visual and auditory experiences. In other words, Ammaniti writes literary text that stimulates the reader towards the intensive creation of mental images. Nevertheless, these images are simultaneously reduced to what can be "seen" through denotative level of written language, because in the case of this book, one reads only of what the main character sees and hears. The visual reading of novel *I'm not scared*, as suggested here, reveals the aesthetic potential of concrete artwork as a possibility for questioning the inveterate relation between (cinematic) image and (literary) text.

NOTES

1. See Guido Bonsaver, "Raccontare 'all Americana': *Io non ho paura* tra autodiegesi letteraria e soggettiva cinematografica," in *Narrativa italiana recente / Recent Italian Fiction* (Torino: Trauben and Trinity College Dublin), 53–73.

2. For a more general insight into the capacities of cinematic narration with Ammaniti, see Viva Paci, "Testo-Immagine, andata e ritorno: *Io non ho paura*," in *Sinergie narrative. Cinema e letteratura nell'Italia contemporanea* (Florence: Franco Cesati editore), 179–92.

3. Niccolò Ammaniti, *I'm not scared*, trans. Jonathan Hunt (New York: Anchor Books, 2003) 7–8.

4. Paolo Brandi, *Parole in movimento. L'influenza del cinema sulla letteratura* (Fiesole: Cadmo, 2007), 158–59.

5. Brandi claims that the visuality of text in French *nouveau roman* evolves from the textual interpretation of film camera's capacities: "È come se la realtà presentata nel romanzo fosse vista attraverso il mirino della macchina da presa: l'obiettivo cattura tutti gli elementi che ha davanti a sé, li registra scru-

polosamente e li trasferisce con la medesima scrupolosità sulla pagina, dove ricompare ogni elemento, ogni oggetto, ogni dettaglio che intenzionalmente o accidentalmente occupava l'ipotetico spazio della ripresa. C'è un furore visivo che sovrasta ogni descrizione letteraria tradizionale, una proliferazione di effetti ottici, un'esuberanza di raffigurazioni spaziali che mira a registrare tutto ciò che è realisticamente presente in una scena; allo stesso tempo tutto ciò che è presente nella narrazione è rigorosamente visivo" (Ibid., 166–68).

6. One particularly damaging consequence of the psychoanalytic paradigm has been the tendency to think of film as an essentially illusory medium, capable of causing the viewer temporarily to think of the film world as real, and of himself as occupying a place of observation within that world. . . . The second assumption of traditional theorizing about film is the semiotic assumption: that there is a fundamental commonality between pictures and language. This is a belief that goes along with the rejection of the hopelessly old-fashioned view that, while words operate by convention, pictures operate by similarity. On the semiotic view, all representation is conventional, and the idea that pictures might in some sense be like the things they picture is part of a benighted ideology of realism. Gregorie Currie, *Image and Mind* (Cambridge: Cambridge University Press, 1995), xv xvi.

7. Brandi, 146–69.

8. Ibid.

9. The reader is referred to my essay "'Kadriranje' teksta: Filmska naracija i fokalizacija u romanu *City* Alessandra Baricca" ("'Framing' of a Text: Cinematic Narration and Focalization in the Novel *City* by Alessandro Baricco"), *Hrvatski filmski ljetopis*, no. 24 (2008): 78–88. The essay extensively discusses the ranges of film semiotics and narratology in interpreting a literary work.

10. Wilson developed his theses on *imagining seeing* on several places. In this context we use two sources: George Wilson, "Transparency and Twist in Narrative Fiction Film," in *Thinking Through Cinema: Film as Philosophy*, ed. Murray Smith and Thomas E. Wartenberg (Oxford: Blackwell, 2006), and George Wilson, "*Le Grand Immagier* Steps Out: The Primitive Basis of Film Narration," ed. Noël Carroll and Jinhee Choi (Oxford: Blackwell, 2006).

11. Wilson, "*Le Grand Immagier*," 191.

12. Along somewhat different lines, Currie—being a true cognitivist convinced in the representational specificity of film medium—places more trust in the act of seeing than in the culturologically appropriated knowledge on (cinematic) images. Therefore, he argues it is not possible to see film without defining the perspectival relation between ourselves as viewers and onscreen occurrences: "there is no such thing as nonperspectival seeing. . . . To imagine seeing it is to imagine seeing it from the point of view defined by the perspectival structure of the picture" (Currie, 178).

13. On the issue of focalization in film and literary work, I wrote more extensively in the above mentioned essay "'Kadriranje' teksta" (see note 9).

14. In addition to theses by Seymour Chatman on imaginary film presenter (*shower,* according to Chatman), Levinson posits an ontological difference between images we see on a film screen and the action which we recognize via those images as the peculiar second level of perception: "The presenter (shower) in a film presents, or gives perceptual access to, the story's sights and sounds; the presenter in film is thus, in part, a sort of perceptual enabler. Such perceptual enabling is what we must implicitly posit to explain how it is we are, even imaginarily, perceiving what we are perceiving in the story, in the manner and order in which we are perceiving it. The notion of a presenter, whose main charge is providing a perceptual access on the fictional world, is simply the best default assumption available for how we make sense of narrative fiction film." Jerrold Levinson, "Film Music and Narrative Agency," in *Post-Theory: Reconstructing Film Studies,* ed. David Bordwell and Noël Carroll (Madison: The University of Wisconsin Press, 1996), 248–82.

15. These syntagms are used by French iconologist Hubert Damisch to point toward the growing interdependence and reciprocal influences between image and texts. The reference is drawn from Damisch's commentary at the exhibition *Sans commune mesure*, Pompidou Center, Paris, 2002.

16. Wilson, *"Le Grand Immagier,"* 195.

17. Of course, this principle can be legitimately challenged through the conscious authorial manipulation of reality levels, such as the very frequent postmodern metafictional interventions into a narrative course.

18. Wilson, "Transparency," 81–95.

19. In this manner, subjectively inflected shot becomes a site of another interesting overlapping that cannot be dealt with here extensively: namely, the viewer's perceptual image (blurred screen) is overlapping with a fictive character's mental image (blurry sight and vertigo).

20. Ammaniti 78–79.

21. Ibid., 63.

22. Ibid., 141.

23. Ibid., 199.

BIBLIOGRAPHY

Ammaniti, Niccolò. *I'm Not Scared.* Translated by Jonathan Hunt. New York: Anchor Books, 2003.

Bonsaver, Guido. "Raccontare 'all'Americana': *Io non ho paura* tra autodiegesi letteraria e soggettiva cinematográfica." In *Narrativa italiana recente / Recent Italian Fiction*, 53-73. Torino: Trauben and Trinity College Dublin, 2005.

Bordwell, David. *Narration in the Fiction Film*. Madison: The University of Wisconsin Press, 1985.

Brandi, Paolo. *Parole in movimento: l'influenza del cinema sulla letteratura*. Fiesole: Cadmo, 2007.

Branigan, Edward. *Projecting a Camera: Language-Games in Film Theory*. London and New York: Routledge, 2006.

Chatman, Seymour. *Coming to Terms: The Rhetoric of Narrative in Fiction and Film*. Ithaca, NY and London: Cornell University Press, 1990.

Colombi, Matteo, and Stefania Esposito, eds. *L' immagine ripresa in parola. Letteratura, cinema e altre visioni*. Roma: Meltemi, 2008.

Currie, Gregorie. *Image and Mind*. Cambridge: Cambridge University Press, 1995.

Levinson, Jerrold. "Film Music and Narrative Agency." In *Post-Theory: Reconstructing Film Studies*, edited by David Bordwell and Noël Carroll, 248–82. Madison: The University of Wisconsin Press, 1996.

Maggitti, Vincenzo. *Lo schermo fra le righe. Cinema e letteratura del Novecento*. Napoli: Liguori editore, 2007.

Metz, Christian. *Film Language: A Semiotics of the Cinema*. Translated by Michael Taylor. Chicago: The University of Chicago Press. Originally published as *Essais sur la signification au cinéma*, vol. 1–1971. Paris: Editions Klincksieck, 1974.

Paci, Viva. "Testo-Immagine, andata e ritorno: *Io non ho paura*." In *Sinergie narrative. Cinema e letteratura nell'Italia contemporânea*, 179–92. Firenze: Franco Cesati editore, 2008.

Purgar, Krešimir. "'Kadriranje' teksta: Filmska naracija i fokalizacija u romanu *City* Alessandra Baricca" ("'Framing' of a Text: Cinematic Narration and Focalization in the Novel *City* by Alessandro Baricco"). *Hrvatski filmski ljetopis*, no. 24 (2008): 78–88.

Turković, Hrvoje. *Teorija filma*. Zagreb: Meandar, 2000.

Wilson, George. "*Le Grand Immagier* Steps Out: The Primitive Basis of Film Narration." In *Philosophy of Film and Motion Pictures: an Anthology*, edited by Noël Carroll and Jinhee Choi. Oxford: Blackwell, 2006.

———. "Transparency and Twist in Narrative Fiction Film." In *Thinking Through Cinema – Film as Philosophy*, edited by Murray Smith and Thomas E. Wartenberg. Oxford: Blackwell, 2006.

II

FILM

6

DUBBING FOR FUN, DUBBING FOR REAL

Antonella Sisto

The title of this chapter is inspired by an article published in an issue of *Focus,* a news and science magazine broadly published around Europe. A couple of summers ago in Italy, the new special monthly edition, *Focus Storia,* with a focus on history was very popular on the beach. A short article grabbed my attention, "Doppiatori per scherzo? Ora si può"[1] ("Dubbers for Fun, Now We Can"). Echoing Barack Obama's electoral slogan the title indicates new possibilities: now we can dub films for the fun of it. As the subject of my research I take dubbing very seriously, while the article takes it very frivolously. Beginning with the title itself I wonder: What is the meaning of the temporal adverb "now" (we can)? Of course it is not intended to speak of a historically conscious notion of dubbing that would juxtapose the "now" of dubbing to a past "then." A "then" which would refer to the origins of dubbing, when the Fascist Regime imposed it on foreign films, and used it to indoctrinate the Italian population and shape its cultural linguistic consciousness. "Then" the function of dubbing was to eliminate foreign voices and languages, thus modes of being, seeing, saying and acting in the world, allowing for and operating as invisible censorship modality of non approved content, characters, scenes, foreign songs, foreign foods, foreign cities. Briefly: manipulating any sociocultural reference that might disrupt the fragile

idea of national self-identity that Italians had. "Then," when every foreign film was packaged into the national phonetic and cultural box, the purpose of dubbing was not to be funny, but to support and create a unique Italianicity. Thus New Yorkers, Parisians, Sicilians, and Milanesi, all spoke, with slight variations, the same, nonexistent standard Italian.

Not only is the "now" of the *Focus* article not referring to the fact that there was nothing hilarious about dubbing "then," it does not even pose the question of what is funny about dubbing today, when it still functions as common and undisputed translation modality, dominating cinema and television screens which project and broadcast foreign films and audiovisual material repackaged into Italian. The article refers to a "now" commonly available technology that allows us to eliminate the original, and superimpose a self-made soundtrack to any image track. Through the use of basic multimedia editing software, a microphone and a set of headphones any video, film, or advertisement can be renarrated *a piacere*.

The web bubbles and blathers with comedians and profane amateurs remaking the plots of famous ads or films. This is a new hobby for many, who can "now" parody old and new Hollywood movies, make fun of famous actors, enjoying the unconditional power of filling their mouths with any word whatsoever. In Italy this often means using the nonglamorous, proletarian, and vulgar dialect of their region, from Neapolitan and Apulian to Florentine and Levornese. Among the many films commonly dubbed for fun are *Rambo*, *The Gladiator*, *Troy*, and *The Godfather*; a favorite has been *Titanic* (1997), a movie in which Leonardo Di Caprio and Kate Winslet have become prey to so many caricatures that their stardom oscillates with vernacular ridicule.

While there is undoubtedly an element of popular critique of hegemonic ideals and narratives in such operations, one must pose the question: how cognizant or oblivious are they to the reality of a past and present linguistic and cultural censorship perpetrated by real dubbing that passes innocuously for translation? These *dubbing for fun* operations seem to be an uncontroversial, if unaware, joke on the workings and misdeeds perpetrated by dubbing as the Fascist Regime's strategy for the anesthetization of foreign and national films too. Because "then" dialects were also forbidden, and thus censored. The point to be emphasized is that the censorial function of dubbing is indirectly

operative nowadays, hidden and protected by its professionalization and the skilled quality of its work. In fact, of all those who saw *Titanic*, how many actually saw the original version, listened to the original dialogues and the real voices and performances of the actors? What would a close analysis of the dialogue translation into Italian reveal? What free and invisible, yet audible, adaptation and domestication, what omissions and substitutions did the dialogue undergo to be synched to the actors' lips while satisfying audiences' cultural expectations and overcoming cultural gaps? And what happened to the aural sonic dimension of the film and the characters?

What this prologue wants to foreground is the irony of this new, computer-age hobby that replays and circuitously uncovers the pathology of a nation that thanks to Fascism never listened to the other, and still today fundamentally knows only one way of relating to him or her, that is, never really listening, ergo never engaging with the other in, and thus on, his/her own terms. The short-circuit going on with "doppiaggio per scherzo," *dubbing for fun,* is not only that of casting a mocking ear on "doppiaggio per davvero"—the dubbing for real of the everyday movie-going experience—but also some form of questioning whether fully conscious or not. Dubbing for fun talks back to the obligatory dubbing of the fascist times, where the Regime intended to reject the foreign other, and the domestic other also because he or she did not speak the "correct" Italian national language but dirty and subversive regional dialects. Thus, dubbing for fun shows that while the fascist operation was successful in the expulsion of the foreign other, it could not get rid of the national regional others, with their dialects, which were manifest symptoms of the fractured consciousness of a nation yet to be, made of separate realities, ruralities, and local languages. Those forbidden dialectal languages are used today to parody the somehow foreign other, somehow foreign because *dubbing for fun* is in fact a dubbing of *the dubbing for real* that the foreign film has already undergone, through the postsynchronization technique that the Regime imposed, made available, and definitively established in the country to the point that Italians today are enculturated in an exclusively dubbed cinema and audiovisual world.[2]

If cosmopolitan ideas and languages failed to enter, provincialism or localism never left. Enormously popular films like *The Matrix* and

Titanic offer the visual surface for the verbal representation of local sketches, voicing dialect and vernacular imagination, narrating, over the original film scenes and already dubbed dialogues, a re-dubbing of domestic traumas, like the theft of a car, some mafia crime, a celebration of local identities via the exuberant performances of local soccer teams' fans, or a parody of Hollywood-sublime love scenes with grotesque body function conversations.

Dubbing for fun, with its technical and cultural demystifying function, shows the powers entangled in dubbing tout court, and in this way gives the lie to those who believe in dubbing as not only suitable but a neutral and democratic modality of audiovisual translation.

Unfortunately the academic conversation about dubbing as articulated in translation studies, and commonly offered as the truth to bigger general audiences, does not pose too many questions. Conceivably, taking into account the fascist origins of dubbing and considering the ease and frequency of its use as censorial dispositive—notions which are virtually forgotten, put aside and if mentioned not problematized—would change the perception of this modality of film translation that was used to govern the dissolute and harmful machine that cinema can be. As Luigi Freddi, father of the fascist cinema machine expressed well in his *Il cinema: Il governo dell'immagine*[3] (Cinema, the government of images), in his sociopolitical theory, censorship is a necessary moral and political foundation for a healthy and safe national life.

The cultural and ideological impingements of the normalization of dubbing have become irrelevant in the general discourse, lost in the economics of its established and professionalized industry and the discursive non-critical investment in Italian dubbing as "the best in the world." Banally no connection is made concerning the scarce foreign language literacy of Italians, and the absence of free circulation of foreign languages on the national screens, where the dubbed present reverberates of a xenophobic past.

The use of subtitles as translation modality which respects the sonic dimension of cinema and grants the possibility of listening to the other's language receives virtually no consideration. Apart from their presence in film festivals, or a few the big city cinematheques, subtitling is virtually nonexistent. It goes without saying that the "art cinema" exhibition space that opts for subtitles shows how, if we were to respect a film—its

cultural creative capital, the actors' performances, the film's author-ship, and spectatorship—we would never dub. But the niche art space reserved for subtitles creates or supports the idea, and the existence of sophisticated film spectators, more demanding than general audiences. Refined viewers who assume it is their obligation and pleasure to hear the film as well as see it.

This false dichotomy takes us back to the referendum that Michelan-gelo Antonioni held from November 1940 to April 1941 in the magazine *Cinema*, directed by Vittorio Mussolini. Over a decade into the legis-lated and imposed practice, and the Regime still in power, the director-to-be wanted to ascertain who was for or against dubbing, and why; his intention was to investigate the possibility of abolishing it. In the end the survey found a small preference for dubbing and a separation between art cinema lovers—against dubbing—and general spectators—for dub-bing. Antonioni affirmed between the lines, for obvious reasons, that he perceived this common notion of diverse spectatorships, as a com-modified and bourgeois lie that served to support the system of dubbing determined by political will for political reasons. Antonioni wryly stated his disapproval, and awareness that dubbing can function as censorship, and that censorship is the reason why it cannot be renounced, given "the simplicity with which it is possible to vary, or what is more, reverse, the meaning of a discourse, and even the assumption of a film that is not fully in tone with those which are the rules of our nation/home."[4]

Today we need to address how we have maintained the fiction of "sophisticated spectators" and "general audiences" to continue dub-bing. In this process of understanding it is necessary to consider the importance played by the dubbing industry, impossible to dismiss given the revenues it generates, and has generated since the start, and the employment created for a growing number of technical workers and professional voice-actors. Moreover it is important to debunk the com-mon notion that being against dubbing is purely an aesthetic matter, it is also, and fundamentally, an ideological one. A change of language, even if conducted as expert translation, carries the weight of the social and shaping nature of language itself. Likewise some considerations on subtitles, commonly dismissed because "the general public does not want to read at the movies" are in order; this lie was already exposed by Antonioni in the forties. He denounced the conventionality and

constructed-ness of the dubbed-film-going habit, a habit mostly intolerable in countries which differently from Italy did not suffer governmental linguistic purism. Moreover had not audiences read inter-titles throughout the silent period, and continued to in Italy when the Regime silenced the dangerous new talkies?

Subtitles leave the soundtrack intact, do not arbitrarily substitute sounds, sonic environments, words, or performances of the actors on the screen. They allow for a holistic apprehension of the film as audiovisual text and for a comparison of the verbal written translation and the original oral dialogue. Thus while they respect the composite artistic audiovisual format of the medium they also allow for the detection of errors. Such detection is not only a priority of sophisticated spectators who may know the film's foreign language but also of responsive general spectators who can become conscious of small inconsistencies, variations and perceptible failures of the translation compared to the actual oral performance. This particular notion is presented by Ella Shohat in her essay "The cinema after Babel,"[5] where she follows Roland Barthes' idea of the ineffable comprehension of pure nonverbal language, that is language as pure sound devoid of its functional and immediate verbal meanings. Understanding things explicitly and articulately is one form of apprehension. As a phenomenologist approach tells us, there is more to how humans make sense than intellectual analysis, the body being the responsive site of multiple interconnected senses that operate together to produce subjective meaning and significance and then cerebral cognition.

Expanding from "the perceivable errors," Maurice Merleau-Ponty[6] writes directly about the general disconnect that he personally senses and experiences when watching/listening to a dubbed film. He tells us how he falls into a quasi stupor, as the aural does not match the visual, the language does not fit the mouth, the face. I would continue, emphasizing that the imposed national language not only mismatches the lip movements—cannot ever be perfectly in synch—and cannot really tell and linguistically perform the foreign people, their bodily gestures, postures, and facial expression, it cannot narrate many of the cultural and social connotators and locators on the screen. A cognitive breakdown occurs and it concerns the area of significance which is where we make sense of the world. This can cause a withdrawal, conscious or not, on

the part of the perceiving subject, that is the spectator, from the film as cultural object. A process of interiorization and normalization of such withdrawal is to be taken into account, so that foreign dubbed films end up having something eerie and unbelievable about them, an inherent and perceived falsity that comes from the deterritorializing language artificiality. We know that not the entire world speaks Italian.

My idea is that dubbing operates as machinery that, perfectly fitting the fascist agenda of expelling anything foreign, undermines the foreign film's credibility and consistency. It creates an imaginary farcical domesticated other, perceived as counterfeit and thus the basis for a pathological dismissal of, at least, the filmic other, no longer a carrier of foreign modes of being, saying and seeing the world, but readapted and cannibalized into national cultural linguistic coordinates that do not really fit the foreign visual narrative. Thus the cultural "schizophonia" caused by the imposition of foreign language and voices on a culturally coherent audiovisual filmic narrative, is ultimately the object of the dubbed reconstruction. I am using the word schizophonia as coined by R. Murray Schafer to express the technical condition of a sound split from its source.[7] Here it serves to indicate the voice split from the body, powerfully suggesting the schism, unsettling and disturbing even at a basic, non-conscious mode of cinema spectatorship and ever stronger the more the audience is aware of it. The language split from its reality— the social, cultural reality of its speakers and their environment. The fascist enterprise of monopolizing national identity was a perverse operation, which is still perversely effective.

What is troubling is that while a considerable number of works in film studies, also in Italy, have been dedicated to the soundtrack—the history of its development and the transformation of filmic writing from purely visual to audiovisual—dubbing appears as essentially a Hollywood strategy for international film distribution with little national history attached. If we look into dubbing and its coming to the movie, investigate the related legislation, we discover how dubbing has everything to do with national matters, and how Hollywood would have preferred to translate its movies with subtitles which were, and are, less expensive. How often do we hear that in Italy, the birth of sound cinema was silent? Sound cinema roared in newspapers, ads, and magazines, while the Fascist Regime ruled the silencing of foreign films. The first

sound films were shown muted—deprived of any speech. Cinema did not talk until the invention of dubbing and its subsequent introduction.

As Jean Gili reports, by 1929 the prohibition to project films in a foreign language was total, and until the 1930s the original soundtrack was stripped of the dialogue and when not substituted there

> remained only musics and noises, while the film scenes were continually—and not very aesthetically—interrupted by the inter-titles with the translation of the dialogue. The original films thus lost their rhythm and their value. For some films, abundant with dialogue, a huge number of inter-titles was necessary: these sometimes were more than the images, generating those films that the satirists of *Marc'Aurelio* called "films 100% read" exactly when cinema boasted about being able to offer films "100% spoken."[8]

This is how a xenophobic rule started creating the "100 percent Italian" cinematic soundscape. Italians, as cinema spectators, have never known foreign films, since the birth of international sound cinema was denied by the Fascist Regime, they had to wait for a second coming, dubbed into the mouths of actors and actresses.

Contemporary film studies, pointing at the audiovisual, emphasizing the aural sonic dimension and its significance, the role of the voice and the sound-scape, after a long period of deafness—given the traditional visual implant—should have the power of drawing attention, in the Italian arena of debate, to the issues concerning dubbing, its history, and its cultural effects. How can we discuss contemporary films and their soundtrack, or simply where they stand as audiovisual creations without recognizing the major alteration they undergo through dubbing? Exemplary of the widespread dubbing denial are columns devoted to sound in major film publications in Italy, like "Segno Sound" in the magazine *Segnocinema,* or "Soundtrack" in *Cineforum*. In a general, if forced, connivance with dubbing, the taboo of the actors' voices is most striking. Almost no comment surfaces on the fact that the voices Italians listen to at the movies are different from the originals, and that the great celebrated or critiqued performances of the actors on the screen are eviscerated by the substitution of the best voice actors in Italy. As if the actor was only a body with an interchangeable voice that can be ventriloquized like a puppet. The "rhetorical-act" that the actor is (attore as

atto-retorico) in Carmelo Bene's formulation,[9] is completely destroyed. How do we talk about the sonic dimension of a film against the reality of its impossibility in the allotted exhibition spaces?

Only a multidisciplinary perspective on dubbing can open up the conversation about it and help us to think critically of the semiotic violence and cultural schizophonia that it produces. I believe that a retracing of its fascist ideological matrix is fundamental. Framing dubbing as neutral, is an act of sociohistorical erasure that willingly ignores its impingements on reality as it conveniently forgets how it functioned then and still today as a controlling dispositive. Despite its deliberate censoring function during fascism, and beyond, its use as a necessary instrument for the moral and political maintenance of a healthy and safe national life, because of the deafness of film studies, the importance of dubbing has been ignored to the point that an Italian film historian of the caliber and perspicacity of Gian Piero Brunetta can say that cinema during fascism had the strength and the ability to constitute itself in the collective imaginary,

> as a real space and a possible world, as a habitat where the presence of fascism could almost be reduced to zero and one had enough freedom to operate and see the cultivation of cultural, linguistic seeds and values systems coming from international realities.[10]

If spectators saw something of international realities, they certainly didn't hear them. They could sense the existence of other voices and other linguistic screens, which were not the ones talking to them.

Critically listening to cinema allows demonstrating the perverse cultural censorship that was operated on the nation and reveals how dubbing constitutes itself today as the sonic-scape of the nation's fascist repressed unconscious, and how its unquestioned status participates in a national disinclination to come to terms, in all its complex reality, with resounding fascist relics.

NOTES

1. Anita Rubini, "Doppiatori per scherzo? Ora si può," *Focus Storia*, July 29, 2008, accessed June 24, 2010, http://www.focus.it/Storia/speciale/Doppia-tori_per_scherzo_Ora_si_puo.aspx.

2. The little mystery concerning the Italian dubbing of the American film *Night at the Museum 2* (2009) offers an interesting footnote for the present discussion. In the original, and the French dubbed version of the film, the protagonist Larry (Ben Stiller), working as night watchman at the Museum of Natural History in New York, encounters a reincarnated Napoleon who tells him of a love affair with a woman pilot. In the Italian dubbed version the story changes. Napoleon talks about his Italian descendants, one of them in particular, one "at his height, a fat cat, funny and powerful, who used to sing on ships" when Larry replies that he does not know him, Napoleon ends with "everybody knows him and everybody loves him." The clear allusion to Mr. Silvio Berlusconi, formulated with bits and pieces of the constant advertisement for the Prime Minister, was immediately familiar to Italian audiences and was justified with requisite nonchalance by the Italian President of 20th Century Fox, Osvaldo De Santis. He stated that the original dialogue made references to unknown characters that would not have been fun for the Italian audience. His position in Mr. Berlusconi's Government in the Ministry for Cultural Activities might offer some indication as to his personal and currently governmental taste in what is funny. And there we have it again another form of dubbing for fun. "Notte al Museo 2, cambiata la battuta su Berlusconi «pronipote» di Napoleone,"*Corriere della Sera,* May 25, 2009, accessed June 24, 2010, http://www.corriere. it/politica/09_maggio_25/notte_museo_battuta_berlusconi_005c28fe-4921-11de-887b-00144f02aabc.shtml.

3. Luigi Freddi, *Il cinema: il governo dell'immagine* (Roma: Centro sperimentale di cinematografia, 1994).

4. Michelangelo Antonioni, "Conclusioni sul Doppiato," *Cinema* 116 (1941): 261.

5. Ella Shohat, "The Cinema after Babel," in *Taboo Memories, Diasporic Voices*, ed. Ella Shohat (Durham: Duke University Press, 2006), 106–38.

6. Maurice Merleau-Ponty, *Phenomenology of Perception: An Introduction* (London: Routledge, 2002), 273.

7. Raymond Murray Schafer, *Our Sonic Environment and the Soundscape: The Tuning of the World* (Rochester: Destiny Books, 1994), 43–47.

8. Jean Gili in Mario Quarognolo, *La censura ieri e oggi* (Milano: Pan, 1982), 49–50.

9. Carmelo Bene, *Opere* (Milano: Bompiani, 1995).

10. Gian Piero Brunetta, "Introduzione. Nuove frontiere e nuove ipotesi di ricerca sul cinema del fascismo," in *Dialoghi di regime: la lingua del cinema degli anni trenta,* by Valentina Ruffin and Patrizia D'Agostino (Roma: Bulzoni, 1997), 31.

BIBLIOGRAPHY

Antonioni, Michelangelo. "Conclusioni sul Doppiato." *Cinema* 116 (1941): 261.

Bene, Carmelo. *Opere*. Milano: Bompiani, 1995.

Brunetta, Gian Piero. "Introduzione. Nuove frontier e nuove ipotesi di ricerca sul cinema del fascismo." In *Dialoghi di regime: la lingua del cinema degli anni trenta*, by Valentina Ruffin and Patrizia D'Agostino, 11–32. Roma: Bulzoni, 1997.

Freddi, Luigi. *Il cinema: il governo dell'immagine*. Roma: Centro sperimentale di cinematografia, 1994.

Merleau-Ponty, Maurice. *Phenomenology of Perception: An Introduction*. London: Routledge, 2002.

"Notte al Museo 2, cambiata la battuta su Berlusconi «pronipote» di Napoleone." *Corriere della Sera,* May 25, 2009. Accessed June 24, 2010. www.corriere.it/politica/09_maggio_25/notte_museo_battuta_berlusconi_005c28fe-4921-11de-887b-00144f02aabc.shtml.

Quargnolo, Mario. *La censura ieri e oggi nel cinema e nel teatro*. Milano: Pan, 1982.

Rubini, Anita. "Doppiatori per scherzo? Ora si può." *Focus Storia,* July 29, 2008. Accessed June 24, 2010. www.focus.it/Storia/speciale/Doppiatori_per_scherzo_Ora_si_puo.aspx

Schafer, Raymond Murray. *Our Sonic Environment and the Soundscape: The Tuning of the World*. Rochester: Destiny Books, 1994.

Shohat, Ella. "The Cinema after Babel." In *Taboo Memories, Diasporic Voices*, edited by Ella Shohat, 106–138. Durham: Duke University Press, 2006.

7

CRONACA DI UN AMORE

Fashion and Italian Cinema in Michelangelo Antonioni's Films (1949–1955)

Eugenia Paulicelli

Antonioni loved clothing. He was fascinated by fashion, by the tactile and sensual components of fabrics, and the ability of dress, costume, and make-up to shape, transform, and play with identity on screen. Self-fashioning and performance are embedded and embodied in both fashion and film. As fashion historian Christopher Breward has put it: "If fashion can be said to be cinematic in its social and visual effects, then cinema is also very clearly a primary product of the aesthetic and technological processes of 'fashioning.'"[1] Fashion and fashioning, however, have a far broader reach. We can extend metonymically the concept to the act of dressing any human manifestation via language, words and discourse, as well as to the practices of the body and its passions. Both literally and symbolically, dress is what defines appearance and plays a significant part in how one is perceived and how one performs in public. The interaction between fashion and cinema can be revealing not so much to "retrieve" the links between the personality of the character and the dress s/he wears on the screen, but more importantly to give access to the folds of the film, to the always unfinished process of fashioning and to the cinematic language employed.

Translation is involved in all these processes. As Walter Benjamin, following Marx, has suggested, the act of translation is a key mecha-

nism that defines fashion's inclination toward newness and the rein-
vention of the past.[2] Translation and transformation are inherent not
only in fashion, but also in cinema as was already evident as early as
1949 in one of Antonioni's first works, the documentary *Sette Canne,
un vestito* (Seven reeds, one suit), of which he declared that he wanted
to recount the "favola del rayon" (the fable of rayon). Here he chron-
icles, in fact, the harvesting and manufacturing of this synthetic fabric
first produced during fascism and then on into the post war years. The
film is set in the Po Valley—a geographical location that will recur in
Antonioni's later films—and in Torviscosa (SNIA[3]), a town that Mus-
solini had built around the production of one of what were known as
the "intelligent fibers." Dealing with textiles, rayon in particular, the
foundation of dress, from the plants and ending up with a fashion show
where clothing transforms itself into fashion, Antonioni shows not only
the process of making clothes (the ultimate product), but also mimes
the process of making a film (of filming). The camera captures the
making of the clothes from a degree zero, recording the creative pro-
cess in which labor, design, and technique are involved in the making,
and pinpointing the different stages at which one step translates and
blends into another until the dress, the final product, is performed.
As the voice over states, it is the hard, skilled work of many people at
different levels in the chain of production that has transformed a plant
into a colorful and stylish dress. This statement also corroborates the
fact that a fashionable garment is always the result of a team effort
and never or not only the outcome of a single auteur or designer. Just
like cinema. The documentary ends with a fashion show in an elegant
setting where we see models on the catwalk wearing beautiful evening
gowns. The glamorous fashion parade marks the final outcome of the
long and meticulous work that is shown in the documentary.[4]

The fashion show also marks the new beginning of Italian fashion,
its global launch during the years of reconstruction. In fact, Antonioni's
documentary appeared two years before the event that is generally
recognized as being the launch of Italian fashion on the world stage:
namely, the show organized by Giovan Battista Giorgini at the Florence
Sala Bianca in 1951 that brought Italian fashion to the attention of for-
eign markets, especially the U.S. one. Despite all the attempts made by
Mussolini's regime to sell Italian style abroad, and nationalize fashion

and Italians, it was only in the postwar years that several Italian artisans, with their hard work and creativity became known to the wider world and its customers. This became possible thanks to a marketing astuteness that positioned Italian fashion through the fashion shows held in the quintessential Renaissance city—Florence—against the background of its aristocratic buildings and breathtaking art. Fashion shows, such as Giorgini's, were important gatherings for promoting Italian fashion and selling Italian style to the world. As has been well-documented, in the immediate postwar years through to the period of the economic miracle, the textile industry—and fashion along with it—were to play a crucial role in Italy's economic reconstruction.[5]

There are then two stories in Antonioni's *Sette canne, un vestito*, two different narratives, one of labor and one of glamor, both hinting at Italian history and identity through the lens of cinema and dress. Both these stories bear on affect in so far as they pinpoint the embodied experience of work and spectacle. The result of this is a history in the making that tells the story of a negotiation with modernity.

The fashion show appears several times in Antonioni's films of the 1950s. It will, each time, establish a different narrative within the context of the film in question as a whole. In fact, the narratives and the nonnarratives surrounding the different tropes, bodies, and images in fashion shows are in a state of constant flux and process, in need of contextualization within the films they appear in and the history they hint at.

Sette canne, un vestito, like other documentaries Antonioni made that came out at the same time, such as *L'Amorosa menzogna* (The amorous lie, 1949), which depicts the social changes that can be observed in the making and the readership of a new popular genre called "fotoromanzi" (comic strip photographic novels), all call attention to the transformations that were taking place at this time in Italy and to how new models of consumption, the negotiation of new models of identity and gender roles were experienced on the Italian road to modernity.[6] Once again, as I noted for *Sette Canne*, Antonioni is interested in capturing the process, to show how to get to the finished product. He is interested in the unfolding, in the "in-between-ness." In *L'Amorosa menzogna*, the spectator is taken into the studio that produces this new popular genre in order to demystify the aura of the new popular heroes and romances

about which a growing readership made up of women could dream. But this is also an affective space or "the passage (and the duration of passage) of forces of intensities.[7] Just like the dream that fashion embodies and sells, transforming the ugly duckling into a beautiful swan, Cinderella into a princess. Interestingly, as shown in Antonioni's films, including his documentaries, fashion is at the core of these complex processes of identity formation and negotiation in the context of social and cultural changes.

It is interesting to see how fashion and the fashion show in film, especially those that came out during crucial periods in Italian history, interact with issues concerning the construction and projection of a new sense of self and national identity. In Antonioni's 1950s films there is both a sense of continuity and a break with the fascist past. The 1937 film *Contessa di Parma* by Alessandro Blasetti, set in a Turin fashion house at the time when Turin had been chosen by the fascist regime as the capital of fashion, directly addressed fashion as a manufacturing industry, as propaganda and as a culture industry. The film is a show case for a Turin based fashion house called "Mattè.'" Its name will reappear in Antonioni's film *Le Amiche* (The Girlfriends, 1955), which is also set in Turin and features fashion, socialites and their discontent and boredom. One of the upper-class women takes a fancy to a blouse of a friend and identifies it as having been purchased at the Mattè sisters' downtown Turin atelier.

To be in line with the "modernity" of more advanced capitalist nations like France, Great Britain, and the United States, the Italian fascist regime, especially in its second decade of existence in the 1930s, by which time it had become a consolidated presence, dedicated a great deal of attention to culture industries (cinema, sport, fashion, popular press and publications). In the culture industry, fascism saw a crucial and powerful machine able to create what historian Philip Cannistraro has called the "fabbrica del consenso" (the factory of consensus). The fascist regime understood via Hollywood that an important link existed between fashion and cinema and how these were both powerful weapons to spread national models, to mold identity and consciousness and to advertise images of modernity and glamour. It is not surprising that the slogan Mussolini used in the spectacular celebration of the inauguration of Cinecittà, the Roman Hollywood, was "cinema is the most powerful

of weapons." And we could well add fashion to cinema as one of those very powerful weapons.

Like cinema, fashion is a complex system of signification that touches on emotions and fantasy, but can also be turned into a very powerful political weapon. It is in this light that we can best see how fashion in film is a rich subtext that touches not only on the personal, but also on wider cultural and political features, especially during times of great transformation and technological progress. Fascism, for example, dedicated a great deal of attention to and had a vested interest in culture industries like fashion and film. They both served as vehicles for domestic purposes but also reached out culturally and commercially to foreign markets. At the same time, in both fashion and cinema, there was still space for fantasy and desire. Similarly to Hollywood films such as *Roberta* (1935), *Stolen Holiday* (1937) and many others, the regime's intent of nationalizing cinema and fashion had propagandistic overtones.[8]

Fashion is a crucial component of Antonioni's cinema. We might say, in fact, that *Cronaca di un amore*, Antonioni's 1950 first feature film (made a year after the documentary *Sette canne un vestito* and a year before Giorgini's fashion show) is a watershed not only in terms of fashion but also in cinematic style. In the film, a shift from a neorealist aesthetic to new experimental film-making techniques and framing can be observed in which fashion and costume play a central role. An analysis of *Cronaca di un amore* can be inscribed and extended, then, to a broader intertwined story between fashion and Italian cinema; and Antonioni's cinema in particular.

In *Cronaca*, translation and transformation are central themes. Often and in different manners, the well-defined borders of Antonioni's characters, their identities, and narratives seem to blur. Images seem to dissolve and blend into each other creating new textures and a cinematic language that positions self and identity at a mid-point, somewhere "in between" (or what Barthes called the neutral where color persists but where its contours blend and dissolve).[9] The same dissolution of the image alluded to by Barthes is also apparent in Antonioni's short 1977 documentary *Khumba Mela*, his personal vision of the Indian cathartic ritual or "festival of immortality" that takes place at the confluence of the Ganges and the Yamuna.[10] Here, his camera reviews men, women, and children belonging to different classes and castes, all wrapped in

beautiful, rich and colored textiles. The camera also settles on naked bodies, as well as other bodies wearing stitched uniforms. The result is a chromatic fluidity where the others blend into the water without ever erasing their difference, transforming, rather, the screen into a flowing, unfinished, sensual fabric, on which Antonioni intervenes and writes.

It is worthwhile recalling that "drape" has traditionally defined eastern dress, whereas western dress is identified by the stitch: the sartorial and the constructed, of the western hand; against the softness and draping of fabric around the body, of the eastern hand. *Khumba Mela*, then, is but one more example of Antonioni's fascination with texture, where the western dress and eye unstitch the fluidity of drape. The western vision blends into the eastern, a translation, but a nonpossessive one that caresses rather than possesses the real (to borrow Barthes' words on Antonioni).[11]

It is within the framework of this process of translation between different languages that I locate fashion and cinema. In historical terms, and for the purposes of this article, the interaction between fashion and film during the immediate postwar years is particularly crucial insofar as it helps us understand the discursive nature of both the one and the other as well as to see how and why both industries contributed to the launch of Italy as a "modern" and "stylish" country. It is necessary to explore, for instance, the culture and business exchanges between Italy and the United States not only in terms of image building, but also in terms of how the circulation and diffusion of Italian fashion abroad was facilitated and translated through different cultural mediations like the cinema and the popular press.

This is the multifaceted role that clothing and fashion play in Antonioni's films, starting with his 1950s trilogy. On the one hand, we see fashion represented both as an industry and as a macro machine of signification whose mediatic and symbolic apparatus plays a prominent role. Many of his characters, for example, are linked directly to the world of fashion, as in the case of Paola in *Cronaca*, playing a trophy wife married to a prominent textile industrialist; or Clelia in *Le amiche* (1955), who is manager of a fashion house or to the world of show business (Clara, in *La signora senza camelie,* 1953). On the other hand, though, clothing and costume in general become an alternative language. Through the different layers of the fabrics out of which identity can be made, cloth-

ing draws on the materiality of memory, aesthetics, and emotions. As Bruzzi and Church Gibson put it: "Clothing is no longer simply a means of *reflecting* meaning, rather it is a way of *creating* meanings and different levels of resonance" (emphasis mine).[12]

My concern here is with the affective power of clothing, with the interaction between image and text and how this interaction affects and triggers emotions on and off screen. I use these two terms—affect and emotion—in a relational mode.[13] The word emotion implies a movement that is already contained in its etymological root (motion in English). This movement is also implied in the moving picture and the materiality of its making and its reception, as Antonioni's documentary on rayon illustrates. Emotions make history. The narratives of this latter are woven into texture, text, and textiles, all of which share the same etymological Latin origin (*textere*: to weave). Fashion in film, in its aesthetic realm aims to create three dimensional life worlds through two dimensional surfaces that in turn trigger "virtual haptic and optical involvement on the part of the spectator."[14] In particular, the attention to details in fabrics and dress captured by the camera establishes an intimacy between viewers and film that characterizes memory. Referring to Shauna Beharry's *Seeing is Believing*, a film made in mourning for her mother, film critic Laura Marks mentions how the story of the artist is told while she is wearing her mother's sari and how the camera looks closely, during her narration "at the fabric of the sari . . . following the folds of silk as they dissolve into grain and resolve again."[15] Through the tactile dimension of looking, which is made possible by the work of the camera on dress and fabrics, the space for a visual/tactile epistemology is created. The visual and the tactile are combined in cinema through clothing and are in turn entwined with the fabric of memory.[16] The object, its transient and ephemeral qualities, becomes, in Benjaminian terms, the remnants that in cinema link experience to discourse in their historical dimensions.

Clothing in Antonioni's films is never simply an obvious and unambiguous representation of his characters' inner or outer self. [17] Rather, in his films, dress is of a piece with the impact his cinematic language registers elsewhere through landscape, architecture, and the framing of objects that, when they appear on-screen, lose their utilitarian function in favor of an aesthetic perception of the image. The use of clothing

and accessories in Antonioni problematizes the very notion of identity and emphasizes a provisional condition of the self, a self caught in the process of becoming. There are however, some major differences in the way clothing functions in the three 1950s films that I am looking at in this chapter: *Cronaca di un amore, La signora senza camelie,* and *Le amiche.* In all these films, the clothes worn by the female characters seem to be costumes; the women themselves appear to be always on stage. Clothing glamorizes femininity, showing—nonetheless—a sense of entrapment, uneasiness, and lack of fulfillment. A further step in the process of translation is the passage from costume to fashion. An important aesthetic shift will occur with a film like *L'avventura* (1960) where we can witness a shift that will affect all the female characters. In this film, for instance, and especially for the female protagonist, clothing functions as the "neutral," as it is described by Barthes. Rather, blurring the boundaries of dress and landscape, a film like *L'avventura* also blurs the boundaries of the inner and outer self, the "marked" and the "unmarked," the "distinct" and the "indistinct."[18] Clothing here loses its connotation with costume.

The performative power of clothing is particularly relevant in the representation of women in Antonioni's 1950s trilogy.[19] In these films, fashion and clothes play, on the one hand, a structural role in the narrative and aesthetics of the films; while, on the other, they establish a trajectory in the process of the films' women's search for subjectivity within the constraints of a patriarchal society. This complex process is exemplified in the attention given in the film to the most personal and intimate side of the women's self, so allowing viewers to see their entrapment. They seem to be imprisoned in stereotypical gender roles and expectations in interpersonal relationships, caught in male dominated creative industries, such as cinema in *La signora,* and driven by an aspiration towards freedom and independence epitomized by Clelia in *Le amiche.* It is not such a strange coincidence that costume defines the women in these three films. And at a more historical level, costume also signals the cinematic shift from neorealism to another kind of aesthetic that captures the changes in Italian society and gender roles then taking place. Antonioni's trilogy, in fact, describes a trajectory in which women and fashion are part of an interaction that frames identities in progress while at the same time creating the premises of a new cinematic language that

undermines conventional narratives and that will be completely manifest in his far more experimental films of the 1960s.

The films of the 1950s trilogy map class contradictions, individual despair and women's desire during the years of Italy's reconstruction. The self is here caught in a nonlinear process that the camera captures in all its haptic and optical dimensions. Despite being very different from one another, the women on these three films share an inner search for identity, economic independence, a sense of freedom and desire for release from their dealings with different kinds of entrapment from love relationships, inner fears, marriage, already established expectations in society for women, etc.

Cinematically, these female characters share the stage as a social space to be considered in a multiplicity of meanings and milieu: from the socialite Paola in *Cronaca*, the character interpreted by Lucia Bosè, the then newly elected Miss Italia, and her appearance in the mundane life of Milan between fashion shows, cafés in Via Montenapoleone, to the Cinecittà studios, movie theatres, and film festivals for Clara in *La signora* to the fashion house for Clelia in *Le amiche*. Space and place in the different urban environments are instrumental for describing the process of women's subjectivity. Space and place are at work in *Cronaca di un amore* where clothing and accessories play a key role in the construction of Paola's public persona. However, Paola sometimes seems excessive, out of place due to the way she dresses. In this film in particular, it is the poetic, affective power of clothing that interests Antonioni, its ability to signify through the effects and texture of fabric and color, and how this all works visually in the composition of the shots, similarly to the twists and turns of folds and details of dress. Milan, Ferrara, Rome, and Turin are the cities that set the stage in the 1950s trilogy, all playing an important role visually and in the narratives of the films and characters, who would be largely incomprehensible without the context of the cities in which they are captured. The cities, which are all Italy's fashion cities, with the exception of Ferrara, are also characters.

There is a kind of intimacy established by the camera in capturing details and texture of dress and fabric on screen. Clothing unfolds its narrative not only on the body of the character/actor on screen, but also on the body of the model. Antonioni's inclusions of models and fashion shows in his films is also worthy of comment. Interestingly, in

Antonioni's films we find several examples of the fashion show, but always employed in a completely different manner and with different meanings. In Antonioni's films, the fashion show is linked to what we may identify with affective and emotional labor, the models as workers, fashion and the show as the result of production processes.[20] In *Cronaca di un amore*, which can also be considered an ongoing fashion parade for the costumes, hats and accessories worn by Paola, we see two specific moments of a single model fashion show. Interestingly, here the body and the condition of the model as worker is juxtaposed to that of the high society *signora*, the trophy wife of the textile industrialist Fontana. In the charity fashion show held in a restaurant, the model who is flirting with Paola's lover, after parading before Paola and the audience, takes off the dress to offer it to her after she bids a ridiculous amount of money to purchase it. Both women here expose themselves with their exaggerated gestures of overly generous bidding and stripping. With her disproportionate monetary donation, Paola defines her class status as opposed to that of the model. The body of the model is the vector of the spectacle of the dress that she takes off in public, under the eyes of Paola and the audience. In this gesture, she actually makes undressing in public a part of a performance that subverts the codes of the fashion show insofar as she deviates from the traditional and expected finale. After the dress she is modeling has been sold and bought she takes it off and promptly delivers it to the buyer for whom the parade has been put on. In subverting the codes of the show, making the backstage the visible front stage, she provocatively interrupts the narrative of submission of the worker in the face of the patronage of the signora. But more importantly she literally separates her body from the dress for sale. However, when Paola is given the dress by the model, she replies: "Se lo prenda pure, glielo regalo" (You can have it, I give it to you).

In cinema, clothes are actions. They are a language that communicates subtle details that can go unnoticed in other kinds of performances. A detail, an accessory, a hat might signal a shift in a narrative, but also add a specific feature to a character. Think of the function of the hats worn by Gino (Massimo Girotti), the male protagonist of Luchino Visconti's *Ossessione* (1942). Even when he changes status from that of a tramp and wears a more respectable suit, albeit one that has too tight a fit as compared to the male fashion of the day, he still wears a beret (a *cop-*

pola) that emphasizes his portraiture as a bohemian type. In *Cronaca di un amore*, instead, hats function as "shifters"[21] in the seamless fabric of the cinematic narrative. Four different hats introduce a shift in the narrative and in the course of the film's actions.[22]

But what is interesting to emphasize here, is that female characters like Paola in *Cronaca* or Clara in *La signora*, would not exist cinematically without the painstaking attention devoted to their clothes and accessories and the performances these make possible. Paola and Clara, for different narrative reasons, seem to be always on stage. Paola, a beautiful young woman from Ferrara, is married to a much older industrialist from Milan, the suspicious Enrico Fontana, who hires a detective agency to find out more about his wife's past. Right from the beginning of the film, we see the detectives he has hired looking at several pictures of Paola and noting the transformations she has been through, from her high school days to the diva-like appearance of the present of a Milan socialite.

Without the couture wardrobe designed by Count Ferdinando Sarmi, Paola would be just a beautiful young lady without any of the theatricality that makes up her character and activates the different levels of perception. Sarmi, an aristocrat from Trieste, transformed Lucia Bosé, a girl from a very poor background and who worked as a *commessa* in a Milan pastry shop, into a sophisticated lady of the Milanese upper bourgeoisie. At the time of *Cronaca* she was only nineteen and Sarmi as a couturier and image maker (at that time not an official profession) was instrumental in the transformation of Lucia Bosé into a star. She looks like a dream, a sort of "apparition designed by Erté" (as Laura Larenzi calls her).[23] When her former lover Guido sees her against the backdrop of "La Scala," she is wearing a stunning white evening gown, complemented with white fur and magnificent jewelry. Even when Paola is at home before going to bed she is dressed in a rich and opulent brocade dressing gown with ample sleeves with fur trim. We see her going to a fashion house, on her way to meet her lover in a semi-squalid hotel room, dressed in a glamorous black suit with a tight jacket and a fur-trimmed pencil skirt, accessorized by a fur bag and a hat (one of the recurring markers of her being an excessive character).

While at the fashion house, she chooses an evening gown that she will wear at the very end of the film. Paola's clothes seem to be excessive

almost exceeding the frame, the narrative of the film and position her as an eccentric vis-à-vis the other characters.[24] Her clothes bear the signs of the aesthetic transformation of neorealism into a new cinematic style.

The tenuous link to neorealism is Massimo Girotti, whose familiar persona recalls another love triangle, the one of Visconti's *Ossessione* (1942). In Antonioni's film, Girotti appears again as the lover who cannot offer any economic security to his partner. But if *Ossessione*'s sordid tragedy ends with a sense of closure, in *Cronaca* the planned murder is not committed. Paola's husband dies in a car accident. The two lovers, however, do not stay together. The film ends with Guido, who has witnessed the accident from a distance, going to Paola's house. She is dressed for a party they are holding and wearing the dress (white again as in the first encounter with Guido near "La Scala") she had picked out during her visit at the fashion house. There is nothing more theatrical than the moment when we see Paola first waiting at the window wearing her beautiful white gown and then going down to see Guido. We are left with a sense of lack of fulfillment, a feeling that belongs to the characters themselves. They decide to take opposite paths. They are unable to cope, unable to be together.

Although *Cronaca* has all the components of a film noir, the last thing Antonioni is interested in is revealing the mechanics of plot and solving the mystery. The mystery is inside the characters themselves and in the intimacy of their emotions, a theme that Antonioni furthers in *Le amiche*. In fact, the fluidity and fragility of emotions that characterize these films are stored away in their nuances and ambiguity throughout the narrative and are never resolved in their endings, always left open and creating a space for further thinking, questioning and desire.

Clara, the protagonist of *La signora senza camelie*, is an attractive shop girl turned movie star who gets married to Gianni, one of her two producers, her "Pygmalion" figure. It might seem that marrying her boss who has transformed the shop assistant into a princess wearing elegant clothes and living in a luxurious villa is the ultimate dream for any girl of Clara's social standing. However, she is drawn into marriage without having the time to think and decide. The only thing she wants to do is continue working in the movie industry, something that turns out to be just as sour an experience with no happy ending. Since the beginning of the film, Clara does not seem to fit in with any of the environ-

ments she frequents, revealing her vulnerability. The film opens at night when we see her, wandering in the streets of Rome until she goes into a movie theatre where they are showing her first feature film. She enters the theatre at the point where she is dressed as a femme fatale singing "Addio Signora." In the darkness of the movie theatre she looks at herself on screen while her character is singing looking out at her in the audience. The gaze is entrapped within the constraints of the roles she is required to perform. Because of her looks and her lack of experience, Clara is manipulated according to the needs and circumstances of a film industry run by males who are pushed either by the need for money or by possessiveness, as in the case of her husband. On the set of Clara's second movie, which will be never completed because of her husband's jealousy, the producer decides to change the script and instead of the "wife" she is made to play "the lover." When Clara appears dressed as a country girl, he says: "But how did you dress her? Please, fix her up differently." And then following the scene of the kiss with her lover, Clara asks: "Was I a good femme fatale?" Throughout, *La Signora senza camelie* stresses the cinematic, fabricating dimension of the protagonist and how the process of refashioning and restyling her responds to the need to fulfill others' desires. Indeed, the film succeeds in showing how Italian moviegoers in the 1950s craved romance and spicy stories. The film industry, for its part, craved commercial gain, while her mother, for her part, wanted her daughter to be a star, no matter what price, even that of remaining unhappily married to the producer. Similarly, the Roman socialites and aristocrats are eager to for their slice of stardom and agree to let their houses be used in the shooting of the film, and to be able to mix and mingle with the glitterati of the fashion and film industries. Nardo, too, the diplomat with whom Clara has a squalid affair, is not excluded from the hypocrisy of a world of appearances. However, if Clelia, who is a more mature woman, can be said to belong to herself in *Le amiche*, Clara Manni in *La signora* does not have the strength or the ability to detach herself from a world that uses her as an object to be displayed and consumed. She is, indeed, defeated when we see her once again in the Cinecittà studios at the end of the film.

After failing to become a serious actress, she has accepted a part in which she plays a sexy queen and is photographed while hiding her tears. She is again on stage wearing a luxurious leopard fur, queen

of a desert island with a puppet show over which she has no say. This beautiful shot calls attention to the form and elegance of style in Antonioni's films and where the choice of costume plays a decisive role. The form, however, as Antonioni himself has stated is not divorced from the content and narrative. In his essay on Antonioni, Barthes has rightly identified the revolutionary features of aesthetic and cinematic techniques that have an inextricable relationship with the meanings of the film: "A revolution in which 'content and form are equally historical; stories . . . are indifferently plastic and psychological" (Plastic in its art-theoretical sense of moldable or capable of being given a form).[25]

The preoccupation with style is also prominent in *Le amiche* where fashion acts as a window and a theater for framing actions. But Clelia is neither blinded by the glittering phantasmagoria of the world of fashion, nor blind to the emptiness and hypocrisy of the upper-class people she meets in Turin who simply do not know how to face life and death, as is illustrated by the suicide of one of their friends, Rosetta. In *Le amiche*, Clelia is the manager of a Rome-based fashion house that is opening a branch in Turin, her hometown. A successful example of a self-made woman from a modest background, she finds herself at odds with the spoilt and corrupted men and women she accidentally encounters in the city. She happens to be involved, in fact, in their lives only because she is an accidental witness to the failed suicide attempt made by the young Rosetta, one of her new acquaintances, whom she attempts to help. Clelia is an outsider, even in her former hometown, where she does not seem to fit anymore. She understands, however, the cultural differences and taste in dress of her wealthy clientele. The Turin branch of the salon has, in her opinion, to adjust and respond to the changes in sartorial choices of the female customers. Toward the end of the film she says to her boss that "Women from Rome want to appear rich and try to spend less money, while women from Turin do not mind spending more to appear 'dimesse.' This is called social diplomacy." Through her work in the world of fashion, Clelia seems to be in control and to keep the world of appearance under control. If clothes in *Cronaca* and *La signora* are powerful signifiers in themselves, in *Le amiche*, because fashion is explored directly, they seem at times to crowd the screen and the frame. This is, however, an additional dimension that corroborates

what Stella Bruzzi identifies in the function of clothing in cinema as having an autonomous meaning.

But there is another layer that we can add here that concerns the relationship between women, clothing, and fashion. Luisa Passerini has suggested how a more complex and nuanced notion of female subjectivity can emerge through exploring the worlds identified as "typically" feminine or expressing traditional female cultures and economies, "concerning cosmetics, dresses, coquette behavior, knitting, cooking, sexual behavior." She says, in fact:

> The doubleness of subjectivity makes untenable the simple dichotomies between a culture of femininity forged by men or patriarchy and a feminist or womanist culture created by women, between feminine ideology and feminine resistance, between "women's culture" and commercial cultures of femininity. These are too easy distinctions, precisely because women as subjects intervene heavily on both sides.[26]

The "doubleness of subjectivity," which should be understood as a tensional space in between, is a key concept not only for women, but for gender in general. It is a space in which "oppositional" and "typical" features of subjectivity can live side by side. In *Le amiche* in particular, women are often caught in a double sided identity in tension and epitomized by the role fashion plays within the narrative. Note, for instance, how Nene is dressed when she appears in the gallery. She wears a dress that is sewn with two different color fabrics. The effect is visually striking, especially when she appears with the portrait of Rosetta painted by her husband, Lorenzo.

Clelia, who can be seen as Nene's counterpart and the only other female character who actually works, can also be seen as the image maker for other women. This emerges clearly at the beginning of the film when, following the attempted suicide of Rosetta in the room next to Clelia, she encounters Momina, the cynical member of the group and the most accessorized and sophisticatedly dressed. She compliments Clelia for her style saying that it's often unusual for somebody working in fashion to be so well dressed. Of course, at the time of Antonioni's film, the figure of the fashion designer as super star did not yet exist, especially in Italy. Clelia dresses as elegantly and stylishly as the group of upper-middle-class people she is with. One of her signa-

ture styles and a component of her public persona is the stunning fur
coat that she wears at the beginning of the film and toward the end.
The coat has an unusual pattern that makes her stand out and again
almost exceed the frame. Her chinchilla fur coat with its intricate
black and white design is a statement in itself. The fur coat and espe-
cially ones like that worn by Clelia is at the highest grade of luxury in
a woman's wardrobe and certainly was one of the most desired items
in the 1950s and 1960s. The newly acquired status that the fur coat
represents also acts as her protective armor in crucial moments of the
film. At the beginning, we see her when she gives instructions to the
male staff including the architect who is taking his time in completing
the renovation work at the fashion house and the evening she decides
to leave Turin. Her coat makes a statement marking and sealing her
role and the newly acquired position in society that she is not willing
to forgo.

The death of Rosetta as a result of her second suicide attempt, how-
ever, disrupts Clelia's sense of order. She decides to leave Turin and her
departure hints, on the one hand, at the impossibility of a return home
while, on the other, it marks her difference and distance from Carlo
and the implicit promise of love and marriage. Clelia is a transitional
character and her "doubleness" is expressed in both the desires and the
doubts she has about conducting an independent life in the midst of a
society that is experiencing deep transformations while being still an-
chored to tradition. Fashion for Clelia is work and the fashion industry
was one of the fields in which women could emerge, as is testified by
fashion houses such the Fontana Sisters (who provided all the costumes
and even some of the models for the film). In fact, Clelia's work in the
world of fashion recounts the kind of 1950s Italian atelier that helped to
launch Italian fashion globally, with great assistance from cinema.

Le amiche is also a fashion parade, Italian style. The show in the
film, however, also acts as a counter narrative in the film. Parallel to
the fashion show and the conventional narrative form it takes, conclud-
ing with the happy ending of a beautiful lace wedding dress, there are
intersections of dialogue, touching upon the crumbling of marriage,
between Nene (the artist), the only one among the women who dresses
differently and Rosetta (her husband's lover). We have then a parallel
parade of fashion models and events happening backstage, that includes

the model who had worn the wedding dress appearing now dressed only in undergarments and corset, and who mocks love after reading the card that Carlo has left for Clelia wishing her success. The fashion show in the film marks the culmination of the different tensions characterizing relationships, friendly or otherwise. In *Le amiche*, the fashion show, which parades the complete collection of the Fontana sisters, prefaces a tragedy, the suicide of Rosetta one of the girl friends, the youngest and the most fragile of them all, the only character who wears flats in a movie made of high-heeled shoes. The film spectators enjoy a privileged position compared to that of the people attending the fashion show. We are introduced backstage and follow the parallel unraveling of the dramas between Nene and Rosetta and the rest of the group of girlfriends, of whom Clelia is the one whose labor has controlled the show and the choice of models and body types. Remember that Clelia is the only character of modest origin who has built her position through hard work. In this context, the happy ending of the show with the appearance of the bride is a sarcastic detail that is played out against the parallel dissolution of Nene's marriage, itself an image of the bourgeois hypocrisy we see in the film as a whole. Fashion and the fashion show in Antonioni are not mere spectacle but feed fantasy and desire in an economy of affective and emotional labor.

Toward the end of the film, we see Clelia at the fashion salon in the middle of another private show of evening dresses for a small group of clients bursting into tears after learning of Rosetta's suicide for which she accuses Momina, who has encouraged Rosetta to embark on the affair with Nene, their mutual friend's husband. Besides Nene, Clelia is the most independent woman in the film and sacrifices love for her career, while Nene gives up a grand opportunity to go to New York City to promote her art for the sake of keeping Lorenzo and what could only be a not so happy marriage. In the film, Clelia is the only woman who continues to travel in the uncertainty of the future. We are left, and this will be typical in Antonioni's film, with an open and unresolved ending. The destination seems to be the journey itself, the act of searching defines the doubleness of the identity of the female characters. In this way, Clelia paves the way for the women travelers and wanderers who will populate Antonioni's 1960s films. And we wander and travel with them.

NOTES

1. Christopher Breward, *Fashion* (Oxford: Oxford University Press, 2003), 132.

2. Walter Benjamin, *The Arcade Project*, trans. Howard Eiland and Kevin McLaughlin (Cambridge and London: Belknap, 1999).

3. Societa' di Navigazione Italo Americana. The company was founded in 1917; later it became "Societa' di Navigazione Industriale Applicazione Viscosa" and became one of the most important companies in Italy to produce rayon.

4. 1949 is also the year in which fashion shows were organized at the Hotel Excelsior in Venice during the Film Festival. Maisons such as Biki, Carosa, and the Fontana sisters participated in the shows. See Maria Giuseppina Muzzarelli, *Breve Storia della moda in Italia* (Bologna: Il Mulino, 2011), 196.

5. See Nicola White, *Reconstructing Italian Fashion: America and the Development of the Italian Fashion Industry* (Oxford and New York: Berg, 2000); and Margherita Rosina and Chiara Francina, eds., *L'età dell'eleganza—le Filande e Tessiture Costa nella Como degli anni Cinquanta* (Como: Modo Libri, 2010), exhibition catalog.

6. *L'amorosa menzogna* is the inspiration of Federico Fellini's *Lo sceicco Bianco* (The White Sheik, 1951). Indeed, Fellini's film takes up again the whole issues addressed in Antonioni's short.

7. Melissa Gregg and Gregory J. Seigworth, eds., *The Affect Theory Reader* (Durham and London: Duke University Press, 2010). Seigworth and Gregg in their introduction "An Inventory of Shimmers" make specific reference to the work of Roland Barthes on "The Neutral." This is particularly relevant to my article on Antonioni and my study as a whole. Seigworth and Gregg, in fact, state that "the Neutral, for Barthes, is not synonymous in the least with ready acquiescence, political neutrality, a lapse into grayness; in short, it does not imply a well-nurtured indifference to the present, to existing conditions. Instead, the neutral works to 'outplay the paradigm' of oppositions and negations by referring to 'intense, strong, unprecedented states' that elude easy polarities and contradictions while also guarding against the accidental consolidation of the very meaning that the Neutral (as 'ardent, burning activity') seeks to dissolve." Roland Barthes, *The Neutral, Lecture Course at the College de France (1977-1978)* (New York: Columbia University Press, 2005), 10.

8. Sarah Berry, *Screen Style and Femininity in 1930s Hollywood* (Minneapolis: University of Minnesota Press, 2000); Jane M. Gaines and Charlotte Herzog, eds., *Fabrications. Costume and the Female Body* (New York and London: Routledge, 1994).

9. For Barthes the Neutral is not the absence of color or the space devoid by politics and action. Rather, he wishes to undermine the language of arro-

gance, violence and a fixed notion of identity and gender. See for instance his report of the following incident: "Thursday, March 9, fine afternoon, I go out to buy some paint (Sennelier inks), bottles of pigment: following my taste for the names (golden, yellow, sky blue, brilliant green, purple, sun yellow, cartham pink—a rather intense pink), I buy sixteen bottles. In putting them away, I knock one over: in sponging up, I make a new mess: little domestic complications. . . . And now, I am going to give you the official name of the spilled color, a name printed on the small bottle (as on the others vermillion, turquoise, etc.): it was the color called Neutral (obviously I had opened this bottle first to see what kind of color was this Neutral about which I am going to be speaking for thirteen weeks). Well, I was both punished and disappointed: punished because Neutral spatters and stains (it's a type of dull gray-black); disappointed because Neutral is a color like others, and for sale (therefore, Neutral is not unmarketable): the unclassifiable is classified—all the more reason for us to go back to discourse, which, at least, cannot say what the Neutral is." Barthes 48-9.

10. The documentary was filmed in 1977 and shown at the Cannes film festival in 1989. Many thanks to Carlo Di Carlo for providing me with a copy of the film.

11. Roland Barthes, "Cher Antonioni," in *Chur Antonioni. 1988–1989* (Rome: Ente Autonomo di Gestione per il cinema, 1989).

12. Stella Bruzzi and Pamela Church Gibson, "Dressing the Part: Cinema and Clothing," in *Between Stigma and Enigma* (London: Fashion in Film Festival, Central Saint Martins College of Art and Design, 2006), 4–7.

13. I am aware of the different classifications that scholars attribute to "affect" as being indistinct, diffuse, and precognitive, nonnarrative If we wish, and "emotion" as being more recognizable on the geography of passions and presenting a more narrative mode. See for instance Debora Gould, *Moving Politics: Emotion and Act Up's Fight against AIDS* (Chicago and London: The University of Chicago Press, 2009) and its introductory chapter where she lays out the paradigm of affect/emotion; see also Jesse J. Prinz, *The Emotional Constructions of Morals* (Oxford: Oxford University Press, 2007). These theoretical issues will be further developed in a longer study on "Fashion, Film and Emotions." My concern in the study is to see how emotions make history and how different kinds of narratives inform the interaction of fashion and film and allow us to touch upon the mechanisms underlying the capability and power of emotionism. I wish to thank all my colleagues who took part in the Mellon seminar on "Emotions" at the Graduate Center of the City University of New York in 2010–2011. In particular, for their helpful comments, I would like to thank Nancy Yousef, Elizabeth Wissinger, Nicola Masciandaro, Anupama Kapse, Peter Liberman, JoEllen De Lucia, David Bahr, Noel Carroll, Mikhal Dekel, and Ran Zwigenberg.

14. Laura Marks, *The Skin of the Film: Intercultural Cinema, Embodiment, and the Senses* (Durham, NC: Duke University Press, 1999). "Haptical cinema" is the title of an important 1995 essay by Antonia Lant that appeared in *October* 74 (Autumn, 1995): 45–73. In addition to Laura Marks, see also Giuliana Bruno, *Atlas of Emotions. Journeys in Art, Architecture, and Film* (New York and London: Verso, 2002); Giuliana Bruno, "Pleats of Matter, Folds of the Soul," in *Afterimages of Gilles Deleuze's Philosophy*, ed. David, N., Rodowick (Minneapolis: University of Minnesota Press, 2010), 213-34; Giuliana Bruno, "Surface, Fabric, Weave: the fashioned World of Wong Kar Wai," in *Fashion in Film*, ed. Adrienne Munich (Bloomington: Indiana University Press, 2012).

15. See Marks, in particular the chapter "The Memory of Touch" (127–93).

16. See Thomas Elsaesser and Malte Hagener, "Cinema as skin and touch," in *Film Theory: An Introduction through the Senses* (London: Routledge, 2010), 108–28.

17. This particular point is developed in Eugenia Paulicelli, "Framing the Self, Staging Identity: Clothing and Italian Style in the Films of Michelangelo Antonioni (1950–1964)," in *The Fabric of Cultures: Fashion, Identity, Globalization*, ed. Eugenia Paulicelli and Hazel Clark (London and New York: Routledge, 2009), 53–72.

18. Barthes, *The Neutral*, 49.

19. I consider Antonioni's trilogy to comprise *Cronaca di un amore, La signora senza camelie,* and *Le Amiche*, even though he made *Il Grido* in 1957. *Il Grido,* which is thematically different from these three films, will be analyzed separately in the longer study from which this paper is drawn.

20. Elizabeth Wissinger, "Modelling a Way of Life: Immaterial and Affective Labour in the Fashion Modelling Industry," *Ephemera* 7, no. 1 (2007): 250–69.

21. Roland Barthes, *The Fashion System* (New York: Hill and Wang, 1983).

22. Interestingly Francesco Maselli, one of the writers who worked with Antonioni on the film, recalls that they were especially taken by Sarmi's creativity when he showed them some sketches of his hats. See Alessandra Levantesi, "Sui sentieri della memoria. Alessandra Levantesi a colloquio con Francesco Maselli rivedendo con lui *Cronaca di un amore,* in *Cronaca di un amore. Un film di Michelangelo Antonioni,* ed. Tullio Kezich and Alessandra Levantesi (Turin: Lindau, 2004), 31–52. Maselli confirmed the creativity of Sarmi who worked in a very well known fashion house in Milan, Biki. "Sarmi was Biki's ragazzo di bottega" (interview with Maselli by Eugenia Paulicelli, Rome, April 27, 2010). Biki was to collaborate again with Antonioni in his *La notte.*

23. Laura Laurenzi, "Firmato Count Sarmi," in *Cronaca di un amore. Un film di Michelangelo Antonioni,* ed. Tullio Kezich and Alessandra Levantesi (Turin: Lindau, 2004), 85–91.

24. Paola wears a quite elaborate gown that during the shooting of the film needed to be repaired almost every day as it got dirty in the rain and mud. In the interview, Maselli has explained that the film crew worked closely with a Milan dress-maker, even working during the night to be ready for the next day's shooting.

25. Seymour Chatman, *Michelangelo Antonioni,* ed. Paul Duncan (Cologne: Taschen, 2004), 11.

26. Luisa Passerini, "Becoming a Subject in the Time of the Death of the Subject," in *Memory and Utopia: The Primacy of Intersubjectivity* (London and Oakville, CT: Equinox Publishing, 2007), 33–53.

BIBLIOGRAPHY

Barthes, Roland. *The Neutral, Lecture Course at the College de France (1977–1978)*. New York: Columbia University Press, 2005.

———. "Cher Antonioni." In *Cher Antonioni: 1988–1989*, 19–21. Rome: Ente Autonomo di Gestione per il cinema, 1989.

———. *The Fashion System.* New York: Hill and Wang, 1983.

Benjamin, Walter. *The Arcade Project.* Translated by Howard Eiland and Kevin McLaughlin. Cambridge and London: Belknap, 1999.

Berry, Sarah. *Screen Style and Femininity in 1930s Hollywood.* Minneapolis: University of Minnesota Press, 2000.

Breward, Christopher. *Fashion.* Oxford: Oxford University Press, 2003.

Bruno, Giuliana. *Atlas of Emotions. Journeys in Art, Architecture, and Film.* New York and London: Verso, 2002.

———. "Pleats of Matter, Folds of the Soul." In *Afterimages of Gilles Deleuze's Philosophy*, edited by David N. Rodowick, 213–34. Minneapolis: University of Minnesota Press, 2010.

———. "Surface, Fabric, Weave: the fashioned World of Wong Kar Wai." In *Fashion in Film*, edited by Adrienne Munich. Bloomington: Indiana University Press, 2011, forthcoming.

Bruzzi, Stella. *Undressing Cinema. Clothing and Identity in the Movies.* London and New York: Routledge, 1997.

——— and Pamela Church Gibson. "Dressing the Part: Cinema and Clothing." In *Between Stigma and Enigma*, 4-7. London: Fashion in Film Festival, Central Saint Martins College of Art and Design, 2006.

Chatman, Seymour. *Michelangelo Antonioni*, ed. Paul Duncan. Cologne: Taschen, 2004.

Carlo, Di Carlo, ed.. *Michelangelo Antonioni, Documentalista*. Barcelona: Daniela Aronica Editore, 2010.

Elsaesser, Thomas, and Malte Hagener. "Cinema as skin and touch." In *Film Theory: An Introduction through the Senses*, 108–28. London: Routledge, 2010.

Gaines, Jane M., and Charlotte Herzog, eds. *Fabrications. Costume and the Female Body*. New York and London: Routledge, 1994.

Giacci, Vittorio. *Michelangelo Antonioni*. Rome: Centro Sperimentale di Cinematografia, 2008.

Gould, Debora. *Moving Politics: Emotion and Act Up's Fight against AIDS*. Chicago and London: The University of Chicago Press, 2009.

Gregg, Melissa, and Gregory J. Seigworth, eds. *The Affect Theory Reader*. Durham, NC and London: Duke University Press, 2010.

Gundle, Stephen. *Bellissima: Feminine Beauty and the Idea of Italy*. London and New Haven: Yale University Press, 2007.

Lant, Antonia. "Haptical Cinema." *October* 74 (Autumn, 1995): 45–73.

Laurenzi, Laura. "Firmato Count Sarmi." In *Cronaca di un amore. Un film di Michelangelo Antonioni*, edited by Tullio Kezich and Alessandra Levantesi, 85–91. Turin: Lindau, 2004.

Levantesi, Alessandra. "Sui sentieri della memoria. Alessandra Levantesi a colloquio con Francesco Maselli rivedendo con lui *Cronaca di un amore*." In *Cronaca di un amore. Un film di Michelangelo Antonioni*, ed. Tullio Kezich and Alessandra Levantesi, 31–52. Turin: Lindau, 2004.

Mancini, Michele, and Giuseppe Perrella, eds. *Michelangelo Antonioni. Architettura della Visione. Architecture of Vision*. Rome: Coneditor, 1986.

Marks, Laura. *The Skin of the Film. Intercultural Cinema, Embodiment, and the Senses*. Durham, NC: Duke University Press, 1999.

Muzzarelli, Maria Giuseppina. *Breve Storia della Moda in Italia*. Bologna: Il Mulino, 2011.

Passerini, Luisa. "Becoming a Subject in the Time of the Death of the Subject." In *Memory and Utopia: The Primacy of Intersubjectivity*, 33-53. London and Oakville, CT: Equinox Publishing, 2007.

Paulicelli, Eugenia. *Fashion under Fascism: Beyond the Black Shirt*. Oxford and New York: Berg 2004.

———. "Framing the Self, Staging Identity: Clothing and Italian Style in the Films of Michelangelo Antonioni (1950-1964)." In *The Fabric of Cultures: Fashion, Identity, Globalization*, edited by Eugenia Paulicelli and Hazel Clark, 53–72. London and New York: Routledge, 2009.

———. "Fashioning Rome: Cinema, Fashion, and the Media in the Postwar Years." In *Capital City: Rome, 1870–2010*, edited by *Cristina Mazzoni*, 257-278. *Annali d'Italianistica* 28 (2010).

Prinz, Jesse J. *The Emotional Constructions of Morals*. Oxford: Oxford University Press, 2007.

Rosina, Margherita, and Chiara Francina, eds. *L'età dell'eleganza—le Filande e Tessiture Costa nella Como degli anni Cinquanta.* Como: Modo Libri, 2010. Exhibition catalog.

Schnapp, Jeffery. "The Fabric of Modern Times." *Critical Inquiry* 24, no. 1 (Autumn 1997): 191–245.

Segre Reinach, Simona. "La moda nella cultura italiana dai primi del Novecento ad oggi." In *Cibo, gioco, festa, moda*, edited by Ugo Volli and Carlo Petrini, 603–61. Vol. 6 of *La cultura italiana.* Turin: Utet, 2010.

White, Nicola. *Reconstructing Italian Fashion: America and the Development of the Italian Fashion Industry.* Oxford and New York: Berg, 2000.

Wissinger, Elizabeth. "Modelling a Way of Life: Immaterial and Affective Labour in the Fashion Modelling Industry." *Ephemera* 7, no. 1 (2007): 250–69.

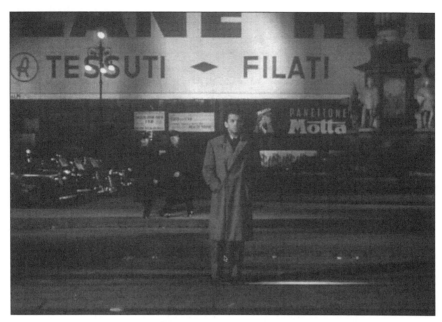

Guido (Massimo Girotti) across the street from La Scala,
looking at Paola (Lucia Bosé), in Cronaca di un amore (1950).

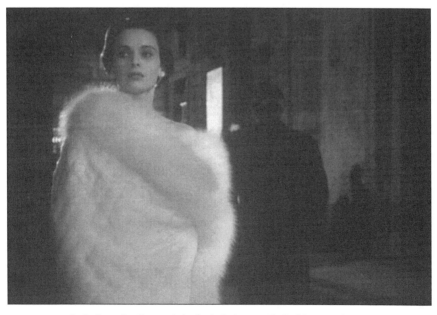

Paola (Lucia Bosé), outside La Scala, looking at Guido (Massimo Girotti),
in Cronaca di un amore (1950).

Paola in the Fashion Hase, in Cronaca di un amore (1950).

Model undressing during fashion show, Cronaca di un amore.

Model undressing during fashion show, Cronaca di un amore.

Lorenzo (Gabriele Ferzetti) and Nene (Valentina Cortese) in Le amiche (1955).

Clelia (Eleonora Rossi Drago) and Carlo (Ettore Manni), in Le amiche (1955).

CONTEMPORARY ITALIAN WOMEN FILMMAKERS

Reframing the Past, the Present, and Cinematic Tradition
Bernadette Luciano and Susanna Scarparo

On the eve of International Women's Day 2010, Kathryn Bigelow became the first woman to win an Academy Award for best director for her Iraq war drama *The Hurt Locker.* Announcing the winner, Barbra Streisand exclaimed, "the time has come,"[1] implying that women had finally broken through the celluloid ceiling. Only the third woman ever to be nominated for an Oscar in the best director category, Bigelow eludes and rejects the appellation of woman filmmaker. She has for decades been a female pioneer in the male-dominated world of action movies and is seen by many as a director in the tradition of tough-guy filmmakers. At the Directors Guild of America Awards, where she also won the top honor, Bigelow said: "I suppose I like to think of myself as a filmmaker rather than as a female filmmaker."[2] While reiterating the same sentiment on the CBS program *60 Minutes*, she also acknowledges what often remains quietly sidelined in post-feminist times, the plight of women filmmakers and indeed of women professionals:

> There's really no difference between what I do and what a male filmmaker might do. . . . we all try to give the best performances we can, we try to make our budget, we try to make the best movie we possibly can. So in that sense it's very similar. On the other hand, I think the journey for women, no matter what venue it is—politics, business, film—it's a long journey.[3]

Bigelow's claim that many of the obstacles she faces are gender specific is made by other women filmmakers and borne out by statistics. When in 2007 Jane Campion joined fellow winners on the stage at Cannes her producer observed: "you saw everyone who won a Palme D'Or up on the stage, and there was one woman," one in a "sea of men."[4] When Campion had won the Palme D'Or in 1993 for *The Piano*, many then, as now with Bigelow, had thought that the prize marked a watershed for women directors. But there is no magic wand that reconfigures the reality of the movie industry. According to Martha Lauzen, "of the top 250 highest grossing films in North America in 2009, only seven per cent were directed by women, a drop of two per cent from a year earlier."[5] The situation does not only hold for Hollywood; in Britain, for example, women account for only 6 percent of film directors.

In Italy, women filmmakers are not only a small minority. They have been marginalized both by critics and by histories of Italian cinema, despite the fact that the only nonnative English speaking woman director to have been nominated for an Academy Award is the Italian Lina Wertmüller for *Pasqualino settebellezze* (*Seven Beauties* 1975).[6] Being overlooked is a predicament that women filmmakers have experienced throughout the history of Italian cinema even though women have been involved in directing, producing, writing, and acting since the industry's early days. Francesca Bertini exemplifies the ways in which women's contributions, particularly as directors or co-directors, have often been disguised. In the more acceptable role of *diva*, Bertini enjoyed public acclaim. However, despite the major part she played in directing her films, her name was never associated with that role.[7] The way women's film history has been written reflects the way women remain marginalized and stereotyped by an industry that is still suspicious of women wanting to step out of their role as actresses.

In a recent interview, the former actress, and now director, Silvia Ferreri explains the problematic position that transgressing the boundary of established gender roles poses for the woman director:

> The cinema is really a place where Italian male chauvinism reaches its peak [...] in Italian cinema it's crazy for a woman. . . . For me it was ten times more difficult because I started out in the cinema as an actress . . . the Italian idea is you are a woman, an actress probably with zero

intelligence, why do you want to get into directing? As a result I run up against some incredible obstacles, but precisely within the institution, with the people in it, with men![8]

Ferreri's position is not so far from Bertini's, notwithstanding that they lived almost a century apart. As Monica Dall'Asta has argued, Bertini was probably the most powerful woman in the Italian cinema industry of her time, more powerful than the majority of men in the sector. And while it is difficult to pinpoint the precise nature of her various roles, she was certainly involved in the selection of actors, narratives, technical decisions, editing and publicity.[9] As a driving force behind *Assunta Spina*, Bertini lamented that she was never acknowledged for her contribution to the "invention" of neorealism. She identified the erasure of her role as director of the film as a major shortcoming in the writing of the history of Italian cinema. In an interview, Bertini stated, in fact, that "you have to rewrite the history of cinema from beginning to end."[10]

Her call for a different history of Italian cinema has, by and large, remained unanswered. As late as 2009, Gian Piero Brunetta, Italy's most respected film historian, makes no mention of Bertini's extensive contributions nor of those of Elvira Notari, the first and most prolific Italian woman director.[11] The brilliant work of scholars such as Giuliana Bruno, who wrote the first monograph about Notari's extraordinary career as director, producer, and founder of her own production and distribution company, has done little to change the historiography of Italian cinema which continues to marginalize films made by women. Women's contributions to Italian cinema, when acknowledged, are presented in much the same way women writers have traditionally been represented in histories of Italian literature, as minor or minority works. Women filmmakers are either discussed as a marginal group or as isolated phenomena, which confirm that Italian cinema is about fathers and sons, with occasional exceptions that conform to, rather than disrupt, the male norm, which is conceived as universal.[12] Emblematic of this approach are Brunetta's subheadings bearing titles such as "Fathers, Sons, and Nephews" when discussing the cinema from the boom years to the years of terrorism, which, incidentally, includes Lilliana Cavani and Lina Wertmüller.

We would like to respond to Bertini's challenge by turning our attention to what we label a quiet revolution, the increased activity and proliferation of films by women in Italian cinema in the past ten years.[13] Despite industry obstacles and financial roadblocks, Italian women filmmakers have made approximately 88 feature films, 119 documentaries, 109 short films, and 4 animations since the year 2000. Before that time, they made a total of 46 feature films, 74 documentaries, 120 shorts, and 7 animations. Women filmmakers are contributing to the revival that Italian cinema has experienced in the first decade of the new millennium among audiences and critics alike, within and outside Italy. In an influential volume of essays about the cinema of the early twenty-first century, Vito Zagarrio identifies the role played by women directors in the Italian film industry as a distinguishing feature of the "New-New Italian Film."

In 1988, in the first and so far only volume of essays in English about women and film in Italy, Paola Melchiori asks, "When a woman becomes the one who looks, what image of her sexual identity does she reflect? How does she go beyond the representations and identities of her unconscious conditioning as mother or sexual object?"[14] To answer this question, we apply the notion of "reframing" on three levels. First, we consider how women filmmakers have reframed cinematic tradition by appropriating and rethinking ways of imagining Italy through both realistic cinema and less conventional cinematic modes and by challenging traditional representations of women through female-centered narratives. Second, we examine how women have reframed female history by rendering the history and stories of women visible in the cinematic space and how they have renegotiated the mother/daughter relationship. Third, we discuss how these filmmakers are addressing pressing social issues through films that reframe Italy by engaging with changing national and transnational contexts from a position of gendered marginality.

REFRAMING TRADITION

The position of "women's cinema" in Italy needs to be understood in terms of the filmmakers' relationship to hegemonic traditions, as Italian women filmmakers are not working in a vacuum but within an established cinematic tradition forged almost entirely by "great" fathers.

The women filmmakers we interviewed, while for the most part sharing Bigelow's rejection of the label of woman filmmaker, repeatedly attributed the challenges they faced to their position as women in a male dominated industry and to the aesthetic challenge of the absence of female role models. Marina Spada defines the context in which Italian women live and work:

> Ours is a very male dominated sector, like all sectors really. At film school female instructors are fewer than male instructors; it's the same in universities, in Parliament, and the women that are there are not necessarily exemplars of a female way of thinking, in fact quite the opposite! It's a question of role models, if you don't have female models . . . for years women in power had male role models.[15]

Working across a number of genres, self-reflexive women filmmakers are interrogating the predominantly male cinematic tradition, their marginalized position within it and their identification with the conditions of their equally marginalized subjects projected on the screen. An obvious starting point for this discussion relates to the way women have come to terms with and appropriated the realist and neorealist traditions.

The shadow of neorealism has loomed large for scholars, critics, filmmakers, and audiences. Subsequent generations of Italian filmmakers have (consciously or subconsciously) regularly reappropriated and renegotiated what have been flagged as neorealist stylistic elements, themes and moods and reengaged with those films in metacinematic, parodic or otherwise imitative ways. Here we would like to limit ourselves to the appropriation and indeed subversion of one of the central tropes of neorealist cinema, the representation of the child. Filmmakers have returned numerous times and by multiple means to the child's gaze as something distinct from the adult way of looking at the world. While the child, usually male, has always been present in Italian cinema, in recent decades there has been a proliferation of films featuring a child protagonist (usually male) or a child's point of view, from Roberto Benigni's *La vita è bella* (*Life is Beautiful* 1997), to numerous films in which a child is plagued by physical or psychological disease, such as *La guerra di Mario* (*Mario's War* 2005) and *Le chiavi di casa* (*The Keys to the House* 2004) or social ills in *Quando sei nato non puoi più nasconderti* (*Once You're Born You Can No Longer Hide* 2005).

Women filmmakers have also participated in this trend, in ways that have acknowledged, but also challenged, the tradition of Italian cinema by featuring a female child protagonist. Neorealism represented a cinematic world with little room for women or young girls. As Laura Ruberto suggests "men, boys and masculinity generally become that on which a country depends for rebuilding itself after war. Likewise women, girls and femininity generally remain secondary actors in the building of that same society."[16] In neorealist cinema female characters are more often than not relegated to the marginal roles of wife, mother, girlfriend, prostitute or evil seductress. Even the few potentially strong female characters either disappear from the text, like the mother in *Ladri di biciclette* (*Bicycle Thieves* 1948), or die, like Pina in *Rome Open City* (*Roma città aperta* 1945).

Francesca Comencini Costanza Quatriglio and Wilma Labate are filmmakers whose feature films have directly cited and subverted the neorealist tradition in their foregrounding of young girls as potentially central figures in the shaping of new Italian landscapes. In *Mi piace lavorare* (*Mobbing* 2003) Comencini replaces De Sica's father/son relationship with a mother/daughter dynamic. Reworking the style of realism, she creates a new realist feminist cinema.[17] Unlike *Ladri di biciclette*, where the film's narrative conflates the father/son story and the futile journey in search of the bicycle, Comencini separates the two threads of the narrative in order to draw greater attention to the breakdown and recuperation of the mother/daughter relationship. Establishing a new and subversive perspective through her use of the double camera (the director's handheld camera and the on-screen surveillance camera) and of the mirror, Comencini's reframing reminds us of how women have been fashioned by the camera and consciously structures a female-centered relationship between director, character, and spectator. Moving beyond the 1948 concern about the crisis of patriarchy and the symbolic loss of father figures, she proposes a new cinema for a new national landscape. In this "other" cinema there is a place for the "othered" women: the mothers and daughters absent in neorealist precursors.

Similarly, Costanza Quatriglio's *L'isola* (*The Island* 2003), set on the Sicilian island of Favignana and focusing on one year in the life of ten-year-old Teresa and her older brother Turi, engages with the tradition

of neorealist cinema located at the social and geographical margins of Italy. In *L'isola* there are clear references to Luchino Visconti's *La terra trema* (*The Earth Trembles* 1948), most obvious in the film's tuna fishing episode. In Quatriglio's film, however, the focus is on the insularity and double otherness of both the setting, an island off an island, and the use of a ten-year-old girl as the guiding conscience of the film although the options open to her remain unresolved in the film's conclusion.

Finally, Wilma Labate's *Domenica* (2001), which features a young orphan girl skilfully negotiating a pulsating, corrupt and run-down Naples, recalls and reinvents the orphan children and urban landscapes in the realist Italian cinematic tradition from neorealism to Pier Paolo Pasolini and Gianni Amelio. In *Domenica* the orphan girl, who corrupt authorities hope will help them frame a man they have killed, emerges as a tough, street-wise child able to elude institutional and masculine authority. While at the end of the film the police investigator father figure exits the screen, disappearing on a ferry that will take him to Sicily and to his inevitable death, Domenica challenges what might appear to be an inevitable destiny. She remains steadfast, clinging to her dreams and standing tall in her geographic and cinematic space.

Mobbing, *L'isola*, and *Domenica* are products of a common cinematic practice. They have as protagonists young Italian women positioned between childhood and womanhood, and share narrative similarities. They are road movies of a sort, featuring young women forging their own identities and conditioning others, traversing a changing cinematic and geographic landscape in search of equilibrium. The open endings can provide hope or can leave us questioning their ability to survive contemporary economic, geographical and social realities that might hamper their development as empowered and empowering subversive figures.

REFRAMING WOMEN'S HISTORY

History, Walter Benjamin writes, "is the subject of a structure whose site is not homogeneous, empty time, but time filled by the presence of the now [*Jetztzeit*]."[18] In her discussion of Elsa Morante's *La storia*, Maurizia Boscagli takes the *Jetztzeit* to be "exactly the moment that cuts through history, the "now" that blasts its continuum open, thus disrupt-

ing and contradicting history's claimed completeness."[19] The acknowl-
edgement of the presence of women in the history of Italian cinema has
the potential to contradict and disrupt the paternal genealogy, to act as
Jetztzeit, as a moment of disruption, questioning the history of Italian
cinema, its completeness and closure both in the present and in the past.

The history of women's contribution to Italian cinema is, indeed,
a history, which for many remains in the realm of story, rather than
History. In a discussion of Elvira Notari's cinema, Vittorio Martinelli
points out that her works represent "microhistories: it's not the History
of cinema as we tend to understand it, in upper case, the History that
you find in books. These are little hi(stories) that nobody knows about
and that add a little spice"[20] Indeed, women filmmakers reframe history
through their commitment to remembering women's history both in
panoramic documentaries, such as *Bellissime* (2004) and the history of
Italian feminism, *Storia del movimento femminista in Italia* (*History of
the Feminist Movement in Italy* 2006), and through films focusing on
"little (hi)stories," which often remain relegated to the margins.

Antonietta De Lillo's *Il resto di niente* (*The Remains of Nothing*
2004), which received government funding and which the director
described as a "small film because it didn't have much funding," is one
such film.[21] A low budget movie with limited distribution, it provides an
alternative representation of history. Based on a novel by Enzo Striano,
Il resto di niente recounts the story of Eleonora Pimental Fonseca and
her involvement in the Neapolitan Revolution of 1799. Eleonora Pi-
mental Fonseca, a revolutionary and a foreigner, was herself "other" to
her social class. De Lillo's character is also an "other" to history and a
forgotten woman from the past. It was screened at the 2004 Venice Film
Festival and won numerous prestigious nominations and awards includ-
ing the nomination for best film at Ciak d'oro in the category, ironically,
of "Bello e invisibile."[22]

Notwithstanding its critical success, only twenty copies were sent to
cinemas and, although the film had been shortlisted as Italy's nominee
for the best foreign language film Oscar, it had to be withdrawn from
competition because the producer went bankrupt. In many ways, the
history of *Il resto di niente* mirrors De Lillo's under-recognized con-
tribution to Italian cinema. As she states, "my history has always been
one of important but not very visible acknowledgements."[23] Women's

participation in an historical moment, finally rendered visible, falls again into the realm of the invisible, despite De Lillo's best efforts to reframe history.

Alina Marazzi's celebrated documentary about the women's movement of the 1960s and 1970s, *Vogliamo anche le rose* (*We Want Roses Too* 2007), is another film about "piccole storie" that become the narrative threads behind an eclectic representation of the pre-feminist and feminist eras. Juxtaposing excerpts from three women's diaries with a wide range of archival and original material including photographs, picture stories, home movies, news reports, television debates, independent and experimental films, militant and private films, advertisements, music and animation, Marazzi's film attempts more than straightforward historical reconstruction. Instead it creates a dialogue between public and private, between story and history. In very different ways these two films stand at the crossroads between history, memory and fiction. Remembering women's contribution to history as well as creating and recreating women's history, a forgotten history, lies at the core of these two works. Without what Spada has called "female role models," they show how women have appropriated the camera and reframed history, and created a place for women's stories by disrupting History.

Women filmmakers, following in the legacy of Italian women writers have also explored women's history through the examination of the mother/daughter relationship and the author/filmmaker's desire to engage with female genealogy through a renewed engagement with the mother. In the past ten years, a number of documentaries have experimented with different aesthetic modes of engaging with this issue. In Alina Marazzi's *Un'ora sola tivorrei* (*For One More Hour with You* 2002) the filmmaker questions the father's and the male filmmaker's authorities through a rereading and reworking of the grandfather's images in which she authorizes and recreates the mother. Fabiana Sargentini's *Di madre in figlia* (*From Mother to Daughter* 2004) represents the heterogeneity of relationships between mothers and daughters through the juxtaposition of intertwining interviews with contradictory and complex messages.[24]

Among feature films dealing directly with the issues of mother/daughter relationships and female genealogy are Anne Riitta Ciccone's *L'amore di Màrja* (*Màrja's Love* 2002) and Cristina Comencini's *Il più*

bel giorno della mia vita (*The Best Day of My Life* 2002). These films offer a new perspective on the long and fraught engagement with the mother which has featured prominently in the Italian literary tradition, and which has preoccupied many writers from Sibilla Aleramo to the present. Ciccone's film follows the evolution from a female foreign otherness that is considered deviant to a celebration of difference, while Comencini's film proposes a protagonist who ultimately appropriates the camera to offer a feminized gaze at the world. These narratives suggest new ways of recuperating the mother and different modes of telling women's stories through self-reflexive films that consciously address the spectator as female.

REFRAMING SOCIETY

Women filmmakers share with the dominant Italian women screenwriters and their male contemporaries a penchant for reflecting on contemporary social and political issues. According to Teresa de Lauretis, alternative feminist films "are those which engage the current problems, the real issues, the things actually at stake in feminist communities on a local scale" and "address a particular [audience] in its specific history of struggles and emergence."[25] Many women filmmakers reframe contemporary society through a female lens, which often interrogates the effect of contemporary social problems on women. As directors, they are increasingly engaging with representations of migration and of the related phenomenon of transnational mobility in numerous documentaries and feature films that draw attention to the complexity and cultural specificity of migration experiences from different locations of origin and at different times.

Francesca Pirani's intimate dramatic 1997 film, *L'appartamento* (*The Apartment*) was among the first to explore the phenomenon of immigration. Inspired by cinematic "fathers" Antonioni and Godard, Marina Spada's *Come l'ombra* (*Like a Shadow* 2006) is a dramatic women-centered film that focuses on the short lived friendship between two women, a Milanese and a newly-arrived Ukrainian immigrant who meets an unexplained death. The immigrant is Giuliana Bruno's configuration of the new female "streetwalker," the *flâneuse* who "wanders

across history, establishing her identity and desire in a space of consumption of images."[26] She is a figure problematized by both history and cinema and corresponds to what Àine O'Healy sees as ambivalent and even contradicting visual strategies in representations of women in the Italian cinema of migration: "the woman is configured by the logic of the gaze as both innocent victim and alluring erotic object."[27]

Women's filmmaking has also embraced comedy as a genre through which to interrogate intercultural romance and reflect on issues of xenophobia in films such as Cristina Comencini's *Bianco e nero* (*Black and White* 2007) and Laura Muscardin's *Billo il grand Dakhaar* (*Billo* 2008). All these films, while imagining an ostensibly changed multi-ethnic Italy, construct narratives of encounters between Italians and migrants in which the migrants disappear, die or remain confined within stereotypes. While courting audience sympathy for migrants, these films construct a nation of transformed landscapes that struggles to hold on to traditional cultural and gender myths. Ultimately, they foreground the limitations of female mobility in post-feminist Italy.

Similar issues are foregrounded in a number of documentaries dealing with migration, such as *Sidelki/Badanti* (*Caregivers* 2007) by Katia Bernardi and *La stoffa di Veronica* (*Veronica's Fabric* 2005) by Emma Rossi Landi and Flavia Pasquini. These films are about the search for a home that requires spatial and mental mobility—away from familiar spaces.[28] Costanza Quatriglio's *Il mondo addosso* (*The Weight of the World* 2006) and *L'insonnia di Devi* (*Devi's Insomnia* 2001) both focus on young immigrants (unaccompanied minors and products of transnational adoptions) and deliberately give voice to the often invisible or unauthorized voices of those with no legal status and privilege the uniqueness of each individual's narrative.

The other social issue that has become a dominant preoccupation in Italian cinema is the instability of the contemporary workplace. The Italian cinema of the 1960s and 1970s had addressed work-related issues in films dealing with the migration to northern Italy and the myth of the *postofisso*. Recently cinema has focused on the lack of job security affecting white collar as well as blue collar workers. A notable feature in the films of the past decade is the centrality of women protagonists (previously relegated to the margins of work films) even in films by men

such as Paolo Virzì's *Tutta la vita davanti* (*A Whole Life Ahead* 2008) and Silvio Soldini's *Giorni e nuvole* (*Days and Clouds* 2007).

Among the most notable films addressing work issues made by a woman is Ada Negri's *Riprendimi* (*Good Morning, Heartache* 2008), which was nominated for the Grand Jury Prize at the Sundance Film Festival. The film adopts a film-within-a-film strategy to look at the pressure that lack of job security places on the lives of struggling artists and of a young mother in the film industry. Reframing the workplace through a movie that interrogates the working conditions of the film industry alongside the effects this has on women, Anna Negri fictionalizes her own personal story in a way that reframes the film industry. The action centers on a documentary team who set out to capture the effects that casual employment in the film industry has on people's lives. The filming begins on what should be a festive occasion but turns into the first day of a couple's break-up. The film-within-the-film digresses, increasingly drawn to the disintegrating relationship, rather than to the issues of temporary employment, suggesting perhaps that the two are inextricably related. By introducing three female friends, who also speak directly into the documentary makers' camera, Negri positions the multiple female storytellers in a frame that places the spectator on the receiving or camera end. By forcing the viewer to identify with the female characters, it becomes a film that speaks to and about women, and provides a new take on cinema and its representation of fact and fiction, of illusion and reality.

Other feature films that address the complexity of the workplace situation and its impact on private lives include Francesca Comencini's *Mobbing* (already discussed) and Wilma Labate's *Signorina Effe* (*Miss F* 2007) a film set at a key moment in the history of FIAT and of Italian industrialization. Labate's film examines the female protagonist's struggle to reconcile professional with personal happiness. Apart from these feature films, there are many documentaries on women and work. Silvia Ferreri's *Uno virgola due* (*One Point Two* 2005) and Tania Pedroni's *Invisibili* (*Invisible* 2002), for example, are based on numerous accounts of discrimination suffered in the workplace by working mothers who struggle to keep their jobs and to negotiate public and private roles. All of these films assume a gendered perspective that draws attention to the veiled prejudices against women in the workplace, a social space where

they continue to come up against a long tradition that renders mother-hood and work in the public sphere incompatible.

CONCLUSION

Women filmmakers who have come of age in the last ten years, while not overtly feminist, are making films that increasingly foreground a desire to engage, create and conceive of female subjectivity on the screen. Nonetheless, despite many women filmmakers' awareness of the difficult position they occupy as women making films, the new generation of Italian filmmakers rarely identify with feminism, which they see as something belonging to a previous generation of Italian women.[29]

This tension emerged repeatedly in our conversations with women directors. Antonietta De Lillo, for instance, is conscious of the unease which her being a woman often generates in others but would not define her awareness as feminist. "I was too young to have experienced feminism first hand. In fact when I was young I considered it aggressive, even anti-feminine, but now I think they [the feminists] played an important role."[30]

Discussing *Di madre in figlia*, Fabiana Sargentini states:

You said "feminism" and that's fine but it is as if those things that were necessary in a particular historical moment come out and exist in me and in my stories as well, like something that in some way you've been brought up with. It's not intellectualized, it's internal, lived, elaborated, but more with your skin, your stomach, your body, your heart, than with your head.[31]

Alina Marazzi, who made *Vogliamo anche le rose* to understand and engage with the legacy of the women's liberation movement, feels she has benefited from feminism but is not a part of it:

When I was growing up that phase of public feminism was over in Italy. Maybe for your studies you might read a related book, but they are pretty much closed circuits in Italy. I lived in London for five years and when I returned in the 1980s that stuff was no longer accessible. I'm certainly a daughter of that generation, and so even the fact of being able to have

access to this type of work, of even having thought of being able to make films means that in any case the conditions were such that allowed me to make a free choice.[32]

Notwithstanding their complex relationship to feminism, it is useful to view these filmmakers in a perspective framed by feminist theories, while recognizing that their works arise out of a post-feminist, post-1990s suspicion of teleological narratives of redemption. Their works engage with the social conditions of contemporary Italy and with women's multifaceted position within that society in ways which would not have been possible without the feminist movement of the 1970s. At the same time their films are also intricately bound by a complex relationship to a cinematic tradition that remains highly patriarchal. Without intending to create a special category for these films, our theoretical framework is therefore informed by feminist discourses on the subordinate/subaltern condition of women both as producers and as subjects of aesthetic production. Their work, we suggest, displays a form of double marginality. Women filmmakers often embody degrees of subordination and marginality within the film industry itself. In addition, when the subject matter of their films focuses specifically on women, many spectators and critics alike consider their films marginal, accusing them of lacking universal appeal.

With these tensions in mind, we also use the term "reframing" in a pejorative and idiomatic sense, whereby framing refers to the act of setting someone up, of contriving events to incriminate someone falsely. Through a range of filmic styles, strategies and practices, contemporary women filmmakers are engaging in a political critique of patriarchal attitudes and institutions that resist change and that are complicit in making it difficult, even in the new millennium, for women's films to be made and distributed.

While women's access to the film industry is still limited, the proportion of films made by women in and outside Italy is increasing. Slowly Italian women filmmakers are appearing from the margins. Their films show that there is a direct relationship between the condition women find themselves working in and the narratives that they construct. It is no coincidence that women filmmakers make films about characters who are perceived as others. These characters mirror the predicament

of women directors who are often others in relation to the film industry and to a history of aesthetics, which pre-dates the advent of cinema.

Recent films by women in the third millennium are providing a multifaceted answer to Melchiori's crucial question: what happens when women take up the camera and face the problematic position of being both objects and subjects of the cinematic gaze? Despite their ambivalence and reluctance to align themselves with feminism, these new filmmakers will become for future generations "female role models," women who have appropriated the camera and reframed the male aesthetic, reframed history, and reframed contemporary social issues to add a new dimension to Italian cinema and to create a place for women's stories by disrupting history.

ACKNOWLEDGMENT

We would like to thank Antonietta De Lillo, Silvia Ferreri, Alina Marazzi, and Marina Spada for agreeing to the interviews and for so generously sharing their thoughts on their films and on women's film-making in Italy. We are also grateful to our research assistant, Teresa Tufano, for the interviews she conducted while in Italy.

NOTES

1. Karl Quinn, "Iraq War Film Makes Oscar History," *The Age* [Melbourne], March 9, 2010): 1.

2. Matthew Weaver, "Kathryn Bigelow makes history as first woman to win best director Oscar," *The Guardian*, March 8, 2010, accessed March 15, 2010, http://www.guardian.co.uk/film/2010/mar/08/kathryn-bigelow-oscars-best-director

3. 60 Minutes, "A Sweet Victory for Kathryn Bigelow," accessed March 15, 2010, http://www.cbsnews.com/stories/2010/03/08/60minutes/main6276814.shtml.

4. This is how Campion's producer, Jan Chapman, describes the anniversary celebration at Cannes. See John Bailey, "Through the Celluloid Ceiling," *The Sunday Age* [Melbourne], March 7, 2010: 17.

5. Rob Woolland, "Women Directors Face 'Celluloid Ceiling,'" Agence France-Presse, March 4, 2010, accessed March 15, 2010, http://au.news.

yahoo.com/queensland/a/entertainment/6884893/women-directors-face-celluloid-ceiling/

6. The others were Jane Campion who was nominated in 1994 for *The Piano* and Sofia Coppola for *Lost in Translation* in 2004.

7. Monica Dall'Asta, "Il singolare multiplo. Francesca Bertini, attrice e regista," in *Non solo dive: pioniere del cinema italiano*, ed. Monica Dall'Asta (Bologna: Cineteca di Bologna, 2008), 63.

8. Silvia Ferreri, personal conversation with Teresa Tufano, Rome, October 26, 2007. Translation our own.

9. Dall'Asta, "Il singolare multiplo", 63. Angela Dalle Vacche also lists Bertini as co-director of *Assunta Spina*. See Angela Dalle Vacche, *Diva: Defiance and Passion in Early Italian Cinema* (Austin: University of Texas Press, 2008), 265.

10. Dall'Asta, "Il singolare multiplo," 70.

11. See Gian Piero Brunetta, *The History of Italian Cinema: A Guide to Italian Film from Its Origins to the Twenty-first Century* (Princeton: Princeton University Press, 2009).

12. In his history of the Italian documentary, Marco Bertozzi includes a section entitled "Occhi di ragazza, dalle donne al mondo." Marco Bertozzi, *Storia del documentario italiano. Immagini e culture dell'altro cinema* (Venice: Marsilio, 2008), 293–97. Similarly, Vito Zagarrio's edited volume, *La meglio gioventù*, has a chapter about women. See Cristiana Paternò, "Un cinema al femminile" (Venice: Marsilio, 2006).

13. This chapter is part of a larger project on Italian women filmmakers.

14. Paola Melchiori, "Women's Cinema: A Look at Female Identity," in *Off Screen: Women and Film in Italy*, ed. Giuliana Bruno and Maria Nadotti (London: Routledge, 1988), 2

15. Marina Spada, personal conversation with Teresa Tufano. Translation our own.

16. Laura Ruberto, "Neorealism and Contemporary European Integration," in *Italian Neorealism and Global Cinema*, ed. Laura E. Ruberto and Kristi M. Wilson (Detroit: Wayne State University Press, 2007), 246.

17. Ruby B. Rich, "In the Name of Feminist Film Criticism," in *Issues in Feminist Film Criticism*, ed. Patricia Erens (Bloomington: Indiana University Press, 199), 283.

18. Walter Benjamin, *Illuminations*, ed. Hannah Arendt, trans. Harry Zohn (New York: Schocken Books, 1968), 261.

19. Maurizia Boscagli, "Brushing Benjamin Against the Grain: Elsa Morante and the *Jetztzeit* of Marginal History," in *Italian Women Writers from the Renaissance to the Present: Revising the Canon*, ed. Maria Marotti (University Park, PA: Pennsylvania State University Press, 1996), 133.

20. Vittorio Martinelli, *Il cinema muto italiano: i film della Grande Guerra.* 1915, vol.1. (Torino: Eri, 1992), 136.

21. Antonietta De Lillo, personal conversation with Susanna Scarparo, Rome, December 16, 2008.

22. *Il resto di niente* won the 2005 Davide di Donatello for best costume design, and was nominated for best actress. In 2005, it also won best actress and best screenplay at the Flaiano Film Festival, and received six nominations at Ciak d'oro. In 2006, the film received the Silver Ribbon nomination (Italian National Syndicate of Film Journalists) for best cinematography, best costume design, best production design, best score, and best screenplay.

23. De Lillo, personal conversation with Susanna Scarparo.

24. For a discussion of *Un'ora sola ti vorrei* and *Di madre in figlia*, see Bernadette Luciano and Susanna Scarparo, "The Personal is Still Political: Films 'By and for Women' By the New *Documentariste*," *Italica* 87, no. 3 (2010): 487–502.

25. Teresa De Lauretis, "Guerrillas in the Midst: Women's Cinema in the 80s." *Screen* 31, no. 1 (1990): 17.

26. Giuliana Bruno, *Streetwalking on a Ruined Map* (Princeton: Princeton University Press, 1993), 51.

27. Àine O'Healy, "Border Traffic: Reimagining the Voyage to Italy," in *Transnational Feminism in Film and Media*, ed. Katarzyna Marciniak, Anikó Imre and Àine O'Healy (New York: Palgrave Macmillan, 2007), 41.

28. For a discussion of *Sidelki/badanti* and *La stoffa di Veronica*, see Bernadette Luciano and Susanna Scarparo, "Vite sospese: Representing Female Migration in Contemporary Italian Documentaries," *Italian Studies* 65, no. 2 (2010): 192–203.

29. This attitude toward feminism, conflated with the women's liberation movement, is consonant with other western countries, in which post-feminist discourses have become the dominant framework in discussions about gender. As Elana Levine argues, "Postfeminist culture takes feminism for granted, assuming that the movement's successes have obviated the need for its continuation." Elana Levine, "Feminist Media Studies in a Postfeminist Age," *Cinema Journal* 48, no. 4 (2009): 138.

30. De Lillo, personal conversation with Susanna Scarparo. Translation our own.

31. Fabiana Sargentini, personal conversation with Teresa Tufano, Rome, October 24, 2007. Translation our own.

32. Alina Marazzi, personal conversation with Susanna Scarparo, Rome, October 24, 2008. Translation our own.

BIBLIOGRAPHY

Amelio, Gianni, dir. *Le chiavi di casa*. 2004.

Bailey, John. "Through the Celluloid Ceiling." *The Sunday Age* [Melbourne]. March 7, 2010.

Benigni, Roberto, dir. *La vita è bella*. 1997.

Benjamin, Walter. *Illuminations*. Edited by Hannah Arendt, translated by Harry Zohn. New York: Schocken Books, 1968.

Bertozzi, Marco. *Storia del documentario italiano. Immagini e culture dell'altro cinema*. Venice: Marsilio, 2008.

Bigelow, Kathryn, dir. *The Hurt Locker*. 2008.

Boscagli, Maurizia. "Brushing Benjamin Against the Grain: Elsa Morante and the *Jetztzeit* of Marginal History." In *Italian Women Writers from the Renaissance to the Present: Revising the Canon*, edited by Maria Marotti, 131–44. University Park, PA: Pennsylvania State University Press, 1996.

Brunetta, Gian Piero. *The History of Italian Cinema: A Guide to Italian Film from Its Origins to the Twenty-first Century*. Princeton: Princeton University Press, 2009.

Bruno, Giuliana. *Streetwalking on a Ruined Map*. Princeton: Princeton University Press, 1993.

Campion, Jane, dir. *The Piano*. 1993.

Capuano, Antonio, dir. *La guerra di Mario*. 2005.

Ciccone, Anne Riitta, dir. *L'amore di Màrja*. 2002.

Comencini, Cristina, dir. *Bianco e nero*. 2007.

———. *Il più bel giorno della mia vita*. 2002.

———. *Mi piace lavorare*. 2003.

Dall'Asta, Monica. "Il singolare multiplo. Francesca Bertini, attrice e regista." In *Non solo dive: pioniere del cinema italiano*, edited by Monica Dall'Asta, 61–80. Bologna: Cineteca di Bologna, 2008.

———. "L'altra metà del cinema muto italiano." In *Non solo dive: pioniere del cinema italiano*, edited by Monica Dall'Asta, 9-16. Bologna: Cineteca di Bologna, 2008.

Dalle Vacche, Angela. *Diva: Defiance and Passion in Early Italian Cinema*. Austin: University of Texas Press, 2008.

De Lauretis, Teresa. "Guerrillas in the Midst: Women's Cinema in the 80s." *Screen* 31, no. 1 (1990): 6–25.

De Lillo, Antonietta. Personal conversation with Susanna Scarparo, Rome, December 16, 2008.

———, dir. *Il resto di niente*. 2004.

De Sica, Vittorio, dir. *Ladri di biciclette*. 1948.

Ferreri, Silvia. Personal conversation with Teresa Tufano, Rome, October 26, 2007. Gagliardo, Giovanna, dir. *Bellissime*. 2004.

Garrone, Matteo, dir. *Gomorra*. 2008.

Giordana, Marco Tullio, dir. *Quando sei nato non puoi più nasconderti*. 2005.

Labate, Wilma, dir. *Domenica*. 2001.

Levine, Elana. "Feminist Media Studies in a Postfeminist Age." *Cinema Journal* 48, no. 4 (2009): 137–43.

Luciano, Bernadette, and Susanna Scarparo. "The Personal is Still Political: Films 'By and for Women' By the New *Documentariste*." *Italica* 87, no. 3 (2010): 487–502.

———. "'Vite sospese': Representing Female Migration in Contemporary Italian Documentaries." *Italian Studies* 65, no. 2 (2010): 192–203.

Marazzi, Alina. dir. *Vogliamo anche le rose*. 2007.

———. Personal conversation with Susanna Scarparo, Rome, October 24, 2008.

———. *Un'ora sola ti vorrei*. 2002.

Martinelli, Vittorio. *Il cinema muto italiano: i film della Grande Guerra. 1915*, vol.1. Torino: Eri, 1992.

Mattoli, Mario, dir. *Assunta Spina*. 1925.

Melchiori, Paola. "Women's Cinema: A Look at Female Identity." In *Off Screen: Women and Film in Italy*, edited by Giuliana Bruno and Maria Nadotti, 25–35. London: Routledge, 1988.

Muscardin, Laura, dir. *Billo il grand Dakhaar*. 2008.

Negri, Anna, dir. *Riprendimi*. 2008.

O'Healy, Àine. "Border Traffic: Reimagining the Voyage to Italy." In *Transnational Feminism in Film and Media*, edited by Katarzyna Marciniak, Anikó Imre and Àine O'Healy, 37–52. New York: Palgrave Macmillan, 2007.

Paternò, Cristiana. "Un cinema al femminile." In *La meglio gioventù. Nuovo cinema italiano 2000-2006*, edited by Vito Zagarrio, 135–42. Venice: Marsilio, 2006.

Pirani, Francesca, dir. *L'appartamento*. 1997.

Quatriglio, Costanza. Personal conversation with Susanna Scarparo, Rome, October 20, 2008.

———, dir. *L'isola*. 2003.

Quinn, Karl. "Iraq War Film Makes Oscar History." *The Age* [Melbourne]. March 9, 2010.

Reale, Lorella, dir. *Storia del movimento femminista in Italia*. 2006.

Rich, Ruby B. "In the Name of Feminist Film Criticism." In *Issues in Feminist Film Criticism*, edited by Patricia Erens, 268-287. Bloomington: Indiana University Press, 1990.

Rossellini, Roberto, dir. *Roma città aperta.* 1945.

Ruberto, Laura. "Neorealism and Contemporary European Integration." In *Italian Neorealism and Global Cinema*, edited by Laura E. Ruberto and Kristi M. Wilson, 242–58. Detroit: Wayne State University Press, 2007.

Sargentini, Fabiana. Personal conversation with Teresa Tufano, Rome, October 24, 2007.

———, dir. *Di madre in figlia.* 2004.

60 Minutes. "A Sweet Victory for Kathryn Bigelow." Accessed March 15, 2010. http://www.cbsnews.com/stories/2010/03/08/60minutes/main6276814.shtml.

Soldini, Silvio, dir. *Giorni e nuvole.* 2007.

Sorrentino, Paolo, dir. *Il divo.* 2008.

Spada, Marina, dir. *Come l'ombra.* 2006.

———. Personal conversation with Teresa Tufano, Bologna, November 11, 2007.

Virzì, Paolo, dir. *Tutta la vita davanti.* 2008.

Visconti, Luchino, dir. *La terra trema.* 1948.

Weaver, Matthew. "Kathryn Bigelow makes history as first woman to win best director Oscar." *The Guardian*, March 8, 2010. Accessed March 15, 2010. http://www.guardian.co.uk/film/2010/mar/08/kathryn-bigelow-oscars-best-director

Wertmüller, Lina, dir. *Pasqualino settebellezze.* 1975.

Woolland, Rob. "Women Directors Face 'Celluloid Ceiling.'" Agence France-Presse, March 4, 2010. Accessed March 15, 2010. http://au.news.yahoo.com/queensland/a/-/entertainment/6884893/women-directors-face-celluloid-ceiling/.

Zagarrio, Vito. *La meglio gioventù: Nuovo cinema italiano 2000–2006.* Venice: Marsilio, 2006.

III

THE ARTS

FEELING ONE'S WAY THROUGH A CULTURAL CHIASM

Touch in Giuseppe Penone's Sculpture c. 1968

Elizabeth Mangini

Since 1968, the Turin-based artist Giuseppe Penone has explored the embodied experience of his materials, with objects, actions, and installations that oppose visual faculty with tactile experience, and explore their interrelationship. He is a central protagonist of the postwar Italian art movement known as *Arte povera*, whose artists considered the radical social politics of their time as an imperative to *present* things rather than *re*-present them. For Penone, this impulse to emphasize immediate first-hand experience developed into a metaphor in which the sculptor's touch is analogous to both the organic formation of matter in nature and to manual labor. The artist is also the youngest member of what critic Tommaso Trini called the "Turin School," a subset of *Arte povera* that coalesced around Gian Enzo Sperone's important gallery in the late-1960s.[1] Though rarely discussed in *Arte povera* literature, Trini identified and qualified a Turinese faction within *Arte povera* in three separate articles: "The Prodigal Maker's Trilogy" (1969), "The Sixties in Italy" (1972), and "Anselmo, Penone, Zorio and the new sources of energy for the desert of art" (1973). He argued that what separated the Turinese artists from others of their generation was "an art concerned with the internal process of the aesthetic object—an art in which the general perceptions of the world, the aesthetics, are closed within the

individual."[2] The counterpoint Trini recognized between the individual and the world in Turin School artworks is a fundamental concept for the philosophical stance and latent social engagement that I will argue for in Penone's *oeuvre*. For the artist, information perceived through the individual body and its sense of touch, is shown to be foundational to understanding one's own being in the world. Physical contact implies presence and agency, and this concern with the tactile imparts the philosophical and social context through which *Arte povera* and this project, in particular, emerged.[3]

The northern Italian city—which curator and *Arte povera* founder Germano Celant hyperbolically claimed was the center of his world at that time—was highly stratified, with deep divides between "industrialist" managers and workaday laborers. The fissures deepened when workers for regional factories like automaker FIAT (*Fabbrica Italiana Automobili Torino*) began to protest recessionary cuts and the growing automation of assembly lines.[4] The national center-left governments of the early 1960s, led most notably by Prime Minister Aldo Moro, were unsuccessful in implementing the promised reforms that might have ameliorated such local stresses.[5] Prefiguring the worker movements by only a few years, the countercultural Italian youth movement gained early momentum at The University of Turin, which was also home to an important school of philosophy. Scholars like Nicola Abbagnano, Luigi Pareyson, Norberto Bobbio, and Umberto Eco were the main conduits in Turin of continental philosophy, resisting the influence of Benedetto Croce's dominant idealism by focusing instead on a blend of phenomenology, existentialism, and the pragmatism, what Abbagnano called "*il nuovo Illuminismo*."[6] The writings of French phenomenologist Maurice Merleau-Ponty and the American John Dewey were crucial to this Turinese philosophical school, especially with regard to ideas of embodied perception and viewer participation in an aesthetic experience.[7] These models will strongly inflect my reading of Penone's contemporary uses of tactile perception within his sculptural practice.

For Merleau-Ponty, the encounter of the body with the sensible world was understood as a moment in which one's own consciousness came into focus. More radically, he argued that conscious perception actively creates the world:

Every sensation is spatial; we have adopted this thesis, not because the quality of an object cannot be thought otherwise than in space, but because, as the primordial contact with being, as the assumption by the sentient subject of a form of existence to which the sensible points, and as the co-existence of sentient and sensible, it is itself constructive of a setting for co-existence, in other words, of a space.[8]

Though certainly not explicitly about the apperception of artworks, Merleau-Ponty's focus on the physicality of sensation as constructive in terms of space provided an alternative to the sterility of idealist aesthetics. Croce, for example, had aimed to distance what he praised aesthetic "intuition" from everyday sense "perceptions," by stating that the latter are "what the spirit of man suffers, but does not produce."[9] He was not interested in perception as a formative act.

Though an oppositional position vis-à-vis Croce began to take shape at least as early as 1948, Dewey's major aesthetic writing, *Art as Experience*, was translated into Italian in 1951.[10] In this text he pointedly argued that the hurdles between art and everyday experience were "philosophies of art that locate it in a region inhabited by no other creature, and that emphasize beyond all reason the merely contemplative character of the esthetic."[11] Indeed, the primary argument of *Art as Experience* sought to defy the idealistic theories like Croce's that "rest upon the separation of the live creature from the environment in which it lives."[12] Instead, the American asserted, "the esthetic is no intruder to experience from without . . . it is the clarified and intensified development of traits that belong to every normally complete experience."[13] This anti-idealist, experience-based philosophy was formative for what became known as the "School of Abbagnano" at the University of Turin.

Equally important to the philosophical climate in Turin, and perhaps even more so in its explicitly aesthetically oriented dimension, was Pareyson. In 1966 the *British Journal of Aesthetics* dubbed him "the first Phenomenological-Existentialist *aesthetician* in Europe."[14] His major aesthetic theory, *Aesthetics: Theory of Formativity* (*Estetica-Teoria della formatività*) (1954), introduced his notion of "formativity," which posited the art object as something simultaneously made and organic, with a life of its own.[15] Pareyson argued that the execution of the work, whether it is written poetry or a dramatic representation, necessarily

extends it beyond the idealist confines of the object to the conditions of its making. The interest in art objects comes from their having been made by someone, instead of being naturally occurring forms. This theory had the twofold effect of privileging both the materiality of the work and the conditions of its production. Though the artist is central to the artwork, its meanings are unfixed, and lay latent, to be traced by the viewer through the work's material appearances. This mode of interpretation—which proposes a potentially infinite exchange between the artist and the viewer through the experience of the object—is, for Pareyson, the fundamental process by which art is actually created. Such positioning of "formativity" as a theory of reception links Pareyson to Dewey, who argued that "a work of art, no matter how old and classic, is actually, not just potentially, a work of art only when it lives in some individual experience."[16] For both writers, the central idea was that a new work of art is created each time the object is experienced by the perceiver. Pareyson's "formativity" laid the ground for thinking about an art object as a communication between maker and perceiver, and had a great influence on the way the dynamics of art were understood and theorized in Turin in the 1960s.

Penone, who was born in Garessio in 1947, emerged against this philosophical backdrop.[17] While studying at the Albertina Academy of Art (*Accademia Albertina di belle arte di Torino*), he followed a regular course of study that included traditional approaches to the modeling of materials. In retrospect, Penone noted that the school served him by negative definition—it helped him understand what he did not want to do.[18] While there, however, he found kindred spirits among the students, such as Turin School artist Gilberto Zorio, who recounted his first encounter with his future colleague:

> It was an extraordinary meeting; by the end of the first days [Penone] demonstrated an exceptional modeling ability (his maternal grandfather was a sculptor). In the turn of a year he had exceeded the praxis of modeling and had completely changed his type of work.[19]

For Penone, it became quickly clear that the artist's shaping contact would be the content of the work, echoing Pareyson's notion of formativity. Since Penone executed many early works *in situ*, in nature,

the artist's body became the explicit point of communication with the viewer's body, requiring empathy and a conceptual inhabitation of the producer's point of view. His sculptures, then as now, stage physical encounters between materials and human bodies over time in order to alter our view of the temporal relationship between man and nature.[20] These tactile investigations into the slow time of organic processes also naturalize industrial labors by intertwining human and geological scales of time. Therefore this corporeal engagement with materials, informed by phenomenology, can also be productively read vis-à-vis Turin's industrial history and the centrality of the body in the student and labor movements of the late 1960s.

Already in 1968, when he was only twenty-one years old, the project Penone exhibited at the experimental space run by Sperone, *Deposito d'arte presente,* exemplified what Trini later identified as the Turin School artists' approach to demonstrating the man/nature relationship via phenomenology and direct physical engagement with materials. This breakthrough project, *Maritime Alps* (Alpi Marittime) (1968), comprised a series of actions performed out-of-doors and their photographic records. Though not sculpture in the traditional sense, it conceptualized and concentrated the important role of touch in the labor of an artist. Here intercessions in the landscape, such as interruptions in natural growth of trees in the woods or disturbances in the flow of a stream through the forest were marked by durable traces left by the sculptor. These interventions showed the impact of sustained human presence on raw materials, on the landscape, and in organic systems.

In one work of this series, named for the small Piedmontese mountain range in which Penone was living at the time, Penone intertwined the trunks of three saplings so that they would grow together, a simple gesture that carried overtones of medieval agricultural practices like grafting. In another action, the artist wrapped his arms and legs around a tree trunk, marking the outline of this embrace—the outline of his entire body—with a thin galvanized wire that traced a series of nails that had been driven into the tree at various points of his body's contact (figures 1–2). As the tree grew it retained the artist's wire silhouette. On one version of the resulting photographic documentation, Penone inscribed the phrase "The growing tree will preserve my action," (figure 2) while he captioned another version of

this same image "The growing tree will remember the points of my contact" (figure 3). The latter phrase is especially interesting because Penone's choice of words signals an animistic understanding of the tree. Instead of merely "preserving" a trace as a passive function of a material acted upon, Penone here uses the Italian verb "ricordare" to suggest that the tree, as a living organism, actively "remembers" the encounter with his body. Penone saw the tree not as inert matter, but as a natural "force" against which he could juxtapose other forces, such as his own, to provoke a reaction.[21]

The *Maritime Alps* actions embodied Trini's statement that for *Arte povera* artists "Mother Nature represents the whole operative area of an art . . . in which place and duration are at the service of the creative experience."[22] Indeed the way the artist's touch might extend over the protracted intervals of nature permeates another episode from this project. In "My height, the length of my arms, my breadth set into a brook," the artist built a rectangular frame to the dimensions of his full figure with limbs extended, and set this concrete frame into a small stream bed (figures 4–5). Permanently "present" in the riverbed, the artist's body continuously diverts the flow of water. Like a stone or fallen tree branch, the surrogate body alters not only the natural movement of the river, but also affects the shape of the water, sculpting it, as it passes over and through the obstruction. Such works offer a way to see the effects of touch, aligning and contrasting tactility with visual information.

This streambed piece foreshadows Penone's sustained interest in the correlation between the sculptor's hand and "natural" sculpture. In a later, 1981 installation *To be river*, he exhibited two identical stones: a found river stone shaped by the flow of water over time, and an exact replica made by hand carving with traditional tools.[23] In drawing an analogy between his conscious effort and the river, Penone continued to consider the symbiotic relationship between natural systems and human labor, using his own body to demonstrate these crossings-over for the viewer in a poetic form. Here as in the earlier work, human presence or "man-hours" are drawn into contrast with the immense temporal scale of the natural world. These small perceptible experiments indicate the enormous scale of civilization's impact on natural systems through the touch and presence of a single body.

One effect of the *Maritime Alps* actions that draw together vastly different scales of time is that they can change the way one looks at the present. That is, by bringing together a human body, with which we can empathize by our experience of our own bodies, with materials that have longer life spans, a new conceptualization of each might be possible. In 1972, the artist wrote about the possibility of accessing an altered perspective through such works:

> If one of the functions of art is the continuous reinterpretation of reality, changing the concept of time puts us in a position to revise and recreate conventions of the real and allows us to imagine new forms with new values.[24]

If apprehending the growth cycles of a tree or the journey of a rivulet of water through these interventions offers a new perspective on human implication in natural systems, then that altered perception can be used constructively, to fashion new realities with corresponding ideals. By contrasting the human and geological scales of time through traces of his own body's presence, Penone offers a means by which the viewer can understand the impact of sustained individual activity on seemingly remote or extreme events. Using sculpture as a metaphor for the reformation of social structures, the *Maritime Alps* works argue for engagement in shaping the future by demonstrating the simple means by which change can be effected.

A second aspect of this series relating to expanded notions of time is a negotiation of the chasm between biological associations of materials and their applications under human hands. In each *Maritime Alps* action, the artist's touch, presented as encounters between Penone's body and nature, are recorded with visible markers fashioned from the materials of industry, such as galvanized steel, iron, concrete, and lead. This contributes an additional layer of meaning, proposing an analogy between the body and industrial labor. The navigation of these two poles parallels the artist's biography: while raised in the countryside, he transplanted himself to Turin, *the* industrial center of post-war Italy, from which he then brought industrial materials back to the rural landscape for the *Maritime Alps* actions. Materials are poetically equalized in an

oscillation between natural and industrial connotations; the hand is human, yet its surrogate is iron, the body's embrace is flesh, yet it is traced with galvanized wire. Trini noted this counterpoint at the time, writing: "for an art like this, which makes nature and culture visibly and plastically converge in a substantial unity, identification is an ongoing process."[25] More recently, curator Didier Semin reflected on how "My height, the length of my arms, my breadth set into a brook," revealed the continuity of man and nature:

> We are made of the same water as the river and of the same minerals as those it carries with it, and it is only by virtue of a tiny percentage of something else that we can look down on that stream with such condescension. It is this percentage that invented the *cogito*, war and the mobile phone.[26]

Semin identifies the important notion that the natural and the industrial are linked on a material level, and hints at the social implications of ignoring this connection. Alternatively, recognizing such correspondence alters one's perspective, by denying stark oppositions. In the context of the intense politicization and stratification of late 1960s Turin, a temporally expanded point-of-view that integrates disparate materials also offers a means for the mediation of political divides. Such polar exchange gives Penone's work its critical energy. What makes Penone's project redolent of its time and place is exactly its negotiation between modern industry and traditional aspects of Italian culture, and, further, between the regional reality of agricultural life and the multinational implications of urban Turin's industry.

Penone maintained a correspondence between modern industry and traditional labors in his works because it allowed him to more fully occupy the complexities of his present moment. In a statement that accompanied the publication of the *Maritime Alps* documentations in 1969, Penone discussed the personal importance of his family land as a function of man-hours or labor put into the earth—14,520 hours of work between 1881 and 1969 by his calculations.[27] In an interview, the artist argued for the centrality of the connections between industrial and natural materials and processes in these early works, rather than a separation:

On close examination even the image of the factory makes reference to that of the field. Take assembly lines: the lines parallel one another just like the furrows of a ploughed field. . . . There's a millennial quality in this way of thinking, and I want to preserve it. Our culture has separated one way of thinking from the other, the human being from nature. I don't believe such a clear distinction can be drawn; there is human material and there are materials called stone and wood, which together make up cities, railroads and streets, riverbeds and mountains. From a cosmic point of view the difference between them is irrelevant.[28]

For the artist, the tree he embraces is not limited to only one interpretation—nature *or* industry, the past *or* the present—but rather fluid enough to encapsulate both concepts at the same time.

Critics like Trini, writing in the moment, read this natural/industrial counterpoint as endemic to Turin and its contemporaneous social turmoil. Correlating the tactics of the student movement and the works of *Arte povera* he wrote:

The sense of nature is such that the attitude of the artists towards nature and matter is marked with nonviolence, in contrast with the idea of domination through scientific conquest that Western thought traditionally exercises on these entities.[29]

Thus, Penone's equalization and normalization of the techno-industrial through material permutation challenges the hierarchy of domination, and perhaps even considers ways in which the two might coexist. The combination of both natural and industrial materials was a metaphoric proposition for a new relationship between physical human labor and alienated industrial labor.

In his most succinct display of this interdependent man/nature relationship in the *Maritime Alps* series, Penone grasped a young tree trunk with his hand. He then made an iron cast of this gesture and affixed it to the tree, creating a permanent encounter between his hand and the tree through an indexical surrogate. The photograph of this action bears the inscription: "The tree will continue to grow except at this point" (figures 6 and 7). The subject of this work is the touch of the artist's hand, a traditional marker of authenticity, to raw material. This touch acts upon, and against, the natural development of the tree,

simultaneously utilizing and undermining the tree's growth cycle. In a work like this, Penone's preoccupation with the physical impact of his presence and touch is self-evident, yet a latent social aspect of these interests emerges upon closer examination. The artist has written that the touch of a human hand, while it presses itself on an object, has the capacity to both create and destroy: "from the negative of his impressed skin infinite positives can be made, as many as there are future contacts with the surface."[30] Like the river, which simultaneously carves away stone and carries water, and like the farmer who both clears the land and cultivates it, the sculptor's touch, his action, can be seen as both additive and reductive. Here the artist's touch is an ambivalent rather than auratic marker. The seemingly simple presence of a single hand, extended over the lifetime of a developing form, is forceful enough to redirect the orientation of growth. The forest, the artist wrote, is "a slow factory producing wood."[31]

I pay significant attention to the Maritime Alps here because the artist was engaged with the project for nearly thirty years, returning to the sites to further document the impact of these interventions with each passing decade. Moreover, the series neatly catalogues Penone's early dedication to primary, corporeal encounters with materials, and the traces of the hand or body distended over long periods of time. In this pursuit, his larger project often has as a sub-textual interest in craft, agriculture, and artisinal knowledge: systems of interaction with natural materials rooted in first-hand, experimental, sensory perception. His approach presumed nothing in advance and relied on experience, taking materials in hand in order to understand their fundamental properties. Penone's physical engagement with raw substances stood in direct contrast to the alienation from traditional processes and systems of knowledge that had emerged in the post-war years, yet it also attempted to naturalize the industrial by that corporeal contact. After years of schooling (and what some might call cultural sublimation), Penone used his early works to "relearn" such alternative systems for himself, in artworks that operate as open channels for the flow of phenomenological knowledge about the world back to the viewer.

In 1969, Penone staged a new encounter with a tree in order to question modern reliance on hyper-rational thinking and scientific systems of learning. In the action Write, Read, Remember (Scrive,

Legge, Ricorda), he inscribed an iron wedge with the twenty-one letters of the Italian alphabet on one side and the ten Arabic numerals (integers) on the other (figure 8). He then drove this wedge into the trunk of a tree, splitting the bark and piercing its "flesh" with the remedial lesson. The absurdity of trying to "teach" a tree a rational system of writing and counting by literally drilling it into its trunk can be understood as a criticism of modern systems of learning and education. Instead of learning by experience, curiosity, and touch, we conventionally learn by rote repetition: "write, read, remember." The animation of these trees—the idea that the material might remember his touch or learn the alphabet—was an embodiment of the material in the service of perceiving its true character. Further, *Write, Read, Remember* contrasted the organicity of the tree and the rational system of language to initiate the viewer's consideration of the material's state of being. As a sculptor aiming to reengage the natural world without retreating to it, Penone empathetically approached the tree, in order to grasp its place among the systems of nature and modern society.

Penone has written about the necessity of using all of his senses to perceive the material aspects of making sculpture. In a text concurrent with these early works, he echoed the central tenets of the *Phenomenology of Perception*, writing of the desire to recuperate, at least for a moment, a state in which the analytic mind might yield to pure sensatory experience—to the world's natural materials and processes—so that vision and touch might again be reintegrated in the object:

> To make sculpture the sculptor must lie down, slipping to the ground slowly and smoothly, without falling. Finally, when he has achieved horizontality, he must concentrate his attention and efforts on his body, which, pressed against the ground, allows him to see and feel with his form the forms of the earth. He can then spread his arms to take in the freshness of the ground and achieve the degree of calm necessary for the completion of the sculpture. . . . The sculptor sinks . . . and the horizon line comes closer to his eyes. When he feels his head finally light, the coldness of the ground cuts him in half and reveals, with clarity and precision, the point that separates the part of his body that belongs to the void of the sky from that which is in the solid of the earth. It is then that sculpture happens.[32]

Here, even if romantically, Penone prescribes a literal and figurative horizontality: a conscious and willful regression to a pre-linguistic state. Tangible evidence is to be experienced for oneself through the whole body, and not solely through the learned mind, nor its "vertical" accomplices, the eyes. The artist identified a split between the mind (indicated here as that part of the body belonging to the sky) and the body (belonging to the earth) as a fundamental dialectic of making sculpture. Furthermore, Penone here formulates the sculptural act as a verticalization of the corporeal, multi-sensory experience. To begin, however, the sculptor needed to resist the intellect and defy sublimation, focusing instead on the ground, the earth, and the horizon line.

Building upon this approach, Penone devised an action that forced him to inhabit a fully tactile, "horizontal" position by apprehending new situations and environments using every sense except sight. In the photographically-recorded actions begun in 1970 titled *To Turn One's Eyes Inside Out* (*Roversciare i propri occhi*), Penone temporarily blinded himself by inserting mirrored contact lenses into his eyes (figures 9–10). In collaboration with an array of photographers, the artist explored areas that were new to him while wearing the opaque lenses, recording his first impressions through sound, smell, and touch.[33] He thus reversed the conventional reliance on sight by forcing himself to relate to his surroundings through nonvisual senses. For most humans, the eye is the most trusted witness to the existence of the self in the world, allowing one to understand oneself as separate from other things in the world. Yet as far back as Plato's cave, vision alone—the eye set loose, without experience and grounding in the other senses—has also been understood to be unreliable. Not wanting to be fooled by shadows, Penone thus choreographed scenarios in which he had to first experience a new place with his flesh instead of his eyes.

This series of actions allowed the artist to temporarily regress to the mode of encountering the world that Dewey referred to as particular to the "savage." For the latter, the savage was a model of a fully alive being, focusing totally on the present:

> His senses are sentinels of immediate thought or outposts of action, and not, as they so often are with us, mere pathways along which material is gathered to be stored away for a delayed and remote possibility.[34]

Along this line of argument, *Arte povera* founder Celant suggests that Penone's emphasis on tactility reveals a "primitive" way of being in the world. When the critic argues that protohistoric man did not separate himself clearly from other organic forms of life, "the clear dividing lines between subjectivity and objectivity, dream and reality, were blurred," he echoes Dewey's formulation of the man grounded in the present.[35] For the artist, the sensory information gathered through this action is used immediately to ascertain his new surroundings, but rather than regressing to savagery, Penone effects a crossover between this alert "primitive" state and a more humanist acculturated mode by connecting the first impressions with the images seen when the lenses were removed and the photographs made by others were developed.

For the viewer of the resulting photographs, the gap between the multi-sensory experience and its purely visual documentation is palpable. This interruption, and the temporal delay it necessitates, probes the traditional artist/viewer relationship as it simultaneously draws together these two modes of experience (for the artist, like the viewer, does not see the experience until later). Instead of receiving information through his eyes and later re-transmitting it through a communicative medium, Penone captured an instantly-reflected image in the mirrored lenses before he had ever actually seen it. In the text that accompanied the 1977 publication of these photos in an artist's book, Penone wrote:

> When the eyes, covered with mirrored contact lenses, reflect back into space the image they gather with the usual movements one has when observing, the ability to see is deferred. . . . The delay with which I capture an image makes mirrored contact lenses into diviners of future sight.[36]

Foregrounding this element of delay destabilized visual authority and questioned the hierarchical separation between artist and viewer.

In the absence of eyesight, skin becomes the primary barrier through which we must pass in order to understand our own being and our "place" within the body. In two texts from the 1960s, *Eye and Mind* (1961) and *The Visible and the Invisible* (1964), Merleau Ponty wrote about to the mind's ability to create a concept for an invisible physical sensation as the *chiasm*, or crossing-over, between perception and the cogito as essential to being.[37] He explained:

> A human body is present when, between the seer and the visible, between
> touching and touched, between one eye and the other, between hand and
> hand a kind of crossover occurs, when the spark of the sensing/sensible
> is lit. . . .[38]

Thus presence is comprehensible through that moment when the vision
and touch correspond. Penone's work attempts to locate that spark,
to operate on the frontier between the seer and the sensible. If this
border seems permeable and difficult to identify, one might consider
that Merleau-Ponty also asserted that touch is reversible: one can feel
oneself being touched as well as actively touch. For him, touch is there-
fore both simultaneously active and passive. Compared to vision, this
"reversibility" of touch requires the mind to interpret more complex
sensible signals, and it can also provide more information, making touch
perhaps better than vision in perceptive terms.

Here too, Dewey's theories of experience align with Merleau-
Ponty's phenomenology, a significant confluence given the importance
of both thinkers to the philosophy produced in Turin. The American
philosopher went so far as to argue that his own theory of aesthetics
and experience relied on an acknowledgment of the foundational im-
port of encountering one's environment through the fragile border of
sensory organs:

> No creature lives merely under its skin; its subcutaneous organs are a
> means of connection with what lies beyond its bodily frame, and to which,
> in order to live, it must adjust itself, by accommodation and defense but
> also by conquest.[39]

Penone's investigation of this living boundary and of the crossover
between touch and sight would be central, in Dewey's terms, to
understanding one's own being in the world, one's own subjectivity.
When Penone "blinded" himself, he denied the itinerant potential of
the eyes, and forced open the boundary created by the skin through
a greater reliance upon touch. Evoking Dewey's sentiment, the artist
wrote of this barrier:

> The skin, like the eye, is a border element, the extreme point that makes
> us able to divide ourselves and separate ourselves from that which

surrounds us, the extreme point that is able to envelop vast physical extensions… it is the point that allows me, still and after all, to identify myself and to identify.[40]

These two borders, then, between the inside and the outside are for Penone the frontier of understanding his own being in the world. Even by simply closing one's eyes, we feel ourselves to be more inside our bodies, less a part of the outside world. "The eyelid," the artist wrote, "separates touch from sight."[41] If being is apprehended through a mediation of vision and touch, the mirrored lens interrupts and delays this crossover by acting as a surrogate for the eyelid. It closes vision to the wearer, and offers it instead to the viewer. In this way meaning becomes a collaborative process, the result of an encounter between the artist and the viewer through the artwork. Viewing the photographs, we offer our eyes to read what his (temporarily) could not. Penone offers his flesh for us to consider the experience of being in that physical place. Both experiences are incomplete without the other.

The artist focused on this counterpoint between the eye and the flesh—and, specifically, the fallibility of sight alone—in another photographically documented work. *To Unroll One's Skin* (Svolgere la propria pelle) (1970–1972) records an action in which Penone photographed every inch of his skin through a microscope slide (figures 11 and 12). His attempt to indexically register the surface of the body's tactile barrier is mockingly analytical.[42] The methodical approach to his own body is replete with detailed images—indeed, it is hypervisual— yet it fails to yield any useful information as to the nature of skin as a material nor, more importantly, of the man who inhabits it. The multiple images in the resulting artists' book are visually accurate, yet they fall short of revealing the whole truth of what it means to be inside of that body, or to encounter the individual in the world.[43] Again the work presents the viewer with a fragment that invites conceptual engagement and participation in the product of its meaning.

This structure, an open structure, also reveals the fundamental ideals of the moment in which Penone's mature work emerged. For the artist as for the phenomenologically-minded philosophers in Turin, the confluence of touch and sight implies presence.[44] Alone, sight can facilitate knowledge through a variety of mediations, distanced

and delayed by pictorial representations or written linguistic systems, for example. Touch, conversely, relies on knowledge gained through presence and proximity. Touch implies immediacy: knowledge rooted in the body. In the context of Turin's student and worker movements, "presence," especially of bodies, was a fundamental issue (immigrant bodies infiltrating the city) and key weapon (sit-ins, walk-offs, strikes) used to publicize political beliefs. In 1968, fellow artist and critic Piero Gilardi wrote about the new kinds of artistic experiences being pursued by *Arte povera* artists like Penone in terms that directly correlated the heightened subjectivity offered to the viewer of the artwork with the political needs of Italy's social moment:

> The new environment is not a space for conditioning the viewer, but an experience of freedom which leads him to the recognition of his own perceptive autonomy; the psychological mechanism involved is similar to that underlying the political 'mobilization' of modern student meetings.[45]

Gilardi's statement evidences a contemporaneous understanding of *Arte povera* as connected to the political and social movements of the day in the way the open structures of artists' installations encouraged viewer subjectivity, rather than on the level of sloganeering or direct political action.

The interdependency of vision and touch in Penone's work can be read as alluding, perhaps, to the essential relationship between the systems of nature and industry, between the powerful and powerless, between the political left and the right. The artist has suggested that there is a latent politics to his project, which he contends was born in "a moment of strong reaction to the political and social system, which didn't allow political indifference." Further, he explains that what was shared among those of his generation was "strong social criticism accompanied by a desire to reset values, in order to be able to rebuild on the basis of rediscovered identity."[46] Indeed, a politics can be found in the foregrounding of presence through touch and in the cross-over between vision and touch, because they are both strategies aimed at a consciousness of being that is fundamental to empowered subjectivity. Beginning with early works like the *Maritime Alps* and *To Turn One's Eyes Inside Out*, awareness of one's own being in the world, and one's

identity, requires an investigation into the limits between what one is and what one is not. By inviting participation in this exploration through their fragmented and open structures, such works defy traditional hierarchical relationships such as between artist and viewer, and have the radical potential to alter viewers' perceptions of dominant paradigms. Since 1968, Penone's project has productively compared the sentient human body with the materials of nature and industry in order to facilitate a better understanding both being and world.

NOTES

1. Tommaso Trini, "The Prodigal Maker's Trilogy: Three Exhibitions: Berne, Amsterdam, Rotterdam," *Domus* 478 (September 1969): 46. Trini was a regular critic for and contributing editor of the design, architecture, and art magazine *Domus*, as well as founding editor of the contemporary art journal *Data* (1971–78).

2. Tommaso Trini, "The Sixties in Italy," *Studio International* 184, no. 949 (November 1972): 166.

3. "*Arte povera*" conventionally refers to Giovanni Anselmo, Alighiero Boetti, Pier Paolo Calzolari, Luciano Fabro, Piero Gilardi, Jannis Kounellis, Mario Merz, Marisa Merz, Pino Pascali, Giulio Paolini, Penone, Michelangelo Pistoletto, Emilio Prini, and Gilberto Zorio. The term was first used by critic and curator Germano Celant in 1966–1967, most notably in an internationally circulating article that came to be read as an ersatz-manifesto: "Arte povera: appunti per una guerriglia," *Flash Art* 5 (November–December 1967): 3.

4. Robert Lumley, *States of Emergency: Cultures of Revolt in Italy from 1968 to 1978* (New York: Verso, 1990), 110–20.

5. Paul Ginsborg chronicles the tangled attempts to find stability and compromise in Italy's parliamentary system. Of note is his discussion of the historical alliance of the moderate Christian Democrats (DC) and the Socialist Party (PSI) referenced briefly here. Paul Ginsborg, *A History of Contemporary Italy: Society and Politics 1943–1988* (London: Penguin, 1990; reprint, New York: Palgrave Macmillan, 2003), 254–97.

6. Nicola Abbagnano, "Verso il nuovo illuminismo," *Rivista di filosofia* 39 (October–December 1948): 313–25.

7. For more on connections between Merleau-Ponty and Dewey, see Victor Kestenbaum, *The Phenomenological Sense of John Dewey: Habit and Meaning* (Atlantic Highlands, NJ: Humanities Press, 1977), 5–7.

8. Maurice Merleau-Ponty, *Phenomenology of Perception*, trans. Colin Smith (New York: Routledge Classics, 2002), 256–57.

9. He argued that intuition required freedom from intellectualism and other external forces. Benedetto Croce, *Aesthetic*, trans. Douglas Ainslie (New York: Noonday Press, 1956), 4th impression of 1922 edition, 5.

10. John Dewey, *Arte come esperienza* (Firenze: La Nuova Italia, 1951). Dewey and Croce exchanged letters on the pages of the *Journal of Aesthetics and Art Criticism (JAAC)* after the book's English publication in 1948. See Benedetto Croce, "On the Aesthetics of Dewey," *JAAC* 6 (1948): 203–7, and John Dewey, "A Comment on the Foregoing Criticisms," *JAAC* 6 (1948): 207–9. See also Thomas Alexander, *John Dewey's Theory of Art, Experience and Nature: The Horizons of Feeling* (Albany: State University Press of New York, 1987).

11. John Dewey, *Art as Experience* (New York: Perigee, 1980), 11.

12. Dewey, *Art as Experience*, 131.

13. Ibid., 47.

14. Hugh T. Bredin, "The Aesthetics of Luigi Pareyson," *The British Journal of Aesthetics* 6 (1966): 193–203, accessed May 21, 2008, http://bjaesthetics. oxfordjournals.org. Emphasis in the original text.

15. Luigi Pareyson, *Estetica-Teoria della formatività* (Turin: Edizione di filosofia, 1954), reprinted in *Luigi Pareyson: Opere complete*, vol. 10–11 (Milan: Mursia, 2000). Page citations refer to the reprint edition.

16. Dewey, *Art as Experience*, 108.

17. For his biographical background, see Giuseppe Penone, interview with Mirella Bandini, [Garessio, 1971], *Data* (Summer 1973): 7–18, reprinted in *1972: Arte Povera a Torino*, ed. Mirella Bandini (Turin: Allemandi, 2003), 66. Page citations refer to the reprint.

18. *"La scuola che ho frequentato mi è servita per capire cosa non dovevo fare."* Giuseppe Penone, email message to the author, September 20, 2009. Translation mine.

19. Gilberto Zorio, interview with Mirella Bandini, Turin 1972, in *1972: Arte Povera a Torino*, ed. Mirella Bandini (Turin: Allemandi, 2002), 109. Translation mine.

20. Penone, "[artist's statement]" in *Arte Povera=Art Povera*, 239.

21. Bandini, 65–66.

22. Tommaso Trini, "Imagination Takes Command," *Domus* 471 (February 1969): 50.

23. For discussion of this work see Ludovico Pratesi, "Showing Traces," in *Giuseppe Penone: paesaggi del cervello*, ed. Costantino D'Orazio, trans. Alexander Martin, exhibition catalog (Prato: Ex Chiesa della Madalena and Turin: Hopefulmonster, 2003), 60–63.

24. Giuseppe Penone, in *Giuseppe Penone: Writings 1968–2008*, ed. Gianfranco Maraniello and Jonathan Watkins, trans. Marguerite Shore (Bologna: MAMbo/Birmingham: IKON, 2009), 78.

25. Tommaso Trini, "Nuovo alfabeto per corpo e materia," *Domus* 470 (January 1969): 46. Reprinted in English as "New alphabet for body and matter," in *Arte Povera = Art Povera*, ed. Germano Celant (Milan: Electa, 1985), 113. Page citation refers to the English edition.

26. Didier Semin, *Giuseppe Penone: The Politeness of Matter*, exhibition catalog (Geneva: Galerie Guy Bärtschi, 2002), 9.

27. See his artist's statement first included in *Conceptual Art Land Art Arte Povera* (Turin: Galleria Civica D'Arte Moderna, 1970), reprinted in English in Maraniello and Watkins, *Giuseppe Penone: Writings,* 90. Page citations refer to the English.

28. Germano Celant, *Giuseppe Penone* (Milan: Electa, 1988), 19.

29. Trini, "New Alphabet," 113.

30. Giuseppe Penone, [statement, 1974], in Celant, *Giuseppe Penone*, 66.

31. Giuseppe Penone [statement, 1970], in Maraniello and Watkins 121.

32. Giuseppe Penone, "Six Statements for Maritime Alps" (1968), in *Zero to Infinity: Arte Povera 1962–1972*, ed. Richard Flood and Francis Morris (Minneapolis, MN: Walker Art Center and London: Tate Modern, 2001), 298.

33. Interview with the author, written notes, May 22, 2006, Turin, Italy.

34. John Dewey, *Art as Experience*, 19.

35. See Celant, *Giuseppe Penone*, 12.

36. *"Quando gli occhi, coperti dalle lenti a contatto specchianti, riflettono nello spazio le immagini che colgono con i movimenti abituali dell'osservare, si dilaziona nel tempo la facoltà di vedere. . . . Il ritardo con cui mi approprio della immagine, rende le lenti a contatto specchianti divinatorie del vedere futuro."* (Translation mine.) Giuseppe Penone, *Rovesciare gli occhi* (Turin: Einaudi, 1977), 73, 76.

37. Merleau-Ponty's text was published in Italian in 1969. Maurice Merleau-Ponty, *The Visible and the Invisible*, ed. Claude Lefort, trans. Alphonso Lingis (Evanston, IL: Northwestern University Press, 1968). See Michael Newman, "Sticking to the World-Drawing as Contact," in *Giuseppe Penone: The Imprint of Drawing*, ed. Catherine de Zegher, 103–10.

38. Maurice Merleau-Ponty, "Eye and Mind," in *The Merleau-Ponty Aesthetics Reader: Philosophy and Painting*, ed. and trans. Michael Smith (Evanston, IL: Northwestern University Press, 1993), 125. Originally published as *L'Oeil et l'esprit* (Paris, Gallimard, 1961).

39. Dewey, *Art as Experience*, 12.

40. *"La pelle, come l'occhio, è un elemento di confine, il punto estremo in grado do dividerci e separarci da ciò che ci circonda, il punto estremo in grado*

di avvolgere fisicamente estensioni enormi . . . è il punto che mi permette, an-cora e dopotutto, di identificarmi e di identificare." Quoted in Tommaso Trini, "Anselmo, Penone, Zorio e le nuove fonti d'energia per il deserto dell'arte," *Data* 3, no. 9 (Autumn 1973): 67. (Translation mine.)

41. Penone [statement 1976], in Maraniello and Watkins, 246.

42. Guy Tosatto has compellingly corresponded Penone's project and the *Santa Sidone* or "Holy Shroud" of Turin, believed to have been the cloth in which Christ's body was wrapped for burial. See Guy Tosatto, *Giuseppe Penone: 1968–1998*, exhibition catalog, trans. Elena Brizio et al. (Galego: Centro Galego de Arte Contemporanea, 1999), 177–78.

43. Giuseppe Penone, *Svolgere la propria pelle* (Turin: Sperone, 1971).

44. Merleau-Ponty, *The Visible and the Invisible*, 144 and 152.

45. Piero Gilardi, "Politics and the Avant-Garde," in *Op Losse Schroeven: situaties et cryptostructuren*, exhibition catalog, by Wim Beeren (Amsterdam: Stedelijk Museum, 1969), unpaginated.

46. Penone [statement 1999], in Maraniello and Watkins, 13.

BIBLIOGRAPHY

Abbagnano, Nicola. "Verso il nuovo illumanismo." *Rivista di filosofia* 39 (October–December 1948): 313–25.

Alexander, Thomas. *John Dewey's Theory of Art, Experience and Nature: The Horizons of Feeling*. Albany: State University Press of New York, 1987.

Bandini, Mirella. *1972: Arte Povera a Torino*. Turin: Allemandi, 2003.

Bredin, Hugh T. "The Aesthetics of Luigi Pareyson." *The British Journal of Aesthetics* 6 (1966): 193–203. Accessed May 21, 2008. http://bjaesthetics.oxfordjournals.org.

Celant, Germano. "Arte Povera: Appunti per una guerriglia." *Flash Art* no. 5 (November-December 1967): 3.

———, ed. *Arte Povera = Art Povera*. Translated by Paul Blanchard. Milan: Electa, 1985.

———. *Giuseppe Penone*. Milan: Electa, 1989.

Croce, Benedetto. *Aesthetic*. Translated by Douglas Ainslie. Boston: Nonpareil / David R. Godine, 1978.

———. *Guide to Aesthetics*. Translated by Patrick Romanell. Indianapolis, IN: Hackett, 1995. First published 1913.

———. "On the Aesthetics of Dewey." *The Journal of Aesthetics and Art Criticism* 6 (1946): 203–7.

D'Orazio, Costantino. *Giuseppe Penone: paesaggi del cervello*. Translated by Alexander Martin. Prato: Ex Chiesa della Madalena and Turin: Hopefulmonster, 2003. Exhibition catalog.

deZegher, Catherine. *Giuseppe Penone: The Imprint of Drawing*. New York: The Drawing Center, 2004. Exhibition catalog.

Dewey, John. *Art as Experience*. New York: Perigee, 1980.

———. "A Comment on the Foregoing Criticisms." *The Journal of Aesthetics and Art Criticism* 6 (1948): 207–9.

Flood, Richard and Frances Morris, eds. *Zero to Infinity: Arte Povera 1962–1972*. Minneapolis, MN: Walker Art Center and London: Tate Modern, 2001. Exhibition catalog.

Gilardi, Piero. "Politics and the Avant-Garde." In *Op Losse Schroeven: situaties et cryptostructuren,* edited by Wim Beeren, unpaginated. Amsterdam: Stedelijk Museum, 1969. Exhibition catalog.

Ginsborg, Paul. *A History of Contemporary Italy: Society and Politics 1943–1988*. London: Penguin, 1990. Reprint, New York: Palgrave Macmillan, 2003.

Kestenbaum, Victor. *The Phenomenological Sense of John Dewey: Habit and Meaning*. Atlantic Highlands, NJ: Humanities Press, 1977.

Lumley, Robert. *States of Emergency: Cultures of Revolt in Italy from 1968 to 1978*. New York: Verso, 1990.

Maraniello, Gianfranco, and Jonathan Watkins, eds. *Giuseppe Penone: Writings 1968–2008*. Bologna: MAMBo and Birmingham: Ikon, 2009. Exhibition catalog.

Merleau-Ponty, Maurice. *Phenomenology of Perception*. Translated by Colin Smith. New York: Routledge Classics, 2002.

———. *The Visible and the Invisible* (1964). Edited by Claude Lefort. Translated by Alphonso Lingis. Evanston, IL: Northwestern University Press, 1968.

———. *The Merleau-Ponty Aesthetics Reader: Philosophy and Painting*. Edited and translated by Michael Smith. Evanston, IL: Northwestern University Press, 1993.

Newman, Michael. "Sticking to the World-Drawing as Contact." In *Giuseppe Penone: The Imprint of Drawing*, ed. Catherine de Zegher, 103–10. New York: The Drawing Center, 2004. Exhibition catalog.

Pareyson, Luigi. *Estetica-Teoria della formatività*. Turin: Edizione di filosofia, 1954. Reprinted in *Luigi Pareyson: Opere complete*, vol. 10–11, Milan: Mursia, 2000.

Penone, Giuseppe. *Rovesciare gli occhi*. Turin: Einaudi, 1977.

———. "Six Statements for Maritime Alps." (1968). In *Zero to Infinity: Arte Povera 1962–1972*, edited by Richard Flood and Francis Morris, 298.

Minneapolis, MN: Walker Art Center and London: Tate Modern, 2001. Exhibition catalog.

———. *Svolgere la proprio pelle*. Turin: Sperone, 1971.

Pratesi, Ludovico. "Showing Traces." In *Giuseppe Penone: paesaggi del cervello*, ed. Costantino D'Orazio, trans. Alexander Martin, 60–63. Prato: Ex Chiesa della Madalena and Turin: Hopefulmonster, 2003. Exhibition catalog.

Semin, Didier. *Giuseppe Penone: The Politeness of Matter*. Geneva: Galerie Guy Bärtschi, 2002. Exhibition catalog.

Tosatto, Guy. *Giuseppe Penone: 1968-1998*, trans. Elena Brizio et al., 177–78. Galego: Centro Galego de Arte Contemporanea, 1999. Exhibition catalog.

Trini, Tommaso. "Nuovo alfabeto per corpo e materia." *Domus* 470 (January 1969): 46-8. Reprinted in English as "A New Alphabet for Body and Material," in *Arte Povera = Art Povera*, edited by Germano Celant, 109–13. Milan: Electa, 1985.

———. "Imagination Takes Command." *Domus* 471 (February 1969): 49–50.

———. "The Prodigal Maker's Trilogy: Three Exhibitions: Berne, Amsterdam, Rotterdam." *Domus* 478 (September 1969): 46.

———. "The Sixties in Italy." *Studio International* 184, no. 949 (November 1972): 165–70.

———. "Anselmo, Penone, Zorio e le nuove fonti d'energia per il deserto dell'arte." *Data* 3, no. 9 (Autumn 1973): 62–67.

Tosatto, Guy, et al. *Giuseppe Penone: 1968-1998*. Translated by Elena Brizio et al. Galego: Centro Galego de Arte Contemporanea, 1999. Exhibition catalog.

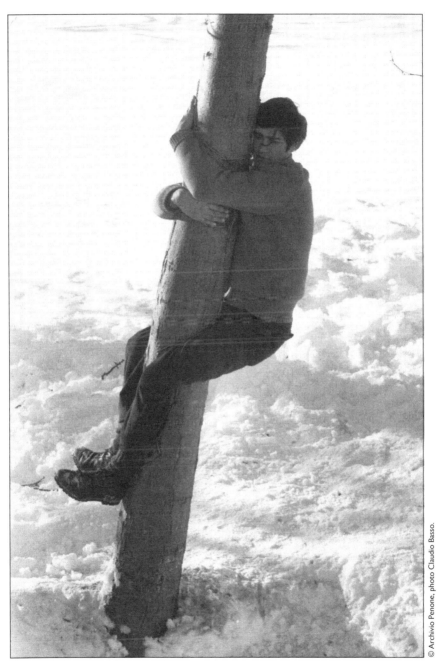

Giuseppe Penone, Alpi marittime. L'albero ricorderà il contatto ("Maritime Alps. The tree will remember the contact"), 1968 photographic documentation of the action by the artist

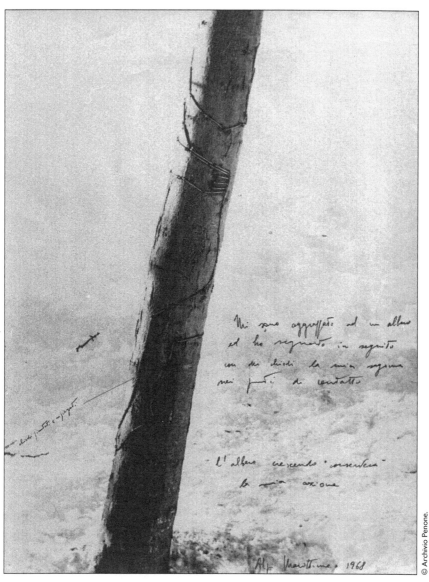

Giuseppe Penone, Alpi marittime. L'albero crescendo conserverà la mia azione ("Maritime Alps. The growing tree will preserve my action"), 1968 black and white photograph, ink 64 x 49 cm

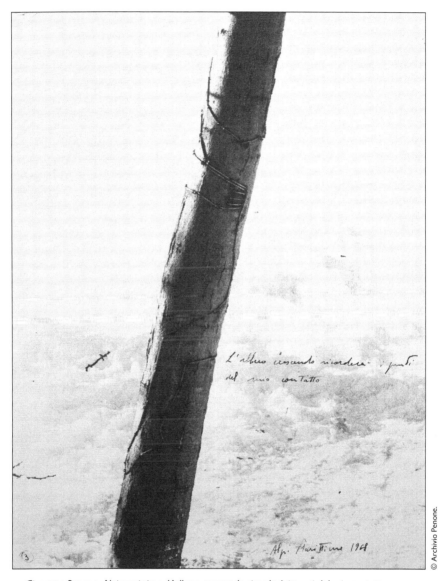

Giuseppe Penone, *Alpi marittime. L'albero crescendo ricorderà i punti del mio contatto* ("Maritime Alps. The growing tree will remember the points of my contact"), 1968 black and white photograph, ink 64 x 48 cm

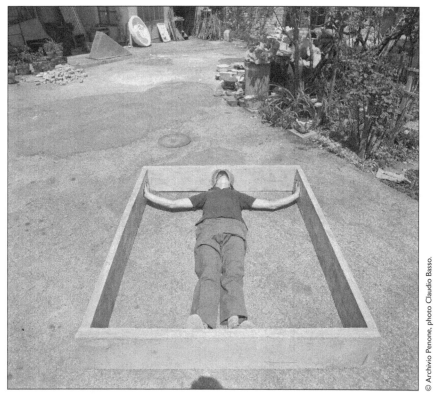

Giuseppe Penone, Alpi marittime. La mia altezza, la lunghezza delle mie braccia, il mio spessore in un ruscello ("Maritime Alps. My height, the length of my arms, my breadth in a brook"), 1968 photographic documentation of the action by the artist

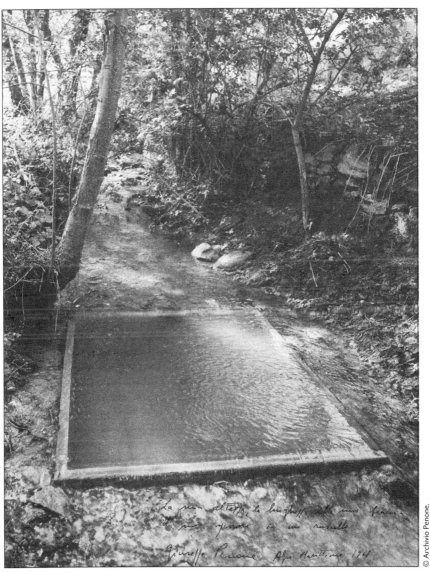

Giuseppe Penone, Alpi marittime. La mia altezza, la lunghezza delle mie braccia, il mio spessore in un ruscello ("Maritime Alps. My height, the length of my arms, my breadth in a brook"), 1968 black and white photograph 64 x 48 cm

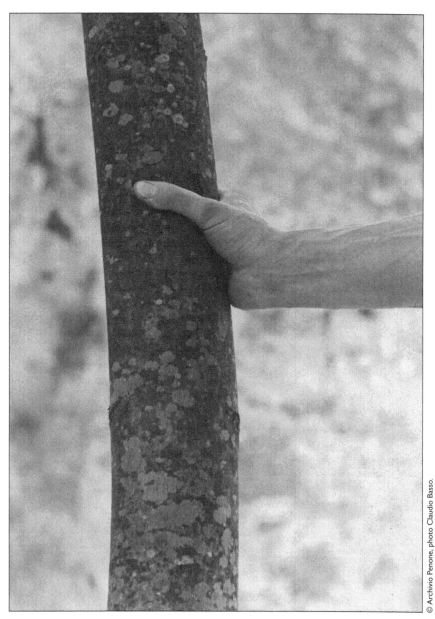

*Giuseppe Penone, Alpi marittime. Continuerà a crescere tranne che in quel punto
("Maritime Alps. It will continue to grow except at this point"), 1968 photographic documentation
of the action by the artist*

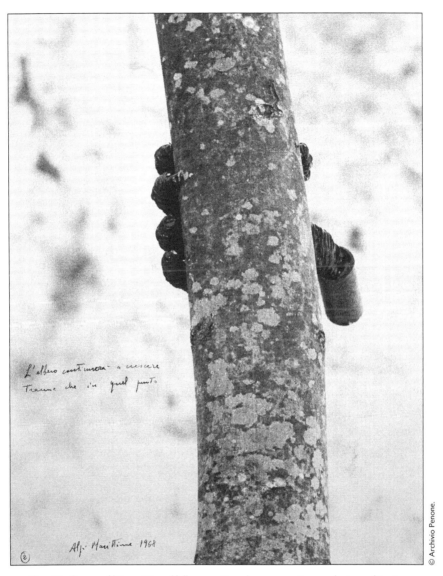

Giuseppe Penone, Alpi marittime. L'albero continuerà a crescere tranne che in quel punto ("Maritime Alps. The tree will continue to grow except at this point"), 1968 black and white photograph 64 x 48 cm

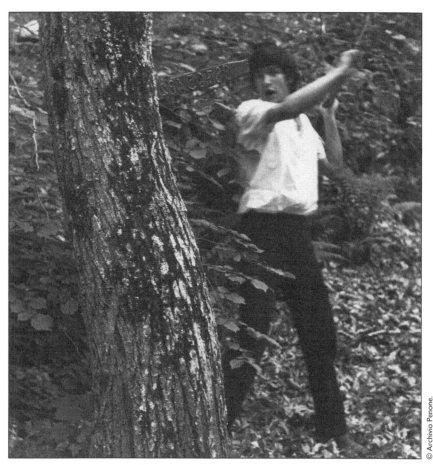

Giuseppe Penone, Scrive, legge, ricorda (Write, Read, Remember), 1969
photographic documentation of the action by the artist

Giuseppe Penone, Rovesciare i propri occhi (To turn one's eyes inside out), 1970
black and white photograph 39,5 x 29,8 cm

Giuseppe Penone, Rovesciare i propri occhi (To turn one's eyes inside out), 1970 reflecting contact lenses, action by the artist.

Giuseppe Penone, Svolgere la propria pelle (To Unroll One's Skin), 1970
104 black and white photographs in 18 framed panels
53,5 x 73,5 x 2,5 cm each panel

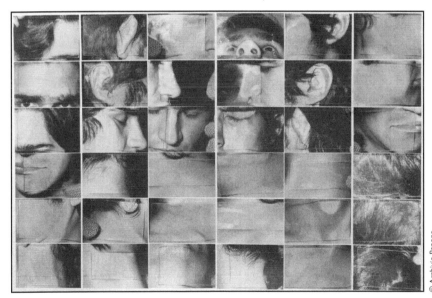

Giuseppe Penone, Svolgere la propria pelle (To Unroll One's Skin), 1970 (detail of panel n.1)
104 black and white photographs in 18 framed panels
53,5 x 73,5 x 2,5 cm each panel

10

BOLZANO BOZEN'S MONUMENT TO VICTORY

Rhetoric, Sacredness, and Profanation

Malcolm Angelucci

Sembrava l'ambizioso progetto di una città coloniale, improvvisato a caso, e interrotto sul principio per qualche pestilenza, o piuttosto lo scenario di cattivo gusto di un teatro all'aperto per una tragedia dannunziana. Questi enormi palazzi imperiali e novecenteschi erano la Questura, la Prefettura, le Poste, il Municipio, la Caserma dei Carabinieri, il Fascio, la Sede delle Corporazioni, l'Opera Balilla e così via. Ma dov'era la città?

—Carlo Levi, *Cristo si è fermato a Eboli.*

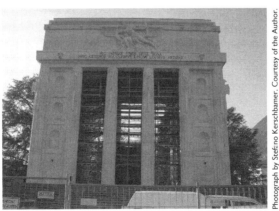

Marcello Piacentini, 'Monument to Victory,' Bolzano-Bozen, 1926-28.

I

The history of ethnicized and linguistic groups in former Austrian South-Tyrol, the struggle of the German- and Ladin-[1] speaking communities under Fascism, the fight for political autonomy from the end of World War II until the ratification, in 1972, of the so called *"pacchetto"* ("package") of laws that define the terms of this autonomy and protect minorities, or the official end of negotiations between Austria and Italy in 1992[2] are not the object of this chapter, but constitute its broad context. A few preliminary words on how the so called *"convivenza"* ("living together") is organized, produced, and reproduced through an administrative and political system are thus necessary, in order to introduce our our topic.

The population of the province of Bolzano-Bozen periodically declares, through a census, its *appartenenza linguistica* ("linguistic belonging"): Italian, German, Ladin.[3] The census does not offer other options, thus groups defined as "other" (e.g. migrants) need to "associate" with one of the above "linguistic communities." Something similar happens for bilingual subjects (*"mistilingue"*), or children of so-called "mixed" families. The results of this survey provide data according to which the administration of the province is organized. Taking into account the "proportions," public schools are either "Italian" or "German" according to the language used for teaching; public jobs are offered to citizens of one group or the other according to the percentages of the census; provincial and town councils political offices and administrative departments are all doubled into "Italian" and "German" language, each catering for its "group." In this sense, after the census choice, a person faces one side and one side only of the administrative machine; and public funds and investments are allocated in a similar fashion. The system that protects minorities, at the same time reproduces, through its arborescence, the group division, partially justifying the political success of the so-called *partiti di raccolta etnica* ("ethnicity-based parties"): *"Südtiroler Volkspartei"* (SVP) and the former right wing party *"Movimento Sociale Italiano"* (MSI), and more recently *Alleanza Nazionale* (AN) and *Popolo della Libertà*.

Almost a hundred years of *convivenza* and of sharing the same space has partially effaced any clear-cut linguistic/ethnic/cultural/architectural

division from the urban landscape of Bolzano-Bozen, the provincial capital; however, through the layers of architectural and urban development, a history of these distinctions, or, better said, a history of the active production, of the "rhetorics" and ideologies of these distinctions can be glimpsed: this article is engaging with one, arguably the most important, example of this—the Fascist *"Monumento alla Vittoria"* ("Monument to Victory," 1926–28)—with the goal of tracing its importance inside the past and present debate on the identities of this border town.

A stroll through the *centro storico* of Bolzano-Bozen offers the picturesque scene of a Tyrolean town framed by the Dolomites: with its *Dom Maria Himmelfahrt* and the famous late-Gothic bell tower, its *Walther Von der Vogelweide Platz*, and a series of intricate alleys and porticos. Walking towards the West, however, at the end of the *Museumstrasse*, and across the *Talfers* bridge, a "rationalized version" of an imperial style triumphal arch suddenly appears, dominating the center of a strangely oversized square, from which wide roads with tall, linear, rational buildings of the 1920s and 1930s radiate southward. This monument parades a most striking iconography: eleven-meter-tall stylizations of Fascist *fasci littori* support an attic that hosts a thirteen meter wide bas-relief of a winged victory, heads of two soldiers, and a Latin inscription, "here are the borders of the Fatherland, fix the signs. From here, we taught to others the language, the laws and the arts."

The "Monument to Victory," built between 1926 and 1928 and designed by Marcello Piacentini, who was to become the most influential, powerful, and successful architect of the regime, has always been a contested site: from the disavowal of the widow of the Trentine irredentist Cesare Battisti, who refused to accept the dedication of the monument to her husband,[4] thus challenging the attempt to embody the cult of the martyrs of World War I into the Fascist ideology of the "natural borders"[5] and consequent "italianizaton," to the polemic around the restoration of the site in the early 1990s and in recent months. Thus, with its rhetorical and ideological charge, it represents a "discourse in place." A semiotic reading of the artefact must in this sense be accompanied, as Ron and Suzie Wong Scollon suggest, by an interpretation of its indexicality[6] (its "context dependency") and its "interaction":[7] all this, one should add, in its diachronic articulations. As a further hermeneutic complication, one must also take into account the level of indifference,

ignorance and meaninglessness implied in the reception. Robert Musil's point on the "invisibility of monuments" should be taken seriously: "there is nothing in the world as invisible as monuments," in the same way as "after a few hours we no longer hear a constant bothersome noise."[8] This article is a preliminary contribution to the interpretation of that bothersome noise still audible in the background of the project of Bolzano-Bozen's *convivenza* and, as I will argue, constituting its very symbolic origin.

Monuments become visible as such not exclusively, but certainly also through a "symbolic maintenance," what Pierre Nora calls "commemorative vigilance,"[9] described by Forest and Johnson also as "physical and symbolic maintenance";[10] the work of Antoine Prost on the French World War I memorials, for example, stresses how ritualized interaction with the site at the same time reactualizes a memory, reiterates a set of values and works as a pedagogical occasion for younger generations.[11] Prost, however, acknowledges and also partially traces the diachronic changes in the history of the ceremonies,[12] thus widening the idea of "maintenance": if even the mere repetition in time introduces a dialectic,[13] what needs to be studied is the complexity of the range of various symbolic interactions, mutations, extinctions, reciprocal re-signification of all the parts involved, etc. The more or less radical reinterpretation of public iconography in the former "Eastern Block" is an example of this process, showing the most diverse outcomes and conflicting agendas of "co-opting," "glorifying," "depoliticizing" and rewriting the past at play.[14] In the Italian context, a fascinating case is the "Monument to Vittorio Emanuele II" in Rome; its controversial ideology and diverse reappropriation throughout history[15] are now part, since the recent reopening of the site to the public, of a fast moving process where sacredness, museification, cultural marketing, and city branding are radically changing the understanding of the site and its visibility: from the panoramic elevators that redesign its fruition to the café on the terrace, from the temporary art exhibitions hosted inside the building to the view of the Roman *Fori*, and to the perpetual fire still burning under the statue of a king overlooking the "symbol of the republic."[16] The goal of this chapter, in this sense, is to inquire into the circumstances in which the "Monument to Victory" of Bolzano-Bozen reemerges from its invisibility, and the consequences of this periodically renewed actualization of its existence.

An exhaustive geosemiological reading of the monument and its history is beyond the space available in this chapter; thus, a series of emblematic moments in the semiotic life of the artefact will be discussed, with the goal of outlining a framework to understand the contemporary discourse, offer a theoretical analysis of the constitutive role of the site for the symbolic universe around which "Italian" and "South Tyrolean" identities are determined and determine each other, and, finally, articulate the possibility of thinking the site outside this symbolic universe.[17]

2.

Let's begin from the beginning.

"It is that the problems of interiors and small buildings always present themselves as three-dimensional masses, which the logical spirit can undisputedly dominate and resolve. In big constructions, on the other hand, one always comes, at a certain point, to the study of the bi-dimensional façade. Here then fantasy comes into play. The logic does not feel that it can compose alone, and calls the spirit for help; spirit which cannot prescind from race, and thus from tradition."[18]

This quote comes from Piacentini's *Architettura d'Oggi*, and represents one of his attempts to synthesise the possible compromise between international Modernism, Italian tradition, and *ambientalismo* ("awareness of the surrounding urban/architectural environment"), the defense of which constitutes the main goal of the text. Here, "fantasy," the necessary element of mediation, is called to integrate the logical, rational, "objective" architectural conception; and "spirit," "race" and "tradition" are synonyms constituting the pool from which the architect should draw his bi-dimensional solutions: thus Piacentini introduces an ideological discourse "written in the stone" of his façades. In *Architettura d'Oggi*, only two of his own works are added by Piacentini as examples, among the series of images reviewing the contemporary international architectural landscape: the *Casa Madre dei Mutilati in Roma*, and the *Monumento della Vittoria in Bolzano;*[19] one must thus conclude that the "Monument to Victory" constitutes, with its façade, *the* example of the embodiment of this "spirit of the race." This is confirmed by a further intertextual reference; in his discussion of the French contemporary

contribution to architecture: "convincing here is the lobby of the Hotel George V in Paris, by Le Franc, where the signs of the race are really fixed by the hand of a master."[20] It would be difficult not to read this in relation to the inscription on the northern façade of the "Monument to Victory," of which it is a partial translation; as much as "the border of the Fatherland" are "fixed" as "signs" through the Monument, so the architect, as a constitutive part of his creative practice, "fixes the signs of the race" in its act of mediation between rationalism and spirit: the monument is then the fixed sign of the borders of the Fatherland, and at the same time its spirit. It is in this sense that an analysis of Piacentini's architecture cannot be emancipated from its ideological context and content/form, without betraying its poetic; in this, diverging from recent comprehensive interpretations of the architect, which necessarily had to engage with the problem of rehabilitation. Sandro Benedetti, for example, writes of a "critical and ideological bloc,"[21] which puts Piacentini "at the limit of a judgement which has not addressed an evaluation of his value and his artistic limits,"[22] while Mario Pisani confirms how "the judgement of the political role played by an artist cannot and should not invalidate that of his creative work."[23] If this is true for the history of Piacentini's criticism, it is also true that the risk of stripping his work from its ideology is very present, leaving Fascism as a sort of unspoken ghost inside a formal analysis that surely refers to a "tradition," without questioning the nature and role of the discourse on this "tradition" at the times contemporary to the architect.[24]

In the case of the "Monument to Victory," not only the rhetorical effort is explicit, but its placement immediately stresses a cultural opposition, and the superiority of the "Italian spirit." As Giorgio Ciucci exhaustively discusses,[25] Piacentini's ideas on urban planning and the expansion of a modern city are constructed around the conviction, not always followed by acts, of the necessity to preserve the *centro storico*, and effectively link it to the new side of the city, developing according to a rational plan and a series of functional zones. In the case of Bolzano-Bozen, however, the old Austrian town center is produced as the defeated enemy and usurper of the province inside the "natural borders of the fatherland." In this sense, the monument is called to perform a double role. On the one hand, it works as the missing Italian *centro storico*: it represents history, tradition, and "the signs of a race," only in relationship to which

the modern, rational planning of Piacentini's *"Bolzano italiana"* can take place. On the other, it links two alternative realities, the Austrian and the Italian; while the urban connections are preserved, and a certain amount of *sventramenti* ("demolitions") on the other side of the river is planned, the monument stresses the geographical line that symbolically divides Italy from its "other," providing at the same time a gate for communication. The terms of this communication are written in the stone of the artefact.

3.

The "Monument to Victory" is (planned to signify) the first stone of the Italian presence in the province: a "foundation after a victory,"[26] in the form of a "triumphal arch." From these two points, triumph and foundation, it is possible to trace a series of parallels with classical architecture to illuminate the specific rhetoric of the monument and at the same times exemplify the teleological evolutionist discourse that underpins Piacentini's ideas.[27] A brief detour into Octavian Augustan time is thus not as irrelevant as it may appear.[28]

Following the battle off Cape Actium against the fleet of Mark Anthony and Cleopatra in 31 BCE, Octavian founded *Nikopolis*, "Victory City," with the intent of both commemorating the victory and boosting the economy of a region in crisis.[29] The location chosen for *Nikopolis*, near the campsite of Octavian's army, is the site of a conspicuous symbolic and celebratory investment. Of particular interest to us is the so-called "Campsite Memorial," discovered in 1913; the building dedicated to Apollo embodies the *rostri* of the captured ships; as in a Roman triumph, and in direct reference to it,[30] victory is signified through the display of the captive. In this case, however, triumph is "forever" frozen in time on the site of its happening. Sandro De Maria, in his survey of honorary arches in ancient Rome and Italy stresses how Octavian Augustus is attempting to "affirm a teleological conception of the history of Rome itself, in order to elevate its *principes* beyond the simple factuality of happenings,"[31] and the proliferation of honorary arches in the first century during the consolidation of the empire is evidence of it. For example, in 30 BCE the Roman senate "establishes

the construction of arches for Octavian, as a celebration of Actium: one in the Roman forum, the other in Brindisi, on the place from which the army embarked." The latter, once again, directly refers to Octavian's triumph, celebrated in 29 BCE, representing "the *imperator* in the act of celebrating the ceremony that draws him closer to divinity."[32]

The "Monument to Victory," built on "Victory square," constitutes "Bolzano," on the western side of the Talvera river, as a *Nikopolis*.[33] The columns have been turned into *fasci littori*—the "bundles of lictors" symbolic of Fascism and referential to Roman law—while straight, orthogonal lines are preferred to the curved arch, thus providing a frame for the statues of the interior, and space for inscriptions and iconography on the attic.[34] Despite these substitutions, not only the architectonic, but most importantly the symbolic functions of the honorary arch are preserved.[35] The "Monument to Victory" *is* triumphal. It is built on the site of a pre-existing Austrian unfinished memorial to the *Kaiserjäger*, thus embodying and "parading" the spoils of the loser while symbolising the annihilation of a captive. Furthermore, the series of allegorical features directly refer to triumph: the "threshold" to be (ritually) passed/trespassed, the bas-relief of the winged victory by Arturo Dazi on the gable facing East (substituting the original idea of a cannon pointing toward the Austrian border), the Latin inscription, etc.

A final embodiment completes the landscape of this "reified" teleology: the covered area of the site, framed by and yet accessible only through the *fasci littori*-like columns, hosts three busts of so-called martyrs of irredentism from the Trentino region, while a statue of a Christ resurrecting from his tomb, by Libero Andreotti (again facing East), further exploits the myth of the fallen soldier as the fulfilment of a Christ-like passion for the sake of the Mother/Fatherland, inside the well known rhetoric of and on World War I.[36] The fascist re-appropriation against the supposed failures of Liberal Italy is here once again reinscribed, in an architectural context where Fascism becomes at the same time the custodian and the fulfilment of the irredentist project. In this sense, the "Monument to Victory" should be intended as an imperialistic act of colonialism whose symbolic role, in the years of consolidation of the dictatorship, should not be underestimated.[37]

4.

As a myth of origin, at least as a rhetorical signification of the "re-conquest" of a land supposedly "naturally Italian," the "Monument to Victory" embodies a multi-layered discourse, a complexly inter-woven historical narrative that provides not only a teleology for the Fascist dictatorship, but re-actualises its role until the present days. On the one hand, the linear evolution from imperial Rome, through World War I, to the dictatorship; on the other, the act of founda-tion, both providing the new Italian community in the mid 1920s with a discursive justification and demonstration of its presence, and making that same justification available for the "Italian" population of today. Willingly or not, the "Italian" community is the "child" of the monument, and dealing with the site becomes a very peculiar problem of *Vergangenheitsbewältigung*. Furthermore, the reified dichotomy "Italian"/"South-Tyrolean" provides a *locus* of sense also for the irredentism of the "defeated." What happened "before," e.g. the resistance against the Naploeonic troups occupying the region, what happened during Nazi-Fascism, e.g. the local resistance after September 8, 1943, and what happened after, with the struggle for "autonomy," have a symbol against which a teleological construction becomes possible.[38] In this sense, the "Monument to Victory" pro-vides, reiterates, and contributes to the symbolic universe around which the political, administrative and social project of the "autono-mous province" is constructed and reproduced.

It is for these reasons, for these connivances—even if inverted in sign—with the structuring and self-representation of the province and town that the site continues to be relevant today, despite the more or less conspicuous changes in the surrounding context. Actually, as we are about to discuss, it is because and through some of these changes, that a degree of ideological effectiveness is gained.

5.

In 1978, after an act of vandalism, the "Monument to Victory" was fenced out, and its access interdicted.[39] Paradoxically, since that

date, one enters the "Italian" side of town from a closed gate. But it would be naïve to think that the fencing off of the site would efface its meaning, distance, or render it innocuous. A quick mapping of the arch's functions and the ways in which they are affected by the fencing off can help to discuss this point. The "Monument to Victory" is a gate, a door to the "Italian side" of town, "Italy" and "Italianness." It is, at the same time, the "sign of a border," and the radiating centre from which, symbolically, "language, laws and arts are taught" (the function of the border as the sign of a conquering civilization is, once again, interestingly analogous to a regional arch of Augustan times, the Arch of Aosta).[40] It is also a "pedestal for statues and inscriptions," and an altar available for a ritual use (e.g. ceremonies of commemoration)[41] that invests the site with sacredness, similar in its intents and somehow reflecting the worshipping of the unknown soldier at the *Altare della Patria* in Rome.[42] Finally, the monument played a crucial role in the urban planning of the town, as the center of a series of radiating streets, linking Bolzno-Bozen with the small town of Gries, reaching the Industrial Zone and providing the blueprint for future developments: Bolzano offered to Piacentini in particular, and to Fascist representatives in general, the chance to work almost *tabula rasa*, potentially creating the first, uncompromised, accomplished Fascist town.

This eastward orientation radically changes with the fencing. The "Monument to Victory" and the small public garden adjacent to it are the only areas east of the river Talvera to be officially categorised as *centro storico*.[43] Despite this status, in recent decades the garden has become progressively destitute. No longer offering an alternative entry point to the fruition of the monument—and, actually, with its growing trees, obstructing its view from the East—frustrating easy access to the two main streets between which it develops, and opening toward "Piazza Vittoria," now a public parking place, the garden is practically abandoned. This carries important consequences for the perception and interpretation of the monument as a whole. More than a "centre" radiating at 360 degrees, the corrupted view and interaction from the East constitute the site as a limit point toward which the major arteries of the Italian town converge, before the narrowing of the "Talvera bridge": a border the semiotic meaning of which remains

entirely intelligible only from the West, from the former Austrian *centro storico*. This newly exclusive view becomes not only, as Soragni states, a reduced "conventional representation,"[44] but actually the only comprehensive view of the site: flattened out in a new bi-dimensionality, the monument becomes the "poster of Italianness," in fact, a "postcard" of its "spirit." In this new context, the already prominent placement of the winged victory and the Latin inscription, acquire an even more powerful status, hegemonic for the interpretation of any passer-by. The rhetorical function of the "pedestal for statues" is thus preserved, but in a new context, where the monument "speaks" almost exclusively to the produced "Other." Thus, the architectural "signs of the race" constituting Piacentini's façade acquire today an importance that is unchallenged by the other features and functions: something new and never planned.

The reduction, and thus radicalisation of the colonial and anti-Austrian features of the monument are further stressed by the interdiction of use, the impossibility of visiting the covered area and the interior of the site. These are the places which, more than anything else, speak to the "Italian" community and justify its presence. In this sense, the single direction of the contemporary rhetoric of the monument, mutated and mutating according to its new indexicality, would be confirmed, and the internal space of the site would acquire a puzzling status: what is a "fenced out sacred site," fenced out from the very possibility of directly re-actualizing and or perpetuating its own sacredness through a ritual? If sacredness is a withdrawal from use,[45] what is this "withdrawal" of a "withdrawal"? Is it a sacredness of the second degree? Is the "Monument to Victory" simply the painful remainder of the deconsecrated church of Fascism, mourned by the followers of post-Fascist parties and despised by the rest of the community? Or is this interdiction a taboo, the infringement of which, would—through the rediscovery and drastic re-signification of the site (its decaying features, its aged iconography, its indigestible rhetoric, the absence, in fact, of a sacred "relic")—precipitate the dichotomies that rule the opposition between "Italian" and "Other" into confusion, ambiguity, a potential new becoming? What would potentially become, in this case, of the construction (political, administrative, etc.) that, as we have seen, is built from the same symbolic order?

6.

Before approaching these questions, and trying to imagine an interaction with the site which would not imply a reiteration of its ideology (one not born from the same myth which it is trying to dismantle), we need to address the fact that there is, indeed, a last recurring symbolic maintenance of the site and its interior, even if this maintenance is not performed by the official representatives of the provincial government, but by members and supporters of the post-Fascist MSI party before, and more recently *"Alleanza Nazionale"* and *"Popolo della Libertà*: it is the ritual of the deposition of a commemorative wreath on November 4, the anniversary of the end of World War I. In terms of contemporary indexicality and the semiotics of the site, it is clear that this act exacerbates the self/other dichotomy; deposition of the wreath —in this context is immediately anti-Austrian and—given the Latin inscription under which the ritual is performed—anti-South-Tyrolean. Furthermore, this opposition becomes possible only by reaffirming a fascist teleology and reappropriating its agenda, against any possible ambiguity: once again, the complexities and the heterogeneity of what are considered "two groups" are wiped out in the name of a simple, "transparent," opposition. The sacredness of the site is preserved (or a new consecration is allowed). Through this ritual overcoming of the interdiction, the officiant, despite not being an official representative of the State, is invested with the hegemonic power to make the site resonate once again. Thus, a space which is not accessible if not through the (news of the) performance, and can only be interpreted through that very enclosure, ignites at regular intervals the multi-faced debate on local identities by positing itself as its center, and dictating the rules of the game.

7.

The various positions against or in favor of the monument, the commemorative act and its political and historical meaning etc., are generally born from within a symbolic order that thinks and structures local identities along the lines of ethnic and linguistic categories. So the critique comes necessarily from within the "arborescent" administrative

and political structure of the provincial autonomy and, paradoxically, from within a symbolic sphere of which the "Monument to Victory" partakes and rhetorically "originates." The parade of the members of the *Südtiroler Schützenbund* alongside the monument in a yearly reclamation of cultural identity[46]—not alien from a discourse of "aboriginality" and links with the land—is just one macroscopic example of the lines along which the "dialogue" ignited by the commemoration takes place. Yet also more critical positions focussed on the *depotenziamento* ("de-powering") of the site fall prey to the same problem: how can a "contextualizing" sign, as an example of critical historical reading and "distancing," undermine the role of the monument, without being perceived at the same time as reinforcing the importance of the site and the relevance of the discourse on which it is founded? Once again, the debate reproduces itself, as much as the structures of the autonomous province do.

A last example can clarify this impasse, at the same time pointing toward a radical—in the etymological sense of the term—possibility for imagining an interaction. The mayor of Bolzano-Bozen Luigi Spagnolli, at a town council meeting on July 29, 2008, declared as part of his agenda his desire to reopen the monument to fruition and remove the fence so that "the monument could become a place of encounter and investigation." Once again, the logic of reproduction is in place. The rhetoric of "encounter" implies indeed the existence of a division, and further still the need for a meaningful "meeting point," as if the two communities, after more than eighty years, were intrinsically *two*, perfectly divided along the lines and structures which organize the administrative and political management of the province. Moreover, the shift from the sacralization of the monument through the ritual of commemoration to the "place of encounter" follows the same mechanism discussed by Giorgio Agamben with regard to "secularisation": "secularisation is a form of repression. It leaves intact the forces it deals with by simply moving them from one place to another."[47] In our particular case, what would change is the custodian of the symbolic meaning of the site, and the performance of its "maintenance": from an "Italian" member of the conservative party, to the government of the town. What remains the same is the (reallocated) hegemony in the interpretation of the site and its power to be a symbol, once of

division and now, equally and differently, of encounter. The vertical axis of a repression which "organizes the encounter" through the new ritual implies the role of a puppet master who re-produces a structure of division by ritually "meeting" in a designated space: what kind of dialogue is the management of a dialogue?

8.

"Profanation neutralises what it profanes. Once profaned, that which was unavailable and separate loses its aura and is returned to use."[48] For Agamben, "profanation" constitutes that radical (again etymologically) act that secularization is not. Profanation allows a consecrated object to reenter the realm of quotidian interaction. In doing so, however, an exclusive redefinition of a new use is not enforced; this act simply allows a renewed availability, the chance for a re-constellation of its possibilities. Profanation thus implies an agency which, through interaction, neutralizes the vertical axis of repression/reproduction, without offering a substitution. Two moments in this process are relevant to our discussion.

Contagion is "a touch that disenchants and returns to use what the sacred has separated and petrified";[49] entering once again the "Monument to Victory," touching once again what had been withdrawn from usage allows it to reenter the time of the town, to partake with its becoming. Play, the game of children, is the second moment: the doll, so alive, defined and connoted in the make-believe game of a child, becomes once again an inanimate object when the game has ended, the value of which resides in the possibility of being brought to life once again, as a totally different character. In this sense, the site is available for the first time to a multiplicity of different and temporary re-constellations, from the banality of a short cut to a bus stop or shelter, to an endless universe of meaningful re-appropriations, not least a renewed indifference for its presence: the monument as an inanimate doll, to return to Musil. This does not imply the introduction of concepts such as "multiple identities," of the "I am Italian but also . . . " type: this multiplicity would be still produced by and reproducing the discourse of the monument.[50] It also does not imply a sort of "counter-monument," or an anti- or a-monument. Many artistic examples of this are to be found, e.g., in

Germany, with very interesting "critical" and political results, and a re-
newed engagement of the public audience;[51] profanation, however, is a
political act at another level, as a radical destitution of the field in which
the particular political discourse is inscribed.

How does one "play with architecture"? The seminal work on the
relationship between architecture and *ludus* by Constant Nieuwenhuys
is somehow coherent with Agamben's argument; in a series of utopian
projects under the general name of *New Babylon* (beginning in 1957),
Constant designs an architectural landscape for a human emancipated
from the necessity to produce, who would live as a *homo ludens*, in and
through totally manipulable spaces, playfully signifying them and then
moving on, leaving that particular section of *New Babylon* available for a
new interaction. Francesco Careri, in his manifold approach to the legacy
of Constant and Situationism,[52] highlights the link between New Babylon
and a "nomadic" idea of space, not only locating the origin of the project
in Constant's encounter with a Romani group in Turin,[53] but also intend-
ing the project inside a different understanding of borders, trajectories
and "enclosures" and a different symbolic construction of space and land-
marks. In this, Careri is indebited to Deleuze and Guattari:

"Even though the nomadic trajectory may follow trails or customary
routes, it does not fulfill the function of the sedentary road, which is to
parcel out a closed space to people, assigning each person a share and
regulating the communications between shares";[54] "sedentary space
is striated, big walls, enclosures and roads between enclosures, while
nomadic space is smooth marked only by "traits" that are effaced and
displaced with the trajectory."[55]

This does not mean that the populations of Bolzano-Bozen should
start moving (the) house; the bet here is to imagine alternative, tempo-
rary, and mutable re-configurations of singularities through interaction
with a historically and politically charged space, avoiding rewriting in
an old stone their new agenda of *convivenza* (the so-called *matrimoni
misti*—"mixed weddings"—skateboarders, joggers, theater-goers, art
lovers, ice-hockey followers, teenagers in love on the benches of the
monument's garden are few random examples of temporary constel-
lations to which ethnicized belonging is already potentially irrelevant.
But these are already definitions of roles, even if temporary and
contingent: Agamben's "whatever"[56] works here as a possible descrip-

tion of the event beyond/outside the identity-construction, the "framing" act of this messenger of the State that is the monument). The metaphors employed in this discussion, are already revealing of the distance between this hypothesis and the "reproductive agenda" of Bolzano-Bozen arborescence. On the one hand, "nomadic" is a concept in direct opposition with the discourse of "ownership of the land" and partition of supposedly "natural" borders; on the other, Careri describes *New Babylon* as a "horizontal tower of Babel":[57] something very different from a "vertically managed" division along the lines of a mother-language.

NOTES

1. Ladin is a language spoken in three valleys of the Trentino–Alto Adige region: Gardena, Badia, and Fassa.

2. The contextualized collection of the laws that govern the autonomy of the Bolzano-Bozen province can be found in *Il Nuovo Statuto di Autonomia* (Bolzano: Giunta Provinciale di Bolzano, 2009).

3. The latest one took place in 2001, and saw, for Bolzano-Bozen, 73 percent declaring themselves "Italian speaking," 26.29 percent "German speaking," 0.71 percent "Ladin-speaking." The percentages for Italian and German are more or less the opposite in the Province. For the official data: "Censimento della Popolazione 2001," Comune di Bolzano. Accessed 17 March 2011, http://www.comune.bolzano.it/context.jsp?ID_LINK=2202&area=19.

4. On this, see Vincenzo Cali, "Il Monumento alla Vittoria di Bolzano. Un Caso di Continuità tra Fascismo e Post-Fascismo," in *La Grande Guerra: Esperienza, Memoria, Immagini*, ed. Diego Leoni et al. (Bologna: Il Mulino, 1986), 663–69.

5. Ettore Tolomei was the main Fascist "ideologue" on the "Italianization" of South Tyrol. In 1923, together with Giovanni Preziosi, he presented the thirty two "provvedimenti per l'Alto Adige," enforcing among other things the abolition of the name "Tyrol-Tirolo," the Italianization of German places, geographic names, family names, etc. This led also to the Italianization of schools and, finally, to the 1939 treatise called "Opzioni-Option" between Hitler and Mussolini, according to which German speaking South-Tyroleans could choose to "become Italian" or emigrate to the Reich. On this see, at least, Rudolf Steininger, *South Tyrol. A Minority Conflict of the Twentieth Century* (New Brunswick, N.J.: Transaction Publishers, 2003), 14–54.

6. Ron Scollon and Suzie Wong Scollon, *Discourse in Place: Language in the Material World* (London and New York: Routledge, 2003), 3.

7. Ibid., 45–81.

8. Robert Musil, *Selected Writings* (New York: Continuum, 1986), 30–31.

9. Pierre Nora, ed., *Realms of Memory: Rethinking the French Past. Vol. 1* (New York: Columbia University Press, 1996), 9.

10. Benjamin Forest and Juliet Johnson, "Unraveling the Threads of History: Soviet-Era Monuments and Post-Soviet National Identity," *Annals of the Association of American Geographers* 92, no. 3 (2002): 524.

11. Antoine Prost, "Monuments to the Dead," in *Realms of Memory: The Construction of the French Past*, ed. Pierre Nora (New York: Columbia University Press, 1997), 307–30.

12. Prost admits heterogeneity as a constitutive trait of the phenomenon in France: "For one thing, what we can observe of ceremonies today does not tell us all we need to know about the ceremonies that took place between World Wars I and II. For another, the ceremonies were probably no less diverse than the monuments themselves, and there were not insignificant differences between villages and large cities." Ibid., 317.

13. "Repetition is a temporal process that assumes difference as well as resemblance. It functions as a regulative principle of rigor but asserts the impossibility of rigorous identity, etc." Paul De Man, *Blindness & Insight: Essays in the Rhetoric of Contemporary Criticism* (New York: Oxford University Press, 1971), 109.

14. See Forest and Johnson, "Unraveling the Threads of History." In the case of the "Statue Park in Budapest," see Sanford Levinson, *Written in Stone*: *Public Monuments in Changing Societies* (Durham, N.C.: Duke University Press, 1998), 72.

15. On this monument, see David Atkinson and Denis Cosgrove, "Urban Rhetoric and Embodied Identities: City, Nation and Empire at the Vittorio Emanuele II Monument in Rome 1870-1945," *Annals of the Association of American Geographers* 88, no. 1 (1998): 28–49, and Bruno Tobia, *L'Altare Della Patria* (Bologna: Il Mulino, 1998). Tim Benton, in a work on Fascist architecture and memories of Italian Fascism, adopts the categories of "aesthetisation" and "mutilation" as an interpretive paradigm; in the case of the monument in Bolzano-Bozen, the aesthetic discourse on the site is complexly woven with a post-Fascist rhetoric of "preservation"; this discussion is far, however, from the goals of this article. Tim Benton, "From the Arengario to the Lictor's Axe: Memories of Italian Fascism," in *Material Memories*, ed. Marius Kwint et al. (Oxford, New York: Berg, 1999), 199–218.

16. The official web site of the office of the president of the republic puts rather uncritically the "Vittoriano" under the "symbols of the Republic." "I

simboli della Repubblica," *Quirinale*, accessed March 18, 2011, http://www. quirinale.it/qrnw/statico/simboli/vittoriano/Vittoriano_home-a.htm.

17. In this sense, this article does not provide a "discourse analysis" of the different ideologies at play. It provides, so to speak, an analysis of the monument as a privileged point of departure from which to approach such an analysis.

18. Marcello Piacentini, *Architettura d'Oggi* (Melfi: Casa Editrice Libria, 2009), 24. All translations from Italian texts are mine.

19. Ibid., 164–66.

20. Ibid., 32.

21. Sandro Benedetti, "Un'Altra Modernità," in *Architetture di Marcello Piacentini. Le Opere Maestre*, by Mario Pisani (Roma: Clear, 2004), 7–17.

22. Ibid., 7.

23. Mario Pisani, *Architetture di Marcello Piacentini. Le Opere Maestre* (Roma: Clear, 2004), 19.

24. Other recent works working on a new understanding of Piacentini are: Mario Lupano, *Marcello Piacentini* (Bari: Laterza, 1991); and Arianna Sara De Rose, *Marcello Piacentini. Opere 1903–1926* (Modena: Franco Cosimo Panini, 1995).

25. Giorgio Ciucci, *Gli Architetti e il Fascismo, Architettura e Città 1922–1944* (Torino: Einaudi, 1989).

26. Other buildings were already present at the time of the construction, but the erection of the monument offers the chance to organise them inside an organic plan. For a history of Piacentini's plans, see Arnaldo Toffali, "Cronache Urbanistiche. Piani e Monumenti a Bolzano (1927–1943)," in *Il Monumento alla Vittoria di Bolzano. Architettura e Scultura per la Città Italiana (1926–1938)* by Ugo Soragni (Vicenza: Neri Pozza Editore, 1993), 101–15.

27. The argument in *Architettura d'Oggi*, for example, is governed by an understanding of architecture as progressive evolution: "race and history are the fundamental reasons behind our distrust in the wide Modern trend. . . . This respect for the past is holy, nobody is contesting it, but it is often exaggerated, or better, is not precisely understood. Too often the evolution is negated and the appellative "Italian" is confused, not always in good faith, with "ancient" (39). Benedetti correctly speaks of "a line of evolution that from inside tradition develops and thinks modernity. . . . A process of transformation "without ruptures," thus without the connotations proper to the experience of "return." Benedetti, "Un'altra Modernità," 9.

28. Surely an analysis of both the "international" adoption of the triumphal arch (e.g. the Napoleonic *Arc de Triomphe de l'Étoile*, site of the burial of the unknown soldier after World War I), and the possible Prussian influence in the architecture of the "Monument to Victory" would contribute to an interesting

deconstruction of Piacentini's rhetoric; however, this would exceed the goals of this contribution. For an example of Prussian influence in public buildings supposedly embodying "Italianness" see at least: Paolo Marconi, "Il Vittoriano, un Valhalla per il Re Galantuomo. Rivalutazione di un Monumento 'Eroico,'" *Ricerche di Storia dell'Arte* 80 (2003): 9-43.

29. In the reconstruction of the history and monuments of *Nikopolis*, I follow Murray's detailed work: William M. Murray and Photios M. Petsas, "Octavian's Campsite Memorial for the Actian War," *Transactions of the American Philosophical Society* 79, no. 4 (1989): i–172.

30. Mary Beard, *The Roman Triumph* (Cambridge and London: Harvard University Press, 2009).

31. Sandro De Maria, *Gli Archi Onorari di Roma e dell'Italia Romana* (Roma: L'Erma di Bretschneider, 1988), 99.

32. Ibid., 94.

33. There is also an agenda of economic development, mainly around the newly built "industrial zone," and the steel factories. The topic is outside the goals of this article; for an introduction, see Rolf Petri, *Storia di Bolzano* (Padova: Il Poligrafo, 1989).

34. The degree of formal stylisation is here incomparable with Piacentini's earlier experiments, e.g. in Genova.

35. This point will be addressed in 1933, in the so called "polemic on arches and columns" against Arturo Ojetti, the latter defending those features as the pillar of "Italianity," while Piacentini opted for their substitution with the introduction of modern techniques. The polemic is now in Ugo Ojetti, Marcello Piacentini, and Masismo Bontempelli, "Polemica sugli Archi e le Colonne," in *Architettura e Fascismo*, ed. Carlo F. Carli (Roma: Volpe, 1980), 135–56.

36. On this, see at least: George L. Mosse, *Fallen Soldiers: Reshaping the Memory of the World Wars* (Oxford, New York: Oxford University Press, 1990).

37. It is interesting to notice how similar interventions in Trieste's city center, such as the excavation of a Roman amphitheatre and the facing "Casa del Fascio," nowadays hosting the Questura, are dated 1937–1940 (I am indebted to Lauren Arena for having introduced me to the recent history of Trieste's architecture).

38. On this, see at least Claus Gatterer, *In Lotta Contro Roma. Cittadini, Minoranze e Autonomie in Italia* (Bolzano: Praxis 3, 2007).

39. Special permission is necessary to access the site.

40. Sandro de Maria provides an analysis of the functions of Roman honorary arches; in our mapping we are following his framework.

41. In an earlier draft of the project, Piacentini actually designed an altar, which would have hosted a perpetual flame, later allegorised through the statue of the resurrecting Christ.

42. Basically this is the only function that this site comes to have during Fascist time. See Tobia.

43. The symbolic and political implications, despite the absence of post-Fascist parties in the government of the town, are somehow clear.

44. Ugo Soragni, *Il Monumento alla Vittoria di Bolzano. Architettura e Scultura per la Città Italiana* (Vicenza: Neri Pozza Editore, 1993), 3.

45. Giorgio Agamben, *Profanations* (New York: Zone Books, 2007).

46. 3,000 people in 2008: Marisa Fumagalli, "Bolzano, Sfilano 3 Mila Schützen Tensione con i Militanti di An," *Corriere della Sera*, November 9, 2008, 17.

47. Agamben, *Profanations*, 77.

48. Ibid.

49. Ibid., 74.

50. The problem of articulating a reading of "multiple identities" without implying a "puppet master" or a manager of masks, and, in general, the issue of the concept of identity are too wide a topic to be addressed in this context.

51. James E. Young, "The Counter-Monument: Memory against Itself in Germany Today," *Critical Inquiry* 2, no. 18 (1992): 267–96.

52. Francesco Careri, *Walkscapes. Camminare come Pratica Estetica* (Torino: Einaudi, 2006); Francesco Careri, *Constant. New Babylon, una Città Nomade* (Roma: Testo & Immagine, 2001). Notable is his collaboration with the Roman architects collective "Stalker."

53. Careri, *Constant*, 24–26.

54. Gilles Deleuze and Félix Guattari. *Nomadology: The War Machine* (New York: Semiotext(e), 1986), 50–51.

55. Ibid., 51.

56. Giorgio Agamben, *La Comunità che Viene* (Torino: Bollati Boringhieri, 2001).

57. Careri, *Walkscapes*, 82.

BIBLIOGRAPHY

Agamben, Giorgio. *La Comunità che Viene*. Torino: Bollati Boringhieri, 2001.
———. *Profanations*. New York: Zone Books, 2007.
Atkinson, David, and Denis Cosgrove. "Urban Rhetoric and Embodied Identities: City, Nation and Empire at the Vittorio Emanuele II Monument in Rome 1870–1945." *Annals of the Association of American Geographers* 88, no. 1 (1998): 28–49.

Beard, Mary. *The Roman Triumph*. Cambridge, MA and London: Harvard University Press, 2009.

Benedetti, Sandro. "Un'Altra Modernità." In Mario Pisani, *Architetture di Marcello Piacentini. Le Opere Maestre*, 7–17. Roma: Clear, 2004.

Benton, Tim. "From the Arengario to the Lictor's Axe: Memories of Italian Fascism." In *Material Memories*, edited by Marius Kwint, Christopher Breward and Jeremy Aynsley, 199–218. Oxford, New York: Berg, 1999.

Calì, Vincenzo. "Il Monumento alla Vittoria di Bolzano. Un Caso di Continuità tra Fascismo e Post-Fascismo." In *La Grande Guerra : Esperienza, Memoria, Immagini*, edited by Diego Leoni and Camillo Zadra, 663–69. Bologna: Il Mulino, 1986.

Careri, Francesco. *Constant. New Babylon, una Città Nomade*. Roma: Testo & Immagine, 2001.

———. *Walkscapes. Camminare come Pratica Estetica*. Torino: Einaudi, 2006.

"Censimento della Popolazione 2001." Comune di Bolzano. Accessed March 17, 2011, http://www.comune.bolzano.it/context.jsp?ID_LINK=2202&area=19.

Ciucci, Giorgio. *Gli Architetti e il Fascismo, Architettura e Città 1922-1944*. Torino: Einaudi, 1989.

Deleuze, Gilles, and Félix Guattari. *Nomadology: The War Machine*. New York: Semiotext(e), 1986.

De Man, Paul. *Blindness & Insight: Essays in the Rhetoric of Contemporary Criticism*. New York: Oxford University Press, 1971.

De Maria, Sandro. *Gli Archi Onorari di Roma e dell'Italia Romana*. Roma: L'Erma di Bretschneider, 1988.

De Rose, Arianna Sara. *Marcello Piacentini. Opere 1903-1926*. Modena: Franco Cosimo Panini, 1995.

Forest, Benjamin, and Juliet Johnson. "Unraveling the Threads of History: Soviet-Era Monuments and Post-Soviet National Identity." *Annals of the Association of American Geographers* 92, no. 3 (2002): 524–47.

Fumagalli, Marisa. "Bolzano, Sfilano 3 Mila Schützen Tensione con i Militanti di An." *Corriere della Sera*, November 9, 2008, 17.

Gatterer, Claus. *In Lotta Contro Roma. Cittadini, Minoranze e Autonomie in Italia*. Bolzano: Praxis 3, 2007.

Levi, Carlo. *Cristo si è Fermato a Eboli*. Torino: Einaudi, 1945.

Levinson, Sanford. *Written in Stone. Public Monuments in Changing Societies*. Durham, N.C.: Duke University Press, 1998.

Lupano, Mario. *Marcello Piacentini*. Bari: Laterza, 1991.

Marconi, Paolo. "Il Vittoriano, un Valhalla per il Re Galantuomo. Rivalutazione di un Monumento 'Eroico,'" *Ricerche di Storia dell'Arte* 80 (2003): 9–43.

Mosse, George L. *Fallen Soldiers: Reshaping the Memory of the World Wars*. Oxford, New York: Oxford University Press, 1990.

Musil, Robert. *Selected Writings*. Edited by Burton Pike. New York: Continuum, 1986.

Murray, William M., and Photios M. Petsas. "Octavian's Campsite Memorial for the Actian War." *Transactions of the American Philosophical Society* 79, no. 4 (1989): i–172.

Nora, Pierre, ed. *Realms of Memory: Rethinking the French Past*. Vol. 1. New York: Columbia University Press, 1996.

Il Nuovo Statuto di Autonomia. Bolzano: Giunta Provinciale di Bolzano, 2009.

Ojetti, Ugo, Marcello Piacentini, and Masismo Bontempelli. "Polemica sugli Archi e le Colonne." In *Architettura e Fascismo*, edited by Carlo F. Carli, 135–56. Roma: Volpe, 1980.

Piacentini, Marcello. *Architettura d'Oggi*. Melfi: Casa Editrice Libria, 2009.

Pisani, Mario. *Architetture di Marcello Piacentini. Le Opere Maestre*. Roma: Clear, 2004.

Petri, Rolf. *Storia di Bolzano*. Padova: Il Poligrafo, 1989.

Prost, Antoine. "Monuments to the Dead." In *Realms of Memory: The Construction of the French Past*, edited by Pierre Nora, 307–30. New York: Columbia University Press, 1997.

Scollon, Ron, and Suzie Wong Scollon. *Discourse in Place: Language in the Material World*. London and New York: Routledge, 2003.

Presidenza della Repubblica. "I simboli della Repubblica." Quirinale. http://www.quirinale.it/qrnw/statico/simboli/vittoriano/Vittoriano_home-a.htm. Accessed March 18, 2011.

Soragni, Ugo. *Il Monumento alla Vittoria di Bolzano. Architettura e Scultura per la Città Italiana*. Vicenza: Neri Pozza Editore, 1993.

Steininger, Rudolf. *South Tyrol. A Minority Conflict of the Twentieth Century*. New Brunswick, NJ: Transaction Publishers, 2003.

Tobia, Bruno. *L'Altare Della Patria*. Bologna: Il Mulino, 1998.

Toffali, Arnaldo. "Cronache Urbanistiche. Piani e Monumenti a Bolzano (1927–1943)." In *Il Monumento alla Vittoria di Bolzano. Architettura e Scultura per la Città Italiana (1926-1938)*, by Ugo Soragni, 101–15. Vicenza: Neri Pozza Editore, 1993.

Young, James E. "The Counter-Monument: Memory against Itself in Germany Today." *Critical Inquiry* 2, no. 18 (1992): 267–96.

● ●

THE CULTURAL CONTRIBUTIONS OF PIER LUIGI NERVI IN THE UNITED STATES

1952–1979
Alberto Bologna

The events related to the professional and intellectual activities of Pier Luigi Nervi[1] in the United States are part of what Sergio Poretti has defined as the "third life"[2] of the Italian engineer. This period of Nervi's career, particularly with regard to his experience in America, has not yet been explored in a methodical and exhaustive way by the critical literature.

This chapter aims to illustrate the nature of the professional and academic experiences of the engineer overseas, and how they bolstered the reputation he carefully and skilfully built for himself over a decade through a dense network of contacts and social relationships, enabling him to become a key figure in the exportation of Italian culture in the United States in the 1960s and 1970s.[3]

For this reason, it is important to consider the interdisciplinary nature of his work going beyond the single issues that can only be linked to the history of architecture. The cultural contributions of Pier Luigi Nervi go beyond the field of engineering making a restricted analysis of his works unsuitable: instead, this figure should be placed within the field of cultural studies.

The buildings constructed between the east and the west coast of the United States unequivocally comprise the pinnacle of Nervi's

career overseas. Nervi's newborn "brand architecture,"[4] iconic models that were the product of decades of work in Italy, were transposed and cleverly distributed in the United States creating around the figure of the aging professor an aura of absolute respect. The profession of engineer, purely technical in nature, suddenly became with Pier Luigi Nervi, something nobler and distinctly intellectual. The honors he received from the most renowned cultural institutions and American universities, Dartmouth College *in primis*, helped to make the engineer as popular as acclaimed architects of the past like Michelangelo and Brunelleschi.[5]

Studio Nervi collected the tangible fruits of its reputation with the commission to design and later build the field house at Dartmouth College in Hanover, New Hampshire. Of all the vicissitudes of the Italian engineer in America, his long relationship with this university is the one that was most productive to build up his prestige.

While the first building to be commissioned in Hanover, the field house, represents the arrival of Nervi's efforts in the United States to publicize his activities, his work for the hockey rink, also at Dartmouth College, symbolically marks the end of Studio Nervi's work overseas and the crisis of the organization that had been set up by the now elderly Italian professor.

The events that link Dartmouth with Pier Luigi Nervi follow a linear path and become clear only through the data in documents obtained from the MAXXI of Rome, the Rauner Library at Dartmouth College and the CSAC of Parma. Archival research is necessary not only in order to understand the story of the construction of the two buildings, but also to write an important chapter in the history of profession and the diffusion of Italian culture in the United States between the 1960s and 1970s.

The long relationship that links Pier Luigi Nervi to Dartmouth College in Hanover began on March 11, 1960, when he received a letter from Mario Salvadori.[6] It was this engineer, who had emigrated to New York previously, who wrote to his friend Pier Luigi Nervi that Richard Olmsted, the business manager of Dartmouth, was arriving in Rome and that he wished to visit the facilities recently completed for the Olympic Games. In 1955, Wallace Harrison, who was also in close contact with Pier Luigi Nervi at that time, had been commissioned

to design the Hopkins Center at Dartmouth College, and Paul Weidlinger and Mario Salvadori were the structural consultants. This building, with its modern forms, was very different from the New England-style buildings that had characterized the campus for two hundred years. Thus, Wallace Harrison, Paul Weidlinger and Mario Salvadori unwittingly laid the groundwork for Pier Luigi Nervi, who later created two buildings that would represent icons of absolute modernity for the college for a very long time.

In 1960 Dartmouth College unequivocally intended to build an athletic field house. The office of Eggers and Higgins in New York had been asked to design a project for its construction, which had already been developed in some detail by 1959.

In the early 1960s Pier Luigi Nervi was at the height of his fame in both Europe and in the United States thanks to the realization of the Olympic Games' buildings in Rome. In addition, the Italian engineer was famous for having designed a building in New York, with the idea of a new American job market in mind, the Port Authority's George Washington Bridge bus station. The administrators of Dartmouth College appreciated his work and it was their wish that a concrete structure by the Italian professor be built on the campus in order to raise the university's image to that of other east-coast cultural institutions like Harvard, which in the same year entrusted the implementation of the Carpenter Center to Le Corbusier, or Yale and the Massachusetts Institute of Technology, which had commissioned their most iconic buildings to Eero Saarinen and Alvar Aalto.

However, an issue of particular importance had to be considered: the complexity of working outside of Italy, namely the costs involved and the feasibility of the construction. The case study represented by the two buildings in Hanover, along with the structure built in Norfolk and the St. Mary's Cathedral in San Francisco, highlight the limits of exporting Nervi's prefabricated structures abroad using a construction company that differed from the Nervi and Bartoli, whose owner was Pier Luigi Nervi himself. For these reasons Richard Olmsted, the astute business manager of Dartmouth College, got American experts to analyze the construction methods employed by Pier Luigi Nervi during the early meetings held in Rome. It should be noted that when Studio Nervi in Rome completed the project and sent it out, they had every

reason to believe that they would get the job. However, the question was still totally open in Hanover, where one of the possible scenarios could have been that of discarding Nervi's design and returning to the one by Eggers and Higgins.[7]

The skepticism in the United States concerning the construction method was due to the use of *ferrocemento* (steel and concrete), the material invented in Italy by Nervi. Several experts from the American east-coast were called in to examine the field house project without the presence of the Italian engineer. They had to determine the feasibility of a prefabricated structure with the "sistema Nervi" built by a local construction company and its possible cost in comparison with a building constructed using traditional methods. In the end, Richard Olmsted favored Nervi's proposal, not for economic reasons, but purely for the future image of the university: the business manager's assessment stressed what the real impact of a building designed by a world acclaimed engineer would be in terms of publicity for the college, also on the basis of what had been done at other prestigious American universities.

It is therefore clear that Pier Luigi Nervi was called to work at Dartmouth College in order to produce a building with the unique characteristics of the structures he had built. He was riding the wave of success from the recent Olympic facilities in Rome, whose forms were partly suggestive of the military hangars he had built in Italy in the 1930s during Fascism. Along with this, he had the prestige of a designer capable of structural solutions that were out of the ordinary. Dartmouth College needed his input in order to unequivocally impart his character to the project.

The office of Eggers and Higgins did not accept the role of supporting actor offered by the prestigious university because they were bothered by a fundamental question: their project, which had been developed in 1959 and had already been approved at the preliminary stage, reached a total cost of $750,000 while that of Pier Luigi Nervi was estimated by the construction company at between $1,000,000 and $1,100,000.[8] Nevertheless, having decided that Dartmouth's future image was their main priority, on October 17, 1960 the Trustees Committee of the University chose Nervi's project and set aside the one previously proposed by Eggers and Higgins.[9] So, in December 1960, Pier Luigi

Nervi received the commission. The office of Campbell and Aldrich of Boston would collaborate with him. Soon after he enrolled in the New Hampshire Board of Professional Engineers using the names of Paul Weindlinger, Mario Salvadori, Pietro Belluschi, Marcel Breuer, and John Kyle as his references in the United States. Work began in January 1961 with much effort on the axis Hanover-Rome.

It was during the construction phase of the first American building built with the "sistema Nervi" that it became more and more evident how difficult it was to fabricate the precast ashlars in Hanover that would be used to cover the field house. Studio Nervi, for its part, was never short of advice, but it should be noted that the end result, documented by the large number of photographs taken on site, was not at all satisfactory and that the interior of the building needed many coats of white paint to mask the imperfections in construction.

About five years went by between the completion of the field house and the beginning of the hockey rink project, which were central to the American career of the Italian engineer. In this period Dartmouth College awarded Nervi an Honorary Doctorate in Human Letters. This was the period of professional consecration, which gave birth to important projects such as the bridges for the Kaiser Steel Corporation, the Fermi Memorial in Chicago and the competition for the *Parcel* 8 in Boston. During those five years the reputation of Pier Luigi Nervi, now author of a unique brand of architecture, was at its highest, so that he was also commissioned for the design and subsequent implementation of the Norfolk Scope Arena in Virginia.

The documents in the archives in Rome and Syracuse (NY) that concern this period once again reveal Nervi's resourcefulness in its fullest expression. His interest in the highly prestigious structural consultancy for the Cathedral of St. Mary in San Francisco led, in the early stages of the work, to his playing a dangerous double game with Mario Ciampi, initially responsible for the design of the church, and Pietro Belluschi.

The construction of the hockey rink designed by Studio Nervi at Dartmouth College was more lengthy and complex than that of the field house. The decision to give the university an ice rink matured in January 1967[10] and early the following February the commission for the project was assigned to Pier Luigi Nervi, despite the fact that it

was clear that one of his now world famous structures would involve a cost twice that of a hockey rink built in steel with ordinary constructive technology.[11] There were several versions of the project: in September 1967 Dartmouth College's Trustees Committee began to think about building a new structure that would contain a concert hall and a theater in addition to the hockey rink. This led to two separate projects: the first, developed by Antonio Nervi in February 1969 was formally the simplest and was the basis for the building that was actually built, while the second, known as the Arena Theatre, which was discarded because it was too expensive, was designed by Pier Luigi Nervi in person.

The final draft was completed in April 1972 thanks almost entirely to the meticulous work of Antonio Nervi, the real engine of this project, which was concluded in November 1975. Evidence of this includes the various documents found at the Rauner Library at Dartmouth College showing the many meetings conducted in English, the compilation of most of the letters to Richard Olmsted, and his proven role in the design of the entire building.

It is very strange that during the period in which Nervi's fame peaked all the correspondence from the United States and the contracts themselves indicate that no one ever understood that Studio Nervi was actually made up of two architects[12] and two engineers.[13] Every reference was to the professor himself, who was by now quite elderly. In the eyes of critics and clients from overseas the architectural forms invented by the engineer, and then used by the studio as part of his brand, were still to be attributed to him, and him alone, and this would continue until his death.

In fact, by the early 1970s Studio Nervi was no longer able to maintain its credibility with American clients, let alone create the image of a design corporation, despite Antonio's efforts with regard to the hockey rink and Mario's with the projects in Norfolk. Studio Nervi had always been regarded as a small family business run by a wise old engineer who had a great reputation and used his children as employees to obtain a product with unique features.

The last structure designed for Dartmouth College can only be seen as the persistent attempt to keep pace with the times within the labor market outside of Europe and to adapt working methods to skills that only pertain to large engineering companies, with results that were not particularly brilliant and sometimes even clumsy.

How did Nervi import the construction method he had invented to the United States, manage to design two prestigious buildings for one of the most exclusive universities in America and become a point of reference for architecture round the world?

To answer this question it is necessary to first define periodization: Pier Luigi Nervi began to work at an international level and to build up his fame worldwide in a systematic way, and especially in the United States, in 1952 with the project and subsequent construction of the UNESCO complex in Paris. In that same year the Italian professor paved the way for the export of his activities to the United States by participating in the Centennial of the American Society of Civil Engineers in Chicago.[14]

Also in 1952, after two years' apprenticeship with Nervi and Bartoli, the family business, Nervi's eldest son, Antonio, began to work in the field of architectural design with another young engineer, Sergio Musmeci, who was his associate for a short time. Two years later, Pier Luigi and Antonio become the owners of Studio Nervi, which in 1960 also incorporated Mario and Vittorio, the professor's two others sons.

The fact that his sons were involved was very important for the export of Nervi's architectural models in the United States: Pier Luigi Nervi did not speak English and Antonio and Mario's work proved crucial over the years for the promotion of professional activity overseas and for the active management of works such as the one built in Norfolk and the two buildings at Dartmouth College in Hanover.

The UNESCO building site on the one hand allowed the then sixty-one-year old engineer to give international visibility to his activities and on the other to come into contact with Marcel Breuer, who was Hungarian by birth but American by adoption, and who would introduce his Italian colleague to the American scene through a small and poorly documented consultation for the roof of the famous church of St. John in Minnesota.[15]

This experience, along with the more complex one of the UNESCO buildings in Paris, must have served to teach Nervi a method for working from a distance, which he had never practiced before, but then used, for example, with Pietro Belluschi when they worked together on St. Mary's Cathedral in San Francisco. It is also possible that Marcel Breuer served as an example. Through him Nervi learned to speak with other

professionals many miles away and absorbed a methodology that led to the realization of projects, including quite complex ones, through the use of a few specialized employees who during his "third life" happened to be two of his four children, Antonio and Mario.

Marcel Breuer, however, was only one of the people who introduced Nervi to North America. Although his social contacts contributed decisively to the creation of his fame overseas, it is also fair to say that it was Pier Luigi Nervi himself who wanted to create the image of the Italian genius in the United States.

Nervi's friendships and personal relationships in the United States often had little to do with the history of architecture since they involved people that were not always part of the world linked to this discipline, but instead can be collocated within the wider field of cultural studies. Without these friendships the Italian engineer would not have gained so much popularity and his career would not have received so much credit overseas, especially in its early phase. His social contacts were the result of a clever strategy pursued over the years to promote his image and to obtain prestigious professional commissions from carefully selected clients during the years of Studio Nervi's greatest popularity in the States.

Pier Luigi Nervi was also able to methodically maintain relations with the major American architectural magazines and the non-specialist press: a period lasting about a decade can be identified, from 1952 to 1961, during which he was intensely committed to propagating the buildings he had constructed in Italy through the widespread dissemination of images that would create a specific iconography around him.

Starting from these events, Nervi's reputation in America is inextricably linked to the proliferation of writings in his honor thanks to Nervi's personal relationships with people like Mario Salvadori, Kidder Smith, and Ada Louise Huxtable, who promoted important publications about his work in Italy and about his theoretical ideas.

The hangars built before the war, as well as Pavillion B of the Exposition Building in Turin, became iconic images of his work. Later came the Sports Center in Rome, which, as a domed structure, in the view of many American journalists, would place Nervi at the end of an Italic tradition begun with the Pantheon and continued with Brunelleschi and Michelangelo.

Magazines such as *Civil Engineering, Concrete, Progressive Architecture,* and *Architectural Record* addressed their attention in detail to the buildings of the Italian engineer and to *ferrocemento,* his invention, while articles published in *Time, Time Life,* and *The New Yorker* tried to create a more private image of Pier Luigi Nervi, who, with his total devotion to work, family, and religion, won the favors of the public earning, in the American press, the title of "Modest Master," which was reinforced by his shyness exhibited almost ostentatiously on all public occasions and promptly reported in the newspapers.

It is curious to note that, while on the one hand, the public overseas was truly interested in the invention of *ferrocemento* and its technology,[16] on the other, the name of Nervi was related to the professional figure of the architect and not to that of the engineer and experimenter, a dichotomy hotly debated in those years by Giulio Carlo Argan also with regard to Nervi's work in Italy.[17] This is undoubtedly due to the iconography that Pier Luigi Nervi himself wanted to spread throughout the first phase of his American career, helping to create around himself the reputation of the architect who can build large, extraordinary constructions.

His merits as structural engineer were rarely brought to light in America. Although his empirical methods were advanced and led to a sophisticated analysis of his structures, Nervi may have been aware that the United States in those years could develop tests using methods with a more solid scientific basis. For example, he never tried to get the American press to write about his experiences on structural models at ISMES in Bergamo. Instead, he aimed at showing his architecture, sure to impress and to influence colleagues and experts in the United States.

Another focal point around which Nervi's fame in the United States was based was how work was organized in his office: he was widely seen as the Master who works in a shop and hands down his craft from father to son, just like in medieval times. This element captured the imagination both of American clients, as in the case of Richard Olmsted of Dartmouth College, and of the nonspecialist press which, as mentioned, gave Nervi's private life the same visibility as his buildings.

The second phase of Nervi's American career began once his fame had taken off and he started obtaining commissions from prestigious clients. The first of these works came from The Port of New York Authority: archival research has not made it possible to reconstruct the

stages through which Nervi got the job because there are no documents concerning the building at the MAXXI archive in Rome and the Port Authority archive was destroyed with the collapse of the Twin Towers at the World Trade Center in New York on September 11, 2001. The drawings of the George Washington Bridge Bus Station in Manhattan, which are conserved at the CSAC of Parma, however, testify that the project developed by Nervi was already at an advanced stage in December 1958. Just as the striking butterfly wings roof had to undergo several changes before its final construction, also the technology used for the elements of the roof had to be changed. From the detailed drawings found in Parma and at the Rauner Library at Dartmouth College in Hanover, it is clear that Nervi's intention was that of exporting the construction technology he had invented in Italy and using it on his first building in the United States. Nervi and Bartoli, understandably, was not responsible for the actual construction, and so Pier Luigi Nervi had to adapt his design to what the local construction company was willing and able to do. Thus, he had to sacrifice the prefabricated building system that is only alluded to at a formal level by the roof's triangular elements, which were cast in place.[18]

The construction of the building contributed to giving further prestige to Nervi's image in America. In addition, it meant that the engineer came into contact with John Montgomery Kyle, his colleague at the Port Authority, with whom he established over the years a relationship of personal friendship and mutual professional trust. This contact led to the ISMES in Bergamo and Nervi being commissioned as consultants for the structural elements of the airport terminal in Newark, New Jersey.

Marcel Breuer is the first well-known architect to introduce Pier Luigi Nervi to the North-American market. However, other figures, who were unknown young professionals and often Italians-Americans, stand out for having contributed, through their work and their contacts, in building up Nervi's reputation and success in the United States. Paolo Emilio Squassi, for example, represented Studio Nervi in New York: he was the professor's mediator for the design of a stadium in Boston, the roof of the new New York Stock Exchange, various projects for the 1964 World's Fair, also in New York, and a cancer hospital in the form of a skyscraper designed by Pier Luigi Nervi and destined to house a clinic directed by his son, Carlo, who was a doctor.

Like Marcel Breuer, Mario Salvadori made great contributions, especially in the first part of Nervi's American career, for the dissemination of the ideas and the work of his colleague. Salvadori accomplished this through his contacts with the specialized press, such as *Architectural Record*, and through his writings, which circulated widely in the United States because of his role as professor at Columbia University in New York.

Mario Salvadori's first major contribution was that of translating the book *Costruire Correttamente* with his wife Giuseppina for a U.S. audience. It is quite possible that only a small number of American experts were aware of the existence of this book, obviously written in Italian. Through this translation another side of Pier Luigi Nervi was made known overseas, that of being a theorist in the art of construction, an aspect which the engineer would use in the years to come to build his fortune overseas.

Structures[19] was published in 1956 by the Dodge Corporation publishing company of New York. This text, as well as all the books about Nervi's activities in design during the years in which he worked in the United States, would be used by the Italian engineer as a true instrument of personal advancement. The focus was not so much on the content of his ideas as on the photographs of the projects presented. This was true of *Structures* which came out in 1956, of the monographic text written by Ada Louise Huxtable[20] in 1960, *Buildings, Projects, Structures*,[21] which came out in 1963, and *Aesthetics and Technology in Building*[22] in 1965. These books were the means through which Nervi tried to make his activities known by colleagues, academics and potential clients, intending for these publications to be both true portfolios of his office's professional work and manifestos that justified the zeal with which he was promoted at that time by European and American cultural institutions. Salvadori's and Huxtable's texts, for example, are indeed successful because of the meticulous precision with which they were written, but also because of the special interest shown by Nervi while they were being put together. As with Mario Salvadori, in fact, the engineer was able to establish a personal friendship with Ada Louise Huxtable between 1950 and 1952. Those were the years when the young American journalist went to Italy on a Fulbright scholarship,[23] where she studied the modern architecture produced

between the thirties and the fifties. The material given to her by Nervi, now preserved in the Archives of the Museum of Modern Art in New York, formed the basis of the book published in 1960. Many images, among them, the canonical ones distributed by the professor to the architectural magazines, aim to better define his iconic buildings. At the time, as the American journalist admits, Nervi was not very well known in the United States and one of her intents was to write about his architecture in the non-specialist press so as to divulge his name and the suggestive images of his buildings. The book published in 1960 had, therefore, general informational purposes and not scientific ones: with its commercialization and subsequent diffusion, the name of Pier Luigi Nervi became popular in America and he began to be seen as one of the greatest living engineers.

If, as we have seen, Marcel Breuer was the first professional active in the United States to give Pier Luigi Nervi the opportunity to enter the U.S. labor market, Giulio Pizzetti was, most probably, the first person belonging to the academic sphere to lead to the Italian engineer's teaching at American universities, heavily contributing to the export of Italian culture abroad.[24]

It is important to note that American universities, at that time, were not only academic and cultural centers, but also had acclaimed designers actively practicing their profession[25] who were part of the faculty: José Luis Sert, Eduardo Catalano and Pietro Belluschi were just some of the academics who at the same time became the protagonists of a thriving architectural season in the United States, and Pier Luigi Nervi was able to take part in a very clever manner, thanks to his network of personal friendships.

Prior to going to the United States, the Italian engineer Giulio Pizzetti had crossed the ocean to go to South America. Pier Luigi Nervi and Giulio Pizzetti had been in contact since 1950 when Nervi received awards from the University of Buenos Aires, where the engineer from Turin had been the holder of two chairs starting in 1948.

Between 1955 and 1958 Pizzetti taught a course on structures at the School of Design in Raleigh, North Carolina. It may have been Pizzetti who suggested that Nervi be contacted and asked to come to Raleigh during his first tour of the North-American universities in April 1956. In fact, at this time Nervi lectured not only in North Carolina, but also

at Columbia University in New York (where Mario Salvadori taught), at Princeton, and he also visited Harvard University for the first time, having been invited by his friend and colleague José Luis Sert.

This tour was extremely important for Pier Luigi Nervi, because at that time he came in contact with people like Pietro Belluschi, Eduardo Catalano, and Richard Neutra, professionals with whom the engineer maintained lasting relationships throughout his personal and professional period in the United States.

Harvard University in Cambridge was undoubtedly the American institution that bestowed the greatest honors to Nervi promoting him to the role of real intellectual by conferring the Charles Eliot Norton Chair on him in 1962.[26] Since that session of the Norton Lectures was devoted to the Fine Arts, it is very interesting to note that the invitation was addressed to Pier Luigi Nervi the architect and not the engineer, his real qualification. This is a clear indication of the way Americans saw him at that time. They thought of him as the Italian designer whose constructions had certain essential aesthetic qualities, characteristics normally associated with the work of an architect and not of an engineer.

Only the archives at Harvard University in Cambridge can help to recount with precision a story full of anecdotes that are crucial to the understanding of the historical figure of Pier Luigi Nervi. The series of four lectures in the program, called "The Relationships between Aesthetical and Technical Aspects of Building," included the first lecture called "From the Past to the Present," the second "The Plastic Richness of Concrete Cast in Place," the third "The Plastic Richness of Precast Concrete," and concluded with the most interesting, "The Foreseeable Future and the Training of Architects."

The topics and titles of all the lectures were the same as the ones that , three years later, would constitute the skeleton of what would be the most successful and important text published by Nervi in the United States, *Aesthetics and Technology in Building*, whose individual essays were edited and translated by Roberto Einaudi, a young student at the Massachusetts Institute of Technology who, along with Paolo Squassi and Paul Gugliotta accompanied Pier Luigi Nervi during his stay in Massachusetts.

The two periods spent in Cambridge in the spring of 1962 would lead to Nervi receiving the *laurea ad honorem* conferred by Harvard

University a few weeks later. On June 14, 1962 fourteen Harvard Honors for Devotion to Human Progress were assigned and among the personalities awarded the American Secretary of Defense, Robert S. McNamara was the most outstanding. Therefore, the local press gave ample space to the event. Pier Luigi Nervi was the only foreigner to receive an honorary degree and the only one to be awarded the title of "doctor of arts."

In 1961, a year before the awards received at Harvard, the Italian engineer was invited by Pietro Belluschi to participate in the celebrations organized for the centennial of the founding of the Massachusetts Institute of Technology, also in Cambridge. On this occasion Nervi was awarded the title Centennial Visiting Professor, reserved only to few selected speakers. On the evening of April 10, 1961 Nervi also gave a lecture entitled "Consideration on Structural Architecture," which was later published, after being translated into English by Pietro Belluschi, in the journal *Student Publications of the School of Design* at *North Carolina State College* in Raleigh.[27]

It should be emphasized, however, that Pier Luigi Nervi had never tried to become a part of the academic world in the United States in an active way, as had happened with other Italian colleagues such as Giulio Pizzetti, Mario Salvadori, or Pietro Belluschi. The professor from Rome never tried to obtain even just one semester of teaching at an American university and he did not try to give cyclical continuity to his celebrated conferences. It is possible to give two complementary explanations for this: Nervi would have never detached himself, even momentarily, from the activities of his office, whose fortunes were tied so essentially to his being the figurehead. At the same time, his visits to the North-American universities were linked to the luster that they could give to his career as designer and for the personal contacts that these institutions could offer him.

With regard to his relationships, which were often cultivated through his visits to the American universities, with people like Eduardo Catalano, Pietro Belluschi, Paolo Squassi, Paul Gugliotta, or Mario Salvadori it is difficult to draw a line between those who were really regarded as friends and those who were possible future contacts for a professional collaboration. The distinction between the personal sphere and the professional one always appeared very thin with regard to Pier Luigi

Nervi's contacts. Nervi's travel schedule, in fact, always contained a precise, almost maniacal list of meetings, as if he were frightened of the unexpected and of having free time to spend in the United States without the presence of an academic, a colleague or a possible future client.

On the occasion of the conference at M.I.T. and during both periods spent at Harvard, Nervi was careful to communicate to his major American clients of that time, Dartmouth College in Hanover and the Port Authority of New York, exactly when he would be in America so as to arrange business meetings.

It is interesting to note that in these circumstances the letters used for professional meetings are archived along with the material inherent to his university lessons, which shows that there were no barriers against the engineer's activities: giving a lecture was held on the same plane as designing a new project and the meetings connected with the lessons, viewed in this light, were for him another part of business.

Starting in 1956, when he received an Honorary Fellowship from the American Institute of Architects, Pier Luigi Nervi began to be awarded with honorary posts in the United States, a country whose language he did not even know, but that represented the worldwide icon par excellence of democracy and technological development, a fact that permitted Nervi to increase his credibility in Italy.

Dartmouth College, as well as the Universities of Raleigh, Harvard, and the Massachusetts Institute of Technology were only the spearhead of American cultural institutions that, over the years, paid tribute to the work of the Italian engineer.

In 1957 when the United States had not yet seen any of his buildings built, Nervi was evidently considered not only a designer but an intellectual worthy of note on the international scene since his Italian projects had already travelled around the world through the architectural magazines. The award received that year from the Institute of Arts and Letters in New York shows that, overseas, he was already not only an esteemed professional, but also a public figure, even if he had not yet designed anything important in America, excluding the bit of advice he had given for the Church of St. John in Minnesota and for the St. Louis Priory Church.

The events related to the award received on June 11, 1957 at the American Embassy in Rome are well documented in the archives of

the New York Institute of Arts and Letters and it is remarkable to note that, once again in the United States, the honor was assigned to Pier Luigi Nervi the architect, not the engineer. Nervi was also presented as an architect to the guests at the award ceremony in Rome, the majority of whom were American citizens residing in Italy. Among the present, a name that stands out in the documents in the archives is Ignazio Silone, who was also an honorary member of the American Institute of Arts and Letters in New York. A few days after this event, on June 13, 1957 Nervi received another *Laurea ad honorem* from the University of Pennsylvania in Philadelphia and on October 16 he was awarded the Brown Medal by the Franklin Institute, also in Philadelphia.

The growth of Nervi's fame in the United States also depended on the presence of his works in exhibits of national importance. For example, among the first was the design of the viaduct in Corso Francia in Rome included in the exhibition *Roads* held in New York in 1961 at the Museum of Modern Art. Another well documented exhibition was called *Twentieth Century Engineering* held in the summer of 1964 again at the Museum of Modern Art in New York.[28] Arthur Drexler, director of the MoMA at that time and organizer of the event, included in the program and in the catalogue as many as four works by Nervi: Turin's *Palazzo del Lavoro*, the B Hall of the Turin Exposition complex, one of Orbetello's hangars and the interior of the Little Sport Palace in Rome. The exhibition was held at twenty-six American institutions, including museums and universities between 1965 and 1971, and also found a space in Nervi's places par excellence in the United States, such as Dartmouth College in Hanover, the Massachusetts Institute of Technology in Cambridge and North Carolina State University in Raleigh. The installation also visited Europe with as many as thirty locations, including the Collegio Regionale degli Architetti in Milan.

Studies have highlighted that Nervi's most permanent contact on the west coast was Henry Lagorio who, in 1957, held the position of Assistant Dean at the Department of Architecture at Berkeley. Their friendship began in March of that year, when Pier Luigi Nervi held some lectures sponsored by the Structural Engineer Association of California. Lagorio did a year's sabbatical in Italy spending most of the time in Nervi's studio and upon his return to the United States he was ready to promote a monographic exhibition dedicated to the work of the

Italian engineer at the San Francisco Museum of Art. The inauguration of the exhibition, complete with catalogue,[29] occurred on June 18, 1961, and, starting in July, it began its tour across the United States.

In 1963 Lagorio acted as interpreter during some advertising conferences held by Nervi in California on behalf of the Kaiser Steel Corporation in Oakland. During that phase of Nervi's career in America, Kaiser Steel had entrusted the engineer to design large steel highway bridges, and the conferences were held in order to promote this project with government authorities and local journalists.

The events narrated here are complex and open questions with very different interpretations depending on one's point of view with regard to Pier Luigi Nervi's work in the United States. The most significant aspect is that of the diffusion of Italian culture in the world, thus making Nervi a real historical figure that has to be considered not just as important for the history of architecture but also within the more complex framework of cultural studies, having been, as illustrated, a key figure in the relations between Italy and the United States between the 1960s and 1970s.

Nervi's popularity overseas was, therefore, a goal that the engineer pursued with great effort over the years despite his apparent disregard for having become a public figure in the United States. What is indicative of this is the attention with which he treated American publications about him, his main source of advertising abroad, as well as his willingness to travel long distances despite his already advanced age, his punctuality in sending photographs and materials to architectural magazines, newspapers and journalists who were interested in his work and his never missing an opportunity, even through interviews on television, to present projects with a strong impact on the public, as in the case of the bridges designed for San Francisco.

The way he conducted his affairs in North-America shows that it was certainly a source of pride for Nervi to know that his office, still structured on work principles of the past, in many cases could work on par with large American engineering firms, organized with modern management principles, and that indeed, he was entitled to dictate when and how to operate from the height of his renown.

In the 1960s in the United States, in fact, the name of Pier Luigi Nervi had become a guarantee of success, especially due to the huge response

that Rome's Olympics facilities, which he designed, had in the world. These buildings immediately became icons of modernity and assumed technological progress, and for this reason it was appropriate that the ideas behind them be exported to North America, on the principle of the research of the idea of the sublime applied to development in technology as theorized in 1994 by David Nye.[30]

The success of his Italian works was indisputably linked to his reputation as an innovator of technology, which Pier Luigi Nervi had been able to earn during the first phase of his career. His American works, however, were carried out during a later phase and were designed with methods and technologies that by the 1960s had become obsolete. In spite of this, they were accepted and indeed sought after by his American clients because of the prestige that the name Pier Luigi Nervi had. It is significant that the business manager of Dartmouth College was skeptical at first of the idea of accepting a prefabricated building with the "sistema Nervi," unknown in the United States. The problems of construction and the economic obstacles were overcome, however, in order to win the prestigious signature of the Italian engineer.

The dynamics related to Nervi's popularity in America are, rather curiously, also useful to determine the real reasons that led Studio Nervi to cease carrying on professional activities in the United States in the seventies.[31] The reasons are not only related to Pier Luigi Nervi's age, but also to the structure of the entire office, which was unable to change the way it was organized, update its technology of construction and produce architecture that by the mid 1970s, after the fashion of reinforced concrete in North America had passed,[32] was not clearly behind the times and the formal brand by now having become obsolete. The project for the hockey rink at Dartmouth College clearly highlights the reasons for Studio Nervi's decline, which are, paradoxically, the same ones that, only twenty years before, had made the work of Pier Luigi Nervi a positive exception in the world and something to be so much sought after.

Today, more than thirty years after his death, which also corresponds to about thirty years of silence on the part of historiography and criticism that has only recently awakened,[33] it is essential to recognize the merit that is due to the engineer for absolutely having been in the United States a clever manufacturer not only of spectacular buildings, but of his own fame, which is common in the case of a high level

professional,[34] but is worth noting in this case, considering the results obtained in little more than ten years. Through the friendships that he cultivated in North America, the relationships that he managed with great skill and the originality of the buildings he constructed, he managed to export from Italy an idea of construction that proved to be a huge commercial success in the United States, even if it was ephemeral. The mere twenty years that Nervi worked in the United States probably contain the sense of an important part of the history of relationships between architecture and engineering, between academia and profession, between contractors and design firms and, last but not least, between cultures that are separate, but not just physically, because of an ocean. Not taking this into account would once again turn Nervi into a mythological figure of architecture; that is no longer acceptable.

NOTES

1. Pier Luigi Nervi was born in Sondrio in 1891. His parents were from Liguria. After graduating in civil engineering from the School of Applied Engineering in Bologna in 1913, he worked for the "Società Anonima per Costruzioni Cementizie" under his Technical Architecture Professor Attilio Muggia, who was the agent in central Italy of the Hennebique patent. During World War I, he served in the Army Corps of Engineers. In 1923 he moved to Rome where he founded his first company, the Ing. Nervi and Nebbiosi, with which he created his first masterpieces in Italy: the Bruno Bianchini Theatre in Prato (1923–1925) and the Augusteo Theatre in Naples (1926–1929); for more information about Nervi's activities up to this period see Giuseppe Guanci, *Costruzioni and Sperimentazione. L'attività del giovane Pier Luigi Nervi a Prato* (Campi Bisenzio: Centro Grafico Editoriale, 2008). The first work that would become famous outside of Italy is the Stadium of Florence (1930–1933). In 1932 he founded the Company Nervi and Bartoli with which he would build his most important buildings in Italy. From 1963 to 1965 Nervi stopped working on engineering projects for his company, but he resumed this activity when the war ended and in 1947 he built Hall B of the Turin Exhibition Hall; for more information about Nervi's career up to this period see Claudio Greco, *Pier Luigi Nervi. Dai primi brevetti al Palazzo delle Esposizioni di Torino. 1917–1948* (Lucerne: Quart Edizioni, 2008). Nervi designed the main buildings for the Rome Olympic Games of 1960, making his firm internationally famous. The engineer worked in the

United States during the latter part of his career in close collaboration with his son Antonio. Pier Luigi Nervi died on January 9, 1979 in Rome. For more information about Nervi's experience in the U.S., see Alberto Bologna, "Pier Luigi Nervi: rapporti statunitensi inesplorati," in Salvatore D'Agostino, *Storia dell'Ingegneria, atti del III convegno nazionale (Napoli, 19-20-21 of April 2010)* (Napoli: Cuzzolin, 2010), 1119–29.

2. Sergio Poretti, "Nervi che visse tre volte," in Tullia Iori and Sergio Poretti, *Pier Luigi Nervi. L'ambasciata d'Italia a Brasilia* (Milano: Electa, 2008), 9–50.

3. This chapter is the result of research carried out up to now by the author at the following Institutions: the Nervi Archives, MAXXI, Rome; the Pusey Library and the Loeb Library, Harvard University, Cambridge, Massachusetts; the Museum of Modern Art of New York, New York; the Institute of Arts and Letters of New York, New York; the Pietro Belluschi and Marcel Breuer Papers at the Special Collections Research Center, Syracuse University, Syracuse, New York; the Dartmouth College Archives at Rauner Library, Hanover, New Hampshire; CSAC in Parma.

4. Conny Cossa, *Modernismo all'ombra. La sala delle udienze pontificie di Pier Luigi Nervi* (Città del Vaticano: Libreria Editrice Vaticana, 2010), 27.

5. Pier Luigi Nervi was responsible for the construction of six buildings in the United States: the roof of the Manhattan Bus Station in New York, the Leverone Field House at Dartmouth College in Hanover, he was the structural consultant for the design and implementation of St. Mary's Cathedral in San Francisco, the Cultural and Convention Center in Norfolk (the arena and the theater), Virginia, and the Thompson Arena Hockey Rink also at Dartmouth College. He also built, with the architect Luigi Moretti, the skyscraper Place Victoria in Montreal.

6. Letter dated March 11, 1960 from Mario Salvadori to Pier Luigi Nervi, MAXXI, Fondo PLN, Pacco Corrispondenza Professore 1960–1961 I-Z, S.

7. See series of correspondence by Richard W. Olmsted, Dartmouth College Rauner Library, UGS 30 C7 DA-643 (14) 5703.

8. Letter October 24, 1960 from Richard W. Olmsted to Jackson Smith, Dartmouth College Rauner Library, UGS 30 C7 DA-643 (14) 5703.

9. Memorandum by Richard W. Olmsted, October 17, 1960, Dartmouth College Rauner Library, UGS 30 C7 DA-643 (14) 5703.

10. Letter dated January 25, 1967 from Richard W. Olmsted to Robert C. Dean, Dartmouth College Rauner Library, UGS 30 A7 DA-643 5730.

11. "Hockey Rink Construction" March 29, 1967, Dartmouth College Rauner Library, UGS 31 B3 DA-643 5750.

12. Antonio and Vittorio Nervi.

13. Pier Luigi and Mario Nervi.

14. Pier Luigi Nervi, "Precast Concrete Offers New Possibilities for Design of Shell Structures," *ACI News Letter. Journal of the American Concrete Institute* 24, no. 6: 537–48. The following is written under the title: "Based on a paper prepared by the author and presented by Louis P. Corbetta at the ACI Fifth Regional Meeting, Chicago, Sept. 12, 1952."

15. Letter dated August 27, 1953 from Father Abbot to Marcel Breuer, Archives of American Art, Washington, D.C., Marcel Breuer Papers, 1920–1986. Series 2: Correspondence August-December 1953, Reel 5712, Frame 56. See also series of preliminary drawings, Syracuse University (New York), Marcel Breuer Papers, Tube n. 698, St. John's Church.

16. The American institution that would focus most on Pier Luigi Nervi's innovative construction technique would be the American Concrete Institute: the relationships developed during the fifties and the professed interest in the technology of *ferrocemento* would lead to the allocation of the Alfred E. Lindau Award to Nervi for the year 1962.

17. Giulio Carlo Argan, *Pier Luigi Nervi* (Milano: Il Balcone, 1955).

18. Tullia Iori, *Pier Luigi Nervi* (Milano. Motta Architettura, 2009), 70.

19. Pier Luigi Nervi, *Structures* (New York: F. W. Dodge Corporation, 1956).

20. Ada Louise Huxtable, *Pier Luigi Nervi* (New York: George Braziller, Inc., 1960).

21. Pier Luigi Nervi, *Buildings, Projects, Structures. 1953–1963* (New York: Frederick A. Preager Publisher, 1963).

22. Pier Luigi Nervi, *Aesthetics and Technology in Building* (Cambridge, Mass.: Harvard University Press, 1965).

23. The study of Pier Luigi Nervi's private correspondence at the MAXXI in Rome has highlighted an ongoing working relationship that lasted a decade, from 1955 to 1965, with the Fulbright program in Rome.

24. For more information regarding the American activities of Giulio Pizzetti, see: Francesco Catalano and Marina Dal Piaz, *Giulio Pizzetti. Ingegnere tra gli architetti* (Venice: Centro Editoriale Veneto, 1994).

25. Anthony Alofsin, *The Struggle for Modernism: Architecture, Landscape Architecture, and City Planning at Harvard* (New York and London: W. W. Norton, 2002).

26. Pier Luigi Nervi was the first Italian invited to hold the Norton Lectures at Harvard and, to date, remains the only person born in Italy to do so in the role of architectural designer; later Italo Calvino was appointed in 1984 and Umberto Eco in 1992.

27. Pier Luigi Nervi, "Some Considerations About Structural Architecture," in *Student Publications of the School of Design North Carolina State College. Raleigh, North Carolina* 11, no. 2 (1963): 41–7.

28. Museum of Modern Art, *Twentieth Century Engineering* (New York: The Museum of Modern Art, 1964).

29. San Francisco Museum of Art, *Pier Luigi Nervi. Space and Structural Integrity* (San Francisco: San Francisco Museum of Art, 1961).

30. David Nye, *American technological sublime* (Cambridge, Mass: The MIT Press, 1994).

31. In the late 1970s, once aware of Studio Nervi's limits on the U.S. labor market, Antonio Nervi focused his energies on the export of his professional office in the Middle East and Africa. See letter dated April 6, 1977 from Antonio Nervi to Richard Olmsted, MAXXI, Fondo PLN, Pacco Velinario Studio Nervi with letters from January 1, 1977 to December 31, 1978.

32. Michael McClelland and Graeme Steward, *Concrete Toronto. A guidebook to concrete architecture from the Fifties to the Seventies* (Toronto: Coach House Books and E.R.A. Architects, 2007).

33. Carlo Olmo and Cristiana Chiorino, ed., *Pier Luigi Nervi. L'Architecture comme défi* (Cinisello Balsamo: Silvana Editoriale, 2010).

34. Andrew Saint, *The image of the architect* (New Haven and London: Yale University Press, 1983).

BIBLIOGRAPHY

"Architect Nervi Slated As Norton Lecturer." Cambridge, MA: *The Harvard Crimson*, News, April 10, 1962.

Alofsin, Anthony. *The Struggle for Modernism: Architecture, Landscape Architecture, and City Planning at Harvard.* New York and London: W. W. Norton, 2002.

Argan, Giulio Carlo. *Pier Luigi Nervi.* Milano: Il Balcone, 1955.

Bologna, Alberto. "Pier Luigi Nervi: rapporti statunitensi inesplorati." In D'Agostino, Salvatore. *Storia dell'Ingegneria, atti del III convegno nazionale (Napoli, 19-20-21 of April 2010).* Napoli: Cuzzolin, 2010. 1119–29.

Catalano, Francesco, and Marina Dal Piaz. *Giulio Pizzetti. Ingegnere tra gli architetti.* Venice: Centro Editoriale Veneto, 1994.

Cossa, Conny. *Modernismo all'ombra. La sala delle udienze pontificie di Pier Luigi Nervi.* Città del Vaticano: Libreria Editrice Vaticana, 2010.

Dartmouth Alumni Magazine. Hanover, NH: Dartmouth College, May 1961.

Greco, Claudio. *Pier Luigi Nervi. Dai primi brevetti al Palazzo delle Esposizioni di Torino. 1917–1948.* Lucerne: Quart Edizioni, 2008.

Guanci, Giuseppe. *Costruzioni and Sperimentazione. L'attività del giovane Pier Luigi Nervi a Prato.* Campi Bisenzio: Centro Grafico Editoriale, 2008.

Huxtable, Ada Louise. *Pier Luigi Nervi*. New York: George Braziller, Inc., 1960.

Iori, Tullia, and Sergio Poretti. *Pier Luigi Nervi. L'ambasciata d'Italia a Brasilia*. Milano: Electa, 2008.

Iori, Tullia. *Pier Luigi Nervi*. Milano: Motta Architettura, 2009.

Museum of Modern Art. *Twentieth Century Engineering*. New York: The Museum of Modern Art, 1964.

Nervi, Pier Luigi. "Precast Concrete Offers New Possibilities for Design of Shell Structures." *ACI News Letter. Journal of the American Concrete Institute* 24, no. 6: 537–48.

———. "Some Considerations About Structural Architecture." In *Student Publications of the School of Design North Carolina State College. Raleigh, North Carolina* 11, no. 2 (1963): 41–47.

———. *Structures*. New York: F.W. Dodge Corporation, 1956.

———. *Buildings, Projects, Structures. 1953–1963*. New York, Frederick A. Preager Publisher, 1963.

———. *Aesthetics and Technology in Building*. Cambridge, MA: Harvard University Press, 1965.

Nye, David. *American technological sublime*. Cambridge, MA: The MIT Press, 1994.

McClelland, Michael, and Graeme Steward. *Concrete Toronto. A guidebook to concrete architecture from the Fifties to the Seventies*. Toronto: Coach House Books and E.R.A. Architects, 2007.

Olmo, Carlo, and Cristiana Chiorino, ed. *Pier Luigi Nervi. L'Architecture comme défi*. Cinisello Balsamo: Silvana Editoriale, 2010.

Poretti, Sergio. "Nervi che visse tre volte." In *Pier Luigi Nervi. L'ambasciata d'Italia a Brasilia*, by Tullia Iori and Sergio Poretti, 9–50. Milano: Electa, 2008.

Saint, Andrew. *The image of the architect*. New Haven and London: Yale University Press, 1983.

San Francisco Museum of Art. *Pier Luigi Nervi. Space and Structural Integrity*. San Francisco: San Francisco Museum of Art, 1961.

LIST OF CONSULTED ARCHIVES

American Academy of Arts and Letters, New York NY, USA.

Fondo Pier Luigi Nervi, Collezione MAXXI Architettura, Ministero per i Beni e le Attività Culturali, Rome, Italy.

Fondo Pier Luigi Nervi, Centro Studi e Archivio della Comunicazione dell'Università di Parma (CSAC), Italy.

Dartmouth College Rauner Library, Dartmouth College, Hanover NH, USA.

Harvard University Archives, Nathan M. Pusey Library, Harvard University, Cambridge, MA, USA.

Institute Archives and Special Collections, Massachusetts Institute of Technology, Cambridge, MA, USA.

Smithsonian Archives of American Art, Washington D.C.

Special Collections, *Francis Loeb Design Library*, Harvard University, Cambridge, MA, USA.

Pietro Belluschi Papers and Marcel Breuer Papers, Special Collections Research Center, *Syracuse University Library*, Syracuse NY, USA.

The Museum of Modern Art Archives, New York NY, USA.

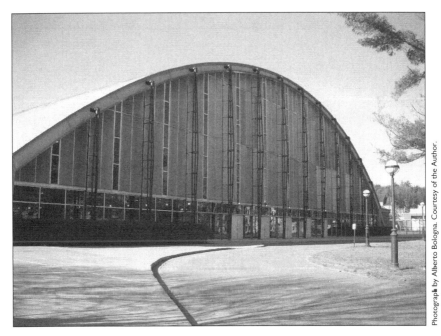

Pier Luigi Nervi, Leverone Field House, Dartmouth College, Hanover, NH (photo by Alberto Bologna).

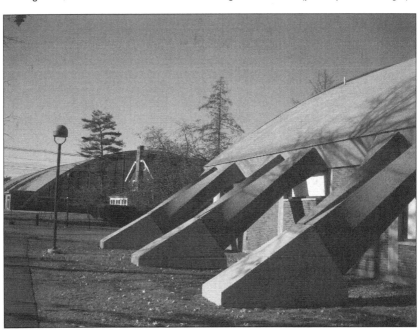

General view of the two Nervi's buildings, Dartmouth College, Hanover, NH.

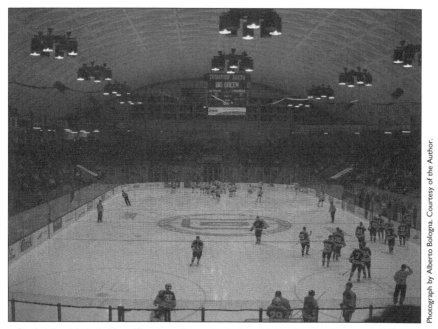

Photograph by Alberto Bologna. Courtesy of the Author.

Pier Luigi and Antonio Nervi, Thompson Arena, the hockey rink, interior view, Dartmouth College, Hanover, NH.

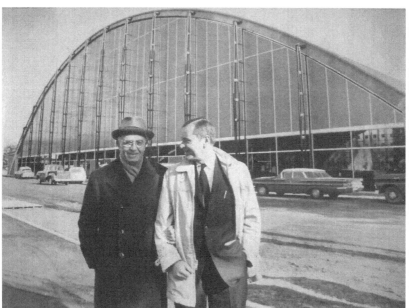

Photo taken from the magazine Vitruvi. Lastre di Vetro e Cristalli, n. 156, July-August 1966, 7.Courtesy of the Author.

Pier Luigi Nervi (the person on the left) with Richard Olmsted in front of the Leverone Field House, Dartmouth College, Hanover NH.

IV

FASCISM

FORM FOLLOWS FICTION

Redefining Urban Identity in Fascist Verona through
the Lens of Hollywood's Romeo and Juliet
Maria D'Anniballe

With great fanfare and press coverage in March 1937, seven months after the New York City premiere, George Cukor's movie *Romeo and Juliet* was released in the city of Verona. Between 1937 and 1942, the long-neglected sites of Juliet's house and tomb underwent a swift and dramatic architectural makeover and plans were drawn up for the restoration of Romeo's house. This paper analyzes the relationship between Cukor's film and the reconfiguration of Verona's urban space and identity under the Fascist administration. I argue that the Hollywood movie industry impacted the city's urban landscape in profound and multifaceted ways. Besides promoting the restoration of sites traditionally associated with the Shakespearean play, the movie affected the portrayal of the city in other media, including documentary films sponsored by the central government, and in the process changed the image of Verona as perceived by the city's citizens and its visitors. Indeed, Cukor's cinematic portrayal of Verona provided tourists and residents alike with a lens through which to view the actual city, and supplied local and central administrators with an ideal model for the reshaping of Verona's urban fabric. Contrary to traditional understanding of Fascist-sponsored restoration projects as top-down undertakings, directly controlled by the central government, the case of Verona shows the contribution of inter-

national narratives to the debate surrounding the refashioning of Italy's built heritage. Scholars have shown how Fascism used mass media as propaganda; however, the case of Verona reveals that mass media affected the regime's relationship with the city's architectural past, forcing the central government to negotiate its project of appropriation of the city's architectural heritage within a broader framework of international assumptions about and identification with Verona's illustrious history.

Starring Norma Shearer and Leslie Howard in the roles of the two protagonists, the Hollywood motion picture *Romeo and Juliet* was a major production featuring a fictional Verona at the center of its action. Irving Thalberg, MGM founder and Hollywood's fabled Boy Wonder, conceived of *Romeo and Juliet* as a prestige film that would enhance MGM's reputation and earn him cultural respectability.[1] No expenses were spared: Thalberg hired George Cukor to direct his movie; Oliver Messel, a famous British artist, was recruited to design the lavish costumes; Cedric Gibbons, Hollywood's most celebrated artistic director, supervised the elaborate sets; and two professors, William Strunk of Cornell and John Tucker Murray of Harvard, were hired to serve as literary advisors. Thalberg also sent a troupe to Verona in the summer of 1935 to research the local libraries and document every corner of the city with more than 2,500 photographs.[2] For a while he even considered shooting Romeo and Juliet on location in Italy. However, the added cost to an already very expensive production and the unstable political climate in Europe dissuaded him from the idea.[3] Instead, an imaginary Verona was built on MGM's largest back lot.

Commenting on the sets, Gibbons underlined that a faithful reproduction of Verona's architectural fabric was never the objective. Rather, set designers aimed at creating a compelling framework for the unfolding of the action. The imaginary Verona square in the opening scene, for instance, was designed to appear like a typical Italian medieval piazza.[4] The space, dominated by the profile of a church reminiscent of San Zeno and surrounded by buildings fronted by loggias and crowned with crenellations, sets the tone for the scenes to come: monumental, authoritative, and highly fictionalized with no direct relation to any urban settings in Verona. The references to Palazzo della Ragione, Palazzo Scannagatti, and the Tombs of the Scaligeri that historians have identified in the architecture of the buildings framing the movie's square did

not in fact dictate the space's overall configuration and appearance.[5] The square's design was determined, as stated by Gibbons, by cinematographic considerations. In particular, the openness of the space and the contrast between vertical and horizontal forms were created to showcase the fight unfolding between the Capulets and the Montagues on their way to the cathedral.[6]

The ballroom scene was designed to display the luxury, majesty, and glory of the Renaissance.[7] Gibbons explained how the ballroom's classicized forms, delicate colors, and rich interiors were intended to make this part of the house look as if it was newly created in the period of the events, while the rest of the palace was made to appear to be from an earlier period.[8] In his view, the architectural proportions of the ballroom and its lavish materials were signs that the palace's austere medieval architecture had been either demolished or altered to fit the new, more material and less spiritual approach to life that characterized the Renaissance and that resulted in the period's quest and appreciation for luxury and display.[9] Unanimously acclaimed as the setting for one of the most beautifully staged sequences in the film, the ballroom was imaginatively executed with no specific reference to any historical palazzo in Verona.

The balcony scene, one of the most demanding for the technical resources required, was filmed in a garden which occupied MGM's largest stage. The architecture displays a combination of elements from several periods. The balcony itself is a faithful reproduction of the exterior pulpit of the Cathedral in Prato, built by Michelozzo da Forlì and decorated by Donatello in the fifteenth century.[10] The Renaissance pulpit is supported by a single column and showcases white marble panels decorated with bas-relief cherubs dancing and playing musical instruments. Hollywood designers appropriated the Renaissance structure adding thin columns to support the canopy and replacing the simple molded capital of the Prato pulpit with a more elaborate and visually complex composite capital, meant to suggest the wealth of the Capulet family.[11] Other architectural elements included corbelled arches, freestanding columns, and arched windows, all from different periods.

The eclecticism of the architectural elements was reflected in the landscaping, which went beyond the historically plausible internal courtyard to showcase a variety of plants and flowers merging English and Italian styles.[12] Twisted vines covered the walls, blossoms supported

the balcony, and cypresses and fruit trees punctuated the cross-axial plan. Designed by Florence Yoch, the garden featured two reflecting pools that expanded the space while adding to the complexity and intricacy of the garden's layout.[13] All the elements were combined to create an ideal site, suggesting longevity (cypress) and young love (blossoms) in a setting that was not wholly compliant to historical accuracy, and yet had its sources in the Mediterranean landscape.[14] Garden and architecture fittingly complemented each other, underscoring the status and power of Juliet's family.

The movie's final scene shows Romeo entering Juliet's burial chamber, a dark, vaulted-ceilinged space, modeled after the Chapel of St. Giacomo in Vicovaro (Rome).[15] The strong visual contrast between the verticals of the candlesticks and the horizontals of the tomb and Juliet's resting body create a powerful setting for the play's dramatic conclusion.[16]

The movie was well received. Critics praised it as "a handsome production, one which is truly cinematic, lavishly costumed, opulently framed, performed by a company which, considered en mass, is little short of brilliant."[17] Reviews commented on the quality of the elaborate setting in which "the deep beauty of . . . romance glows and sparkles and gleams with breathless radiance."[18] They also underlined the inventiveness of the staging. Commenting on the sets and costumes, *The Times* reported: "Mr. Oliver Messel had the wit to feed his imagination on the early Italians. . . . The result is an appropriately young production, not based on any artist in particular."[19] The opulent costuming and calibrated direction won Cukor's film four Academy award nominations including one for best picture.[20]

Romeo and Juliet had a direct impact on Verona's urban fabric. Although highly imaginative in its rendition of the city, the film created among movie audiences an image of Verona as a charming medieval town, with a picturesque city center and pristine architectural monuments. The house and tomb of Juliet in particular became objects of great interest and curiosity to travelers. Left unmarked and unkempt for centuries, the two sites underwent a timely and highly controversial makeover in the aftermath of the renewed interest the movie had brought to the city. Restoration projects were initiated at the local level. The city entrusted to Antonio Avena, Verona museums director, the task of drawing up plans for the refashioning of both sites, allocated

money for the projects, and submitted plans for approval to the *Soprintendenza*, the local government office in charge of the preservation and restoration of historic monuments. In a letter sent to the minister of public education on June 2, 1938, Verona's Superintendent Alfredo Barbacci explained that the reasons that prompted the city to engage in the refashioning of Juliet's house and tomb were both economic and sentimental. With these projects the city aimed at "attracting tourists, especially foreign ones and reinforcing the link between Verona and the legend of the two lovers."[21] In accordance with this aim, the two buildings were stripped of their centuries-old architectural layers and restored to an idealized medieval appearance. Juliet's house, an L-shaped thirteenth-century structure along Via Cappello, one of the city's busiest streets, was originally owned by the Dal Cappello family, whose coat-of-arms is carved into the keystone of the courtyard's inner archway. Although there are no records linking this house to Juliet's family, the Capulets, the similarities between the two family names—Dal Cappello and Capuleti—started the popular belief that this was the house of the famous Shakespearean heroine.

Following Cukor's movie, the house was totally reconfigured. First the façade on the inner courtyard was cleaned and repointed, while new arches and arched windows were opened to enhance its medieval appearance. The balcony, one of the architects' most imaginative solutions, is a medieval sarcophagus formerly housed in the nearby museum of Castelvecchio. Modified to serve the new function, the structure was attached to the first floor of the newly restored façade to match the Shakespearean text.[22] Lastly, the interior of the house was decorated with paintings and frescos reproducing medieval motifs, furnishings from the sixteenth and seventeenth centuries, and Renaissance ceramics from Verona. The refashioning of the first floor main hall was inspired by the popular painting by Francesco Hayez "The Last Kiss of Romeo and Juliet" showing the two lovers kissing as they say their last goodbye.[23] Antonio Avena, who directed the restoration project, faithfully reproduced the interior arcade of double columns lit by the profile of the trilobite windows that frames the lovers' last kiss. Historical accuracy was not an issue as archeological investigations and philological approach to restoration yielded to the fantastic creation of an idealized medieval architecture.

A similarly imaginative approach guided the refashioning of Juliet's grave. The tomb, consisting of a fairly simple red marble sarcophagus, was originally housed in the cloister of the former medieval convent of San Francesco al Corso.[24] Identified by various sources as the burial place of Juliet as early as the beginning of the nineteenth century, the site quickly became one of Verona's favorite destinations for illustrious foreign visitors including George Byron, Charles Dickens, Madame de Stael, and Empress Maria Luisa of Austria.[25] Travelers wrote extensively about the profound awe that captured them at the sight of Juliet's resting place but also expressed dismay over the lack of care affecting the site, "a most miserable little inn" according to Dickens's account.[26] Indeed, by the mid-nineteenth century, the structural stability of the entire complex appeared to be seriously compromised. Although limited attempts to stop the decay of the complex were carried out at different points in its history,[27] a comprehensive plan for the restoration of the site was drawn up only after the publicity brought to the city by Cukor's movie. On April 4, 1938, Podestà Alberto Donnella approved a budget of 100,500 Lira to finance the refurbishing of Juliet's tomb. In the document, Donnella stressed the need to repair the site, "one of the most visited monuments in Verona, especially by foreign tourists," and give Juliet's tomb "a more dignified appearance, coherent with the image celebrated in the Shakespearean play."[28] As a result, Via Franceschine, the street leading up to the tomb, was refurbished with stone benches, columns, fountains, and trees, which created a powerful prelude to the experience of Juliet's grave. The red marble sarcophagus was moved from the cloister to a brand-new crypt created for the occasion out of two underground rooms. Dismissed by the preservationists as "a ridiculous fake, made necessary to give historic credibility to a place that any cultured visitor would disapprove,"[29] the tomb instantly became one of Verona's most visited sites.

The controversial refashioning of the Shakespearean sites could be carried out in spite of the resistance of the preservationists because of the ability of Verona's social and political elites to capitalize on the interest of the central government in their city in order to impose their vision of the past and neutralize the opposition of the preservation agency. Indeed, the Ministry of Public Education, the branch of the central state authority responsible for granting final approval to restoration projects,

appears to have been unable to resist the pressure of local authorities seeking authorization for their projects. In a few instances local officials did not hesitate to seek the support of the Ministry of Internal Affairs, held by Mussolini himself, who responded by granting authorization and funds to controversial restoration projects. Studies have shown that in many medieval towns across Italy, Fascism often favored simplified narratives about the past, (re)creations in a neo-medieval style rather than faithful restitutions of the buildings' multiple historical layers.[30] The celebration of an idealized medieval heritage, devoid of complicating factors such as successive additions, had several goals including those of celebrating a historical era of military strength and political independence, promoting a feeling of shared national identity, and asserting Fascism as the legitimate heir of that tradition.[31] In Verona, the regime did not oppose and in many cases openly favored local initiatives aimed at recreating simplified versions of the architectural past. The list of monuments restored according to an idealized appearance—however remote this may have been from the building's historical realities—extended to other monuments, including Castelvecchio (1923–1926) and Palazzo del Podestà (1929–1930). These cleansed, highly selective, and often arbitrary recreations cohered with Mussolini's agenda of asserting Italy's cultural supremacy while promoting an ideal and immediate association between the Fascist present and Verona's historic tradition. It was mainly for these reasons that the central government took special care in facilitating MGM's stay and work in Verona. A letter sent by Galeazzo Ciano to the Prefect requested that full support and help be given to the MGM executives while in Verona.[32] The simplified medieval narrative of Verona's political elite, then, gained strength as it received the support of central state authority.

The impact of *Romeo and Juliet* extended beyond the refashioning of sites linked to the Shakespearean play. Indeed, the movie reframed the regime's portrayal of the city and reshaped the perception of Verona's identity for locals and tourists alike. A comparison between two film documentaries on Verona and its architectural landscape reveals changing attitudes toward the city and what the regime deemed worthy of consideration. The two documentaries, filmed respectively before and after the release of Cukor's movie (1932 and 1941), offer distinctly different cinematic portrayals of the city: the 1932 docu-

mentary is steeped in Roman and medieval tradition while the 1941 version emphasizes a city of multilayered identities—historic, artistic, and literary. The two documentaries were part of a series of short films—five to ten minutes long—sponsored by the central government to promote relevant artistic and historic sites in Italy to movie-going audiences.[33] They were shown prior to the main feature presentation in all commercial film theaters. Where movie theaters were not available, traveling trucks projected newsreels and documentaries on freestanding, portable screens in piazzas and open fields throughout the peninsula.[34] Besides featuring Italy's cultural and artistic treasures, documentaries covered a variety of topics, touching on all aspects of agriculture, industry, sport, culture, and education.[35] As such, these short films provided Fascism with a powerful tool to inform audiences on the achievements of the regime and advance its agenda.

The 1932 documentary opens with an aerial view of Verona and the surrounding area. As the camera descends to ground level, spectators are presented with images of the train station, railroad tracks, and moving trains. The main arrival point for Verona, the train station elicited the idea of a productive and modern city that both contrasted with and complemented the images of Roman and medieval monuments to which viewers were about to be introduced. A streetcar moving through Verona's city gate (Porta Nuova) provides the ideal transition to introduce viewers to a tour of the historic city. Verona's most iconic monuments are shown in rapid sequence: the piazza dei Signori with the recently restored Palazzo del Podestà, the monument to Dante, the Tombs of the Scaligeri, and the monument to Verona's ruler Can Grande della Scala are followed by snapshots of the thirteenth-century Palazzo del Capitanio with its monumental staircase and soaring bell tower. Piazza Erbe is shown next; its outdoor market provides a lively contrast to the timeless nature of the square's landmarks, including the marble column bearing the Lion of St. Mark and the fourteenth-century fountain of Madonna Verona. After showing the city's oldest bridge, Ponte Pietra, spanning the Adige River, the camera pans Colle San Pietro, the hill rising on the east bank of the river. One of the city's most picturesque sites, San Pietro is home to many historic buildings including the first-century BCE Roman Theater, the Romanic church of San Pietro in Castello, and the imposing nineteenth-century fortress built by the Austrians on

the remains of a fourteenth-century castle. The documentary then introduces audiences to the religious architecture of Verona, showing images of the cathedral and multiple views of San Zeno with its monumental portal and delicate cloister. Two minutes from the end, the aerial view resumes to reveal the imposing complex of Castelvecchio. The camera scans the crenellated silhouette of the castle and its bridge, emphasizing the medieval character of its architecture. As the camera zooms out to a panoramic view of the city's skyline, viewers are presented with the instantly recognizable profile of the *Arena*, the first-century CE Roman amphitheater for which the city was best known. The monument is introduced from above, a perspective that best reveals the integrity and monumentality of its architecture. Spectators are then brought back to ground level to contemplate a frontal view of the Arena and explore the adjacent Palazzo del Municipio in the context of Piazza Bra, Verona's largest public square.

The documentary ends with images of Giardino Giusti, a typical Renaissance garden featuring a geometrical layout of flowerbeds and hedgerows, fountains, mythological statues, and avenues of cypresses. Six minutes long, the silent documentary is conceived as a series of snapshots of Verona's architectural treasures taking viewers from the present time to the city's oldest Roman tradition, with the two monuments shown at the end, Castelvecchio and the Arena, symbolizing Verona's twofold identity: Roman and medieval, both constituting the source of current Fascist state power.

The 1941 documentary reveals a more fictional approach. The production company that produced the movie, INCOM (Industrie Cortimetraggi), was founded in 1938 by Sandro Pallavicini, partly in response to complaints by militant intellectuals about the poor quality and insufficient mass appeal of current newsreels and documentaries.[36] INCOM specialized in dramatic angles, juxtaposition of shots, and interesting contrast of light that gave documentaries the look and appeal of fiction movies. These films, according to historian Elaine Mancini, "are characterized by a search for the past, or at least the past as reflected in the present, a search for history and a search for tranquility."[37]

The 1941 documentary on Verona is a clear example. It begins with scrolling credits in an old-style font, which prepares the audience for a movie-like experience and sets the tone for a historic narration. The

fast-moving trains of the 1932 documentary are replaced by images of the Adige River slowly flowing through the historic city. Verona is a town steeped in history and literary associations; as the voice-over commentary emphatically states, "History and legend; love tales and hate stories . . . shouts of condottieri and visions of poets. On this ideal background Verona lays down its proud and graceful structure." Thus, audiences are provided with a narrative to read and a lens to interpret the images of the city they are about to see.

As the documentary unfolds, viewers are taken on a journey that begins with Roman antiquity and ends in the Middle Ages, both eras constituting the basis of Verona's present greatness. The Fascist regime is implicitly portrayed as the heir to those celebrated historic traditions and as the agent that has resurrected the city's glorious past. First an impressive series of monuments from Roman antiquity are shown. They mirror those featured in the 1932 documentary: Ponte Pietra, the Roman theater perched on the hillside of San Pietro, high above the city, and the Arena, "the last voice of a vigorous and carnal world." Great emphasis is also devoted to Arco dei Gavi, the Roman arch built in honor of the Gavia family in the first century CE. Dismantled in 1805 by the French Army, the arch was reassembled in 1932, in the fervor of Fascist celebration of Roman classical tradition. In slow camera movements, the documentary shows the architectural and decorative details of the arch, emphasizing its Corinthian columns and the large, well preserved tympanum. Roman architecture is portrayed as being at the basis of Verona's urban identity. Dramatic camera work and suspenseful music crescendo underscored the monumentality of the featured sites while engaging the audience on a visual and auditory level.

After returning to the river, which functions as a spatio-temporal transitional element, the camera scans Verona's medieval monuments from the Romanic complex of San Zeno, to the Lamberti Tower, to the city's main public squares. Piazza Erbe, occupying the site of the Roman forum, is introduced as "the most unique market in the world, where history, art, and trade come together." As the camera pans a market-place bursting with life and activities, viewers are invited to contemplate the historic nature of the architecture framing the square. Piazza Bra, "inspired by the memory of Roman rule," is shown next. Its ample scale and sense of openness contrast sharply with the

intimate and secluded nature of Piazza dei Signori, the last public square featured in the documentary. As the camera zooms on the monument to Dante, viewers are told that the Florentine poet, exiled from his city, found refuge in Verona at the court of Can Grande, the great condottiere who ruled the city from 1311 to 1329. Images of Can Grande's equestrian statue follow. The film then turns to Castelvecchio. The fortress is approached from the river, a perspective that best reveals the profile of its soaring architecture.

Three minutes from the end, images of a dining room in a warm dim light cast by the flickering fire in the hearth introduce viewers to the story of Romeo and Juliet. As two off-camera voices recite verses from the Shakespearean play, viewers are taken through the sites of the legend: Juliet's bedroom, the famous balcony, and lastly her tomb. The Shakespearean-inspired architecture is presented as if the two lovers had just left the scene: the dining table set for two, the bedroom's open window, and the oil lamp burning next to their grave leave viewers with a tangible feeling of Romeo and Juliet's presence, which in turn gives historic credibility to the sites featured in the documentary. With no references to Avena's dramatic reconfiguration, the house and tomb of Juliet are presented as pristine medieval structures, an integral part of Verona's built heritage. They are allocated three minutes, one third of the entire documentary, leaving no doubts about the relevance Shakespearean Verona had gained in Fascist policies in the aftermath of Cukor's movie. The movie ends with the camera zooming on the waters of the Adige River while the distant music of church bells fades into the film score's finale. The narrator's final words, "and while tragedy dissolves into the light of love, the voice of the Bard falls into silence," leave viewers to ponder on the relation between Shakespeare and the city they have just explored.

Subject to direct governmental control, documentaries were, along with newsreels, powerful propaganda vehicles. They represented the most effective form of mass media, being able to reach very diverse audiences, educated and illiterate, urban and rural. Because of their extraordinary communicative potential, these short films offered, according to film historian James Hay, "ways of distilling and magnifying events so that audiences could re-read a national landscape that appeared both natural and ideological."[38] Documentaries featuring cities as protagonists, such as

the ones on Verona, allowed the central government to mythologize the urban landscape while shaping and directing the experience of the city for movie-going audiences.[39] By emphasizing specific sites and eliminating others, by highlighting the historic nature of monuments and withholding references to their twentieth-century refashioning, they created a specific narrative of pristine architectural heritage, which was meant to inculcate in viewers a feeling of shared national pride while supporting the regime's universalistic ambitions. The 1941 documentary exploited the Hollywood film's narrative to foreground a more complex and appealing image of Verona compared to the 1932 documentary. Verona was to be visited and remembered for its Roman and medieval monuments and equally relevant, for the immortal legend of the two Shakespearean lovers, whose presence can be felt in the seemingly pristine medieval sites featured in the documentary. The literary prestige of the Romeo and Juliet play was harnessed by the regime as a manifestation of Verona's great cultural tradition and evidence of Italian genius.

Nevertheless, Shakespeare's nationality posed a threat to the Fascist claim of Italian cultural universalism. The regime, well aware of the need to address the impasse, chose to revive dubious theories claiming an Italian origin for the Bard. Studies arguing the possibility of an Italian Shakespeare had been circulating since 1925. Although diverging in details, these works argued that William Shakespeare was born either in Valtellina (Lombardy) or Messina (Sicily) as Michele Agnolo Florio, of the doctor Giovanni Florio, and Guglielma Crollalanza, a Sicilian noblewoman. The family, known for its Calvinist sympathies, was forced to flee to London at the time of the Inquisition. There, the young Florio changed his name to William (the English equivalent of his mother's name, Guglielma) Shakespeare (the English translation for Crollalanza).[40] Although lacking in concrete evidence, the theory was revived in the 1930s and announced to the general public in a plethora of newspaper and magazine articles. *L'Arena* published several editorials on the topic. R. Begalli, for instance, wrote that claiming the Italian origin of Shakespeare was "a noble battle, one that cannot be opposed by intelligent people as it is not about stealing a glory from England but rather claiming a glory, which perhaps belongs to us."[41] Although the 1941 documentary did not make the argument for the Italian origin of Shakespeare, by highlighting Verona's multilayered artistic and literary heritage, it fed into Fascist claims

for Italy's cultural and historical primacy. Filmed one year after Italy had joined Germany in the war against the Allied Powers, the documentary was a manifestation of Italian nationalistic rhetoric, renewed and intensified by the escalation of the conflict.

As for the impact the documentary had on viewers' perception of Verona's identity, sources reveal that by the end of the Fascist rule, Juliet's house had been raised to the status of the second most visited site in Verona after the Arena. Other marketing strategies may have contributed to the popularity of Shakespearean sites among visitors, including guidebooks, pamphlets, and organized tours. OND (the Opera Nazionale Dopolavoro), the government agency that organized recreational activities for the lower classes, sponsored regular trips to Verona and guided tours of the city's monuments. OND's local chapter was active in organizing activities for the *sabato fascista* (non-working Saturday afternoon holidays), which included visits to the city's museums and tours of Verona's landmarks.[42] Postcards and prints depicting Verona's monuments, including the house and tomb of Juliet, contributed to publicizing the city's architectural heritage while reinforcing the canon of Verona as a center steeped in history and culture. These forms of mass marketing of Verona were also influenced by Cukor's film, and deployed strategies similar to the 1941 documentary featuring Verona as the city of Can Grande and, equally relevant, of Romeo and Juliet.

Addressing the relationship between cinema and the city, James Hay has noted how "a cinematic connection to certain places transforms those places, their relations and social subjects' relation to them (not only their perception and conception of places, but also their access to, investment in, and movement through them)."[43] According to Hay, cities have been shaped by their relation to cinema in profound ways, which go beyond the material fabric to invest the social reality of the city, its image, myth, and concept. The case of Verona illustrates Hay's point. Cukor's movie portrayal of Verona appears to have unleashed a series of transformations of the city's material fabric as well as a reframing of Verona's image and identity in other media, which in turn conditioned the experience of the city in visitors and citizens alike. More generally, the case of Verona confirms that urban spaces are culturally constructed entities; they are, as posited by Victor Burgin, "the product of representations."[44]

NOTES

1. Roland Flamini, *Thalberg: the Last Tycoon and the World of M-G-M* (New York: Crown Publishers, 2004), 134.

2. Douglas Brode, *Shakespeare in the Movies: from the Silent era to Shakespeare in Love* (Oxford and New York: Oxford University Press, 2000), 44.

3. Flamini, 245.

4. Cedric Gibbons, "Notes on the Design of Motion Picture Settings for Romeo and Juliet," in *Romeo and Juliet: a Motion Picture Edition, Illustrated with Photographs*, ed. William Shakespeare et al. (New York: Random House, 1936), 255.

5. Stefano Lodi, "L'immagine monumentale di Verona nel cinema tra finzione e realtà," in *Luci sulla città*, ed. Paolo Romano and Giancarlo Beltrame (Venezia: Marsilio, 2000), 57.

6. Gibbons, 255.

7. Ibid., 256.

8. Christina Kathleen Wilson, *Cedric Gibbons and Metro-Goldwyn-Mayer: the art of motion picture set design*. Thesis (Ph.D.), University of Virginia, 1998, 180.

9. Gibbons, 256.

10. Juan Antonio Ramírez, *Architecture for the Screen: a Critical Study of Set Design in Hollywood's Golden Age* (Jefferson, NC: McFarland, 2004), 145.

11. As noted by Ramirez, the appropriation in a movie of an architectural structure traditionally used for funeral orations, the preaching of pilgrims, and the exhibition of relics, appeared sacrilegious to one commentator at the time who wrote "Love from a pulpit, eroticism on holy ground—it is a vision deserving of the divine comedy—and of Hollywood which has sublimely risen to the occasion." See A. M. Frankfurter, "Love from a pulpit or the Renaissance in the Movies" in *The Art News* 35, no. 8 (1936): 15 as cited in Ramirez, 145.

12. James Yoch, "Garden for a Director," in *Ah Mediterranean! Twentieth Century Classicism in America*, ed. Charles Moore and Wayne Attoe (Austin: Center for the Study of American Architecture, School of Architecture, University of Texas at Austin, 1985), 61.

13. James Yoch, *Landscaping the American Dream. The Gardens and Film Sets of Florence Yoch, 1890–1972*. (New York: Harry N. Abrams, 1989), 100.

14. Yoch, "Garden for a Director," 61.

15. Mario Tommasoli, "Romeo e Giulietta. Verona giudica per prima la revisione cinematografica della celebre leggenda d'amore," *L'Arena* [Verona, Italy], March 5, 1937: 4.

16. Wilson, 184.

17. Frank Nugent, "The Bard Passes His Screen Test," review of Romeo and Juliet, directed by George Cukor, *New York Times*, August 30, 1936, 3 (X).

18. Frank Nugent, "Metro's Film of 'Romeo and Juliet' Opens at the Astor," review of Romeo and Juliet, directed by George Cukor, *New York Times*, August 21, 1936, 12.

19. Charles Castle, *Oliver Messel: a Biography* (New York: Thames and Hudson, 1986), 104.

20. The movie was also nominated for best actress in a leading role, best actor in a supporting role, and best art direction (though it did not win any).

21. Alfredo Barbacci to Giuseppe Bottai. Letter of 2 June 1938. ASBAPVr, f. 91/170.

22. Daniela Zumiani, "Giulietta a Verona: spazi e immagini del mito," in *Medioevo ideale e Medioevo reale nella cultura urbana: Antonio Avena e la Verona del primo Novecento*, ed. Paola Marini (Verona: Comune di Verona, Assessorato alla cultura, 2003), 215.

23. Ibid.

24. Built in 1230, the church was first destroyed in 1447. In 1459 the church was built again, and in 1548 was entrusted to the convent of the Converted Women, commonly known as the "Franceschine." The complex was partially destroyed by the explosion of a powder magazine, situated in the Tower of the Straw (Torre della Paglia), in 1624. Built up again after the Napoleonic suppressions, it became property of the State in 1803, and was destined to military uses and to welfare institutions. Damaged during World War II, the entire complex fell into disrepair and, in 1961, the bell tower of the church fell. In the 1970s, the building was restored and became a museum (museum of frescos.) See Maristella Vecchiato, "Le fabbriche del dominio scaligero e le loro trasformazioni novecentesche," in *Suggestioni del Passato. Immagini di Verona Scaligera*, ed. Maristella Vecchiato and Ruggero Boschi (Vago di Lavagno: La grafica, 2001), 444.

25. Annamaria Conforti Calcagni, "La Tomba di Giulietta a San Francesco al Corso," in *Medioevo ideale e Medioevo reale nella cultura urbana: Antonio Avena e la Verona del primo Novecento*, ed. Paola Marini (Verona: Comune di Verona, Assessorato alla cultura, 2003), 198.

26. Charles Dickens and David Paroissien, *Pictures from Italy* (New York: Coward, McCann & Geoghegan, 1974), 73.

27. The first partial attempt to stop the decay of the tomb occurred in 1868, when the sarcophagus was moved under a portico, along with the ruins of the ancient cloister. A new, more serious intervention took place in 1910, when the city authorized works to secure the exterior walls of the convent. Nevertheless, as noticed by Superintendent Venè in 1933, more extensive repairs were

needed in order to secure the site and make it accessible to the general public. See Vecchiato, 441.

28. Estratto di deliberazione podestarile, July 15, 1937. ASBAPVr, f. 91/163.

29. Alfredo Barbacci to Marcello Vaccari. Letter of October 27, 1938. ASBAPVr, f. 91/93.

30. The numerous restoration projects undertaken during the Fascist regime were documented in the National Exhibit of Restoration, held in Rome in 1938. See the catalogue of the exhibit, Gustavo Giovannoni, *Mostra del restauro dei monumenti dell'era fascista. Per iniziativa del centro di studi per la storia dell'architettura e della confederazione fascista professionisti e artisti. Sotto l'alto patronato di S.E. il Ministro dell'Educazione Nazionale* (Rome: Mercati Traianei, October 1938).

31. On the motivations driving Fascist refashioning of Italy's medieval heritage see Diane Ghirardo, "Inventing Palazzo del Corte," in *Donatello among the Blackshirts: History and Modernity in the Visual Culture of Fascist Italy,* ed. Claudia Lazzaro and Roger J. Crum (Ithaca, NY: Cornell University Press, 2005), 97–112; and D. Medina Lasansky, *The Renaissance Perfected: Architecture, Spectacle, and Tourism in Fascist Italy* (University Park: Pennsylvania State University Press, 2004).

32. Erik Hesselberg, "La Giulietta di Hollywood. E cominciarono le lettere," *La Cronaca*, February 10, 1993: 24–25.

33. For a discussion of the role of documentaries in the promotion of newly restored towns see Medina Lasansky, "Towers and Tourists: the Cinematic City of San Gimignano," in *Donatello among the Blackshirts: History and Modernity in the Visual Culture of Fascist Italy*, ed. Claudia Lazzaro and Roger J. Crum (Ithaca: Cornell University Press, 2005), 113–31.

34. Ruth Ben-Ghiat, *Fascist Modernities: Italy, 1922–1945*. Studies on the History of Society and Culture, 42. (Berkeley: University of California Press, 2001), 71.

35. Marcia Landy, *Italian film*. National film traditions (Cambridge: Cambridge University Press, 2001), 49.

36. Claudio Fogu, *The Historic Imaginary: Politics of History in Fascist Italy,* Toronto Italian Studies (Toronto: University of Toronto Press, 2003), 106.

37. Elaine Mancini, *Struggles of the Italian Film Industry during Fascism, 1930–1935*, Studies in Cinema, 34 (Ann Arbor: University of Michigan Research Press, 1985), 156.

38. James Hay, *Popular Film Culture in Fascist Italy* (Bloomington: Indiana University Press, 1987), 207–8.

39. Lasansky, "Towers and Tourists," 113.

40. See Martino Iuvara, *Shakespeare era italiano* (Ispica: Ragusa, Sicily, 2002).

41. As reported in Maurizio Zangarini, *Verona Fascista: miscellanea di studi su cultura e spirito pubblico fra le due guerre* (Verona: Cierre, 1993), 130.

42. Marco Girardi, *Verona tra Ottocento e Novecento.* Veneto immagini, 7 (Treviso: Canova, 2004) 158.

43. James Hay, "Piecing together what remains of the cinematic city," in *The Cinematic City*, ed. David Clarke (London: Routledge, 1997), 222.

44. Victor Burgin, "Geometry and Abjection," in *Abjection, Melancholia, and Love: The Work of Julia Kristeva*, Warwick Studies in Philosophy and Literature, ed. John Fletcher and Andrew Benjamin (London: Routledge, 1990), 108.

BIBLIOGRAPHY

Ben-Ghiat, Ruth. "Liberation: Italian cinema and the Fascist Past, 1945–1950." In *Italian Fascism: History, Memory, and Representation*, edited by Richard J. B. Bosworth and Patrizia Dogliani, 83–101. New York: St. Martin's Press, 1999.

———. *Fascist Modernities: Italy, 1922–1945.* Studies on the History of Society and Culture, 42. Berkeley: University of California Press, 2001.

Bordone, Renato. "Medioevo ideale e medioevo reale nella cultura europea della prima metà del Novecento." In *Medioevo ideale e Medioevo reale nella cultura urbana: Antonio Avena e la Verona del primo Novecento*, edited by Paola Marini, 53–62. Verona: Comune di Verona, Assessorato alla cultura, 2003.

Boschi, Ruggero, and Maristella Vecchiato. *Suggestioni del passato. Immagini di Verona Scaligera*. Verona: Edizioni La Grafica, 2001.

Brode, Douglas. *Shakespeare in the Movies: From the Silent Era to Shakespeare in Love*. Oxford and New York: Oxford University Press, 2000.

Brugnoli, Pierpaolo, and Arturo Sandrini. *L'architettura a Verona: dal periodo napoleonico all'età contemporanea*. Verona: Banca popolare di Verona, 1994.

Burgin, Victor. "Geometry and Abjection." In *Abjection, Melancholia, and Love: The Work of Julia Kristeva*. Warwick Studies in Philosophy and Literature, edited by John Fletcher and Andrew Benjamin. London: Routledge, 1990.

Camerlengo, Lia. "Gli architetti veronesi e Antonio Avena." In *Medioevo ideale e Medioevo reale nella cultura urbana: Antonio Avena e la Verona del primo Novecento*, edited by Paola Marini, 223–32. Verona: Comune di Verona, Assessorato alla cultura, 2003.

Cannistraro, Philip V. *La fabbrica del consenso: fascismo e mass media*. Roma: Laterza, 1975.

Castle, Charles. *Oliver Messel: A Biography*. New York: Thames and Hudson, 1986.

Conforti Calcagni, Annamaria. "La Tomba di Giulietta a San Francesco al Corso." In *Medioevo ideale e Medioevo reale nella cultura urbana: Antonio Avena e la Verona del primo Novecento*, edited by Paola Marini, 195–202. Verona: Comune di Verona, Assessorato alla cultura, 2003.

De Grazia, Victoria. *The Culture of Consent: Mass Organization of Leisure in Fascist Italy*. Cambridge: Cambridge University Press, 1981.

Dickens, Charles and David Paroissien. *Pictures from Italy*. New York: Coward, McCann & Geoghegan, 1974.

Falasca-Zamponi, Simonetta. *Fascist Spectacle: The Aesthetics of Power in Mussolini's Italy*. Studies on the History of Society and Culture, 28. Berkeley: University of California Press, 1997.

Flamini, Roland. *Thalberg. The Last Tycoon and the World of M-G-M*. New York: Crown Publishers, 2004.

Fogu, Claudio. The *Historic Imaginary: Politics of History in Fascist Italy*. Toronto Italian Studies. Toronto: University of Toronto Press, 2003.

Forti, Giorgio. "L'immagine di Verona attraverso i secoli." In *Medioevo ideale e Medioevo reale nella cultura urbana: Antonio Avena e la Verona del primo Novecento*, edited by Paola Marini, 275–86. Verona: Comune di Verona, Assessorato alla cultura, 2003.

Gentile, Emilio. *The Sacralization of Politics in Fascist Italy*. Cambridge, MA: Harvard University Press, 1996.

Ghirardo, Diane. "Inventing the Palazzo del Corte in Ferrara." In *Donatello among the Blackshirts: History and Modernity in the Visual Culture of Fascist Italy*, edited by Claudia Lazzaro and Roger J. Crum, 97–112. Ithaca, NY: Cornell University Press, 2005.

Gibbons, Cedric. "Notes on the Design of Motion Picture Settings for Romeo and Juliet." In *Romeo and Juliet: A Motion Picture Edition, Illustrated with Photographs*, edited by William Shakespeare et al. New York: Random House, 1936.

Giovannoni, Gustavo. *Mostra del restauro dei monumenti dell'era fascista. Per iniziativa del centro di studi per la storia dell'architettura e della confederazione fascista professionisti e artisti. Sotto l'alto patronato di S.E. il Ministro dell'Educazione Nazionale*. Rome: Mercati Traianei, October 1938.

Girardi, Marco. *Verona tra Ottocento e Novecento*. Veneto immagini, 7. Treviso: Canova, 2004.

Goethe, Johann Wolfgang von, and W. H. Auden. *Italian Journey, 1786–1788*. New York: Pantheon Books, 1962.

Grimoldi, Alberto. "Restauri a Verona: cultura e pubblico 1886–1940." In *L'architettura a Verona dal periodo napoleonico all'età contemporanea*, edited by

Pierpaolo Brugnoli and Arturo Sandrini, 121–193. Verona: Banca Popolare di Verona, 1994.

Guidorizzi, Mario. "Giulietta e Romeo da Verona a Hollywood." In *Medioevo ideale e Medioevo reale nella cultura urbana: Antonio Avena e la Verona del primo Novecento*, edited by Paola Marini, 195–202. Verona: Comune di Verona, Assessorato alla cultura, 2003.

Hay, James. *Popular Film Culture in Fascist Italy*. Bloomington: Indiana University Press, 1987.

———. "Piecing Together What Remains of the Cinematic City." In *The Cinematic City*, edited by David Clarke, 209–29. London: Routledge, 1997.

Hesselberg, Erik. "La Giulietta di Hollywood. E cominciarono le lettere." *La Cronaca*, February 10, 1993: 24–25.

Iuvara, Martino. *Shakespeare era italiano*. Ispica: Associazione Trinacria, 2002.

Jackson, Russell. *The Cambridge Companion to Shakespeare on Film*. Cambridge: Cambridge University Press, 2000.

Lambert, Gavin, and Robert Trachtenberg. *On Cukor*. New York, NY: Rizzoli, 2000.

Landy, Marcia. *Fascism in Film: The Italian Commercial Cinema, 1931–1943*. Princeton: Princeton University Press, 1986.

———. *Italian Film*. National Film Traditions. Cambridge: Cambridge University Press.

Lasansky, D. Medina. *The Renaissance Perfected. Architecture, Spectacle, and Tourism in Fascist Italy*. University Park: Pennsylvania State University Press, 2004.

———. "Towers and Tourists: the Cinematic City of San Gimignano." In *Donatello among the Blackshirts: History and Modernity in the Visual Culture of Fascist Italy*, edited by Claudia Lazzaro and Roger J. Crum, 113–32. Ithaca, NY: Cornell University Press, 2005.

Lasansky, D. Medina, and Brian McLaren. *Architecture and Tourism: Perception, Performance, and Place*. Oxford: Berg, 2004.

Lenotti, Tullio. *Giulietta e Romeo nella storia, nella leggenda e nell'arte*. Collana le "Guide," 27. Verona: Vita Veronese, 1955.

Levy, Emanuel. *George Cukor: Master of Elegance: Hollywood's Legendary Director and His Stars*. New York: Morrow, 1994.

Lodi, Sefano. "L'immagine monumentale di Verona nel cinema tra finzione e realtà." In *Luci sulla città*, edited by Paolo Romano and Giancarlo Beltrame, 56–65. Venezia: Marsilio, 2000.

Mancini, Elaine. *Struggles of the Italian Film Industry during Fascism, 1930–1935*. Studies in Cinema, 34. Ann Arbor: University of Michigan Research Press, 1985.

Marini, Paola. *Medioevo ideale e Medioevo reale nella cultura urbana: Antonio Avena e la Verona del primo Novecento*. Verona: Comune di Verona, Assessorato alla cultura, 2003.

Martelletto, Maria Grazia. "Sulle tracce del mito shakespeariano." In *Suggestioni del Passato. Immagini di Verona scaligera*, edited by Ruggero Boschi and Maristella Vecchiato, 129–139. Verona: Edizioni La Grafica, 2001.

McGilligan, Patrick. *George Cukor: A Double Life: a Biography of the Gentleman Director*. New York: St. Martin's Press, 1991.

Morachiello, Paolo. "Dall'annessione a fine secolo." In *Ritratto di Verona: lineamenti di una storia urbanistica*, edited by Lionello Puppi, 471–530. Verona: Banca Popolare di Verona, 1978.

Nugent, Frank. "The Bard Passes His Screen Test." Review of Romeo and Juliet, directed by George Cukor. *New York Times*, August 30, 1936, 3 (X).

———. "Metro's Film of 'Romeo and Juliet' Opens at the Astor." Review of Romeo and Juliet, directed by George Cukor. *New York Times*, August 21, 1936, 12.

Pesci, Flavia. *Romeo and Juliet in the Verona of the Shakespearian Legend*. Milan: Electa, 1999.

———. *Imago urbis: il volto di Verona nell'arte*. Verona: Fondazione Cassa di risparmio di Verona Vicenza Belluno e Ancona, 2001.

Provincia di Verona. *Un quadriennio di amministrazione fascista: Marzo 1935–XII-Marzo 1939–XVII*. Verona, 1939.

Ramírez, Juan Antonio. *Architecture for the Screen: A Critical Study of Set Design in Hollywood's Golden Age*. Jefferson, NC: McFarland, 2004.

Ricci, Steven. *Cinema and Fascism: Italian Film and Society, 1922–1943*. Berkeley: University of California Press, 2008.

Romano, Paolo and Giancarlo Beltrame. *Luci sulla città: Verona e il cinema*. Venezia: Marsilio, 2002.

Sandrini, Arturo. "Appunti per una storia urbana: Verona 1900–1945." In *Verona 1900–1960. Architetture nella dissoluzione dell'aura*, edited by Arturo Sandrini and Francesco Amendolagine, 33–54. Venezia: CLUVA, 1979.

Shakespeare, William, Irving G. Thalberg, George Cukor, Talbot Jennings, and William Shakespeare. *Romeo and Juliet: A Motion Picture Edition, Illustrated with Photographs*. New York: Random House, 1936.

Thomas, Bob. *Thalberg: Life and Legend*. Garden City, NY: Doubleday, 1969.

Tommasoli, Mario. "Romeo e Giulietta. Verona giudica per prima la revisione cinematografica della celebre leggenda d'amore." *L'Arena* [Verona, Italy], March 5, 1937: 4.

Vecchiato, Maristella. "Le fabbriche del dominio scaligero e le loro trasformazioni novecentesche." In *Suggestioni del Passato. Immagini di Verona Scaligera*, edited by Ruggero Boschi and Maristella Vecchiato, 149–455. Vago di Lavagno: La grafica, 2001.

Willson, Robert Frank. *Shakespeare in Hollywood, 1929–1956*. Madison, NJ: Fairleigh Dickinson University Press, 2000.

Wilson, Christina Kathleen. "Cedric Gibbons and Metro-Goldwyn-Mayer: The Art of Motion Picture Set Design." PhD diss., University of Virginia, 1998.

Yoch, James. "Garden for a Director." In *Ah Mediterranean! Twentieth Century Classicism in America*, edited by Charles Moore and Wayne Attoe, 58–63. Austin: Center for the Study of American Architecture, School of Architecture, University of Texas at Austin, 1985.

———. *Landscaping the American Dream. The Gardens and Film Sets of Florence Yoch, 1890–1972*. New York: Harry N. Abrams, 1989.

Zalin, Giovanni. *Storia di Verona: caratteri, aspetti, momenti*. Vicenza: N. Pozza, 2002.

Zangarini, Maurizio. *Verona Fascista: miscellanea di studi su cultura e spirito pubblico fra le due guerre*. Verona: Cierre, 1993.

Zumiani, Daniela. "Giulietta e Verona: spazi e immagini del mito." In *Medioevo ideale e Medioevo reale nella cultura urbana: Antonio Avena e la Verona del primo Novecento*, edited by Paola Marini, 203–222. Verona: Comune di Verona, Assessorato alla cultura, 2003.

13

READING CRIME IN FASCIST ITALY

Victoria Belco

Late on the evening of April 30, 1931, outside the remote village of Chiozzo in the commune of Castiglione in the Tuscan province of Lucca, five middle-aged men gathered to light a bonfire in celebration of the reappointment of their friend, Signor Pasquale Pighini, as *Podestà* (mayor) of the comune.[1] The group included the local schoolmaster, the local postmaster, a couple of landowners, and (not least) the former political secretary of the comune's *Fascio*, or local Fascist Party organization.[2] These were men of some position and substance in the local community. Having extinguished the fire sometime after 9:00 p.m. or so, they were on their way back to the village, about 150 meters from the first houses at the edge of town, when they met a group of young men—about twenty in number, all dressed in uniforms of the Fascist Party Militia (MVSN), and a number of whom carried sticks or clubs and at least one hunting rifle or shotgun. The thirteen who were later identified ranged in age from nineteen to twenty-three, were mostly agricultural day laborers (*braccianti*), members of smallholder (or peasant farm) families, and craftsmen.

The two groups might have passed one another without confrontation, until a large stone, apparently thrown by one of the younger men, grazed the postmaster. Increasingly heated words then were exchanged

and included the younger men's insults against the newly reappointed *Podestà*. One of the young militia members, Renato Guazzelli, raised the large stick he was carrying—aiming for the schoolmaster's head—but the teacher was able to deflect the blow with his large black umbrella. Guazzelli then grabbed a companion's hunting rifle (whose ownership was later denied by all), swung the butt at the schoolmaster's head— this time fracturing the teacher's left arm (with which the teacher had covered his head). As the other (older) men tried to run away, both the postmaster, Ferruccio Piagentini, and Amadeo Stefani—the twenty-three-year-old son of Angelo Stefani—were shot, and Angelo was repeatedly struck across the back with a stick. Piagentini died a few days later, and the younger Stefani was permanently incapacitated. The preliminary investigation—that is, the interviews *Carabinieri* carried out with those perpetrators who were identified and with those victims not too badly injured to be interviewed—revealed two dramatically different and conflicting versions, not surprisingly. Further details (and defenses) surrounding the incident proved far thicker than at first look, again, not surprisingly.

What can such an incident tell us, especially when considered together with the official investigation and with the trial that followed? In particular, what can such a case tell us about the presence and place of Fascism in everyday life—or, why were Fascist militia members fighting Fascist Party members that night and what did it mean? How deeply Fascism penetrated society and culture, or how thoroughly Italy was "Fascistized" continues to be an open question, the answer to which varies depending on where one looks.[3] More pertinently, the question of a distinctly Fascist legal or juridical culture is also open, as scholars examine the degree to which courts, judges, magistrates, attorneys, and police were "Fascistized," or consider how successful the regime was in transforming justice and its administration to "make it Fascist."[4] This chapter extends the question of a Fascist penal culture to crime itself— or real crimes themselves—to search for the presence of Fascism and the Fascist conception of penal law in the facts, narratives, and cultural texts of crime and criminal trials.[5]

The period under consideration is the 1930s, because those were the years when Italy was "in full Fascism" ("*in pieno fascismo*," as they were and are referred to) or the "years of consensus" for Fascism (as they are

now often acknowledged) and the years of the corporatist state—and it was also the decade that saw Fascist reform of criminal law through the adoption of the new Penal Code of 1930.[6] The crimes examined here are not political crimes, that is, they are not crimes against Fascism that would have been subject to the Special Tribunals for the Defense of the State, but rather are apolitical, ordinary crimes. Ordinary, in this context does not mean petty crimes, but serious crimes—though without overt political components (or without what authorities interpreted as such). Because such crimes and cases are less transparently related to Fascism and the repressive methods used to defend the regime, they are therefore more telling as valuable sources in which to find the success or failure of Fascism's aim to reform law and thereby reform society and the nation. Each crime and case also tells many other stories: stories of local history, of gender and class relations, family dynamics, generational and ideological divides, rural sociability and rural violence, as well as the complex relationships between "ordinary" Italians and those with power over them.

Law is culture, as well as being both a reflection of political and societal attitudes and a response to social and political exigencies.[7] That is why the literature on crime and trials in particular places at particular times throughout early modern and late modern Europe has been so productive.[8] As Edward Muir and Guido Ruggiero have noted, criminal records "take the reader far beyond the crime itself into the social and cultural worlds revealed."[9] We learn about society, culture, and interpersonal relations in general from studying crime records and court cases; and we can learn about Italian society, culture, and about life under Fascism in particular. Law (criminal law to be more precise here) is, of course, an instrument of control, and in the case of Italy during the 1930s the Penal Code was the idea manifested that a consciously "Fascistized" set of laws would penetrate and shape the culture and behavior of ordinary people—not just in the courtroom, but even before they got there.

The Penal Code of 1930 is obviously important here. Also known as the Rocco Code after the Fascist Minister of Justice, Alfredo Rocco, who sponsored it, the code was "part of a political program the object of which was to 'make Italy fascist.'"[10] Jurists Carlo Saltelli and Enrico Romano-Di Falco wrote in the introduction to their multi-

volume *Commento teorico-pratico del nuovo Codice Penale* (which they dedicated to Rocco), the "transformation of a State also calls for the transformation of its penal laws, because they profoundly influence the State's political, economic, and social structure, and also constitute one of its most effective defenses.[11] That is, a "new" state had the right and the duty to write new penal laws that both enforced the state's specific interests and protected the state itself. Similarly, as the older criminologist and legal positivist Enrico Ferri said of Rocco's ongoing "project" in 1927, the promulgation of a penal code was one of the most fundamental manifestations of the state's will, because a penal code disciplines the *"anormali, immorali,"* and *"antigiuridiche"* forms of human activity, and thus serves as a daily and formidable expression of the state's political power.[12]

This new code, together with the new Code of Criminal Procedure, would show the power of the Fascist state, would protect the state, and would help "make Italy Fascist" in part by criminalizing additional behaviors and by increasing penalties, thereby bringing the laws in line with Fascism's harsh and repressive character or "personality", and by emphasizing the authority and reach of the Fascist state. Professor of law at the University of Pavia and editor of *Rivista italiana di diritto penale*, Giulio Battaglini, wrote in 1933 of the new code: "It deals with one of the greatest attributes of sovereignty, that is to say, the power to punish," and he commented more generally on law itself:

> The law, in common with the realities of history everywhere, must adapt itself to political ideas, to economic exigencies, and to the social needs of a given country. The theory of government is reflected particularly in the penal law, because this is the most powerful legal means which the government has at its disposal to achieve its political objectives.[13]

Subtitling his article "Defense of the Personality of the State," Battaglini noted that the code guarded not only the "safety of the State" (as common with the codes of other countries as well), "but also, all the entirety of fundamental political interests represented by the State's personality."[14]

In addition to longer sentences for many crimes and limiting the use of both passion and voluntary intoxication as defenses or partial

defenses (and disallowing voluntary intoxication as mitigation of fault), while creating a confusing procedure for calculating aggravating and extenuating circumstances (including provocation as an extenuating circumstance, thereby letting defenses of passion and honor in through another door, as it were), what made the justice system particularly new, modern, and Fascist, it was claimed, were two important additional innovations: the abolition of a jury in criminal trials and the provision for security measures, including *libertà vigilata*, after a prison sentence was completed, for those deemed "socially dangerous."[15] In his inaugural address for the Court of Cassation judicial year beginning January 1933 (at which Mussolini was present in recognition of the first decade of the Fascist regime), President of the court (and ardent Fascist), Silvio Longhi, termed the introduction of security measures and the abolition of the jury as the two most important innovations "signaling the closing of one epoch and the opening of another."[16]

Writing in the journal *La giustizia penale*, Judge Francesco Gabrielli emphasized that the penal reform of 1930 was "founded on the *"duplice principio"* of responsibility (or fault) and social dangerousness of the guilty person.[17] The Code did not abandon the traditional principle or requirement of "fault," but added the supplementary consideration of social dangerousness. The socially dangerous were a danger to the state (and to the personality of the state), and also posed a danger to the health and integrity of Fascist society in the way that ordinary criminals did not (in that they could "infect" the new sort of Italy and Italian that Fascism wished to create), and so the socially dangerous were to be monitored and kept under control—often for years after their prison sentences had been served. That is, ordinary criminals now received and served longer sentences, while socially dangerous criminals also served their sentences, but after which they were then subject to security measures or additional confinement (as in a mental hospital or *casa di cura*) depending on the nature of the social danger presented. The "socially dangerous" included those who had been acquitted of the crime committed by reason of insanity; those whose legal culpability was diminished or mitigated by "partial" mental illness (*"vizio parziale di mente"*); and those determined to be habitual or professional criminals (*"delinquenti abituali o professionali"*). Certain other categories of persons were also considered socially dangerous under Penal Code

article 208 and subject to security measures (including custodial measures) even without commission of a crime or finding of guilt. These included the mentally ill, drunks, beggars, and of course those suspected as dangerous to public security—public safety "offenses" in other words. The criminally dangerous and the socially dangerous could be, but were not necessarily the same person.[18]

The new code bore the stamp of Fascism, and contemporary commentators often termed it, together with the new Code of Criminal Procedure, as being neither purely positivist nor purely classical—but particularly "Fascist."[19] Thus, a Fascist legal culture—or a distinct and consciously created Fascist penal culture—most clearly existed at the statutory level of the codes themselves and at the theoretical level of those criminologists, jurists, and legal scholars who wrote about them, and those Italian experts who presented Italian Fascism's "unique solution" at international conferences. In other words, penal law and procedure were Fascistized from the top, but what did that mean at the level of ordinary crime? Did Fascism, the strong state, and the Fascist conception of crime, dangerousness, and penal law make for a Fascist criminal legal culture (or penal culture) in practice or in theory and intent only, and where did Fascist penal culture intersect with the real world of crime, criminal trials, and determinations of justice?

Fascism generally factored indirectly in crimes and their trials, but was often present in small ways. Most common are the many cases where Fascism was mentioned as part of a defendant's, victim's, or witness's personal information. Someone's membership in the National Fascist Party (PNF) or status as a *milite* of the MVSN might be noted, just as with military service, marital status, and occupation.[20] In occasional cases Fascism was the alibi, as when a defendant told the investigating *Carabinieri* he was at the *Casa del Fascio* at the time, and so could not have committed the crime.[21] More often, local party officials, usually the head or political secretary of the town's *Fascio*, were called as character witnesses for the defendant, presumably because their assessment and testimony carried more weight in the courtroom than the ordinary (non-Fascist official) person's.[22] And in other cases, a defendant, victim, or witness falsely claimed to be a party member—or even to have marched on Rome—thinking it would bolster credibility or standing in the eyes of the magistrates.[23]

Fascism, or anti-Fascism was sometimes cited as the impetus for a crime (as we will also see in the violent encounter outside Chiozzo). Tuscany's Courts of Assize records reveal more than one case in which a sharecropper killed his neighbor, because, as he said, that neighbor made disparaging comments about Fascism, or had been overheard muttering or yelling "down with Mussolini." Investigation and evidence made clear, however, that the defendant had not acted to defend the regime's honor, but rather because after too many years of bickering over old grudges like hanging oak branches, pilfered apples, missing hay, or wandering chickens, and after too much to drink on the evening in question, he shot the neighbor with a hunting rifle or clubbed him with a hoe, deciding after the fact that the neighbor's alleged anti-Fascism would make a more compelling excuse.[24] Particularly telling are the cases not involving political offenses, but in which a defendant's local reputation for subversion and anti-Fascism figured prominently in the investigation and trial—and defendants were always convicted and stiffly sentenced in such instances.[25]

Fascism played a more direct role when a defendant attempted, directly or indirectly, to use his position in the party or MVSN to influence potential witnesses or the court's decision. One terribly unsympathetic provincial official defrauded poor, illiterate, Great War invalids of their government loans to buy small farm plots (loans that he was supposed to help them obtain). When charged, he asked influential friends in Rome to write *raccomandazioni* on his behalf, reminding them how he had always "done his duty as a Fascist."[26] In another case, a jealous young husband shot the doctor he wrongly suspected of having an affair with his estranged wife. His fellow militia members (called his "supporters" in the court records) and the head of the local *Fascio* tried to "convince" (first with a small bribe, and then by using more "Fascist" methods of persuasion) someone else to say he was having relations with defendant's estranged wife, in order to make the husband's suspicions sound more reasonable, as well as to damage the wife's credibility.[27]

A couple of cases deserve a closer look, however, and we will also return to the fight outside Chiozzo. The first case took place in 1935 in the town of Castiglioncello in the province of Livorno.[28] On the night of March 18, 1935, Antonio and Egisto, both in their late twenties, posing as agents of the *forza pubblica*, surprised Saverio (also in his late

twenties) and Omero (age forty-eight) engaged in obscene acts in the woods outside of town—or at least both had their pants down around their ankles and were embracing. The two "agents" pointed a revolver at Saverio and Omero and told them to come back the next night between 8:30 and 9:00 p.m. to the same spot pay a "fine" of 2000 lire from Omero and 1000 lire from Saverio, in order to avoid criminal prosecution.

The next morning, Omero went to the local *Casa del Fascio* to ask the political secretary if it was true that agents of the *forza pubblica* could levy a fine in that manner. Sensing something suspicious, the secretary called in the *Carabinieri*, whereupon a more complete story emerged. The *Carabinieri* (along with a couple of MVSN militia members) went with Omero and Saverio back to the spot in the woods at the appointed time, but the two "agents" never showed up. The *Carabinieri* did learn that Omero had had similar sexual contacts in the same woods three or four times with other men, and two or three times previously with Saverio. Saverio acknowledged the previous meetings with Omero, but elaborated that in this particular instance, knowing that Omero had recently inherited several thousand lire from his father-in-law, he had planned with his two friends Antonio and Egisto (the two false agents), that they would surprise Saverio and Omero in the act—actually, just before the act—and extort a sum of money which the three would share.

Antonio and Egisto both eventually confessed that they had acted "in a moment of weakness, without having considered the seriousness of the crimes for which they might be held responsible." As to why they did not show up the following evening to collect the 3000 lire "fine," Antonio and Egisto told the *Carabinieri* that they felt bad about what they had done and had never had any real intention to go back for the money. The *Carabinieri* could not determine whether that was true, however, or whether Saverio had tipped them off, or they had become aware of all the *Carabinieri* and Fascist militia suddenly in the area.

The defense attorneys for Antonio and Egisto told the instructing judge that their clients indeed had no intention of ever collecting the money that they "jokingly" had attempted to extort. Neither needed the money: Antonio was a shoemaker, and Egisto a *commerciante* whose father owned several successful small businesses. During the case preparation phase, they planned to call several character witnesses, including the *commissario* of the Fascist Party and the secretary of the

comune. They would also call other witnesses who would testify that on the night of March 19, instead of going back to get the money, they had been in Egisto's father's shop telling some friends about the "joke" they had played on "a certain Omero"—who public rumor (*"voce pubblica"*) accused of being a pederast.

The most culturally interesting part of the defense, however, was the very long handwritten letter that Saverio (who had been caught in the embrace with Omero and who admitted he had had more than one previous sexual encounter with Omero) wrote to the Procuratore— explaining who he (Saverio) "really" was: "I have always taken my duties seriously in all matters, both social and political." He started the letter— and the explanation of his "real self"—with the Fascist revolution, and how he shared its sacrifices and pains with his Fascist companions of the town. In May 1924 he became a regularly inscribed member of the party, and not long after that met his fiancée, now wife, while doing his military service. Since his marriage, he has concentrated his entire attention on work (he was a mechanic), on his family, on the *"idea fascista,"* and on sport—about which he was always very enthusiastic. He was a member of the directing council of the Società Unione Sportiva, and had been chosen by the director of the local *Fascio* to be a sports instructor for the Fascist youth group—which he did willingly and with great pleasure. He also helped out with the projector at the local *Fascio*'s Cinemateatro, where he had favorably impressed the Federal Secretary of the Fascist Party for the province. He had two sons, one age three and one age four—who were "angels." Saverio was happiest coming home from his day of labors and being with his family, where all his thoughts were of caring for them. And, his wife was currently seven months pregnant with a third child.

Thus, even though Saverio had an admitted weakness for or attraction to other men (which he did not mention in his letter), he was—his "real self" was—a true Fascist male—from the enthusiasm during the revolution's earliest days, to his current active participation in party activities, to his hard work as a mechanic, to his wife and two angelic sons, to his love of sports. He was, he wrote of himself, "the kind of Italian the Duce wanted."

Antonio, Egisto, and Saverio were charged with armed robbery and attempted extortion. Antonio and Egisto were also charged with

impersonating officers and having an unregistered revolver. Saverio and poor Omero were also charged with public indecency and committing obscene acts in public. And so the case proceeded to the Court of Assize, where the court saw the three younger men—Antonio, Egisto, and Saverio—as real Fascist men. "Sono tre giovani l'uno meglio dell'altro": these three young men, "each better than the other," were absolutely incapable of planning and carrying out criminal actions. They were all well known locally, respected since childhood, married with children, with jobs. Saverio had merely proposed to his two friends "to give a good lesson to that pederast" Omero (and so the court lightly treated Saverio's participation in the sexual encounter in the woods). They had not done this for money, but because of the audacity (*"audacia"*) characteristic of (and appropriate to) "normal" young men, as a joke, in lightheartedness. The court had nothing but sympathy for the three (though not for Omero): the three *giovani* had neither the will nor the conscience (the mental willingness) to commit serious crimes. They lacked the essential psychological element to do so. The court acquitted the three of armed robbery and attempted extortion.

The Public Minister appealed to the Court of Cassation, asking how it was not a crime when people pointed a revolver at someone and demanded money. Even saying they were going to teach Omero a lesson—that was not the same thing as a joke. The Supreme Court rejected the appeal, adding something even the defendants had not raised at trial: Saverio, Antonio, and Egisto all had been tired of the continuing obscene proposals Omero directed at Saverio. The reasoning on the part of both the Court of Assize in acquitting and the Court of Cassation in affirming the acquittal was that even though the three defendants had done things that factually, technically, and legally constituted armed robbery and attempted extortion, what they had done had not been armed robbery or extortion, because of the sorts of young men they were.

The next case presented four very different defendants.[29] David, Giuseppe, Silvia, and Luigina arrived in Livorno in 1937. They went about in a brand new luxury automobile—a Lancia Augusta. David wore the uniform of a Centurion in the Fascist militia. Giuseppe was his personal secretary. Luigina was his wife. Silvia was the wife of an official currently in Italian Africa. They were there in Livorno, they said,

because of David's work with the National Fascist Federation for the Struggle against Tuberculosis. None of that was true. However, their elegant car, their appearance, and the way they freely spent money around town soon engendered the conviction among the "better sort" in Livorno society that these were influential persons. The four quickly became friends with and frequent dinner guests at the villas of the local (and prosperous) dentist, the engineer, the general secretary of the Fascist Agricultural Syndicates, the retired colonel, and other local notables. It "became known" (through the "*voce pubblica*") that David was a personal friend of his Excellency, the General Secretary of the Fascist Party, Achille Starace. It became known—but this only to a select few—that David was actually a secret inspector for the National Fascist Party, was a friend of another "very important person ("Alta Personalità"—capital letters); and was in Livorno incognito to carry out certain unspecified inspections for the party. Thus, around town, they were very much in the public eye and the public gossip; they were clearly important, yet somewhat mysterious.

But, like cons everywhere, they eventually went too far in making up and representing their own story. David promised the hairdresser they frequented that he would get him a permit to open a salon in Asmara. He promised the owner of the café they frequented that he would get him made a Cavaliere. He promised the retired colonel he would get him recalled to an important post in Italian Africa, and so on. And all this was what finally got the *Carabinieri* suspicious—while apparently none who invited them to dinner or who were promised those preposterous favors had doubts.

One evening, while the four were dining at someone's country home, the *Carabinieri* arrived. The two women stayed, while David and Giuseppe went with the officers. In the car on the way to be questioned, David pulled a revolver and a shoot-out with the *Carabinieri* ensued. No one was killed, but David and Giuseppe both had been armed. Their hotel rooms were searched, and the search turned up suitcases containing real identification documents and many more fake identification documents, other false documents of a variety of sorts, assorted Fascist militia and other uniforms, and various Fascist insignia. One particularly interesting discovery was that Silvia—who was posing as the wife of an official serving in Africa—was actually the wife,

of many years, of David, while the woman Luigina, with whom he was living as husband and wife, was not his wife.

The investigation, the interrogations, and the formal instruction exposed a "vast criminal enterprise" that had been going on since 1934—throughout northern Italy, Turin in particular—involving multiple frauds, a long trail of bad checks (which was how they paid for the car), and numerous unfulfilled promises to use their influence and Fascist connections for favors or *raccomandazioni*. All four—including the two women—had been convicted before (David had seven or eight prior convictions, mostly for fraud, but it was difficult to tell because of the number of aliases he had used). David, who had convinced everyone that he was a high-ranking Fascist, turned out not to have gone beyond the fifth grade and the only trade he had ever practiced was as a carpenter—for a very short time, and not very well. He really had been a member of the Fascist Party, but had been kicked out of the militia in 1925 for theft. He later rejoined the party in another town, but was kicked out a second time as well. Giuseppe was only twenty-four, but already had been in prison. Luigina was an illegitimate child as well as a convicted criminal. In the eyes of the Procuratore, she was difficult to explain: she had no education, no culture, but nevertheless had intelligence and uncommon "*audacia*." This *audacia* was very different from the young male Fascist harmless *audacia* exhibited by the three men in the previous case. Also troubling, but for another reason, was Silvia, who remained married to, traveled with, and continued to conspire with a man (David) who was living with another woman (Luigina) as his wife. To the Procuratore, it would be useless for Silvia to claim (in her defense) that she was an innocent victim; rather, she put up with Luigina and David (who together were the "brains" of the organization) because she wanted the money and the "*vita allegra*" that came with their life of crime, and was untroubled by moral considerations. These were obviously not the kind of Italians the Duce wanted.

The list of charges was twelve pages long, and for the purpose of this article the most relevant charge was not attempted homicide stemming from the shoot-out, but "*associazione a delinquere*." "Associating for purposes of delinquency" or to commit crimes is a somewhat inadequate translation, but the term means more than "criminal association" and refers to the Penal Code's (and the state's) concerns in reforming both

law and society. Forty-two prosecution witnesses testified at the trial, and dozens of depositions were submitted, because earlier frauds also were added in. David received a twenty-six-year sentence for attempted homicide, aggravated by being a recidivist. Giuseppe was acquitted of attempted homicide, but got four years, six months. Luigina got one year, eight months. And only Silvia was acquitted of the charge of "*associazione per delinquere*," despite the Procuratore's prediction.

Although David, Giuseppe, and Luigina were delinquents (and David certainly a frequent one), the court did not find them to be socially dangerous (even though it was discovered that both David and Luigina had tuberculosis—and David clearly fit more than one socially dangerous criterion). They were simply old-fashioned con artists dressed up like Fascists. Thus, Fascism entered directly into both cases, though in different ways. In the first case, "being good Fascists" was essentially the defense presented by the three would-be extortionists. In the second case, Fascism was the very *modus operandi* of the crime and what made the frauds possible.

Returning to the violent encounter outside Chiozzo on that night in April 1931: the younger men's version of events was that the schoolmaster (who, interestingly, had been their teacher some years earlier) had urged them to join in a cheer for the reappointed *Podestà*—"*Eviva Piaghini*" and "viva il *Podestà*." The older men followed that cheer, however, with "down with the Duce," "down with Mussolini," and "down with Lemmi" (the local Fascist Party Commissioner), and other derogatory, anti-Fascist comments—purposely provoking the young men, who refused to join in. Then, according to the young men, Amadeo Stefani of the older group pulled a pistol which he shot in the air to intimidate them. Rubini aimed his shotgun at Stefani's arm to get him to drop the pistol; and then a general melee ensued during which Stefani (rather than Rubini) accidentally shot Piagentini while aiming for the younger men. The older men's version coincided only in that the teacher said he told the young men that his group had been out celebrating the *Podestà*'s reappointment, before the young men assaulted them. If the younger men's version were true (or believed to be true) in that the other group really had repeatedly yelled "down with Mussolini," the older men could have been charged with crimes "against the personality of the State," including subversion, and sent to the Special Tribunal.

What makes the matter more interesting, of course, is that both groups were Fascists. The older men were all long time Fascist Party members; they included the former secretary of the local *Fascio*, and the schoolmaster had also been an instructor for the Fascist Youth organization (the *Balilla*) since 1924. All or most of the younger men were members of the Fascist Party Militia. It was, as one *Carabinieri* report put it, a case of "Fascists and Fascists": old ones and young ones, while another report described both "sides" as Fascist. Yet, neither the investigating *Carabinieri* nor the court interpreted or represented the crime as a Fascist (or anti-Fascist) or political crime, despite the young men's attempt to bring Fascism directly into it. Instead, it was considered that the bad feelings leading to the assault stemmed from complicated local events involving those who supported and those who opposed the *Podestà*'s reappointment, and involving a long, ongoing feud (which had split the small town into two camps) between the ex-secretary of the *Fascio* (one of the victims) and the priest whose less than full commitment to Fascism had manifested itself through the priest's refusal to ring the church bells for a Fascist meeting some years earlier.

In the end, what mattered most was that the court believed the older men. The schoolmaster, who was the strongest witness for the older group, was "a person of intellect and education," "far superior" to any of the younger men. The young men's story was "puerile" and had the ring of "a lesson learned by memory" (the court meant, of course, that the young men had concocted their story). What was not explicitly said, but what was implied throughout the investigative reports, was that the older men's status in the village was also "far superior" to that of the younger men. What was explicitly said was that the characters of the older men were also superior to the younger men, who were described variously as light-hearted, excitable, aggressive, and hot-headed. More to the immediate facts, however, witnesses stated that the young men had been seen around the village earlier that same day, drinking, and pretty clearly spoiling for a fight. They had heard about the *Podesta*'s reappointment, donned their militia uniforms, armed themselves with clubs and some guns, and gone looking for trouble.

Was this incident a continuation of Fascist violence of the 1920s— were these young Fascist Party Militia members the 1930s equivalent

of the earlier *squadristi* who used their position with impunity and as excuse for some violent diversion? They represented a new generation, certainly, one which had grown up with Fascism and viewed its bullying violence as ordinary and acceptable. And, as shown, they had no respect for the older, more respectable Fascists they knew. Whereas the crime was about Fascism—or at least about feuds made possible by Fascism, the investigators' assessments and the court's decision, however, more clearly reflect class, status, and generational divides.

These ordinary cases do not reveal a powerful Fascist state in action (when observing the administration of justice, it is plain that room to maneuver remained in the system at the local level), or a state particularly paranoid about its safety and personality, although the case of the four Fascist impersonators certainly shows how far powerful Fascist connections (even pretended connections) could carry someone. The law journals and legal commentary of the time spoke of a Fascist penal culture created by the new code, which was organized, efficient, rather fierce, and one that would Fascistize Italy and Italians. The Fascistization did not exactly result in the more disciplined, hardworking Italians Rocco and his colleagues envisioned, however, despite Saverio's successful claim that he was indeed "the kind of Italian the Duce wanted." These, like so many other ordinary cases, demonstrate how crime and justice remained mostly a local and subjective matter, governed by concerns that had little to do with the personality of the Fascist State. What makes them important, nevertheless, are the glimpses they offer of society and culture at the local level against the backdrop of Fascism, including the near omnipresence of Fascist militia members in town and village life by the 1930s and the extent to which Fascism made up part of everyday life and discourse.

NOTES

1. Archivio di Stato, Florence, Court of Assize, Lucca, 1932, fasc. 6.

2. This group also included Amadeo Stefani, the twenty-three-year-old son of Angelo Stefani.

3. See generally, R.J.B. Bosworth, *Mussolini's Italy: Life under the Fascist Dictatorship, 1915–1945* (New York: Penguin, 2006).

4. See, for example, Lutz Klinkhammer, "Was there a Fascist Revolution? The Function of Penal Law in Fascist Italy and Nazi Germany," *Journal of Modern Italian Studies* 15 no. 3 (2010): 390–409; Irene Stolzi, *L'ordine corporativo: Poteri organizzati e organizzazione del potere nella riflessione giuridica dell'Italia fascista* (Milan: Giuffrè Editore, 2007); Antonella Meniconi, *La "maschia avvocatura": Istituzioni e professione forense in epoca fascista (1922-1943)* (Bologna: Il Mulino, 2006); Orazio Abbamonte, *La politica invisibile: Corte di Cassazione e magistratura durante il Fascismo* (Milan: Giuffrè Editore, 2003); Aldo Mazzacane, "La cultura giuridica del fascismo: Una questione aperta," in *Diritto economia e istituzioni nell'Italia fascista* (Das Europa der Diktatur—Wirtschaftskontrolle und Recht), ed. Aldo Mazzacane (Baden-Baden: Nomos, 2002), 1–19; Mario Sbriccoli, "Le mani nella pasta e gli occhi al cielo—La penalistica italiana negli anni del fascismo," *Quaderni fiorentini* 28 (1999): 817–52; Luisa Mangoni, "Cultura giuridica e fascismo. Il diritto pubblico italiano," in *Cultura e società negli anni del fascismo*, ed. Luigi Ganapini and Camillo Brezzi (Milan: Cordani, 1987), 433–44. On policing and Fascism, see Jonathan Dunnage, "Surveillance and Denunciation in Fascist Siena, 1927–1943," *European History Quarterly* 38, no. 2 (April 2008): 244–65; and Jonathan Dunnage, "Mussolini's Policemen, 1926–1943," in *Policing Interwar Europe: Continuity, Change and Crisis, 1918-40*, ed. Gerald Blaney (Basingstoke: Palgrave Macmillan, 2007), 112–35.

5. The phrase "Fascist conception of law" references H. Arthur Steiner, "The Fascist Conception of Law," *Columbia Law Review* 36 (December 1936): 1267–83. The cases discussed in this article are all from the Courts of Assize in the provinces of Tuscany.

6. The new Penal Code was promulgated on October 19, 1930, and went into effect July 1, 1931. The 1930s were an enormously active period—not just in Italy—for rewriting Penal Codes and for rethinking on the part of legislators, criminologists, criminal anthropologists, and other social scientists about the purposes and methods of punishment, and about the nature, causes of, and responsibility for crime according to new scientific principles. This is the decade when psychological or psychiatric evaluations of a defendant's mental state or capacity, and expert testimony in that regard, became commonplace, and oftentimes became the deciding factor in a trial or in what punishment a defendant would receive. The editors of the journal *La giustizia penale: Rivista critica settimanale di giurisprudenza, dottrina e legislazione* added a new, separate section (in addition to existing parts on jurisprudence, doctrine, and legislation) on "criminal anthropology, criminal psychology, psychoanalysis, medicine, and law, and scientific policing," for example. Neither is it a coincidence, I think, that the 1930s were the "golden

age" of mystery and crime fiction: there was a widespread interest in crime and how it "worked."

7. See, in general, Lawrence Rosen, *Law As Culture: An Invitation* (Princeton: Princeton University Press, 2006).

8. See, for example, Edward Muir and Guido Ruggiero, ed., *History from Crime: Selections from Quaderni Storici* (Baltimore: Johns Hopkins University Press, 1994); Stephen Gundle and Lucia Rinaldi, ed., *Assassinations and Murder in Modern Italy: Transformations in Society and Culture* (Basingstoke: Palgrave Macmillan, 2007).

9. Muir and Ruggiero viii.

10. Edward M. Wise, introduction to *The Italian Penal Code*, trans. Edward M. Wise (Littleton, CO: Fred B. Rothman, 1978), xxxi. Italy was already partially Fascist in its laws, thanks in large part to Rocco's legislative efforts of the mid-1920s that, among other things, elevated the constitutional position of the prime minister, gave the government power to legislate by decree, outlawed opposition parties, abolished freedom of the press, authorized administrative restrictions that included internment for those who engaged in "politically hostile speech, acts, and intentions," restored the death penalty for political crimes, and set up semi-military Special Tribunals separate from the ordinary courts to try "offenses against the regime."

11. Carlo Saltelli and Enrico Romano-Di Falco, *Commento teorico-pratico del nuovo Codice Penale* (Rome: Tip. delle Mantellate, 1930), 4. Both men had served on the Ministerial Committee for the Reform of the Penal Code.

12. Enrico Ferri, "Il Progetto Rocco di Codice Penale Italiano. Prolusione, detta il 22 novembre 1927 nell'Aula Magna dell R. Università di Roma," in *Principii di diritto criminale. Delinquente e delitto nella scienza, legislazione, giurisprudenza in ordine al Codice penale vigente—Progetto 1921—Progetto 1927* (Turin: UTET, 1928), 810.

13. Giulio Battaglini, "The Fascist Reform of the Penal Law in Italy," *Journal of Criminal Law and Criminology (1931–1951)*, Century of Progress Number: The Development of Criminology in the State of Illinois during the Past Quarter-Century, in the United States of America at Large and in Other Nations of the World during the Past Quarter-Century 24 no. 1 (May-June 1933): 278.

14. Ibid. The reference is to Title I of Book II of the Code: "Crimes against the Personality of the State."

15. See Arturo Rocco, "Le misure di sicurezza e gli altri mezzi di tutela giuridica," *Rivista penale* (Anno II, Gennaio-Febbraio 1931): 22.

16. Silvio Longhi, *Rivista penale* (Anno IV, Gennaio-Febbraio 1933): 9.

17. Francesco P.Gabrielli, "Esposizione dei principi direttivi e speigazione practica del nuovo codice penale italiano," *La giustizia penale: Rivista critica settimanale di giurisprudenza, dottrina e legislazione* (XXXIX 1933): 30–38.

18. The overlap and distinction were quite confusing. Professor Anselmo Sacerdote provided a useful table first categorizing offenders into six groups, and then dividing those categories into two groups according to whether a criminal sentence had been imposed or not. Anselmo Sacerdote, "Sul riesame della pericolosità determinato dall'art. 208 C.p.," *La giustizia penale* (XXXIX 1933): 145–55. Post-sentence security measures were also imposed on any "ordinary" defendant who received a prison sentence of longer than ten years.

19. In addition to being referred to as the Rocco Code, the new Penal Code was also sometimes called the Mussolinian Code (*"codice penale mussoliniano"*). See Francesco Dematteis, *La genesi dello Stato unitario fascista ed il riflesso dei nuovi ordinamenti e delle nuove concezioni nel Codice penale mussoliniano* (Giurisprudenza delle Corti regionali, Milan 1931), parte 2a, fasc. 8, col. 143. See contemporary American comments on the code: Julius Stone, "Theories of Law and Justice of Fascist Italy," *The Modern Law Review* 1, no. 3 (December 1937): 177–202; and H. Arthur Steiner, "The Fascist Conception."

20. Archivio di Stato, Florence, Court of Assize, Siena, 1932, fasc. 1.

21. Archivio di Stato, Florence, Court of Assize, Grosseto, 1938, fasc. 5.

22. Archivio di Stato, Florence, Court of Assize, Siena, 1936, fasc. 2.

23. Archivio di Stato, Florence, Court of Assize, Arezzo, 1937, fasc. 3.

24. The majority of rural homicides, especially those involving neighbors, were committed over long-standing grudges and arguments about minor things, and were fueled by too much alcohol. See, for example, Archivio di Stato, Florence, Court of Assize, Arezzo, 1933, fasc. 2; Court of Assize, Siena, 1934, fasc. 7.

25. Archivio di Stato, Florence, Court of Assize, Grosseto, 1931, fasc. 6; Court of Assize, Arezzo, 1939, fasc. 5.

26. Archivio di Stato, Florence, Court of Assize, Arezzo, 1939, fasc. 1.

27. Archivio di Stato, Florence, Court of Assize, Arezzo, 1932, fasc. 5.

28. Archivio di Stato, Florence, Court of Assize, Livorno, 1934, fasc. 4.

29. Archivio di Stato, Florence, Court of Assize, Livorno, 1937, fasc. 5.

BIBLIOGRAPHY

Abbamonte, Orazio. *La politica invisibile: Corte di Cassazione e magistratura durante il Fascismo.* Milan: Guiffrè Editore, 2003.

Battaglini, Giulio. "The Fascist Reform of the Penal Law in Italy." *Journal of Criminal Law and Criminology (1931–1951)*, Century of Progress Number: The Development of Criminology in the State of Illinois during the Past Quarter-Century, in the United States of America at Large and in Other Nations of the World during the Past Quarter-Century, 24, no. 1 (May–June 1933): 278–89.

Bosworth, R.J.B. *Mussolini's Italy: Life Under the Fascist Dictatorship, 1915–1945.* New York: Penguin, 2006.

Dunnage, Jonathan. "Mussolini's Policemen, 1926–1943." In *Policing Interwar Europe: Continuity, Change and Crisis, 1918-40*, edited by Gerald Blaney, 112–35. Basingstoke: Palgrave Macmillan, 2007.

———. "Surveillance and Denunciation in Fascist Siena, 1927–1943." *European History Quarterly* 38, no. 2 (April 2008): 244–65.

Ferri, Enrico. "Il Progetto Rocco di Codice Penale Italiano. Prolusione, detta il 22 novembre 1927 nell'Aula Magna del R. Università di Roma." In *Principii di diritto criminale. Delinquente e delitto nella scienza, legislazione, giurisprudenza in ordine al Codice penale vigente—Progetto 1921—Progetto 1927.* Turin: UTET, 1928.

Gundle, Stephen, and Lucia Rinaldi, ed. *Assassinations and Murder in Modern Italy: Transformations in Society and Culture.* Basingstoke: Palgrave Macmillan 2007.

Klinkhammer, Lutz, "Was there a Fascist Revolution? The Function of Penal Law in Fascist Italy and Nazi Germany." *Journal of Modern Italian Studies* 15, no. 3 (2010): 390–409.

Mangoni, Luisa. "Cultura giuridica e fascismo. Il diritto pubblico italiano." In *Cultura e società negli anni del fascismo*, edited by Luigi Ganapini and Camillo Brezzi, 433–44. Milan: Cordani, 1987.

Mazzacane, Aldo. "La cultura giuridica del fascismo: una questione aperta." In *Diritto economia e istituzioni nell'Italia fascista (Das Europa der Diktatur—Wirtschaftskontrolle und Recht)*, edited by Aldo Mazzacane, 1–19. Baden-Baden: Nomos, 2002.

Meniconi, Antonella. *La "maschia avvocatura": Istituzioni e professione forense in epoca fascista (1922–1943).* Bologna: Il Mulino, 2006.

Muir, Edward, and Guido Ruggiero, ed. *History from Crime: Selections from Quaderni Storici.* Baltimore: Johns Hopkins University Press, 1994.

Neppi Modona, Guido. "La magistratura e il fascismo." In *Fascismo e società italiana*, edited by Guido Quazza, 125–81. Turin: Einaudi, 1973.

———. "Diritto e giustizia penale nel periodo fascista." In *Penale giustizia potere: Metodi, ricerche, storiografie per ricordare Mario Sbriccoli*, edited by Luigi Lacché, Paolo Marchetti and Massimo Meccarelli, 341–78. Macerata: EUM, 2007.

Rosen, Lawrence. *Law As Culture: An Invitation*. Princeton: Princeton University Press, 2006.

Saltelli, Carlo, and Enrico Romano-Di Falco. *Commento teorico-pratico del nuovo Codice Penale*. Rome: Tip. delle Mantellate, 1930.

Sbriccoli, Mario. "Le mani nella pasta e gli occhi al cielo—La penalistica italiana negli anni del fascismo." *Quaderni fiorentini* 28 (1999): 817–52.

Steiner, H. Arthur. "The Fascist Conception of Law." *Columbia Law Review* 36 (December 1936): 1267–83.

Stolzi, Irene. *L'ordine corporativo: Poteri organizzati e organizzazione del potere nella riflessione giuridica dell'Italia fascista*. Milan: Giuffrè Editore, 2007.

Stone, Julius. "Theories of Law and Justice of Fascist Italy." *The Modern Law Review* 1, no. 3 (December 1937): 177–202.

Wise, Edward M. *Introduction to The Italian Penal Code*. Trans. Edward M. Wise. Littleton, CO: Fred B. Rothman, 1978.

14

THE RHETORIC OF RACE IN FASCIST ELEMENTARY EDUCATION

Eden Rebecca Knudsen

In the narrative of Italian cultural memory, the Fascist legacy of the twentieth century holds an especially sensitive place. Despite the significant volume of scholarship on the subject, a sizable number of writers have resisted a critical exploration of the events of the *ventennio*, their implications, and their consequences for the present and future shape of Italian society. This tendency has not only inhibited a critical study of the nature of Fascism among Italians at large, but it has also hindered an understanding of the current political and cultural situation in Italy and Europe. Of particular importance and delicacy to an understanding of Fascism's domestic and international impact is an honest and straightforward analysis of the role race and racism played in the policies and actions of Benito Mussolini's regime. The desire to define Italian identity and superiority inspired much of the Fascist rhetoric. Still, well into the 1930s the government insisted that it did not believe in racism. This paper seeks to reconcile these two contrasting, but equally evident claims.

The Fascist state used language—and in particular the terms *italianità, patria, stirpe,* and *razza*—in a way that created a complex landscape of ideas about identity and that allowed for a comprehensive, increasingly aggressive racial campaign while simultaneously allowing

Italians to deny the existence of domestic racism. Ultimately, that discourse has also allowed Italians in a post-Fascist society to perpetuate many of those beliefs about identity and race and the challenges they create in an increasingly diverse Italian nation. A substantive analysis of these words and Fascist rhetoric in general is a valuable starting point to a greater exploration of ideas about identity in Fascist society and their lasting impact on Italian thinking about race, ethnicity, and the past.

Despite common beliefs to the contrary, the concepts of race or racism have never been static. They were no less volatile under Italian Fascism. There was no one idea of race or racial identity at any point during the regime, and individuals changed their beliefs over twenty years of Fascist rule.[1] Nevertheless, as in English, there were certain components of the terms used to talk about identity in Italy that remained fundamental to the evolving conversation; these fixed characteristics need to be explored in order to discuss the role of race in the regime. First, however, it is important to come to a general understanding of the ideas of race and racism and how we, as scholars, can use such ideas in an analysis of Fascist rhetoric.

Present-day academics have shown that the presumed scientific foundation of race often collapses under close scrutiny: those that are superficially presented as biological characteristics largely reduce to social, political, and cultural factors. As the scholar of racism David Theo Goldberg has argued, "racism is found to be a function of the fashions of racial formation in given socio-temporal conditions."[2] Consequently, a more basic understanding of race is required to illuminate the fundamental components of race and racism. Drawing upon the work of the American historian Matt Jacobson, the most useful explanation of race—one that works with the multitude of historical and cultural permutations—articulates it as an invented category characterized by allegedly heritable attributes "coined for the sake of separating peoples along lines of presumed difference."[3] In turn, racism could be described as the privileging of one category of people— separated by presumed inherited differences—over other categories of peoples, resulting in the discrimination against, and persecution of, those unprivileged categories. Armed with these definitions, a look at Fascist language clearly shows how Fascist rhetoric defined the Italian population as a biologically, culturally, and historically privileged group,

giving legitimacy to increasingly aggressive and discriminatory policies and actions, such as the 1935 invasion of Ethiopia and the passage of the 1938 race laws.[4] Despite variations in individual terms, the fundamentals of Fascist discourse created a theoretically and linguistically racial framework on which the regime based its policies.

One set of sources that helps identify an "official" Fascist stance on Italian racial identity is the literature associated with elementary education for students between the ages of six and twelve.[5] These texts presented a relatively unified voice that was prescribed by the state and accessible to Italians at the time and to us today. More than that, educational texts present an image of the Italian people that the state wanted to perpetuate in its youngest members. Benito Mussolini believed the protection of children was critical because it provided for the renewal and future of the Italian race, preparing abundant, healthy, and vigorous generations of New Italians. The Fascist doctor Emilio Alfieri wrote, "all that we do for the defense of motherhood and the protection of childhood ensures life of the race [*stirpe*], and supports its development, strength, and splendor."[6] Furthermore, Italian educational idealists who helped organize the education system in the 1920s believed that clearly forming a sense of collective identity—culturally, spiritually, and physically—would enable students to better understand their role in the more significant national project. The questions then become: what did the Fascist regime have in mind for this new generation? How did the state envision the privileged group that Italians comprised?

ITALIANITÀ

Developing among Italians a strong sense of *italianità*, inadequately translated as "Italian-ness" and more appropriately explained as "the essence of being Italian," was the fundamental mission of Fascist discourse about identity. This campaign above all relied on defining a concept of the nation. Italian nationalists had worked to define an idea of the nation and identify a united national character for the very disparate communities of the peninsula since the early nineteenth century.[7] Still, when Mussolini organized his March on Rome in 1922, dozens of dialects and regional cultures still existed throughout the

peninsula and on the islands, far from the reach of a central government. Many "Italians" remained indifferent and unaffected by the concept of belonging to a nation, in large part because of the lack of a bureaucratic infrastructure, both in terms of the political involvement of many communities, but also an educational system that could teach Italians to think about their local communities as integral parts of a united whole. The challenge remained, therefore, to define a nation that incorporated numerous distinct communities and to make its inhabitants aware of the common bonds with their countrymen and countrywomen.

PATRIA

In Ernst Renan's famous 1882 speech, "What is a nation?," the French philosopher concluded that "A nation is a spiritual principle, the outcome of the profound complications of history; it is a spiritual family not a group determined by the shape of the earth."[8] Though this speech was written forty years before the Fascist rise to power, a similar argument for the "spiritual" unity of Italy infused the educational and political rhetoric of the era. One of the key terms that captured the spiritual community of the nation, as well as its geographical and historical characteristics, was *patria*, or fatherland. As one author explained to his fifth-grade readers: "Without a fatherland you would have no name . . . or feel any brotherhood with its peoples."[9] The following passage from a 1927 textbook intended for students on summer vacation before entering the second grade presented an even more articulate description of the many layers of the idea of *patria* and, ultimately, *italianità*:

> Child, learn from a young age to love your Fatherland, the great and beautiful Italy. It is the country that gathers many families like your own and who speak like you; it has high mountains, wide rivers, and rich cities; it contains forests, waterfalls, gardens, lakes, and magnificent fields that you will become acquainted with when you are more involved in your studies. Imagine that, at one point not long ago, this Italian land was prey to evil men who did not speak our language, who came from other, faraway lands and stole our treasures. In order to be free, the Italians had to go to war, and they fought numerous enemies: it cost many young men and cities; the struggle caused many fires and created many ruins, all so

that we could finally gain the freedom to live peacefully in our homes. For that reason, love your Fatherland that has cost many sacrifices; honor its symbol, the tricolor flag, and think that you, too, so young, working and studying in school, will make it stronger and more powerful.[10]

In this passage, the author Armando Esposito touches on three aspects of *patria* that were particularly important to the evolving ideas of Italian identity under Fascism: language, geography, and history.

Of the themes Esposito introduced, he gave pride of place to the linguistic characteristics of the fatherland.[11] Edmondo De Amicis (1846-1908), a popular writer at the end of the nineteenth century, wrote that language was "the strongest link in the unity of our people, the echo of our past, the voice of our future" and the essence of the fatherland.[12] Reflecting similar sentiments, the broader education of standard Italian throughout the Kingdom was of utmost importance to the first Fascist minister of education, Giovanni Gentile, and his 1923 educational reforms. An education in a single, vernacular language would, as the historian Benedict Anderson has argued, allow a much larger community to communicate and connect.[13] Gentile's reforms required elementary students to be versed not only in standard Italian grammar and vocabulary, but also in famous passages and speeches from Italian history and literature.[14] An education in these quotations taught students about the Italian language and famous figures in Italian history, as well as the shared literary tradition that united Italians. The historian Adrian Hastings has explained, a vernacular language "creates a more conscious community of those who read it, of those in whose houses it is to be found and it quickly builds up an enhanced sense of historical cultural particularity."[15] The movement to expand and standardize basic education throughout the Kingdom was the central approach to linguistically defining and unifying the nation and, ultimately, proving its inherent superiority as a nation, culture, and civilization.

Second were the physical, geographical considerations of the *patria*. Fascists urged young Italians to learn about the land on which they lived, and texts presented the nation as the literal progenitor of the people. One 1928 textbook for rural schools claimed: "The land is our mother; she gives us bread, oil, fruit, colorful flowers and grass; then, when we are dead, she welcomes us into her arms and holds us there forever,

as children, all equal and all in peace."[16] Being a true Italian required an understanding of one's connections and debts to the land that sustained the population, and many of the educational texts integrated imagery of Italian landscapes to familiarize students with the character of the Italian land. A key policy implemented to promote connections between Italians and their land was the "ruralization" campaign, or the encouragement of Italians to leave the corrupting influences of cities and return to the rural roots of the nation. An author for the government journal *Motherhood and Childhood* wrote that "[r]uralization, according to the Duce's concept of Fascism, as everyone knows, is the return to a love of the fields and to the rural life, the return to the legendary virtues of the race [*razza*] that was born of the earth and from the earth, enriched by its labor. . . . "[17] Public education was the primary weapon with which to fight for ruralization, and the ideal of having the Italian people in touch with their nation on both a physical and spiritual level permeated all of the Fascist elementary curricula.[18]

Also entwined in the idea of *patria,* along with the translation of environmental surroundings into cultural attributes, was a "spiritual consciousness"—an awareness of the values and history that all Italians inherited. According to Mussolini, "the Nation is, above all, spiritual and not territorial. There are States that have had immense territories and have not left a trace on human history. . . . A Nation is great only when it can translate its power into the strength of its spirit."[19] This idea of an Italian spirit is what Fascist educators were most concerned with instilling in their young students, and embedded within it was the belief that every Italian should have an active knowledge of Italian— and, in particular, Roman—history. A fifth-grade textbook exclaimed, "We are proud to be Italians and to be a part of this people that has thirty centuries of civilization, that was big when others were not yet born!"[20] History became an increasingly important component of Fascist elementary curricula. The Fascist orator and scholar Carlo Delcroix wrote to his young readers that, "History is the greatest teacher of a Nation, and the most maternal voice for a people. . . . For you children it must have an even greater purpose, more maternal and more important: to educate and ignite love and pride in the Fatherland and the sweetest feeling of being able to say you are Italian."[21] Understanding the glory of the Italian past meant inspiring

children with the possibilities for the future and clarifying their roles in making such a future possible.

Textbooks invariably recalled the power and respect of the Roman Empire, reminding their readers both of the grandeur of the fatherland and the singular heritage of the Italian population. Italians were the only true descendants of Rome: "of course victory will be for Rome, which always was the dominator and the teacher of peoples throughout the centuries, and which, therefore, represents civilization."[22] The Roman glory upon which the modern Italian nation was founded, and which the Fascist regime hoped to resurrect and surpass, was at the core of each individual Italian. Teachers simply needed to recall that memory within their students and revive the values that lay within that heritage.

The focus of Fascist education on the history of the fatherland—both in the form of ancient Rome but also recent history—served the essential purpose of justifying the national claim to political and cultural superiority. Quoted in a book for elementary students, Mussolini stated, "We respect other peoples: but our Italy, *Balilla*, is the most beautiful, the most holy, the greatest! No one will ever be able to equal the power of Rome, the heroism of our martyrs, the courage of our small and proud infantry, the impulse and audacity of our Black Shirts, the strong will of our workers."[23] According to the Duce, the roots of Italian superiority were found in the history and spirit of the people that were passed down through the generations.

The historian Michel Ostenc aptly described the Fascist campaign to educate students about Italy's historic greatness as "instilling a child with the conviction that the great periods of his national history are those in which the people knew self-sacrifice."[24] The state stressed the importance of teaching Italians that the state was bigger than the self—that Italian history stretched far behind and ahead of the lives of individual Italians, and that their primary role in the world was to contribute, sacrificially if need be, to that great history. One contemporary journalist explained that Italy's youngest generations needed to understand "how much blood the success of our new life costs; that there is no victory without sacrifices; that, when necessary, one must willingly sacrifice one's life for an idea; and, in the end, that the heroic spirit of our race [*razza*] is as native to us as the sun is to our lands."[25] The history lessons that took place in the classroom, therefore,

were combined with the routine practices of saluting the Italian flag at school, honoring the tombs of unknown soldiers, establishing memorial parks, and observing critical anniversaries, all of which incorporated the memory of Italy's past into the everyday life of the students.[26]

The nation of Italy and the concept of *italianità* clearly could not be reduced to a series of linguistic or geographical characteristics. Educators and officials wished to impress upon Italians the complexity and richness of their identity. The educational idealist Pietro Romano wrote that the "fatherland is not only a physical place, but a complex of traditions, customs, institutions, laws, language, and also religion, all of which distinguish one people from another."[27] Obviously, the concept of place—of nation—was critical to the evolution of *italianità*. In fact, many historians have argued that such a characterization of *italianità* was simply a version of nationalism and therefore not racism. In reality, however, it would be impossible to separate ideas of Fascist nationalism from the belief in an Italian race. The Italian notion of nation relied upon an ethno-cultural definition of nationalist entitlement.[28] The political scientist and sociologist Liah Greenfeld has explained that "[i]n ethnic nationalisms, "nationality" became a synonym of "ethnicity," and national identity is often perceived as a reflection or awareness of possession of "primordial" or inherited group characteristics, components of "ethnicity," such as language, customs, territorial affiliation, and physical type."[29] In the Italian case, nationalism and ethnicity—or race—formed a dialectical relationship and, as the philosopher Etienne Balibar has written, "the articulation of nationalism and racism cannot be disentangled by applying classical schemas of causality, whether mechanistic (the one as the cause of the other, 'producing' the other according to the rule of the proportionality of the effects to the cause) or spiritualistic (the one 'expressing' the other, or giving it its meaning or revealing its hidden essence)."[30] While drawing much from the physical characteristics of the Kingdom, *italianità* expanded beyond any physical or temporal location. Creating an image of the ideal Italian—one who was in touch with the characteristics that both unified the people of the peninsula and islands and made them superior to other peoples around the world—was essential to preparing young Fascist students for the real work that lay ahead for them: to embody and perpetuate these ideals, leading the people and the nation to a new height of Italian glory throughout the world.

STIRPE

Under Fascism, the idea of an historical lineage of greatness that resided in all people who were born to the land of the Italian peninsula and its islands moved beyond the ideas of a fatherland and nationality; it was at the center of the term *stirpe*. As one Fascist educator argued, "There is a beauty, a kindness, a grace—'the great Latin blood'—in our *stirpe* and our land, that we must admire, possess, and refine with all our potential."[31] The word *stirpe* is still used today to denote family heritage. Both then and now, the word carries with it a sense of personal connection to all those who came before, through a process of spiritual birthright. As one fifth-grade textbook proclaimed in 1929: "And the *stirpe* was one: the *stirpe* of Rome!"[32] Under Fascism the term became highly beneficial to denote the historical lineage of the Italian people: a common spiritual identity that ran through the entire population.

Mussolini further reinforced the connections between ancient Rome and contemporary Italy in his vague but emotional call to Italians to return to their "Roman, Latin, Mediterranean style."[33] In his 1932 book on the fundamentals of Fascist culture, *Fascismo: Scuola di potenza*, renowned children's author Giuseppe Fanelli began with a description of Mussolini's push for the advancement of the Latin *stirpe* and Italy's immortality even before his founding of the Fascist squads in 1919.[34] In part as a result, he argued, the "immortal spirit of Rome" was resurgent throughout Fascism, as the strength and richness of that spirit was inherent in the name of Rome. In the end, he concluded, it was not enough simply to look at the successes of the contemporary regime; it was essential also to consider the Roman traditions upon which the successes of Fascism relied.

In the 1930s, elementary education exhibited a growing emphasis on the idea of the Italian *stirpe*. Elementary teachers and Fascist officials increasingly focused on the continuities between the ancient Roman people and the contemporary Fascist population. As evidence of the necessity for a broad understanding of this shared cultural heritage, in 1938 the regime organized an exhibition on *romanità*, or "Roman-ness," for school children and adults alike in honor of the two-thousandth anniversary of Augustus's birth. The retrospective focused on ancient Roman society, highlighting the cultural, martial, and

political accomplishments of the imperial power. Such an educational showcase acted as public classroom, identifying some of the most valued bonds among Fascists. Very clearly, visitors were meant to find comfort in the supposedly obvious connections and similarities between ancient Roman society and contemporary Fascist society.[35]

The idea of *stirpe* was not as concerned with the physical characteristics with which an Italian was born; more important was the historical, moral, and, in short, spiritual, inheritance of the people. The children's author Vincenzo Meletti explained that the "Italic *stirpe* has always cherished the original characteristics of its healthy and prolific race, since the characteristics of the Italian family, particularly of the countryside, which the Duce has often exalted, have always been these: profound religiosity, unquestioned morality, attachment of fathers to their homes, complete dedication of the woman to her children and home."[36] The critical element to this statement, and to Fascist ideas of identity in general, was the belief that these qualities were inherited. They might additionally be strengthened through moral and healthy lifestyles, but these values were born within all Italians. And while over the course of the 1930s and early 1940s Fascist officials increasingly developed a "scientific," or "objective," veneer for their ideas of the Italian race, these "spiritual," moral, and cultural characteristics were the most valued of the Italian people.

RAZZA

Most closely translated by the English word "race" but more loosely defined as "breed, stock, family, or descent," the concept of *razza* is somewhat difficult to distinguish from the idea of *stirpe*. The difference—which became ever more nominal as the regime progressed—could be encapsulated in the idea that *stirpe* categorized individuals as belonging to the same group diachronically, as having a common historical heritage, whereas *razza* primarily identified a relationship among individuals synchronically, as having a contemporary similitude. In one source that used both terms, the author argued that an imperial consciousness would reaffirm the youth of Italian Fascism. More colonies would illustrate how "the new Italic [*razza*] has kept the glorious destiny of

bringing the [*stirpe*] back to the height of its historic origins."[37] In this statement, the word *razza* indicated a group in which an awareness of its inherent greatness had been reawakened in order to perpetuate the glory that had been passed down through the *stirpe*.

As the sources here indicate, the term *razza* was certainly present in the earliest years of the regime. If it was originally intended to indicate breeds of animals—a kind of cow or dog—it soon became a term used to differentiate ethnic populations. Still, into the 1930s many Italian scholars did not believe in the idea of a nation containing one single "race." Instead, as Arcangelo Ilvento wrote in 1932, "every people [*popolo*] is formed through the historical processes of invasions and wars and the biological processes of encounters between the invaders and the invaded, by an amalgam of various sub-races, fused in the crucible of the Nation, so that one can speak more of a *Stirpe* in an historical sense than of *razza* in a biological sense."[38] In particular, most Italian scholars argued that Italy historically was comprised of several "races" in various regions of the peninsula, but, as Giuseppe Steiner wrote, "the Roman empire slowly equalized and fused all of these various Italic groups into one people, which shared many particular regional characteristics, customs, and habits, but were not different enough to break the unity of the Nation, and instead served to make the civilization more complicated and varied."[39] The theory that the combination of different *razze* actually produced a stronger and more vital people pervaded the Italian racial theories of the late 1920s and early 1930s.[40] Mussolini claimed in his interviews with the prominent German journalist Emil Ludwig, "Of course there are no pure races left; not even the Jews have kept their blood unmingled. Successful crossings have often promoted the energy and the beauty of a nation."[41] Despite the growing usage of the terms *razza* and *stirpe* at the beginning of the new decade, the ambiguity of their definitions allowed the state—and particularly the educational system—to continue creating its own terms for Italian identity.

Particularly as the campaign to develop a more concrete imperial consciousness intensified in the 1930s, the term *razza* became more prominent. Explaining the imperative to inspire an imperial consciousness in students, the Fascist pedagogue Nazareno Padellaro explained that "[t]o know how to instill in children the fair valuation

of other peoples means giving them the healthy pride in being a part of a privileged *razza*. This providential privilege does not need to be verbalized, since it must constitute the atmosphere in which the mind of the child exists. Before admiring others, we must teach students to admire ourselves in our strengths and in the value of our mission."[42] But again, this idea of race did not focus on physical traits. As Mussolini proclaimed in the mid-1930s, "The *razza* for us is not as much blood as it is spirit, it is not so much the quantity of physical things as the ideality of spiritual values that are handed down from generation to generation in a constantly increasing number of citizens."[43]

In part, Fascist ideas of the Italian race could not focus on defining a national physical identity because of the dramatic variety of physical types on the peninsula and the islands. The regime faced significant difficulties in such a task when their nation contained such disparate images as the six-foot, fair-skinned German-speaker from Venezia Tridentina and the five-foot-two, swarthy Calabrese speaking a dialect combining remnants of Greek, Arabic, Spanish, and Italian. Given the rather vague biological composition of the Italian *razza* and the even less clear definition of *stirpe*, the Fascist campaign to strengthen the Italian people and nation logically turned to more historical, moral, and spiritual characteristics that defined the Italian inheritance.

IMPLICATIONS AND CONSEQUENCES

The fact that the terms *italianità, patria, stirpe,* and *razza* had no stable or finite definitions allowed Italians under Fascism to make seemingly contradictory statements. For example, in 1933, one textbook announced, "Italy is a great country and the Duce wants our people to affirm its superiority over all others."[44] Within that same year, in the volume of interviews between Mussolini and Ludwig, Mussolini argued, "Race! It is a feeling, not a reality; ninety-five per cent., at least, is a feeling. Nothing will ever make me believe that biologically pure races can be shown to exist to-day. . . . National pride has no need of the delirium of race."[45] In essence, because the Fascist regime largely did not focus on a "scientific" explanation of the Italian inheritance in the designation of its own identity, it was able to deny the presence of racial discrimination.

Neither Mussolini nor his ministers made a consistent effort to provide a scientific basis for the Italian race, thus allowing the flexibility necessary to include all of the peoples that Fascists identified as "Italian."

The fact of the matter is, however, that the regime identified a framework of attributes embedded in the historical and cultural inheritance of the Italian population that set it apart as a privileged group of people with an inherited legacy of military, political, and cultural grandeur. The idea that the magnificence of ancient Rome lay dormant within the citizens of the Fascist state, waiting for the regime to reawaken the strength that begot the Roman Empire, necessarily created a Fascist imaginary of Italian superiority over other populations outside the peninsula and islands. As Mussolini stated: "It is Fascism which formed the new Italian, the Italian who is proud to be Italian in comparison to all the other, more or less civilized, peoples of the world."[46] While Italian superiority was innate, Mussolini believed he could draw out and strengthen its dominance so that the nation could, once again, become a global civilization.

Linguistically, the use of the same terms throughout the twenty years of the regime familiarized the population with them and made it much easier for Italians to accept modifications to their definitions. In particular, the state was able to use the terms *stirpe* and *razza* in rhetoric that justified increasingly discriminatory and aggressive policies while it was also able argue that, since the terms had been used throughout the regime, such policies were not a departure from fundamental Fascist principles.[47] Ideologically, Fascist rhetoric about Italian identity was vague about what constituted national borders. The essential identity of an Italian, while originating in the land itself, encompassed a nebulous spiritual understanding of the Italian destiny that transcended national borders. This identity then allowed Italy both to invade Ethiopia and to claim the millions of Italian emigrants dispersed throughout the world as its children. It allowed the regime both to pursue political aims on the Greek islands and to pass the 1938 racial laws against Jewish Italians and other undesirables. In short, the Fascist sense of Italian racial superiority gave the regime the ideological legitimacy to privilege certain individuals and discriminate against others.

The fact that the Fascist regime avoided a scientific foundation for these terms for much of the *ventennio* has also allowed many in post-

Fascist society to deny the presence of Italian racism in the twentieth and twenty-first centuries. This argument is both erroneous and quite dangerous. The fact that Fascists used words such as *italianità, patria, stirpe*, and *razza* as well as the Italian education system to create within children a sense of historical and cultural superiority over other populations while allowing them to believe that they were impervious to the more popular "scientific" racism, has allowed many people in postwar Italy to adhere to a set of values that rejects the integration of newer—or simply minority—elements of Italian society: the cultures, histories, and politics of immigrants, visitors, and even victims of Fascist violence.[48] The belief remains, despite strong evidence to the contrary, that there is one pure Italian culture, and this culture can and should remain untouched by outside influences. Until Italians and scholars of Italian history can understand the immense prejudicial qualities of the Fascist rhetoric about Italian identity, the clashes between Italian society and its perceived contaminants will continue, perpetuating some of the greatest evils of Italian Fascist racism. More generally, until scholars of twentieth-century European history start analyzing the Fascist rhetoric of race on a more substantive basis, the full extent of its legacy will remain obscured, within Italy, but also within European society at large.

NOTES

1. For an in-depth analysis of the scholarly trends in Fascist concepts of race, see Aaron Gillette, *Racial Theories in Fascist Italy*, Routledge Studies in Modern European History (New York and London: Routledge, 2002).

2. David Theo Goldberg, "Introduction" in David Theo Goldberg, ed., *Anatomy of Racism* (Minneapolis, MN: University of Minnesota Press,1990), xiv.

3. Matthew Frye Jacobson, *Whiteness of a Different Color: European Immigrants and the Alchemy of Race* (Cambridge, MA and London: Harvard University Press, 1998), 4.

4. Much of the published scholarship on Italian Fascism holds that racism, and in particular anti-Semitism, did not play a significant role in Fascist doctrine and that the invasion of Ethiopia was a result of nationalism and international power politics, while the 1938 race laws were a consequence of colonial realities or Mussolini's fraught relationship with Adolf Hitler. The most prominent of the scholars who hold these views was Renzo De Felice, but he certainly was

not alone. All of these interpretations eclipse the long-standing objectives of the Fascist project—namely the expansion of the Kingdom's borders and the reestablishment of the nation as one of the world's greatest powers—and the very steady evolution of the regime's policies to realize those goals.

5. Research for this chapter relies primarily on published sources: pedagogical and popular journals, teaching manuals, textbooks, and ministerial publications. The texts cited here were collected from a variety of archives, libraries, museums, and flea markets. I would like to extend special thanks to the staffs of the *Archivio Centrale dello Stato* (ACS), *Biblioteca della Storia Moderna e Contemporanea* (BSMC) in Rome, *Biblioteca Giustino Fortunato*, *Biblioteca Nazionale* in Florence, *Biblioteca Nazionale* in Rome, *Biblioteca Marciana* in Venice, *Museo Storico della Didattica* in Rome, American Academy in Rome, Wolfsonian Museum and library in Miami Beach, Florida, and Hoover Institution at Stanford University. All translations are my own, unless otherwise noted.

6. Emilio Alfieri, "La protezione della maternità di fronte al problema demografico," *Maternità ed infanzia* 5, no. 3 (1930): 281–99.

7. For a concise overview of the Italian Risorgimento, see Lucy Riall, *The Italian Risorgimento: State, Society and National Unification* (London and New York: Routledge, 1994).

8. Ernst Renan, "What is a Nation?" in Homi K. Bhabha, ed. *Nation and Narration* (London and New York: Routledge, 1990), 8–22.

9. Armando Esposito, *Nei lieti riposi: Corso euristico di esercizi per gli alunni delle scuole elementari nelle vacanze, classe quinta* (Palermo: Remo Sandron Editore, 1927), 56.

10. Ibid., 45.

11. Anthony D. Smith places the role of common language as critical to an "ethnic" (or, I would say, racial) conception of the nation that characterized the Italian nationalist movement under Fascism. Anthony D. Smith, *National Identity* (Reno: University of Nevada Press, 1991), 12–13, 20.

12. Piero Domenichelli, *L'Adunata: Nuovo coro di letture per le scuole elementari, libro per la quinta classe maschile e femminile* (Florence: R. Bemporad & Figlio, 1929), 23.

13. Benedict Anderson, *Imagined Communities: Reflections on the Origin and Spread of Nationalism*, revised ed. (London and New York: Verso, 1991), 44, 145.

14. Michel Ostenc, *La scuola italiana durante il fascismo*, trans. Luciana Libutti (Rome, Bari: Editori Laterza, 1981), 77.

15. Adrian Hastings, *The Construction of Nationhood: Ethnicity, Religion and Nationalism* (Cambridge: Cambridge University Press, 1997), 31.

16. Arpalice Cuman Pertile, *Fiori di campo: Letture per le scuole rurali; Libro per la quarta classe*, 3rd ed. (Florence: R. Bemporad & Figlio, 1928), 258.

17. Guido D'Ormea, "Le cattedre ambulanti di assistenza materna e puericultura e la protezione del lattante," *Maternità ed infanzia* 5, no. 7 (1930): 704.

18. Giulio Santini, "Le opere assitenziali dei Fasci femminili," *Annali dell'istruzione elementare* 3, no. 5–6 (1928): 6. Specific versions of the state textbooks were published for rural schools and, to further address the needs of the rural population (and the state), the Fascist government established the Rural Radio Organization (ERR) in 1933 under the auspices of the Ministry of Communication. The organization was to help state propaganda "penetrate and conquer the countryside" through radio programs, accompanied by teaching manuals, for elementary classes throughout the Kingdom.

19. Antonio Aliotta, *La formazione dello spirito nello stato fascista* (Rome: Francesco Perrella, 1938).

20. Italiano Marchetti, *Alle soglie della vita: Letture per la formazione dell'italiano nuovo, classe quinta elementare*, 7th ed. (Florence: R. Bemporad & Figlio, 1929), 13.

21. Luigi Adami and Piero Domenichelli, *Il mio libro di preparazione agli esami di ammissione alla prima classe delle scuole medie* (Florence: Vallecchi Editore, 1933), 22–23.

22. Vincenzo Meletti, *Il libro fascista del balilla* (Florence: La 'Nuova Italia' Editrice, 1936), 96.

23. Vito Perroni, *Il Duce ai Balilla: Brani e pensieri dei discorsi di Mussolini, ordinati e illustrati per i bimbi d'Italia* (Rome: Libreria del Littorio, 1930), 51–52.

24. Ostenc, 86.

25. Ercole Di Marco, "La Mostra della Rivoluzione," *Annali dell'istruzione elementare* 8, no. 3 (1933): 200.

26. Benedict Anderson writes most concisely about the importance of communal activities for the creation of national identity in Anderson 141–47. For an interesting discussion on the meaning of a Tomb of the Unknown Soldier, see Thomas W. Lacquer, "Memory and Naming in the Great War", in John R. Gillis, ed. *Commemorations: The Politics of National Identity* (Princeton, NJ: Princeton University Press,1994), 150–67.

27. Pietro Romano, *Per una nuova coscienza pedagogica* (Turin: G. B. Paravia & C., 1923), 42–3.

28. Smith 82–3, 123–42.

29. Liah Greenfeld, *Nationalism: Five Roads to Modernity* (Cambridge, MA: Harvard University Press, 1992), 12.

30. Etienne Balibar, "Racism and Nationalism," in *Nations and Nationalism: A Reader* (Edinburgh: Edinburgh University Press, 2005), 167.

31. Alessandro Marcucci, "Il 'bello' come elemento di educazione," *Annali dell'istruzione elementare* 10, no. 4–6 (1935): 317.

32. Domenichelli 174.

33. Perroni 66.

34. G. Fanelli, *Fascismo: scuola di potenza* (Venice: Tipografia Veneta, 1932), 6.

35. Oreste Gasperini, "Ente radio rurale radioprogramma scolastico n. 80 del 20 aprile 1938–XVI : La mostra augustea della romanità," (Milan and Rome: Tumminelli & Co., 1938).

36. Vincenzo Meletti, *Civiltà fascista per la gioventù, per gl'insegnanti, per il popolo*, 3rd ed. (Florence: "La Nuova Italia" Editrice, 1933), 96.

37. Felice Casale, *A cuore aperto: Libro di lettura per la quinta classe elementare maschile e femminile* (Florence: G. B. Paravia & C., 1929), 261–62.

38. Arcangelo Ilvento, "La salute della stirpe e la sua difesa," *Maternità ed infanzia* 7, no. 10 (1932): 927–28.

39. Giuseppe Steiner, *Coltura Fascista: Brevi nozioni intorno all'opera e alla dottrina fascista* (Turin: G. B. Paravia & Co., 1931), 1–2.

40. The Mediterraneanist school dominated Italian academic circles of racial theorists in this period, with only a few Nordicists advocating the predominant German racial theories. For a discussion of the Italian academic trends in racial theories at this time, see, for example, Gillette 41–49.

41. Emil Ludwig, *Talks With Mussolini*, trans. Eden and Cedar Paul (Boston: Little, Brown, and Company, 1933), 69–70.

42. Nazareno Padellaro, "Coscienza imperiale nella scuola," *Annali dell'istruzione elementare* XII, no. 5–6 (1937): 287.

43. Partito Nazionale Fascista, *Il cittadino soldato* (Rome: La Libreria dello Stato, 1936), 24.

44. Opera Balilla di Milano, *Manuale per il capo squadra balilla* (Milan: Quaderni dell'Opera Balilla di Milano, 1933), 15.

45. Ludwig 69–70.

46. Perroni 89.

47. The Ministry of Popular Culture (MCP) finally put together a document in February 1939 outlining Mussolini's life-long efforts toward the protection of the Italian race. Ufficio Razza Ministero della Cultura Popolare, "Appunto per S. E. il Ministro: La razza nei discorsi del Duce" (Rome, February 24, 1939), ACS, MCP, Gabinetto, Ufficio Razza, b. 12, f. 130: Razzismo—"Appunti Vari." A related article was published in *La difesa della razza* in August 1939. "La

consegna di Mussolini: Raccolta completa delle frasi sulla razza contenute negli scritti e discorsi del Duce," *La difesa della razza* 2, no. 19 (1939): 5–13.

48. Certainly the violent political and popular anti-Roma and anti-Albanian campaigns of the last fifteen years stand out in this regard. Of a less aggressive nature but perhaps more insidious in some ways, are the more recent measures in northern Italy to ban "foreign" food and limit immigrant-owned businesses. See, for example, Rachel Donadio, "A Walled City in Tuscany Clings to Its Ancient Menu," *New York Times*, March 13, 2009, accessed April 20, 2010, http://www.nytimes.com/2009/03/13/world/europe/13lucca.html; Elisabetta Povoledo, "In Italy, Sign of Defiance in a Kebab and a Coke," *New York Times*, April 23, 2009, accessed April 20, 2010, http://www.nytimes.com/2009/04/24/world/europe/24kebab.html?scp=5&sq=italy%20bans&st=cse.

BIBLIOGRAPHY

Adami, Luigi, and Domenichelli, Piero. *Il mio libro di preparazione agli esami di ammissione alla prima classe delle scuole medie*. Florence: Vallecchi Editore, 1933.

Alfieri, Emilio. "La protezione della maternità di fronte al problema demografico." *Maternità ed infanzia* 5, no. 3 (1930): 281–99.

Aliotta, Antonio. *La formazione dello spirito nello stato fascista*. Testi di filosofia e pedagogia. Rome: Francesco Perrella, 1938.

Anderson, Benedict. *Imagined Communities: Reflections on the Origin and Spread of Nationalism*. Revised edition. London and New York: Verso, 1991.

Balibar, Etienne. "Racism and Nationalism." In *Nations and Nationalism: A Reader*, edited by Philip Spencer and Howard Wollman, 163–72. Edinburgh: Edinburgh University Press, 2005.

Casale, Felice. *A cuore aperto: Libro di lettura per la quinta classe elementare maschile e femminile*. Florence: G. B. Paravia & C., 1929.

Cuman Pertile, Arpalice. *Fiori di campo: Letture per le scuole rurali; Libro per la quarta classe*. 3rd edition. Florence: R. Bemporad & Figlio, 1928.

Di Marco, Ercole. "La Mostra della Rivoluzione." *Annali dell'istruzione elementare* 8, no. 3 (1933): 189–209.

Domenichelli, Piero. *L'Adunata: Nuovo coro di letture per le scuole elementari, libro per la quinta classe maschile e femminile*. Florence: R. Bemporad & Figlio, 1929.

Donadio, Rachel. "A Walled City in Tuscany Clings to Its Ancient Menu." *New York Times*, March 13, 2009. Accessed April 20, 2010. http://www.nytimes.com/2009/03/13/world/europe/13lucca.html.

D'Ormea, Guido. "Le cattedre ambulanti di assistenza materna e puericultura e la protezione del lattante." *Maternità ed infanzia* 5, no. 7 (1930): 702–11.

Esposito, Armando. *Nei lieti riposi: Corso euristico di esercizi per gli alunni delle scuole elementari nelle vacanze, classe quinta.* Palermo: Remo Sandron Editore, 1927.

———. *Nei lieti riposi: Corso euristico di esercizi per gli alunni delle scuole elementari nelle vacanze, classe seconda.* Palermo: Remo Sandron Editore, 1927.

Fanelli, G. *Fascismo: scuola di potenza.* Edizioni del Popolo. Venice: Tipografia Veneta, 1932.

Gasperini, Oreste. "Ente radio rurale radioprogramma scolastico n. 80 del 20 aprile 1938–XVI : La mostra augustea della romanità." Milan and Rome: Tumminelli & Co., 1938.

Gillette, Aaron. *Racial Theories in Fascist Italy.* Routledge Studies in Modern European History. New York and London: Routledge, 2002.

Gillis, John R., ed. *Commemorations: The Politics of National Identity.* Princeton, NJ: Princeton University Press, 1994.

Goldberg, David Theo, ed. *Anatomy of Racism.* Minneapolis, MN: University of Minnesota Press, 1990.

Greenfeld, Liah. *Nationalism: Five Roads to Modernity.* Cambridge, MA: Harvard University Press, 1992.

Hastings, Adrian. *The Construction of Nationhood: Ethnicity, Religion and Nationalism.* Cambridge: Cambridge University Press, 1997.

Ilvento, Arcangelo. "La salute della stirpe e la sua difesa." *Maternità ed infanzia* 7, no. 10 (1932): 926–45.

Jacobson, Matthew Frye. *Whiteness of a Different Color: European Immigrants and the Alchemy of Race.* Cambridge, MA and London: Harvard University Press, 1998.

"La consegna di Mussolini: Raccolta completa delle frasi sulla razza contenute negli scritti e discorsi del Duce." *La difesa della razza* 2, no. 19 (1939): 5–13.

Lacquer, Thomas W. "Memory and Naming in the Great War." In *Commemorations: The Politics of National Identity*, John R. Gillis, ed., 150–67 (Princeton, NJ: Princeton University Press, 1994).

Ludwig, Emil. *Talks With Mussolini.* Translated by Eden and Cedar Paul. Boston: Little, Brown, and Company, 1933.

Marchetti, Italiano. *Alle soglie della vita: Letture per la formazione dell'italiano nuovo, classe quinta elementare.* 7th edition. Florence: R. Bemporad & Figlio, 1929.

Marcucci, Alessandro. "Il 'bello' come elemento di educazione." *Annali dell'istruzione elementare* 10, no. 4-6 (1935): 313–28.

Meletti, Vincenzo. *Civiltà fascista per la gioventù, per gl'insegnanti, per il popolo*. 3rd edition. Florence: "La Nuova Italia" Editrice, 1933.

———. *Il libro fascista del balilla*. Florence: La 'Nuova Italia' Editrice, 1936.

Milano, Opera Balilla di. *Manuale per il capo squadra balilla*. Milan: Quaderni dell'Opera Balilla di Milano, 1933.

Ministero della Cultura Popolare, Ufficio Razza. "Appunto per S. E. il Ministro: La razza nei discorsi del Duce." Rome, February 24, 1939. ACS, MCP, Gabinetto, Ufficio Razza, b. 12, f. 130: Razzismo—'Appunti Vari.'

Ostenc, Michel. *La scuola italiana durante il fascismo*. Translated by Luciana Libutti. Rome, Bari: Editori Laterza, 1981.

Padellaro, Nazareno. "Coscienza imperiale nella scuola." *Annali dell'istruzione elementare* 12, no. 5-6 (1937): 279–89.

Partito Nazionale Fascista. *Il cittadino soldato*. Testi per i corsi di preparazione politica. Rome: La Libreria dello Stato, 1936.

Perroni, Vito. *Il Duce ai Balilla: Brani e pensieri dei discorsi di Mussolini, ordinati e illustrati per i bimbi d'Italia*. Rome: Libreria del Littorio, 1930.

Povoledo, Elisabetta. "In Italy, Sign of Defiance in a Kebab and a Coke." *New York Times*, April 23, 2009. Accessed April 20, 2010. http://www.nytimes.com/2009/04/24/world/europe/24kebab.html?scp=5&sq=italy%20bans&st=cse.

Renan, Ernst. "What is a Nation?" In *Nation and Narration*, Homi K. Bhabha, ed., 8–22. London and New York: Riutledge, 1990.

Riall, Lucy. *The Italian Risorgimento: State, Society and National Unification*. Edited by John Davis, Geoffrey Crossick, Joanna Innes, Tom Scott. London and New York: Routledge, 1994.

Romano, Pietro. *Per una nuova coscienza pedagogica*. Turin: G. B. Paravia & C., 1923.

Santini, Giulio. "Le opere assitenziali dei Fasci femminili." *Annali dell'istruzione elementare* 3, no. 5–6 (1928): 5–7.

Smith, Anthony D. *National Identity*. Reno, NV.: University of Nevada Press, 1991.

Steiner, Giuseppe. *Coltura Fascista: Brevi nozioni intorno all'opera e alla dottrina fascista*. Turin: G. B. Paravia & Co., 1931.

INDEX

ABOUT THE CONTRIBUTORS

Malcolm Angelucci is a lecturer in Italian studies and cultural studies at the University of Technology, Sydney. He researches in Italian early modernist literature, Italian theatre of the second half of the twentieth century (Carmelo Bene), poetic, rhetoric, and stylistics. Parallel to his focus on literature and aesthetics, he pursues his interest in the study of public monuments, focused on the relationships between rhetoric, ideologies and space. Among Malcolm's recent publications is the volume *Words Against Words: On the Rhetoric of Carlo Michelstaedter* (Leicester: Troubador, 2011).

Victoria Belco holds both a JD and a PhD from the University of California, Berkeley. After practicing as a criminal defense attorney, she is now an associate professor of modern European history at Portland State University. Her book, *War, Massacre, and Recovery in Central Italy, 1943–1948*, was released by University of Toronto Press in June 2010. She is currently researching crime and criminal justice in Fascist Italy.

Floriana Bernardi is a teacher of English in secondary schools and a PhD candidate in theory of language and sign sciences in the Depart-

ment of Lettere, Lingue Arti of the University of Bari. Her research focuses on social semiotics and cultural studies. Her more recent publications include "Gazes, Targets, (En)Visions: Reading Fatima Mernissi through Rey Chow" in *Social Semiotics* (Routledge 2010) and *Studi culturali: Teoria, Intervento, Cultura Pop*, an edited and translated volume of selected essays by Paul Bowman (Progedit 2011).

Emilio G. Berrocal is a social anthropology PhD student at Durham University. He previously attended the University of Rome "La Sapienza" where he obtained both his first ("Laurea Triennale") and second ("Laurea Specialistica") university degrees in anthropology as well. For his PhD research, Berrocal is working on a multisited ethnography project about hip-hop culture. He is carrying on his fieldwork research in London after having completed an ethnographic work on "black Italian hip hoppers" in Rome.

Alberto Bologna, architect, PhD, is now a postdoc researcher in the history of architecture at Ècole Polytecnique Fédérale de Lausanne in Switzerland. He focuses his research on the design and intellectual activities of Pier Luigi Nervi in the United States between 1952 and 1979. He is author of several articles and editor of books. He works as a freelance architect and is engaged in the presentation of his studies at international conferences in Europe and in the United States.

Paolo Campolonghi graduated in Philosophy of Science at the Università Statale degli Studi in Milan and received a master's in Italian cultural studies from the University of Illinois at Urbana-Champaign. He is currently a PhD student in the Department of Italian Studies at New York University, working primarily on nineteenth- and twentieth-century Italian and European intellectual history.

Michele Cometa is a professor of comparative literature at the University of Palermo. He is the author of *Studi Culturali* (Napoli: Guido, 2010) and of a cowritten volume with Alain Montandon entitled *Vedere. Lo sguardo di E.T.A Hoffman* (Palermo: Duepunti, 2009). He has edited the book *L'età classico-romantica* (Roma: Laterza, 2009).

Maria D'Anniballe holds a PhD degree from the University of Pittsburgh, where she is currently teaching as a visiting lecturer in the Department of History of Art and Architecture. Her areas of specialization include architectural history and theory, the avant garde, and modern Italian art and architecture. Her dissertation entitled "Urban Space in Fascist Verona: Contested Grounds for Mass Spectacle, Tourism, and the Architectural Past" focuses on the relationship between mass media, tourism, and architecture in Verona during the Fascist regime. She has published articles on the subject in Italian and English journals.

Alessandro Dal Lago, a former visiting professor at the University of Pennsylvania and UCLA, is professor of sociology of culture at the University of Genoa, Italy. He has published on sociological theory, sociology of art, and theory of culture. Among his recent books in English are *Non-persons: The exclusion of migrants in a global society* (Milan: Ipoc Press, 2009) and *Conflict, Security, and the Reshaping of Contemporary Society: The Civilization of War* (London: Routledge, 2010) (with S. Palidda). He is also author of two collections of short stories.

Roberto Derobertis completed his PhD in Italian studies in 2007 at the University of Bari. His research interests focus on the relationship between migrations, colonialism, postcolonial condition and Italian literature. He has coedited the volume *L'invenzione del Sud. Migrazioni, condizioni postcoloniali, linguaggi letterari* (Bari 2009), and has edited *Fuori centro. Percorsi postcoloniali nella letteratura italiana* (Rome 2010). He teaches English in high schools and currently collaborates with the chair of Italian literature at the Faculty of Modern Languages and Literatures at the University of Bari.

Derek Duncan is professor of Italian cultural studies at the University of Bristol. He has published extensively on modern Italian literature and film with a particular emphasis on issues of sexuality, gender, and migration. He is author of *Reading and Writing Italian Homosexuality: a case of possible difference* (2006), and has edited a number of publications on Italian colonial and postcolonial culture, including *National Belongings* (2010). He is editor of the cultural studies issue of the long-established journal *Italian Studies*. His current research project looks at the intersection of sexual and racial identities in contemporary Italian culture.

David Forgacs is Guido and Mariuccia Zerilli-Marimò Professor of Contemporary Italian Studies at New York University. He formerly held the established Chair of Italian at University College London and before that he taught at Royal Holloway University of London, Cambridge and Sussex. Publications include *Italy's Margins* (2012), *Mass Culture and Italian Society from Fascism to the Cold War* (with Stephen Gundle, 2007), *L'industrializzazione della cultura italiana* (2nd edition, 2000), *Italian Cultural Studies* (ed., with Robert Lumley, 1996).

Eden Knudsen is a historian specializing in modern Italy, comparative fascism, and the politics and culture of nationalism. She received her PhD in history from Yale University in 2010 and is currently a visiting assistant professor at Western Connecticut State University.

Bernadette Luciano is an associate professor of Italian in the School of European Languages and Literatures at the University of Auckland. She has published articles and book chapters on Italian cinema; film adaptation; Italian women's historical novels; women's autobiographical writing; and literary translation. She has coedited an interdisciplinary book on NZ/European cross-cultural encounters and has written a book on Italian filmmaker Silvio Soldini, *The Cinema of Silvio Soldini: Dream, Image, Voyage*. She is currently working with Susanna Scarparo on a book on contemporary Italian women filmmakers.

Elizabeth Mangini is an assistant professor of visual studies at California College of the Arts in San Francisco. An art historian specializing in social histories of postwar and contemporary art, her current research projects include a study of *Arte povera* in Turin c. 1968. She has held curatorial positions and postgraduate fellowships at the Museum of Modern Art, New York, the Walker Art Center, Minneapolis, and MASS MOCA. She writes for *Artforum* and is on the editorial board of *Palinsesti, Contemporary Italian Art On-Line Journal*.

Valerie McGuire is a PhD candidate in Italian studies at New York University. Her dissertation is a cultural history of Italian rule in the Dodecanese archipelago between the wars. She focuses on the creation of a Mediterranean modernity in the urban landscape in the islands, and

through the use of oral history, its potential impact on the local community. She is also coeditor of the volume, *Power and Image in Early Modern Europe* (Cambridge Scholars Press, 2008).

Toshio Miyake is currently a Marie Curie International Incoming Fellow at Ca' Foscari University Venice (2011–2013). He received an MA in Sociology from Ritsumeikan University Kyoto and a PhD in Japanese Literature from Ca' Foscari University Venice. His revised PhD thesis has been published as *Occidentalismi. La narrativa storica giapponese* (Cafoscarina, 2010). His main research interests are Occidentalism, Orientalism, and Self-Orientalism in Italy-Japan relations, especially in terms of nation, race/ethnicity, gender related issues, as well as globalization of Japanese popular cultures (manga, anime, youth subcultures).

Graziella Parati is the Paul D. Paganucci Professor of Italian Literature and Language and professor of comparative literature and women's and gender studies at Dartmouth College, NH. She is the author of a number of books including *Migration Italy: The Art of Talking Back in a Destination Culture* (Toronto: University of Toronto Press, 2005) and a number of edited or coedited volumes: *The Cultures of Italian Migration: Diverse Trajectories and Discrete Perspectives* coedited with Anthony Tamburri (Madison, NJ: Fairleigh Dickinson University Press, 2011) and *Multicultural Literature in Contemporary Italy,* coedited with Marie Orton (Madison, NJ: Fairleigh Dickinson University Press, 2007).

Eugenia Paulicelli is a professor of italian and women's studies at Queens College and at the CUNY Graduate Center where she codirects the Concentration in Fashion Studies. Among her recent publications as author and editor: *Fashion under Fascism: Beyond the Black Shirt* (Oxford: Berg, 2004), *Moda e Moderno. Dal Medioevo al Rinascimento* (Rome: Meltemi, 2006), *The Fabric of Cultures: Fashion, Identity, Globalization* (London: Routledge, 2008), *1960. Un anno in Italia: Tra cultura e spettacolo* (Cesena: Societa' editrice Il Ponte Vecchio, 2010).

Loredana Polezzi is an associate professor in Italian studies at the University of Warwick (UK) and director of the Warwick Centre in Venice. Her main research interests are in translation studies and the

history of travel writing. Her recent work focuses on how geographical and social mobility are connected to theories and practices of translation and self-translation. She is currently completing a monograph on images of Africa produced by Italian travelers and coediting special issues of the journals *Studies in Travel Writing* and *Textus*.

Elena Pulcini is a full professor of social philosophy in the Department of Philosophy, University of Florence. Her main research focuses on the topic of passions in the sphere of a theory of modernity and modern individualism, also paying attention to the problem of female subjectivity. Her current research revolves around the transformation of identity and social bonds in the global age. Between her publications: *L'individuo senza passioni. Individualismo moderno e perdita del legame sociale* (Torino: Bollati Boringhieri, 2001) and *La cura del mondo. Paura e responsabilità in età globale* (Torino: Bollati Boringhieri, 2009): English translation forthcoming by Lexington and Springer, 2012.

Krešimir Purgar specializes in visual studies, film, and contemporary Italian literature, as well as in the relationship between text and image. He is author of two books: *The Neo-Baroque Subject* and *Surviving Image*, and has edited *Visual Studies—Art and Media in the Times of Pictorial Turn*. He has given papers in many cities, including Guadalajara (Mexico), Genova, Colorado Springs, Dartmouth College, Manchester, London, Barcelona, and others. He is a researcher and head of the Center for Visual Studies in Zagreb.

Susanna Scarparo is Cassamarca Senior Lecturer in Italian Studies, Monash University, Australia. She is the author of *Elusive Subjects: Biography as Gendered Metafiction* (2005) and has coedited *Violent Depictions: Representing Violence Across Cultures* (2006), *Across Genres, Generations and Borders: Italian Women Writing Lives* (2005), and *Gender and Sexuality in Contemporary Italian Culture: Representations and Critical Debates* (2010). She has published numerous articles and book chapters on Italian women writers, Italian feminist theory, Italian-Australian literature, and Italian cinema. She is currently writing a book with Bernadette Luciano on Italian women filmmakers.

Antonella Sisto is a Mellon Post-Doctoral Fellow at Smith College and University of Massachusetts, Amherst. She received her PhD from Brown University in 2010 and is currently working on a manuscript on the politics, ethics, and aesthetics of the soundtrack in Italy, from its fascist dubbed-coming to the screens, to the audiovisual cinema of poetry of Pier Paolo Pasolini and Michelangelo Antonioni. Her research interests include history of ideas and technologies, fascism, cinema and identity, aural and visual studies.

Gabriella Turnaturi is the Alma Mater Professor at University of Bologna, Italy. Her fields of research are sociology of culture, sociology of emotions, sociology of literature, theory of public sphere. She has published many books and articles. Her more recent works are: *Betrayals*, Chicago University Press, and *Signore e Signori d'Italia—una storia delle buone maniere*, Feltrinelli.

David Ward is author of four books, three in English—*A Poetics of Resistance: Narrative and the Writings of Pier Paolo Pasolini*; *Antifascisms: Cultural Politics in Italy, 1943–46* (both Fairleigh Dickinson University Press, 1995 and 1996 respectively); *Piero Gobetti's New World: Antifascism, Liberalism, Writing* (University of Toronto Press, 2010) –and one in Italian, *Carlo Levi: Gli italiani e la paura della libertà* (Rizzoli/ Nuova Italia, 2002). He is professor of Italian in the Department of Italian Studies, Wellesley College.

Paola Zaccaria is a professor of literary and visual Anglo-American cultures, director of the degree course in communication studies at the University of Bari, Italy. She is an activist in human rights and gender issues. She has published books and essays on twentieth-century Anglo-American avant gardes, women's poetry, feminist criticism, Chicana and African American literature, border and diaspora studies, transnationalism, interculturality, translations/transpositions/transcodifications, film theory, public culture, space and sentiments. She has also translated and edited *Borderlands/La frontera,* by G. Anzaldúa (Bari: Palomar 2000), and produced a documentary about Anzaldúa's heritage, *ALTAR: Cruzando Fronteras, Building Bridges* (directors Daniele Basilio, P. Zaccaria, 2009).